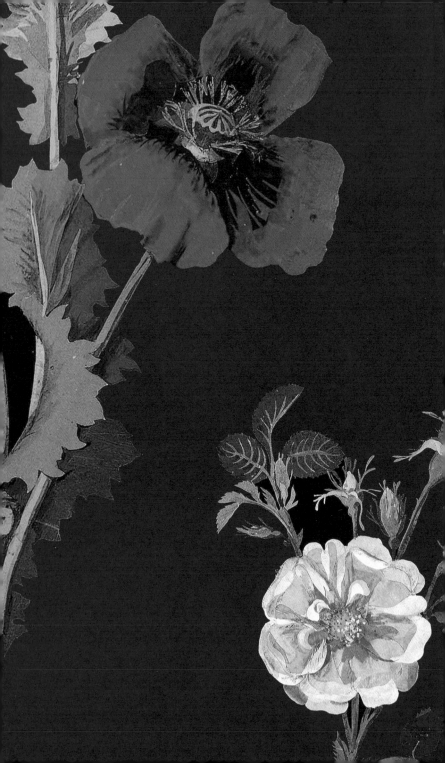

MOLLY PEACOCK

THE

PAPER

GARDEN

AN ARTIST
{BEGINS HER LIFE'S WORK}
AT 72

BLOOMSBURY
NEW YORK · BERLIN · LONDON · SYDNEY

Published by Bloomsbury USA, New York

All papers used by Bloomsbury USA are natural, recyclable
products made from wood grown in well-managed forests.
The manufacturing processes conform to the
environmental regulations of the country of origin.

LIBRARY OF CONGRESS CATALOGING-IN-PUBLICATION DATA HAS BEEN APPLIED FOR.

ISBN: 978-1-60819-523-7

Originally published in Canada in 2010 as *The Paper Garden: Mrs.
Delany Begins Her Life's Work at 72* by McClelland & Stewart Ltd.

First U.S. Edition 2011

1 3 5 7 9 10 8 6 4 2

Printed in China by C&C Offset Printing Co., Ltd.

for

Michael Groden
Ruth Hayden
Augusta Hall, née Waddington (1802–96)
Ruth McMann Wright (1896–1976)
Pauline Wright Peacock (1919–92)

&

all those for whom it's never too late

How can people say we grow indifferent as we grow old?
It is just the reverse . . .

Mary Delany to her sister, Anne Dewes,
Dublin, July 7, 1750

The career of flowers differs from ours only in inaudibleness.
I feel more reverence as I grow for these mute creatures whose
suspense or transport may surpass my own.

Emily Dickinson to her cousins
Louise and Frances Norcross,
ca. April 1873

CONTENTS

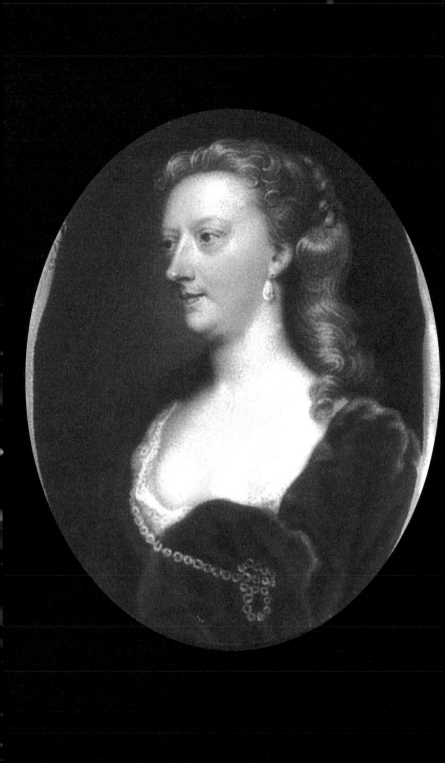

Chapter One.

SEEDCASE

Imagine starting your life's work at seventy-two. At just that age, Mary Granville Pendarves Delany (May 14, 1700–April 15, 1788), a fan of George Frideric Handel, a sometime dinner partner of satirist Jonathan Swift, a wearer of green-hooped satin gowns, and a fiercely devoted subject of blond King George III, invented a precursor of what we know as collage. One afternoon in 1772 she noticed how a piece of colored paper matched the dropped petal of a geranium. After making that vital imaginative connection between paper and petal, she lifted the eighteenth-century equivalent of an X-Acto blade (she'd have called it a scalpel) or a pair of filigree-handled scissors – the kind that must have had a nose so sharp and delicate that you could almost imagine it picking up a scent. With the instrument alive in her still rather smooth-skinned hand, she began to maneuver, carefully cutting the exact geranium petal shape from the scarlet paper.

Then she snipped out another.

And another, and another, with the trance-like efficiency of repetition – commencing the most remarkable work of her life.

1

Portrait of Mary Granville Pendarves (later Delany) in gold box, by Christian Friedrich Zincke, ca. 1740

Her previous seventy-two years in England and Ireland had already spanned the creation of Kew Gardens, the rise of English paper making, Jacobites thrown into the Tower of London, forced marriages, women's floral-embroidered stomachers, and the use of the flintlock musket – all of which, except for the musket, she knew very personally.

She was born Mary Granville in 1700 at her father's country house in the Wiltshire village of Coulston, matching her life with the start of this new century, one that would be shaped by many of her friends and acquaintances. She would see the rise of the coffee house (where she took refuge on the day of the coronation of George II) and of fabulously elaborate court gowns (one of which she designed). She would hear first-hand of the voyage of Captain Cook (financed partly by her friend the Duchess of Portland) and be astounded by that voyage's horticultural bonanza (instigated by her acquaintance Sir Joseph Banks). She would attend her hero Handel's *Messiah*. She would share a meal with the soprano Francesca Cuzzoni and read in a rapture Samuel Richardson's epistolary novel *Clarissa*. She would flirt with Jonathan Swift. In middle age, at mid-century, she would see the truth of his cudgel of an essay on Irish poverty, and in her old age she would feel the sting of a revolution on the other side of the world that divided North America into Canada and the United States.

By the time she commenced her great work, she had long outlived her uncle, the selfish Lord Lansdowne (a minor poet and playwright and patron of Alexander Pope); she had survived a marriage at age seventeen to Alexander Pendarves, a drunken sixty-year-old squire who left her nothing but a widow's pension; she had tried to get a court position and found herself in a bust-up of a relationship

with the peripatetic Lord Baltimore. But with a life-saving combination of propriety and inner fire, she also designed her own clothes, took drawing lessons with Louis Goupy, cultivated stalwart, lifelong friends (and watched her mentor William Hogarth paint a portrait of one of them), played the harpsichord and attended John Gay's *The Beggar's Opera*, owned adorable cats, and wrote six volumes' worth of letters – most of them to her sister, Anne Granville Dewes (1701–61), signifying a deep, cherished relationship that anyone with a sister would kill for.

She bore no children, but at forty-three she allowed herself to be kidnapped by love and to flout her family to marry Jonathan Swift's friend Dean Patrick Delany, a Protestant Irish clergyman. They lived at Delville, an eleven-acre estate near Dublin, where Mary attended to a multitude of crafts, from shell decoration to crewelwork, and, with the Dean, renovated his lands into one of the first Picturesque gardens in the British Isles.

But she made the spectacular mental leap between what she saw and what she cut four years after he died, and eleven years after her sister died. She was staying with her insomniac friend Margaret Cavendish Bentinck, the Duchess Dowager of Portland, at the fabulous Bulstrode, an estate of many acres in Buckinghamshire. The Duchess, who would stay up being read to for most of the night and rarely rose before noon, was one of the richest women in England. Her Dutch-gabled fortress, presiding over its own park, with its own aviary, gardens, and private zoo, housed her collections of shells and minerals, and later the Portland Vase, a Roman antiquity which now occupies a spot in the British Museum. By then the two women had been friends for more than four decades. (They met when Margaret was a little girl and

Mary was in her twenties. Margaret would always have been referred to by her title, except by those of us centuries later who seek to know her on a first-name basis. Mary would have called Margaret "Duchess," and Margaret would have called Mary "Mrs.")

Snip.

Mary Delany took the organic shapes she had cut and recomposed them in the mirror likeness of that geranium, pasting up an exact, life-sized replica of the flower on a piece of black paper.

Then the Duchess popped in.

She couldn't tell the paper flower from the real one.

Mrs. D., which is what they affectionately call her at the British Museum, dubbed her paper and petal paste-up a *flower mosaick*, and in the next ten years she completed nearly a thousand cut-paper botanicals so accurate that botanists still refer to them – each one so energetically dramatic that it seems to leap out from the dark as onto a lit stage. Unlike pale botanical drawings, they are all done on deep black backgrounds. She drenched the front of white laid paper with black watercolor to obtain a stage-curtain-like darkness. Once dry, she'd paste onto these backgrounds hundreds – and I mean hundreds upon hundreds – of the tiniest dots, squiggles, scoops, moons, slivers, islands, and loops of brightly colored paper, slowly building up the verisimilitude of flora.

4 "I have invented a new way of imitating flowers," she wrote with astonishing understatement to her niece in 1772.[1]

How did she have the eyesight to do it, let alone the physical energy? How, with her eighth-decade knuckles and wrists, did she manage the dexterity? Did her arm muscles not seize up? Now Mrs. D.'s works rustle in leather-edged

volumes in the British Museum's Department of Prints and Drawings Study Room, where they have been sequestered since her descendant, Lady Llanover, donated them in 1895.

Seventy-two years old. It gives a person hope.

Who doesn't hold out the hope of starting a memorable project at a grand old age? A life's work is always unfinished and requires creativity till the day a person dies. Even if you've managed major accomplishments throughout your life and don't really need a model for making a mark, you do need one for enriching an ongoing existence.

Where was she when she cut out her first mosaick? In the spacious ground-floor apartments that the Duchess had assigned her at Bulstrode. What time was it? Probably sometime in the morning. At night, with short candles burning (she preferred short candles because they shed more intense, lower light), it would have been time for embroidery or handiwork. Was it messy? Oh, it was messy. The Duchess was always having to clean up all their projects when she was expecting guests: her vast collection of shells and their flaking, her minerals and their dust, her exotic plants and their shedding particles of leaves.

Mrs. Delany did not pick up a quill pen, nor did she draw. Instead, she entered a mesmerized state induced by close observation. If you have ever looked at a word so long that it becomes unfamiliar, you have crossed into a similar state, seizing on detail, then seizing up, because that very focus blurs the context of meaning. This is the mental ambi-ence in which a ghost of something can appear. A memory. An atmosphere of a time in life long gone but now present and almost palpable to the touch. Touch is the operative word here because Mary Delany touched many implements. According to those who've tried to recreate her technique,

Mrs. Delany used tweezers, a bodkin (an embroidery tool for poking holes), perhaps a thin, flat bone folder (shaped like a tongue depressor and made for creasing paper), brushes of various kinds, mortar and pestle for grinding pigment, bowls to contain ox gall (the bile of cows which when mixed with paint made it flow more smoothly) and more bowls to contain the honey that would plasticize the pigment for her inky backgrounds, pieces of glass or board to fix her papers, pins to hang her papers to dry.[2] It was a feast for the tactile sense; it was dirty, smelly, prodigious.

If you make an appointment to see the flower mosaicks in the Prints and Drawings Study Room of the British Museum, they will let you hold these miracles by the edges of their mats (provided you borrow a pair of chalky curatorial gloves) or even let you turn the pages of their albums. I dare you not to release a dumbfounded syllable or two out of sheer disbelief and disturb the whole staid mahogany room. The flowers are portraits of the possibilities of age. They *are* aged. They can be portraits of sexual intensity – but softened. Softer, and drier, as our sexuality becomes. Yet they also can be simple botany, nearly accurate representations of specimens. They all come out of darkness, intense and vaginal, bright on their black backgrounds as if, had she possessed one, she had shined a flashlight on nine hundred and eighty-five flowers' cunts.

Flowers are plants' sexual organs, after all. There are only four parts a person has to remember that each flower has in common, no matter how different they look: sepals (the leaves that encase the bud), petals, stamens (the male organs), and pistils (the female organs). The work Mrs. Delany labeled her "first essay," the *Scarlet Geranium and Lobelia cardinalis*, resembles two pressed flowers in

ladylike quietude, but a bully of inspiration begins to burst forth in the ones she began to create after that, muscular, vibrant, petiolate. They do not exude the full-flesh sexuality of the flower paintings that Georgia O'Keeffe executed in her sensual thirties, but they are sensuous in the tender, yielding way of deeply adult touch.

As they veer between the dignified and the sensual, the flower mosaicks seem to be as complex as Mrs. D.'s personality. They hold the opposites of intrepidity and shyness, inspired daring and the deliberate anonymity that frustrated her beloved husband Patrick Delany yet endeared her to him. (He wanted her to show off, to play the harpsichord or dance in company, and though she was reputed to be a stunning musician and a delightful dancer, she would adamantly refuse.) But don't confuse her with the prissy ladies in nineteenth-century novels. She lived a century before, when politeness did not mean squeamishness, when elaborate manners existed side by side with blood and bile. Mary Granville, then Pendarves, then Delany was a complicated character in a multi-leveled, socially ornate world. But if a role model in her seventies isn't layered with contradictions – as we all come to be – then what good is she? Why bother to cut the silhouette of another's existence and place it against our own if it isn't as incongruous, ambiguous, inconsistent, and paradoxical as our own lives are?

A few of the papers she used – all of the papers in the eighteenth century were handmade – in fact were wall-papers, but mostly she painted large sheets of rag paper with watercolor, let them dry, then cut from them the hundreds of pieces she needed to reproduce – well, to re-evoke might be a better word – the flower she was portraying. There is no reproduced hue that matches the

thrill of color in nature, yet Mrs. D. went after the original kick of natural color, and she did it like a painter. If you look at photographic reproductions of her work in a book like this, you may swear to yourself that her flowers are painted. But if you go to the British Museum Web site,[3] zoom in on the image, then zoom in again and again, at last you will see the complicated overlapping layers of cut paper that this book shows in enlargements of details.

The black background of the mosaicks meant that Mrs. Delany downplayed light sources and shadows, as she was taught. The conventions of English botanical painting intentionally aimed to depict the form of each specimen with utmost clarity.[4] Her flowers are, for the most part, botanically accurate, but not realistic. They provoke a person to understand that there is a material difference between accuracy and realism. The full flower heads with their main flower parts, along with the buds, the vines, the stems, and the leaves, are palpable, but they don't appear exactly as in nature. (For one thing, the root systems aren't shown.) Because of the seeming absence of light, they loom as if they are imaginary. They are more like incredibly vivid memories than representations and are reminiscent of poems in their layerings of lines and in the ways they rhyme their colors. Just as it takes a magnified attention to see how an actual flower is made, it takes an Ultra Optix 2x power lens with a 5x bifocal magnifying glass to tackle the poetic complexity of these virtual flowers. After all, Mrs. Delany dissected her specimens in order to render their splendor in her cut-out likenesses.

Each of Mrs. Delany's flower mosaicks is a portrait, highly individual, full of personality, the bloom posed as a human figure might be positioned in a painter's portrait. In the

dream-like, luminous atmosphere of memory, imagination, and mourning, the flowers have something of the feel of self-portraits as well. The flowers are like dancers. Like daydreamers. Like women blinking in silent adoration. Like children playing. Like queens reigning or divas belting out their arias. Like courtesans lying on bedclothes. Like girls hanging their heads in shame. Like, like, like. Along with the scissors, the scalpel, the bodkin, the tweezers, the mosaicks make use of one of the main tools of the poet: simile. By comparing one thing to another, a simile leaves the original as it is – say, just a flower – but it also states what that is *like*, making a threshold into another world.

When Mrs. D. picked up her scissors, grief was the chief prompt. After her beloved Dean Delany's death in 1768, which followed the death of her sister, Anne, in 1761, she wrote that she considered each of her flower portraits to be "an *employment* and *amusement*, to supply the loss of *those* that had formerly been delightful to me; but had lost their power of pleasing; being depriv'd of that friend, whose partial approbation was my pride, and had stampt a value on them."[5] By "those" she meant Anne and the stopping of their lively, vital correspondence. By "friend" she meant the Dean, in the eighteenth-century sense of friendship that was familial. He was absolutely the friend that a husband can become. She was bereft of the spark of his approbation and encouragement and deprived of that sturdy sounding board that Anne had provided all their lives.

Patrick Delany had not been one of those family-assigned eighteenth-century aristocratic mates. She'd already had one of those as a teenager, and it had almost deformed her emotionally. For her second marriage (and her second life), she decamped from England to live in Ireland, though she

9

maintained her house in London and her ties to family and friends. With Patrick her life metamorphosed from something brittle and sometimes desperate into an existence that was softer and more expansive.

He was born on March 15, 1685, in Rathkrea, Queen's County, Ireland, the son of a servant to an Irish judge. Educated in Athy, County Kildare, his intelligence won him a place at Trinity College, where he was much loved and admired.[6] He was not part of the aristocracy, but part of an emerging meritocracy. He wrote many turgid sermons and some hopeful poetry. He was too earnest to be really witty, although he was a great pal of Jonathan Swift, the wit of his age. Swift described him to Alexander Pope in a 1730 letter as "a man of the easyest and best conversation I ever met with in this Island, a very good listener, a right reasoner, neither too silent nor talkative . . . but hath too many acquaintance." A vastly social man, Delany loved entertaining, which is how he met Mary. Friends had brought her along to dinner at his Dublin house, Delville. But Delany was already engaged to the very wealthy Margaret Tennison.[7] Mary would hear about him in subtle, casual inquiries, sometimes through Jonathan Swift, throughout the twelve years of this marriage. Then Margaret Tennison died. Mary was forty-three; Patrick was sixty-one. She was at a point in her life when wit fizzled, irony paled, and she was ready to fall in love with earnestness. In the spring of 1743 Patrick Delany tracked her down and popped the question.

Mrs. Delany throve for twenty-three years in her marriage to the Dean – embroidering, mounting shells in grottoes, raising a herd of deer, drawing, painting, redecorating, and entertaining all who passed through Dublin, from influential bishops to the extravagant Lennox sisters, daughters of the

Duke of Richmond. And it was at Delville that gardening became a true devotion. By refusing to level the contours of the estate, she preserved the twisting paths through the woods and downplayed the ordered parterres and *allées* that Patrick Delany and his friend Richard Helsham had spent a fortune on. (Their garden debt was mocked by Swift: "And when you've been at vast expenses / in whims, parterres, canals and fences, / Your assets fail . . .")[8] Instead, Mrs. D. designed natural theatres to show off her flowers and spaces to share with women friends, such as a "Pearly Bower"[9] (a sheltered arbor planted with flowers) for her sister Anne.

By the time she was widowed at sixty-eight, she had been loved candidly and clear-sightedly, not in a blur of romance but in clarity of observation, with true acceptance. It was not a sweeping love but a lucid love, or, as Dean Delany would write in a poem to her, twelve whole years after their wedding, "My pride, my life, my bliss, my care!"[10] When the Dean died, she knew as a stout Christian that she would meet him in the next world. But she was still on earth, recuperating from his last years. After a grueling extended lawsuit and professional complications, the Dean's reputation had been narrowly snatched back from a precipice, with a huge physical toll on the elderly clergyman. So after the lawyers came the doctors, the repeated trips to the spa at Bath to take the waters, the blisterings, the bleedings – all the brutal methods of eighteenth-century medicine that could kill you.

Mrs. D.'s letters reveal her to be an absolute wreck in the first years of her widowhood. She was dislocated, indecisive, and heavily reliant on the presence of her friend the Duchess Dowager, generous and considerate and eccentric and a widow herself. She no doubt understood the vigor

unique to mourning. It's an emotional workout as much as an emotional drain. The Duchess, about fifteen years younger than Mary, must have understood that a shadow of an idea could slip into place as the new routines of widowhood and the bustle of reconnecting friendships increased, understood that her house and her interests were providing for her friend a feeling of safety as, very, very slowly, Mary woke from her stupor of grief and held a piece of black paper behind that first geranium, emphasizing the plant's profile, its silhouette. In the embrace of Bulstrode the inchoate inventor of collage, or the *Flora Delanica*, as she wryly called her group of botanical concoctions, played around with her papers, scissors, scalpel, and paste – filling in an atmosphere of absence with color.

The mosaicks unveil the vision of a person who was not remotely interested in simplification, or the lessening of experience in order to smooth out the contrariness of its elements. Mary Delany took her scissors and she got it all, every single wisp in her field of vision. She was determined to find out the dimensions and names of things. On nearly every flower she would write the Latin name, and often the vernacular name and the place and the date the work was executed. These notations combine elements of botanical labels and the headings of diary entries. They are botany and reflection both.

We know so much about Mrs. D. because she wrote a partial memoir in mid-life, and she also wrote thousands of pages of letters to her relatives and friends, and occasionally to names we still recognize, emblems of the eighteenth century. But mostly she wrote to her younger sister Anne. These letters entwine like the tendrils on the climbing flowers she loved to render. Intense and caring, the sisters

had a mutual snap of communication, that feeling of knowing how one felt in the other's skin. Mary, the older sister who lived in London society and the world of the court, had a horror of private or personal information coming to light. She destroyed many of the letters she received and, in her bossy older-sister-ish way, advised the younger Anne to do the same.

> . . . I believe I have burnt this week an hundred of your letters: *how unwillingly* did I commit to the flames those testimonies of your tender friendship! but I *have preserved* more than double their number, which I shall take with me as so many charms. I thought it prudent to destroy letters that mentioned particular affairs of particular people, or family business.[11]

But Anne, who led a much more retiring life in the small town of Gloucester with their mother, didn't share Mary's fear of exposure. She disobeyed her older sibling's advice, quietly, just as she disobeyed other sisterly injunctions, such as how she should conduct herself as a fiancée or how she should raise her children. She kept for posterity Mary's lively, opinionated missives, written in her lucid, utterly readable hand.

There are more than three thousand pages of these epistles, and they are as layered as the collages themselves, full of squiggles and loops and interconnections of information, family ties, and juicy portraits of scandalous, modest, aristocratic, servile, and artistic figures. They don't present a complete record of her artistic efforts, but they do contain intermittent references to her works and clues to her process. Glints of her nascent creative life surface

and go underground and surface again in hints, dropped fragments, and passionate descriptions. Written with an eye for a button or a piece of lace, in a narrative *joie de vivre*, they're emotional and social outpourings with breezy opinions and the details of living that allow one to drink in the brewed quotidian existence of the eighteenth century. She wrote down what she ate and with whom, where she went and with whom, and above all what everyone wore. She described the dresses, the waistcoats, the fabrics, the rooms and stairwells, the wildflowers, domestic flowers, cold remedies, bloodlettings, cats, clerics, gossips, suitors, satirists, artists, botanists, and royals. She could size up an individual in the flick of an eyelash, then go to her desk and write it down. "Up comes the gentleman," she wrote of a caller, "so spruce and so finical you would have sworn he had been just taken out of a box of cotton."[12]

Given Mrs. D.'s penchant for burning evidence, there are obviously many fewer surviving letters from her sister Anne. Those that endure are calm and softly witty; their self-possessed tone implies a woman with intelligent reserve. Anne passed on the letters she had squirreled away to her daughter, Mary Dewes Port (1746–1814). Mary Port gave them to her daughter Georgina, who was Mrs. Delany's charge and companion in late life. Georgina Mary Ann Port Waddington (1771–1850) in turn gave them to her daughter, Augusta. Augusta Waddington Hall, Lady Llanover (1802–96), transcribed and edited the letters, which were published in six volumes as *The Autobiography and Correspondence of Mary Granville, Mrs. Delany: With Interesting Reminiscences of King George the Third and Queen Charlotte*, by Richard Bentley, Publisher in Ordinary to Her Majesty (Queen Victoria), in 1861 and 1862.

Sarah Chauncey Woolsey (1835–1905), best known for her children's book *What Katy Did* (written under the name of Susan Coolidge), edited *The Autobiography and Correspondence of Mrs. Delany* into a compact two volumes for North American audiences, published in 1879, and R. Brimley Johnson (1867–1932) used Lady Llanover's edition as the basis of *Mrs. Delany at Court and Among the Wits* in 1925. But not Woolsey or Johnson or Emily Morse Symonds (1860–1936), who, under the name of George Paston, compiled *Mrs. Delany (Mary Granville): A Memoir 1700–1788* in 1900,[13] or John St. Clair Muriel (1909–75), who wrote the biography *Mrs. Delany* under the name of Simon Dewes in 1940, are much responsible for what we know about her now.[14]

Lady Llanover's monumental effort at editing the volumes of letters still influences all who are interested in Mrs. Delany, including Ruth Hayden, her living descendant and author of *Mrs. Delany: Her Life and Her Flowers*. In that book's dedication, Hayden thanks her children and late husband for tolerating her obsession with her ancestor, and I find myself thanking her, too. At the age of eighty-six she showed me how to feed currants to a robin from my bare hand in the garden of her small house in Bath, just as Patrick Delany had shown his reticent but opinionated wife Mary two hundred and forty–odd years earlier in the garden of their house outside Dublin. But the newest way to learn about Mrs. D. is through the renaissance in recent scholarship about her. Harvard garden historian Mark Laird and Walters Art Museum curator Alicia Weisberg-Roberts gathered essays from thirteen scholars in *Mrs. Delany and Her Circle*. Deploying expertise from historians, art historians, botanists, paper specialists, and experts in textiles and

crafts, the essays probe, tickle, tease out the social, aesthetic, and scientific sources and mysteries of her work. Yet all who investigate the life of Mrs. Delany owe a debt to Lady Llanover. As Weisberg-Roberts reminded me, "These scholars are like Lady Llanover's grandchildren."[15]

Bursting from the bright spirit that wrote those volumes of letters come the flowers themselves, made by two hands that had seventy-two years of flexion in other crafts, and by eyes that had seventy-two years of pure noticing. As Mrs. D. embarked on her great work of art, she was in a position, as we all are at a certain time of life, to review, to respond, to re-evaluate all that has happened – and to revive. Bluestocking writer and reformer Hannah More, after visiting Mrs. Delany when she was in her eighties, wrote that the old artist still had "that tenderness of heart which people are supposed to lose, and generally *do* lose in a very advanced age."[16] Mrs. Delany's flowers contain that tenderness. How did she keep hold of it? Can such a great talent behave like a seed? How can it lie dormant for so long? We all know the truism: people who seem to spring into artistic action were, in fact, quietly preparing for years.

{ BUD }

I saw my first flower mosaick at three o'clock on Saturday, September 27, 1986, at the Morgan Library in New York City, after an elderly guard (at least I viewed him as elderly then) eyed me suspiciously as he checked my coat. There, in the beige gallery off the dimly lit foyer, glowed one hundred and ten of the flowers. They had been sent across the Atlantic from the British Museum. The gallery was as under-lit as a room beneath the ocean. The handful of viewers

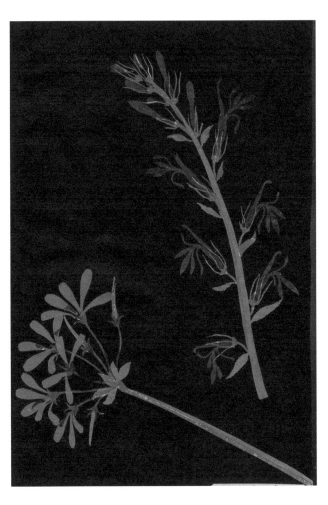

Scarlet Geranium and Lobelia cardinalis 17
Bulstrode 1773
Verso inscribed "first essay"

almost swam from flower to flower, as though snorkeling to discover coral glimmering through another element. And these were only a *tenth* of them, emanating from a place beyond sex and beyond death but thoroughly of both.[17]

I was thirty-nine and had published two books of poetry. Those flowers had the carefully crafted but mysterious quality of the poems I most admired. I went around the show twice, not methodically but flowing across the gallery from frame to frame. I could not get over the dexterity, the eyesight, and the fine muscle coordination that had produced them. I was hooked, I was sunk. My grandmother and my great-grandmother, whose ordinary needlework talents I exalt, would have loved them.

I felt nearly ashamed about how deeply I swooned over her work, because the botanicals seemed almost fuddy-duddy. Somebody like Georges Braque or Pablo Picasso probably would have hated them. They were not shiny, abstract, or hanging in the Museum of Modern Art. They were not avant-garde, even in their own day. They were derrière-garde, and not even technically collages. Collage, I'd been taught, was a twentieth-century invention, supposedly a lot more involved than Mrs. D.'s pasting of paper on paper. Now one might even view Mrs. Delany as a mixed media artist, since she painted on the papers and occasionally added dried leaves as well.

How I wished I loved in my heart the art I could love in my mind. Big, bold, epic, symphonic. But I love the small, the miniature, the detailed, the complex: the tiny, boundaried world that has its sources in handiwork. Handiwork, crisply bordered or patched with cut geometrical shapes and defined by stitching, was what I watched my maternal grandmother do – in the quilts for

our beds, the quilt for my doll, the embroidered and crocheted runners on the buffet, the corners of the tablecloths, and the handkerchiefs that primly blinked from her pocketbook. I'd had plenty of the unboundaried world as a child. In the tumult of the working-class household where I grew up and the crowded post-war elementary school I attended, where the floor space was so limited that each child's mat overlapped another, I longed for distinct outlines to things.

At an age when other women had left New York City to marry or remarry and move to affordable places to have their families, I had stayed. I was divorced and lived in a studio apartment on the Upper East Side, a tiny spot in a neighborhood so wealthy my blue-collar Buffalo family or their farmer cousins west of the Finger Lakes would never have imagined it. My family were my earliest role models, but since my first attachment to a teacher as a child, I have never stopped my search for others. Past adolescence, the usual time for bright examples, as Mrs. Delany's brother-in-law would say, my quest went quietly on, well into middle age – and beyond. It hasn't been a focused canvassing but almost its opposite, something full of happenstance. Years ago, I lit upon teachers and slightly older girlfriends, then professors, older colleagues, and therapists, and I was always scanning likely characters in stories and novels. At times the role models proliferated; at others the world emptied of them. Yet my blurry radar scanned on, as if I were always looking for something at the back drawers of experience.

At the age I am now, these guides no longer come from the ranks of the living – yet I find a good dead role model to be ideal. Life has its rushing formlessness, but an

existence from centuries ago has a *shape*. Mrs. Delany's life is so shapely that it feels like a complete work of art, cut and pasted – a still life rich with the captured curves of petals, bristling with the leaf, and still, in a sense, breathing. Her post-life suggestions are succinct and piquant. They almost have a scent, like the imagined perfume that might arise from her blooms.

The Morgan Library exhibit was accompanied by Ruth Hayden's book, and I was determined to have it. But even as I tromped to the quiet gift shop staffed by silk-bloused, wool-skirted volunteers who may have appreciated the handiwork detail of the mosaicks more than the ebullience, I knew that an imported hardcover would be expensive and that I had to make my rent. My salary as a middle-school English teacher at Friends Seminary School was so low that I couldn't eat, take the subway, *and* pay for the Upper East Side studio, so I sublet my apartment illegally for the last weekend of each month, moved out to Queens to stay with my boyfriend at the time, and returned to pay my rent on the first of the next month with the sublet money. I paged through the British Museum publication, with its horrific conversion price from pounds to dollars, and gave up the chance to buy it. Credit card debt would *not* have stopped Mrs. Delany, who never had enough money but who spent all her life as befit an aristocrat. In retrospect, I know it wasn't my credit card that stopped me. It was where I was in life. Like reading a novel you know is too old for you but being fascinated anyway, I read the opening of *Mrs. Delany: Her Life and Her Flowers* – and put it down.

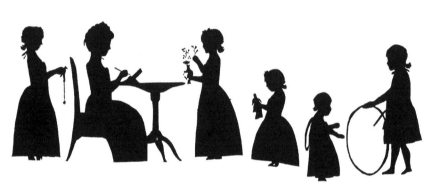

Chapter Two.

SEEDLING

Twenty little petticoated girls, all of them scissoring, must have made the room of the French refugee Mademoiselle Puelle seem like a cage of hummingbirds. Even under the restraints of the eighteenth century – the mini-corsets and posture boards – the London rooms of Mademoiselle Puelle's school for lgirls in 1706 might have been vibrating slightly out of control with the flying intensity of twenty self-possessed tykes from families with elegant histories and distinguished names. Mary, too, had a distinguished name: Granville. She was quite at home in this satin company, the livelier ones looking and leaning to see what the intent ones were cutting out.

In 1740 Mrs. Delany began the short memoir she drafted at the Duchess of Portland's urging with a bit of the name's history: "My father was grandson of Sir Bevil Granville, who was killed on Lansdown, in the year 1643, fighting for his king and country. . . . At the very moment he was slain, he had the patent for the Earldom of Bath in his pocket, with a letter from King Charles 1 acknowledging his services. This letter is still in the family."[1] She was

23

A silhouette cut by Mrs. Delany in the late 1760s at Longleat, thought to be the children of the third Viscount Weymouth and his wife Elizabeth, daughter of Mrs. Delany's friend, the Duchess of Portland (Margaret Cavendish Bentinck)

descended from a long line of royalist supporters in service to the crown. Sir Bevil's oldest son was also named Sir Bevil; his middle son, George, was Baron Lansdowne of Bideford and secretary of war to Queen Anne. Sir Bevil's youngest son, Bernard, was Mary's grandfather. He was His Majesty's Groom of the Bedchamber at the onset of the Restoration and "the messenger to Charles II of the joyful tidings that he might return to his kingdom in safety."

To imagine Mademoiselle Puelle is all we can do – the brief record of her existence is in the single sentence the grown-up Mary Granville Pendarves (not yet Delany) wrote for the Duchess: "At six years old I was placed under the care of a Mad^lle. Puelle, a refugee of a very respectable character, and well qualified for her business." Mrs. D. remembered her as "my good and kind mistress."[2] The sonority of her name might put a reader in mind of Miss Clavelle, Madeline's teacher, a long, black, scissory-looking figure slicing angularly through the rooms of Ludwig Bemelmans' twentieth-century children's books. In 1706 the girls would have perched on footstools or sat primly at tables, each with her silhouette paper.

Mary cut out birds and flowers. Her classmate, the very young Lady Jane Douglas, plucked one up and stole it for herself. Lucky that she did, too, for this is the only evidence that Mary's art germinated here at Puelle's, a slender thread to her great work seven decades later, thin as a child's eyelash. Lady Jane Douglas, whom, Mary tells us, she never saw again after her two years at the school, "would pick up the little flowers and birds I was fond of cutting out in paper, and pin them carefully to her gown or apron, that she might not tear them by putting them in

her pocket." The classmate, "whose regard for me made her delight in all my little occupations,"[3] had valued what Mary Granville did, and Mary knew it and held on to it for a lifetime. Her six-year-old fingers learned a skill in this eighteenth-century playschool that would prove her rescuing when she was more than eleven times her age. It would have taken intense muscle-patterning to keep those fingers in shape to be in readiness all those years later when she embarked on her *Flora Delanica*.

One truism about art-making is that we can't control our subjects: they are given to us unconsciously and by predisposition. But we can control our technique: that is consciously learned. Yet learning how to do something and being appreciated for what you've done are often quite separate. Happily they weren't for Mary Granville as a little girl. Lady Jane was enraptured by those silhouettes. As an adult Mrs. Delany recalled, "I have heard of her preserving them many years after." Lady Jane "kept a partial remembrance of our early affection to the end of her life, though I never saw her from the moment of leaving school; but I received numberless proofs of her regard by messages and enquiries which were sent to me by every opportunity she could meet with."[4] It was as if Mrs. Delany had pinned her friend Lady Jane's admiration to some emotional equivalent of a "gown or an apron," and in private moments, decade after decade, dressed herself in its esteem.

To have a tactile understanding of just how intricate the cutting of a silhouette can be, you might try it yourself. It's something like peeling an orange so that the peel comes off in one piece. Careful!

Many of us get stymied by mistakes and quit right there; in this way are acres, miles, vast continents of childhood

concentration on a task disrupted with a single misstep. Integrating frequent failures is part of how one learns a craft. In a poof of patterned fabric (girls wore gowns cut down from their mother's clothing) the child Mary Granville would have sat in the face of her mess-ups. The stays of a diminutive corset would have kept her impossibly upright by our standards. (Sometimes a particularly slumpy little girl would have a posture board braced to her back.) The girls at Mademoiselle's school would grow up stem-straight, wing bones back, breasts high. Posture-perfect herself, no doubt, respectable, well-qualified Mademoiselle must have spent at least some of her time bending beautifully forward to pick up the flower stems and leaves that lay on the floor. After all, teachers are there to rectify mistakes – or better yet, show us how to fix them.

Mademoiselle Puelle's paste might have been made from egg whites, and the girls would have soiled their smocks with albumen. But another paste could have been made from flour and water. In an age of epoxy cement it is hard to believe in the staying power of flour and water, but the paste is in fact quite potent. (In 1927, when she was eight years old, my mother created a school project using flour, water, and newsprint. In triumphing over her papier mâché, she managed to glue strips of newsprint to an oak dining room table that stuck there for the next fifty-two years. Her own mother embroidered tablecloth after tablecloth to cover it.) Mrs. Delany later used just this sort of homely paste on the flower mosaicks.

As a grown woman, Mrs. D. entertained herself and her friends and family by cutting out complicated silhouettes. One of them, possibly done in her late sixties, has six children in it, all embroiled in childhood activities. There are

Silhouette of Children, detail

four girls, all wearing posture boards, a boy (who gets away with not wearing one), and a toddler of indeterminate sex who sports "leading reins," a kind of halter for dragging a child quickly back from venturing too near a fireplace or other danger. The silhouette boy rolls a hoop with a stick. The silhouette toddler tries to grab the older boy's hoop. One girl holds what looks like a ball-and-cup game. The oldest girl writes with a slender quill at a desk, another arranges teeny flowers in a tiny vase, while the littlest girl totes a wee doll.

Surprisingly, the impossibly thin details are not cut out of black paper and pasted on white, but the reverse. They are hollow cut, a method of making silhouettes (or shades, as they were called before the tyrannical eighteenth-century French finance minister Étienne de Silhouette[5] retired and

began obsessively cutting out profiles in paper) that is much more rare. Mrs. Delany drew an image on white paper, then probably used a knife to cut the paper away from inside the image. In other words, she ingeniously worked with a kind of negative image. The middle of the white paper contains a detailed but empty space that doesn't really materialize until it's mounted on a black background. It's the background that forms the silhouette – the exact opposite of what you'd conclude by looking at a photograph of it. (If your hand is steady and your knife is sharp, this method yields two silhouettes, one to give away and one to keep.)

Yet in the midst of this delicious accomplishment is the imperfection of someone who never thought her pastime would be viewed by the public. There are stray pencil marks on the white paper. She left them there, her guidelines, never bothering to erase them. Maybe someone called her to the harpsichord and she abandoned the silhouette on a table. You can see that she drew outlines, then cut along them, but not entirely. However perfect the silhouette looks now under glass, Mrs. D. wasn't fastidious about preserving it.

Great technique means that you have to abandon perfectionism. Perfectionism either stops you cold or slows you down too much. Yet, paradoxically, it's proficiency that allows a person to make any art at all; you must have technical skill to accomplish anything, but you also must have passion, which, in an odd way, is technique forgotten. The joy of technique is the bulging bag of tricks it gives you to solve your dilemmas. Craft gives you the tools for reparation. And teachers give you craft, for a good teacher urges you beyond your childish perfectionism. From there you

proceed into the practice that eventually becomes expertise. In a letter dated December 20, 1729, at the age of twenty-nine, Mary wrote to her younger sister, instructing her about cutting silhouettes: "I am to make my acknowledgments to you for the help of your scissors. The little poppets [puppets, or characters] are very well cut, but you must take more pains about the trees and shrubs, for no white paper must be left, and the leaves must be shaped and cut distinctly round the edges of the trees."[6]

In her own silhouette, Mrs. Delany pays particular attention to the vase of flowers; amazingly, she even cuts a white shadow (or is it sunlight?) onto the vase itself. Or was that a mistake? – Well, if so, it was felicitous, because it looks intentional, and that's another aspect of error that an artist learns to advantage. Sometimes a blunder shifts the observer into greater tenderness of observation. Mrs. D.'s devotion to detail in the silhouette is so moving because to note with such concentration is to be full of emotion, even if one wears that emotion lightly. In the same letter she told her sister that "most of the [colored] paper I have cut has cost me as much pains as if it was white paper." When invention fails and you are overcome by what you may have ruined, knowing how to reconstruct releases the energy to fix the flaws and go on. Craft dries your tears.

Downstairs from the Prints and Drawings Study Room in the British Museum is the Conservation Room, a sunlit dream of a spot to spend one's working day. On the day I was there, by now obsessed with how this woman could have begun inventing an art at seventy-two, I noticed that someone had stuck a geranium on a sill beneath the tall, north-facing windows. The high-ceilinged room with its light tables seemed like a surgery amphitheatre with

operating tables for the bodies of disabled prints. The professional staff were solely women. It occurred to me that I hadn't spoken to a single man since I'd wormed my way down the stairs, into what seemed like the brain stem of the British Museum, finding myself in the museum's light-filled cranium, trying to answer my question of just what they do to repair Mrs. Delany's fragile collages.

Etherized upon the light tables were some of her damaged works. "Yes," said the willowy Helen Sharp, straight-haired, makeup-less, slow and graceful, as if a sudden movement might disturb the sleeping ailing prints. "Really, very few men in this area. They tend toward paintings and sculpture."[7] Helen Sharp is a paper conservator, a curator-restorer. She lifted a thin, sharp plastic pick, the size of a ghost of a guitar pick, and gently attempted to raise the edges of the flowers on some of the more fragile Delanys. If the pick could slide between the flower and the background, then Sharp knew she could slip a filmy layer of wheat-based paste beneath that portion of the flower to re-secure it.

Sharp stood at her light board in her green cardigan, dusting each flower with a soft, dry brush and looking for cracks in the black background. Tests have detected wheat on the mosaicks, and the assumption is that Mrs. D. used flour and water for her glue, but current conservation philosophy sensibly won't allow the amputation of a mosaick just to get a proper chemical analysis of the exact adherent she used. However, another, less destructive technique uses X-ray fluorescence to reveal the composition of the materials in her dark backgrounds, which vary from shiny (the early ones) to matte (the middle and later ones). Where she used pure black pigment, the backgrounds have stayed

relatively unimpaired. But analysis has found that some of the substances contained impurities such as copper. Worse, in hasty moments Mrs. D. may have mixed in iron gall ink (the black ink that degrades with age to brown) to stretch the coverage of the paint. Iron gall ink acidifies paper, cracking and drying it out and ultimately destroying the skin of the collage. If such a background began to disintegrate, Helen Sharp could adhere a support of Japanese tissue paper onto the reverse side, reinforcing it.

As they lay on their backs, surrounded by light, all kinds of details about the mosaicks vivified, especially their dates, written in Mrs. Delany's careful loop-filled hand: 1773, 1776, 1781 . . . Though Mrs. Delany wrote that she began the flowers in 1772, the first one she actually labeled is dated 1773.

{ TIGHTLY FOLDED BUDS }

My husband Mike and I have been together for so long (he is my second husband, but I first laid eyes on him when we were thirteen) that we each still remember the smells of the kitchens of the suburban houses where we grew up. We recall his finished basement and the basement of my house, with the overfilled laundry baskets. I can still hear how the cutlery drawer clattered as his mother shut it with her hip while she balanced the hot dog buns on a platter for the Groden backyard barbecues. He can still hear the cash register drawer and its bell at Peacock's Superette.

After our high school romance, we lost track of each other for nineteen years – married other people in the same year, divorced them in the same year, found each other again. By now we have become the collages that

adults become, multiply pieced. His cancer checkups, either two or four times a year depending on whether his melanoma has recurred, remind us that waiting so long to have something doesn't mean you get to have it forever. On the other hand, he's lived with this disease for three decades. Although uncertainty pigments our marriage, we are glued, we are happy. We've had what by now is seventeen years of overlapping and overlayering that even an Optix magnifying glass might not reveal.

I wasn't thinking about Mrs. Delany's flowers when we traveled to Dublin in 2002. Though I had always wanted to go to Ireland, drawn to the landscape of my great-grandparents, I wasn't prepared for feeling instantly at home. Connecting with moist weather, filtered light, and hospitable, soft-spoken people, I relaxed as I had as a child with my grandmother Ruth McMann Wright, the fanatic embroiderer. We stayed in Buswell's Hotel, built in Mrs. Delany's day, and walked streets that she would have walked, though of course I didn't know that then.

I had not completely embraced the flora metaphor as a way of life as I walked down Lower Baggot Street and north to Merrion Square while Mike was busy with his work at the National Library. As I was falling in love with the human-sized architecture of Georgian Dublin, so fully preserved that two centuries of time instantly drop away, my charge of happiness was undercut by a sliver of a feeling that this lovely marriage we had built also could be taken away. Before we'd left, Mike had one of those checkups. He was fine. But as other people seemed to cut out their lives as quickly as little Mary Granville cut out her birds and flowers, the checkup was a reminder that my husband and I have had to use the older Mrs. D.'s hollow-cut

silhouette approach. Poise, balance, the art of living is just a little bit harder when you shape your life from the inside of the paper out – but it's entirely doable if you have the skill set. He seems to have the skill set. (Yes, he's a role model. The secret of marriage is thinking that your partner is better than yourself.)

Mrs. Delany's skill set (her fierce observation and her eye-hand coordination) seems to have held up for a lifetime, its source in her six-year-old hands. If only one could trace how the sharp silhouette of childish intensity turned into the layers of collage, then we'd know how she accomplished it. Such detective work would combine the skill sets of mind-reader, forensic art historian, psychologist, biologist, all with expertise in landscape, in papermaking, in eighteenth-century collecting, in botany, in conchology . . . Could an amateur ever do it? An amateur armed only with a poet's skills: noticing and comparing one thing to another? The very word *amateur* sends a frisson up our professionalized spines.

Yet Mrs. D. was an amateur. She belonged to the world of limners. She had a botanist's bent, but no one would have called her a crack botanist. She had a painter's bent, but no one would have called her a first-class painter. She had a remarkable fashion design sense and knew how to embroider like a spider, but no one would have called her a couturier. She up and wrote a *roman à clef* called *Marianna* at the age of fifty-nine, but no one would have called her a novelist. She wasn't an expert in anything except observing. And then she did something no one had ever done before.

To place oneself as an amateur in the twenty-first century invites an extreme vulnerability that would probably have mystified Mrs. Delany. To declare amateur status now

means confessing that you're not serious; if you were, you'd aim to be a professional. Stepping into the position of an amateur, on the other hand – someone who loves something and wants to learn about it – repeats the confusion of youth. The state of not-knowing, especially for a person of age and accomplishment, recaptures youth's novel excitements. This is a way of keeping young that Mrs. Delany engaged in throughout her widowhood. Not to know is also sometimes the position of the poet, who depends on close observation to magnify a subject, hoping to discover an animating spirit. There's romance in that forensic impulse, because it yields surprise – an antidote to the jaded mind age has to fend against.

One of my mother's prized possessions was a headshot silhouette of my profile that my teacher had done in the early 1950s when I was in elementary school. At the time I hated it, because my ponytail had gone slack and the teacher had cut out each loose tendril of hair in the silhouette paper. (She had asked each child to step into the light of a projector and to stay still – a feat we accomplished only after being told again and again not to move – while she drew each of our silhouettes onto a piece of construction paper. Later she cut the figure of each child's head and shoulders out of the paper.) I was fascinated by the teacher's dexterity. And my mother was over the moon! She marveled at the tendrils that embarrassed me, and at the fact that the teacher had even cut out the lines of my eyelashes.

Now I, too, see the tendrils as moving. The fact that the teacher cared so much for details moves me, and the profile of myself from so many decades ago, so foreign to the profile I have now, moves me as well. In her collages Mrs.

Delany pays particular attention to the tendrils of the vines, cutting the thin-thinner-thinnest lines out of the varied greens of her paper. It is as if she delved into the details of her happinesses, sadnesses, fears, frenzies, and daydreams. She cut into them. She snipped them out and touched them again and again as she positioned them and pasted them on black paper.

They became her next life.

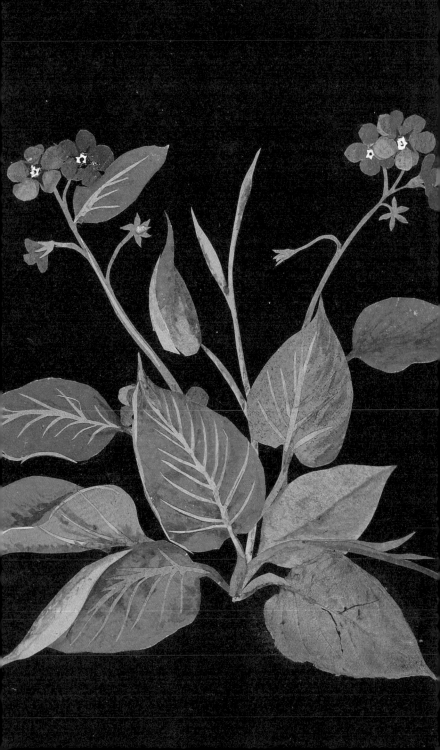

Chapter Three.

HOUND'S TONGUE

Mrs. Delany perched at an oiled wooden table in her house on St. James's Place in Mayfair, the one she had bought at the urging of the Duchess after the death of the Dean, on April 1, 1776 (April Fool's Day even then). She was regarding a sample of *Cynoglossum omphalodes*, now known as *Omphalodes verna*. Its well-known common name is Creeping Forget-me-not; another charming label is Mary Blue-Eyes. (Mrs. D.'s own eyes were dove-colored, according to the Dean.) However, underneath her flower mosaick she wrote its sterner, tougher name, Hound's Tongue. She proceeded to cut four bright white rings of anthers like the headbands that children might wear at weddings. Then she centered them into four of the eight tiny five-petaled blue flowers she had floated at the ends of the stems. Earlier she had glued these stems into a cluster of acuminate, spade-shaped leaves. And earlier than that she had cut out a small square of white paper and painted it black in readiness for the whole pasted assemblage.

Hound's Tongue was not a particularly exotic plant at all, botanist and Editorial Secretary of the Linnaean Society of London John Edmondson good-humoredly explained to me. It peeped out of the eighteenth-century English

37

Cynoglossum omphalodes, Hound's Tongue [now known as Omphalodes verna], St. James's Place, April 1, 1776

garden before the snow was gone, as it does still. Nicholas Culpeper, the seventeenth-century herbalist, said he cured rabies – "the biting of a mad dog" – with Hound's Tongue.[1]

Forget-me-not petals had their minor culinary uses, too; sometimes they were added (and still are) to batters for puddings. So *Omphalodes*, with its leaves that recall the tongues of small baying dogs and its flowers that sometimes flavor confections, was both sweet and curative at the same time. In placing its fragile stems and royal blue flowers above her rough and resolute leaves, Mrs. Delany created in the portrait a whiff of the plant's ambiguity – and a little of the Granville family's attitude toward child rearing, too.

Mrs. Delany's creamy-skinned, long-nosed, full-bosomed mother, Mary Westcombe, was the daughter of Sir Martin Westcombe, first Baronet Westcombe, the Consul of Cadiz, Spain (a center for trading in gold and silver between Europe and the Americas). In a portrait of Mary Westcombe by an anonymous painter[2] we see a woman with a high forehead framed by brown curls – and a set-jawed, slant-wise look that suggests she held the world suspect. With the portrait as the only visual clue to her personality, it's easy enough to imagine her peachy bosom heaving in the arms of a young officer like Mary's father, Colonel Bernard Granville. Yet from the held-back distrust of her posture it's equally easy to sense an ambivalence about those arms.

Whenever Mrs. Delany mentioned her father, she flushed with affection. The Colonel was the third son of Bernard Granville, Groom of the Bedchamber to Charles II. His two older brothers controlled the family fortune. The oldest, Sir Bevil Granville, Governor of Barbados, died in 1706, leaving the family's wealth, as well as the obligation to help his siblings and their children, to the second

oldest, the arty, opinionated Tory George Granville. George Granville became Lord Lansdowne, his name ringing with the derring-do of his ancestor who died at the Battle of Lansdowne. But, as the third son in his family, Mary's father, Bernard, had to make his own way, never able to count on his older sibling for regular support. After Bernard retired from the King's Army, he became Lieutenant Governor of Hull as well as Member of Parliament for Camelford and Fowey. There is no available portrait of him, and so we're left to imagine him in his scarlet uniform, far from the birth chambers of his wife.

She bore him four children in eight years, giving birth to her first son, Bernard, called Bunny, in 1699. Barely a year later, in 1700, came Mary. Her next was Bevil, born between 1702 and 1706. And after bringing her fourth and last child, Anne, into the world in 1707, she was exhausted. Her husband took her away to what was then the tony resort of Little Chelsea. He took another opportunity as well.

He decided to better the social prospects for his oldest daughter, Mary, by sending her to live with his adored but stern and childless sister Lady Ann Stanley. (Colonel Granville had two sisters, Ann and Elizabeth. Elizabeth, the younger sister and a Maid of Honor to Queen Anne,[3] never married and lived with their older brother Lord Lansdowne.) Ann had been a Maid of Honor to the previous Queen, Mary. She married Sir John Stanley of Grange Gorman, Ireland, who had been Secretary to the Lord Chamberlain to Queen Anne.[4] Granville knew that his sister would manage his daughter's education, teaching her how to take care of herself in the only way a girl of her class could do: by making an excellent marriage match.

As the hand of the April Fool's prankster reaches and inverts a world (or even as the hand of the old lady artist Mrs. Delany spun the black square of paper from side to side or upside down to fix her Hound's Tongue in place), the Colonel reached into his eight-year-old's routines and spun his daughter out from Mademoiselle Puelle's, and out from her family house, to Whitehall, the former royal residence and seat of power, now at a fraction of its former glory after a fire in 1698 destroyed it, but still the location of Sir John and Lady Stanley's apartments.

Aunt Stanley would teach Mary everything about being a Lady in Waiting to the Queen. Mary would learn to dance in quadrilles, curtsy low, and walk backward in the sight lines to royalty. If she learned tact and restraint, she might, in a few years, secure a job as a royal companion, be paid a yearly stipend and given clothes, food, a place to live, not to mention proximity to gentlemen who might eventually marry her. After all, her swashbuckling great-great-great-grandfather, Sir Richard Granville, had died heroically for the orange-haired Queen Elizabeth 1. The Granvilles had served the Crown, and Mary, by acquiring all the skills she needed, might also serve. She was eight years old, and Aunt Stanley, stiff as a posture board with her rules, was determined to train her niece as impeccably as a gardener espaliering a fruit tree. Mary was not going to run in her stocking feet or shout with excitement or laugh at nonsense. Nobody fooled with Aunt Stanley.

Each of Mary's years from the ages of eight to fourteen became a pointy-tipped hound's tongue of admonishment from her aunt, who detected, Mrs. D. recalled at the age of forty, "an impetuosity in my temper, which made her judge

it necessary to moderate it by mortifying my spirit, lest it should grow too lively and unruly for my reason."[5]

As Mary met her dancing master at Whitehall and learned to step precisely, as she learned to embroider meticulously (the term she would have used for embroidery is simply "work"), as she studied French to read and speak it faultlessly, as she worked at her spinet to play it sublimely, as she perfected her seat on a horse, she was somehow managing to hoard her rowdiness and to compost it into fuel for later adult engagement with life. Her passage through her early years was a negotiation between her unruliness and society's tamings. The huge task for the little girl – largely an unconscious task – was to conjure up the trick of retaining a degree of her wildness, what we might think of as her true self, while learning the endless shades of social distinction and internalizing the endless rules of comportment. "I own I often found it rebellious, and could ill bear the frequent checks I met with, which I too easily interpreted into indignities, and have not been able wholly to reconcile to any other character from that day to this."[6] She was an intrepid child, and though that audacity was not pressed out of her, it was transformed. Her aunt checked her, curbed her, restricted her, and within each limit that was set, Mary's liveliness was distilled, then distilled again.

Anchoring the lower right of Mrs. D.'s floral composition is real plant material – an honest-to-God Hound's Tongue leaf, now brown and crackly, over two hundred and thirty years after she detached it from the plant and pasted it onto her black square. This is one of a number of the mosaicks that mix painting and cutting with dried plant parts, and though it's one of the smaller ones, it's also one of the more

amazing because of the sheer tenacity of that actual leaf. Hanging on and not disintegrating, despite the odds, was one of Aunt Stanley's qualities – and Mary Delany's, too. It's also one of the details that lifts the work into the realm of collage – not just paper on paper, but a work that employs other materials.

You can think of the Hound's Tongue leaf as a *trompe l'œil* trick or a ploy in a camouflage game. That a quite real leaf is pasted among the other leaves in the *Hound's Tongue* creates a witty fillip of Mary's impetuosity, long transformed from girlish impulsiveness into shrewd adult drollery. It reminds us that the origin of what she manufactured is nature itself. It is as wild as the child she once was. But the natural leaf is so cleverly disguised among the paper leaves that it seems tame. It appears as cultivated as she had to become to please her aunt. Even if you view this flower mosaick in the flesh, so to speak, you might not notice that the leaf in the lower right-hand corner is, well, mummified. It takes careful observation to get it, especially because the leaf above it is painted to look like the real one. This imitation leaf is one of the few completely painted elements in any of her works. In a way the simulation is like protective coloration for the actual one, in the way that a civilized self can conceal a secret, cherished barbarity.

Music Lesson:

Then the little girl found a bright example of how a great talent had tamed the wild. George Frideric Handel (1685–1759) was twenty-five years old and had been touring as an organist when he was invited to Aunt and Uncle Stanley's

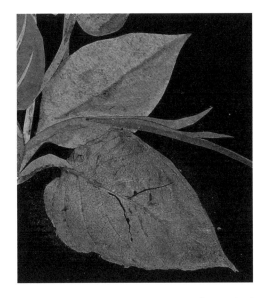

*Hound's Tongue, detail of plant matter (bottom leaf)
and painted leaf (top)*

apartments at Whitehall in 1708. He had thick, dark, pas-
sionately quizzical eyebrows, black eyes, the hint of a double
chin, and a hairline that gave him a grand forehead. He sat
down to play for her uncle and aunt and eight-year-old
Mary – at her own spinet, which had been sent with her to
the Stanleys, perhaps along with her one- and two-piece
gowns covered in the front by bibbed aprons and fastened
in the back.

Handel was writing *Rinaldo*, which would debut at the
Queen's Theatre the following year. His own childhood
spinet, given to him by his aunt when he was seven years
old, was in the attic of his house, and he climbed many
stairs to play it. Coincidentally, the overture to *Rinaldo*
ascends and descends like stairs. The opera, Handel's first,

43

was something very new – Italian-style, the whole thing sung, no speaking. As her spinet warmed under his curiously long, plump fingers and the plump base of his thumbs, Mary stood watching. There were seventeen years between them. He was not a contemporary, not a parent, not a boy her own age, but a young man like a very much older brother, or a dashing cousin. He became a lifelong friend, and she even drafted a libretto for him. (The work was never performed.)

The minute Handel rose from the spinet and took his leave, Mary hoisted herself up on the seat and began to play, but the shadow of her uncle, Sir John Stanley, cast itself across the keys. His voice lowered toward her, and he asked "whether I thought I should ever play as well as Mr. Handel. 'If I did not think I should,'" she stared at him and said, "I would burn my instrument!" In Mary's memoir, she added this postscript: "Such was the innocent presumption of childish ignorance." [7]

In 1714, when Queen Anne died without a direct heir, Aunt and Uncle Stanley were fresh out of court cachet. The Granvilles gathered themselves up, as did all the other members of the aristocracy, and faced their options. The Jacobites favored returning the Stuarts to rule, even though that meant risking a Catholic on the throne. At least, the Protestant Granvilles reasoned, an English family would retain the monarchy. But in opting to be supporters of James the Pretender, they chose the wrong side. It was the Whigs who prevailed. Seeking a Protestant monarch at all costs, the Whigs followed a branch of royal

bloodlines back to Germany and plucked the Elector of Hanover, who brought his wheaten eyelashes, eyebrows, and hair and his German manners and German language to the throne as George I.

Bereft of influence, and rocked by the beat of all the changes that were to come, Aunt Stanley sent Mary home to her parents, to Poland Street in Little Chelsea. She would not become a Maid of Honor to a Queen after all.

But Sir Bevil had saved King Charles, and wasn't she to be at court, to curtsy straight down in a kind of plié, head inclined? Perhaps she would have helped manage the dress of the Queen, might have ordered manifold pairs of stockings for Her Majesty. Both her aunt and her father had nearly promised her. She had endured six years of discipline and learned to emulate a multitude of delicate shades of behavior as she grew out of her childhood frocks and childhood shoes and caps, and as she stood for the dressmakers to put her in the silks of a young woman with pubic hair who would have to learn to use a *voideur* when she excused herself to pee. The *voideur*, which looks like a gravy boat, was held by a female servant positioned behind a screen, and Mary would have had to learn to slip quietly behind such a screen, hike her skirts, and micturate right into it. She was fourteen years old, and she was pre-pared to stand around court assembly rooms for hours. But she was going home instead.

"Nevertheless," she wrote much later about her early years with her aunt, "the train of mortifications that I have met with since, convince me it was happy for me to have been early inured to disappointments and vexations."[8]

In Little Chelsea, Mary re-met her sister Anne. Anne had been an infant when Mary left the household, but

now she was an ebullient eight-year-old, curious about this adolescent creature-sister who had appeared, all the way from Aunt Stanley and Sir John. They were to share a bed – and a daily schedule. They were to dress together and to eat together and to play music together. And Mary was to have a special gift from their father: her portrait was going to be painted. Day after day in the winter of 1715, she dressed and sat for the painter.

One morning, she thought the hard rap on the door was her notice that it was time to get up early for another day of posing for her portrait. But it was two soldiers with guns in their hands barging toward their bedside like red exclamation points topped by gold epaulets.

"'Come, Misses,' cried one of the men, 'make haste and get up for you are going to Lord Townshend's.'"9

The little Jacobites.

The girls heard their mother scream from the hallway, and from the hall her father's voice rose above the mother's howls.

Tempestuously, Mary's uncle Lord Lansdowne had teamed up with others of James's supporters to overthrow the Whigs (and therefore George 1) and put James the Pretender on the throne. But the plot had failed. Lord Lansdowne had been escorted to that dreary and magnificent clink, the Tower, soldiers loomed over Anne and Mary's bed, and their mother was sobbing.

46 The minute Mary's father had learned of his older brother's involvement, he had feared that he, too, would be jailed, and planned a fast, secret getaway for himself and his family. Friends and servants were not to know. "He ordered two carriages to be at his door at six o'clock," Mary wrote. "The man from whom the horses were hired,

and who proved to be a spy, immediately, in hopes of a reward, gave information at the Secretary of State's Office of these private orders, affirming that it was his belief the Colonel and his family were going secretly out of the kingdom."[10] Betrayed by the equivalent of an undercover cop at a car rental agency, the family was to be taken to Lord Townshend, the Secretary of State.

Now Mary herself was screaming. "I cried violently,"[11] she wrote later, summing up in three words the toppling volumes of terror of waking up to devil-red strangers at the end of her bed, witnessing her new breasts through her chemise. The soldiers would have smelled of cold, wet wool and sweat and ale. The sisters must have smelled like the sweet cheese of sleepy girlhood. Someone was trying the door. It was her mother's maid, arguing with the soldiers that she must be admitted to dress Anne and Mary. At last they allowed her in.

But as frightened as the more knowing Mary was, little Anne Granville was curious and imperious with the soldiers, and with the maid. She insisted on being properly dressed for this occasion, their abduction. "My little sister, then but nine years' old," Mary wrote, "had conceived no terror from this intrusion, but when the maid was going to put on her frock, called out, 'No, no, I won't wear my frock, I must have my bib and apron; I am going to Lord Townshend's.'"

Fourteen soldiers swarmed the adult quarters of the house, as well as two officers and two messengers. The Granvilles were besieged. The maid would have helped shimmy the girls into their gowns right over their chemises (no distinction then between sleeping clothes and underwear), perhaps doing the dressing under the covers, for it was cold in those Little Chelsea rooms. The stale pee in the

chamber pots may have formed ice crystals. After the girls were ready, the epauletted soldiers swooped them up and carried them, Mary Granville wrote, "to my father and mother, whom we found surrounded. . . . My father was extremely shocked by this scene, but supported himself with the utmost composure and magnanimity; his chief care being to calm and comfort my mother, who was greatly terrified, and fell into hysteric fits one after another."

Shortly, however, the prow of Aunt Stanley's bodice burst through the door and commanded the soldiers, shaming them as she had shamed the niece once in her charge, and applying similar tactics to the men who were arresting her brother. "She was not," Mary recalled, "to be denied; she told the officers that she would be answerable for everything to Lord Townshend, and insisted on passing, with a courage and firmness that conquered their opposition."

Aunt Stanley, all business, cowed eighteen swarming intelligence and security officers and messengers and rescued Mary and Anne. She convinced the men that they had no business carting the children off to jail with their parents, and that she should harbor them. She soothed their mother, she argued for their father, she used her hound's tongue for good. "I can never forget her meeting with my father," Mary said of her aunt at this moment of panic, "she loved him with the extremest affection, and could never part from him, even for a short absence, without tears; they embraced one another with the most tender sadness." As their father and panicked mother were escorted off by the soldiers, their aunt led the girls to her own coach, and they stayed with her through the ordeal.

Sixty-one years later, as Mrs. Delany sat cutting and pasting, severing the Hound's Tongue leaf and inserting it

into her mosaick, across an ocean the British troops had secured Quebec, while George Washington, in Boston, was inoculating his troops against smallpox – by making a cut in the skin and pushing a pox in – turning poison into medicine, and saving lives that would turn a war.[12] The world was never black and white to her – it was black and bright, surprising colors. She never saw her aunt in only two tones, but in all the variations she would later bring to the blues and greens and browns and white of the *Hound's Tongue.*

The embraces that Mary witnessed between her father and her stern aunt were a kind of inherently contradictory flowering. In reaching out with such warmth of emotion to her brother, it was as if Aunt Stanley had grown out of the rough leaves of the Hound's Tongue and had reached up like the thin stems of the plant to its impeccable blue flowers. The woman who had tried to curb her niece's impetuosity with censure also demonstrated a courage and a loyalty that allowed her to bully the soldiers, soothe her brother's wife, take charge of her nieces. She failed at interfering in her brother's arrest but at least valiantly tried, and, best of all for Mary, threw her arms around her beloved Bernard, and Mary saw it. Aunt Stanley, too, had grown up being boxed by rules, and she, too, had contained – and preserved – her impetuosity.

Love in extremity, such as this was, an embrace in the middle of the night, surrounded by soldiers, is like a blue flame in the midst of darkness – or even, perhaps, a blue flower against a ground of paper washed in the blackest, mattest pigment. Scenes of our parents blur from day to day into indistinguishable childhood routines, but scenes such as this freeze-frame in a child's mind, becoming

talismans for an artist later in life. No wonder Mrs. D. called Aunt Stanley "Valeria" when she nominally disguised her in her letters. Valeria, the valiant, witnessed by Mary, swollen-faced from tears, on the cusp of adult complexity. Life has an unbounded complexity; the simplest plant is complicated in its growth. The eye can barely take in the planes of connections among stems, flowers, pistils – the whole organism of life as it grows.

And is transplanted. Down the steps Mary went with her sister and her aunt and into the coach. She would never come back.

Mary had survived her first transplant when she went to Aunt Stanley's, then survived the planting in the soil of her return to her parents, absorbing transitional shock after shock in the bumpy forward motion of childhood, in the way that creative children do: in all likelihood she had her scissors and her needlework with her, and no doubt there was a spinet to play. These activities require focused attention. To truly listen so that one can perform, as Handel did, communicating life in a series of notes, or to imitate life in its silhouettes, following an outline minutely with scissors, is to be like a cartographer mapping a river. It requires an all-absorbing skill, and learning that skill requires an attention that moves the mapmaker, the music maker, the cutter-outer beyond the self to the focused-on thing. All else drops away, all that would tear at us: the restrictions of others' words, the denigrations of others' absences, and, for Mary Granville, the soldiers, the hysterics, the rushing maids, the messengers, the fact that she was back at her Aunt Stanley's again and that her father was in jail.

Dumped from the Tower, returned to a newly powerless life, Bernard Granville, who hadn't been incarcerated for

more than a few days, acted fast. Even though he'd been quickly discovered to be of no consequence to the Jacobites, and therefore no threat to the throne, his older brother George, Lord Lansdowne, was retained in the Tower, where he would languish for nearly two years. Bernard swept his family out of London and prepared to wait out the downturn in the Granvilles' political fortunes at Buckland, a quiet house in the country that Mary called "The Farm." They were to live like the Bennet family in *Pride and Prejudice* a century later – in a kind of exile away from intrigue. But intrigue happens in the country, too, and the ground had been laid for it. Bernard Granville, anxious wife, two sons, and two daughters became the tiniest of x's on a vast and complicated cross-stitch that was English politics after the death of Queen Anne.

It was cramped and cold in that coach in November 1714. As Mary shifted her hips against her sister and Anne shifted her feet against her mother and as her father leapt out of the carriage to see what had stopped them on the journey, a trip she described as "miserable," Mary repeated the words of a poem to herself. The poem was written by Alexander Pope, a Catholic, who received the patronage of her jailed uncle (though Lord Lansdowne was a Protestant). The poem was "To a Young Lady, on Her Leaving the Town after the Coronation."

As some fond virgin, whom her mother's care
Drags from the town to wholsom country air,
Just when she learns to roll a melting eye,
And hear a spark, yet think no danger nigh; . . .
Thus from the world fair *Zephalinda* flew,
Saw others happy, and with sighs withdrew;

Not that their pleasures caus'd her discontent,
She sigh'd not that They stay'd, but that She went.[13]

As she was being dragged from the town to boring rural life, as she flew from the world she knew, where others were happy, she engaged in the comforting mental play of repeating memorized verse. Memorizing lines engages a person with the rhythms of another mind and allows the thought of another, perfectly preserved, to act as a comfort to be turned to in emergencies, like a house that remains standing.

Childhood, that place where purity of feeling reigns, was merging into adolescence, where ambiguity begins. She had begun to have experiences that repeated earlier ones. This one layered itself over the earlier disappointment at leaving Mademoiselle Puelle's school, plucked each time from one place and sent to another. The uprooting of her family in hysteria and disgrace both replicated the earlier dislocation and provoked a new set of emotions: now she was exiled.

It's nearly impossible to see the shape of your life as you are living it, swimming through the bobbing detritus of the everyday. But occasionally huge events scissor your living into a shape, and you feel it sharply. At these moments, lived life takes on the feel of a found novel, as if you were a character in a piece of fiction, your author reaching in to cut you from one section, then paste you into another.

The Granvilles' coach arrived at Buckland in a fiercely cold winter. The whole family was snowed in, and the snowfields swept down to the River Avon. Their windows opened to a stunning vista. Even Mary, wrenched from London, thought so. "The Farm is a low house," she wrote, "with very good, convenient room in it, the outside entirely covered with laurel, the inside neat furnished with home

spun stuff, adorned with fine China and prints. The front of the house faces the finest vale in England, the Vale of Evesham, of which there is a very advantageous view from every window."[14] And under cover of snow, the first part of a romance began.

Up to the house rode a young man in riding boots named Robert Twyford. He was "twenty-two, tall, handsome, lively" and in need of companionship, just as Colonel Granville was. The Colonel, enervated after his escape from London, appalled at his ever-diminishing income, drained by his wife, who had taken to her bed, and constantly summoning up energy to entertain his children, needed a friend. A young man such as Robert, of a similar political persuasion, was a likely candidate. "The first Sunday after he came he met us all at church, and my father asked him to eat beef and pudding with his landlord: he came the next day – he came again. He pleased my father extremely."[15] Twyford was the last of twenty-two children born to a hateful mother.

While the Colonel was making a friend of Robert Twyford, and his wife was sinking and moaning under her covers (except when rousing herself to extend encouraging invitations to Twyford), his daughter was concentrating on her artistic interests. Before breakfast at nine, Mary would practice at her harpsichord. It had been seven years since she had met Mr. Handel. Now her fingers were lithe, strong, and flexible because she loved to play. She went willingly to the discipline of it. If you're living a life out of control, your mother weeping into her hankie, your father making jokes, London so far away, then to lift your hands above the harpsichord keys and play with your whole melancholy fifteen-year-old heart is a consolation. You might even conjure up Handel's white cravat and the smell of the brown-black

ink he used for transcribing his notes. While Mary Granville poured her loneliness and passion into her instrument, Robert Twyford was attending. He should have been listening to his new older friend, her father – and with half an ear he was. But the other half was hearing a girl burgeoning into womanhood, and doing it in musical notes.

Then the young man was called away.

Spring passed into summer and fall at Buckland.

"I took great delight in a closet I had," Mary wrote, "which was furnished with little drawings and cut paper of my own doing; I had a desk and shelves for my books."[16] She doesn't mean the kind of closet we know now; she means a little room that was her own. This was her first studio. Buckland became a de facto home school. "I was kept to my stated hours for practising music, reading, writing, and French, and after that I was expected to sit down to work."[17] (By "work" she meant the handiwork of sewing such as crewelwork, as well as drawing and cutting silhouettes.) In this sentence she describes a young artist's ideal day.

Ideal, but lonely. About this time Mary made a much-needed friend who matched her own ebullience, Sarah (Sally) Kirkham Chapone (1699–1764). Mrs. D. called Sally an "intrepid spirit," but her "appearance of being too free and masculine" alarmed Colonel Granville, who "loved . . . reserve in the behaviour of women."[18] The girls met secretly "in the fields between our fathers' houses" and became fast friends. "She entertained me with her wit, and she flattered me with her approbation." Mary worked on her father to accept Sally, and eventually he did. The girls played their adolescent games while Mary's little sister Anne, their hanger-on, was "offended at our

whispers and mysterious talk." Later Mrs. Delany would dub Sally Chapone "Sappho," a name that to our twenty-first-century ears, along with the touchstone word "masculine," conjures up an electric atmosphere of intense teenage connection. Their friendship would prove lifelong. They would stay friends through their marriages, and Mrs. D. would become the godmother to Sally's daughter.

Soon, Mary passed her fifteenth birthday, and in an ideally romantic spot.

> The back part of the house is shaded by a very high hill which rises gradually; between lies the garden, a small spot of ground, but well stocked with fruit and flowers. Nothing could be more fragrant and rural: the sheep and cows came bleating and lowing to the pales of the garden. At some distance on the left hand was a rookery; on the right a little clear brook run winding through a copse of young elms (the resort of many warbling birds), and fell with a cascade into the garden, completing the concert. In the midst of that copse was an arbor with a bench, which I often visited . . .[19]

By the fall Twyford had returned. He began arriving at Buckland early in the morning as Mary was practicing the harpsichord, and he sat beside her, watching her in profile. He seemed to be in an agony that Mary couldn't quite face – and didn't have to, because she was looking down at her keys and playing, seeing him only in sideways glances.

Her chirpy little sister skipped in, poking fun at her, making the eighteenth-century equivalent of "Mary's got a boyfriend!" teases, and Mrs. D. remembered the sting of Anne's mocking all of twenty-five years later – and

also recalled how she and Robert blushed. She wasn't entirely sure why he was there, but Mrs. Granville understood and forbade her elder daughter to leave her room in the morning. If Robert Twyford came around, which he did, again and again, a servant was dispatched to attend Mary at all times.

Thus Mrs. Granville maneuvered Twyford into speaking to her husband. Colonel Granville responded to him with bitter candor. Mary hardly had a dowry, there wouldn't be much of a marriage settlement, and Twyford would have to take his daughter as is. Not a devastatingly pretty girl, but a fresh girl, rose-lipped, with quick eyes in her longish face.

One day on the stairs Robert Twyford grabbed his love by the hand and burst out in frustration that he wished he had never known her, so overwhelmed was he by his dilemma. But he had to have her, money or no.

Above the leaves of the *Hound's Tongue* are two stems of blue flowers, and the white ring in their centers makes them look as though they have eyes. One stem leans to the left, the other drifts to the right, as if they were growing toward two separate light sources. One group of flowers seems to be gazing at the other, which almost seems to be struggling off in the other direction. By positioning them so delicately, Mrs. Delany infused the portrait of her specimens with personal affect. Just because they seem to have faces, the blossoms appear to have their own eccentric characters. She fixed the two stems in opposition – yet they face each other. The apt verb for how the stems behave is "cleave," a word that contains its opposite, suggesting both to cling together and to separate. You don't

know whether the Hound's Tongue flowers are cleaving or leaving.

Robert Twyford set off again, home to his mother – who had borne twenty-two children and who felt that her son deserved more than a fancy connection to the Stuarts when it was the Hanovers who were on the throne. But her son persisted like a politely buzzing fly. No, again and again, no, Mama swatted back. He didn't quite have whatever it took to flout her – or did he? He left for Buckland. This time he outmaneuvered the Granvilles, going directly to Mary herself. Despite his mother's disapproval, he pressed her. He could go out on his own, he could find some money somewhere, they'd be fine, really they would, if she would just run away with him.

She said no.

The very same word his determined mother had used, now coming out of the mouth of his beloved. She didn't want to refuse him, but Mary Granville was too pragmatic to elope. Unlike Robert, she did not want to embarrass her family or lose her own position. If she were a character in a novel she might strike boldly off on her own, but she was a practical girl who was very aware that her family was dependent on her Uncle George, Lord Lansdowne, now out of jail and writing poetry again at Longleat, the fabulous house of his new wife.

No, she said to him unequivocally. And to release them both from this torture, he had better leave.

Leave. Leaf.

Did Robert Twyford steal a kiss? He did steal something from her closet at Buckland, as she would find out later.

Mary Granville could have rebelled, she could have moped, she could have let a bowl slip from her hand and smash to bits on the floor, she could have sulked. Instead she returned to a routine, back to the schedule her father had invented for her. Back to the relief and attachment of Sally Chapone. Back to her lessons, her handicrafts, her harpsichord with just herself on the narrow seat, looking at the keys. And at night, for entertainment, she listened to her father read to the family, to cheer them all up, and to try to cheer her mother, depressed at how far they had fallen in the world.

At Buckland, when Mary looked at her mother, she saw a woman victimized by her own disappointments and hysteria, yet when she looked at her father, she saw a man ordering his diminished existence. For me, it was the opposite. When I looked at my father, who was an alcoholic, I saw a man victimized by his own disappointments and hysteria, yet when I looked at my mother, I saw a woman ordering her diminished existence. Like Mary's father, my mother was a reader, though she did not read aloud. She plowed through her romance or Wild West novels every day or two, assuming I would do the children's book equivalent of the same. Even though she herself would abandon crafts, reacting against my grandmother's life of embroidery and quilt work, she bought boxes of craft projects for me. A routine in our household was established of mealtimes and reading times and homework and crafts. It was disrupted a thousand times by my father's rages, but after each drunken tsunami, time folded back into the household syllabus.

Mary was not going to have Twyford, but she was going to have a morning. Music and breakfast. And she

58

was going to have an afternoon. Crewelwork and walks with her friend, and then dinner. And she was going to have an evening. Words floating on the night air read aloud by her father. Though it was an order imposed from without, a domestic order, it was one that she could internalize. Daily-ness, like sewing, puts one stitch after the other. At first you don't see how on earth you will cover a whole piece of linen with manipulated thread. And then you start, making each long stitch count, each short stitch, each French knot as good as you can make it, as perfect, pouring all your energy into the measure of the thread, like a measure of music, and watching the work grow under your very hands, and going to bed, and getting up the next morning. Having one day, and then the next.

Her life at this time was a mere paragraph in a novel. In novels, especially the romance books my mother took out of the library, routines are boring and the novelist must dispatch them in a sentence or two. But in life our routines are the signposts of destiny.

By the time I reached high school the routines of our household had frayed, and I had become a silhouette of a person. My outline to the world was efficient and sharp (editor of the high school yearbook; a girl capable of cleaning a house top to bottom, cooking six nights a week, and writing an A paper), but the inner world, the place one grows from, lay fallow as all my energy was pushed to maintain that exterior. We lived in an impossible situation: my father was degenerating; my mother was trying to earn a living; my little sister was trying just to be a girl; and I was trying to be good, to hold it all together, since an enormous amount of adult responsibility fell on me. At the dark hollow of the silhouette of responsibility, something

nameless roiled and formed lines: poems. In some ways the poems themselves were Hound's Tongues: terrifying and curative. Sometimes they were Mary Blue-Eyes, sweet to eat. And always they were Creeping Forget-me-nots, insisting I remember. I hadn't discovered that I could drive this wild whatever-it-was inside me into a sonnet or a villanelle, propelling it into lines, stanzas, and rhymes. I did not yet know that these patterns, just like the embroidery patterns my grandmother gave me to guide my colored floss into chain stitches and knots (and like the much more fluid, enticing patterns that survive from Mrs. Delany's designs for embroidered chair cushions, bed curtains, and ladies' stomachers), were crucial to crafting a poem. All the discipline I learned was outside me: the timetable of a fast-track academic suburban school and the extreme schedule of the demands of our household. It tamed me from the outside in.

At Kenmore East Senior High in Tonawanda, New York, with its baby boom bulge, Mike Groden had turned into the smartest boy in the Advanced Track. (We were also briefly exchange students at our sister school, Earl Haig High School in Toronto.) He earned his own money from his summer jobs, so he had bought a used chrome-dazzler of an old Chrysler. Into the passenger seat I slipped on a Saturday morning in the fall of 1964. We had been assigned our senior papers, and we were driving to the Grosvenor Research Library of the Buffalo Public Library system. In ecstasy he catapulted through the oak card catalogs amassing references, only to discover me in the P section, with nothing as yet on my ruled tablet. He was a researcher in his bones; I was just a searcher, distracted by the smell of the polished wood in the high-ceilinged room, the

fretwork of shadows that the wrought-iron balcony cast over the army of the card catalogs.

Unable to do a thing, half fainting from exhaustion, I was nearly sobbing. He doesn't remember that he guided me to the section of the card catalog likeliest to show resources for Japanese poetry (my subject) and started me off. How easy he made it. How clear. Then he got busy cruising the open stacks and picking out a library carrel for himself, one with a beam of light shafting down from the high windows. It wasn't always easy or clear for me. I almost never had enough sleep, for one thing, rocked by the late-night extravaganzas of the Peacock household.

My mother, when she wasn't working, could be quite a noticer. The previous week she had looked at Mike's pale skin, mottled with tiny black moles, and remarked presciently, "That boy had better stay out of the sun." She was layering pieces of memorabilia in a yellow Cutty Sark box she had picked up from the liquor store next door to Peacock's Superette. It was a Sunday, her big day off. One of the prized possessions she stacked in the box was that silhouette of my profile that my teacher did when I was in elementary school.

On each night other than Sunday my parents staged their battles. Sitting in the blue duster she wore to Peacock's Superette, my mother would lay against my father the charges of failed promises and overspending, and repeat her negative syllable: no, no, no. My father, his workpants drooping (by day he worked as an electrician for the power company, and by night he was supposed to man the grocery cash register), in turn begged my mother to respond. Each day after high school, I came home to our empty house and found the wilderness of college applications, the

basket of ironing I was supposed to do, the groceries to unpack, the note my mother had left about what I should cook for dinner for my sister and my dad. I hacked iceberg lettuce into chunks, drowned them in catsup and mayonnaise, burnt the hamburgers, and threw the dinner onto Melmac plates. I ditched the ironing to flee into the arms of Mike Groden.

My responsibilities were my posture board. But Mike Groden was my Robert Twyford. The fall after graduation, having necked, petted, and groped our way to everything but the final act of sex, we made love at last in a freezing room in a New England inn outside of Hanover, New Hampshire. There, in the blue snowlight with the frost figuring the insides of the windows, we became living proof of the fact that two kids could have the right instincts for a life partnership. It was 1965.

In 1716, less than a year after she had to refuse the marriage proposal, Mary sat at a dinner table at her uncle's house, hearing one of the guests mention that Robert Twyford had been "struck with a dead palsy." Mary "blushed excessively," wondering if she herself could have been the cause. Twyford, who may have had a stroke, or perhaps epilepsy, could no longer speak above a word or two, although he could write. His brain disorder caused him to write "perpetually," Mary says, perhaps a kind of hypergraphia. Many, many years after that dinner, Mary met a woman who had been a great friend of Twyford's, who told her that Twyford's obnoxious mother's "cruel treatment of him, and absolute refusal of her consent for marrying" Mary Granville "affected him so deeply, as to throw him into the palsy."

"He lived in this wretched state about a year."

After he died, Mrs. D. found out what he'd stolen. As they removed his body from the bed where it lay, his pillow was overturned. And there beneath it was a piece of cut paper – cut by Mary, and stolen from her closet at Buckland.

"I could not help thinking I might perhaps have been the unfortunate cause of his misfortune, as *in truth I was*, though I did not know that till some years after his death."[20]

How many lifetimes does it take to learn the facts of life? (And how long do you have to live to recover from them . . . ?) Is it fact that helps us recover – or is it metaphor? Is it the hard knowledge of what really happened, like actual botanical material? Or is it the flesh of comparisons between what happened and what that was like, the blooming of explanations? The story that Mrs. D. heard about Twyford's death may have been apocryphal, but she believed it with her whole heart.

When Mrs. Delany sat down to the enterprise of her botanicals, she was at that grieving moment of reviewing her life. Making the flower portraits was like assembling a visual memoir, an album. She collected all the *Flora*, in alphabetical order, into albums, and starting in 1781 she called the group the *Flora Delanica*, directly attaching them to her name.[21] But that was sixty-some years after Robert Twyford. Not only had little Lady Jane Douglas filched cut-out birds and flowers from Mary to keep and delight in, but Twyford, as far as Mary was concerned, had purloined cut paper to keep and love. To have what you have made so esteemed that it seems to be keeping a person alive, or comforts a person as he makes his transit to the next world, is to assign a magnitude to what you do that is so tremendous you must keep doing it.

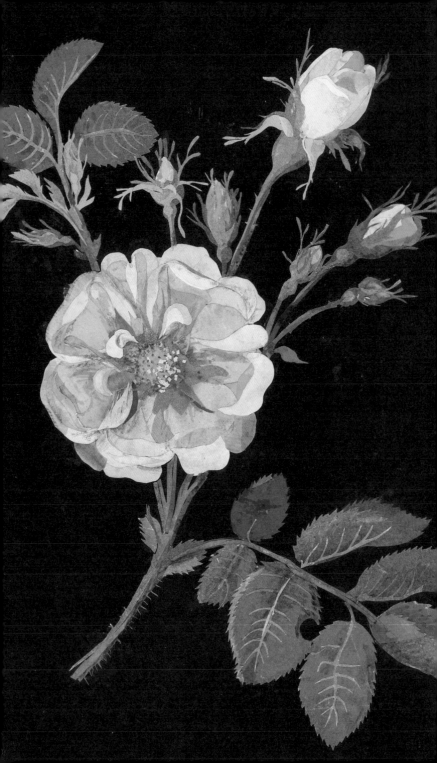

Chapter Four.

DAMASK ROSE

Rosa gallica, the subject of the flower mosaick that eighty-year-old Mrs. Delany hovered over at Bulstrode in the humid summer of 1780, is the rose whose attar is distilled to produce essential oil, and it provides the inspiration for one of Mrs. D.'s most famous, most popular images. It appears on placemats, coasters, postcards, note cards, aprons, tea cozies, tea towels, and canisters, and it offers possibilities for anything else that can be adorned by a rose.

Mrs. D. composed the main flower of *Rosa gallica, Cluster Damask* in seventy-one pieces (the number that my eye can count), each a separate single color, from tongue pink to inside-the-lower-lip pink to under-the-fingernail pink – all accented with three slivers of red. The effect is as deep as a blush. After it was assembled, she painted certain shadows over the petals with a grayish pink watercolor. Under the Ultra Optix lens, it looks as if she either dry-brushed it in gray or penciled in other shadows at – if the rose had a round watch face – 1, 8, 9, and 11 o'clock.

The number of colors and the shadows give the muddled head a heaviness. It has the quality of curtsying, or

Rosa gallica, Cluster Damask Rose, Bulstrode, July 1780, showing an insect bite cut in a leaf

bowing, from its stem. "Muddled" is actually a technical term for a type of flower head. It means a full but flat-faced flower with petals of various overlapping sizes, a rosette. Who is more like a rosette than a blooming teen-age girl, and who more muddled?

Into the silence of the household routine at Buckland after Robert Twyford left came a letter, an invitation all the way from Longleat, a stately house outside of Bath. The invitation issued from Mary's paternal uncle, George Granville, Lord Lansdowne, the poet and playwright who had been released from prison and had married the adorable and wicked widow Mary Villiers. Villiers was an

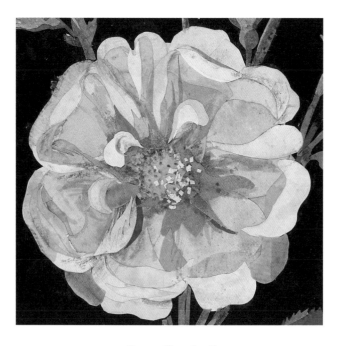

Rosa gallica, detail

arch-coquette English rose who had first married the Marquess of Bath and bore him a son, Lord Weymouth. When the Marquess died, she became the mistress of his estate, Longleat, which would be inherited by their son when he came of age. George Granville, exhilarated by his freedom after two years in the Tower, moved into Longleat with his new wife. There they entertained scads of guests with country dancing every night. The house hadn't been used for several years and the income from the estate was down, but they hired a cook, a housekeeper, a butler, and laundry maids, and retained a group of musicians so that their extended house party could go on for days, weeks, months, a vortex of socializing and celebrating being alive – and, for Lansdowne, consolidating lost political power, too.

The letter noted that it was time for Mary to come out into society, and it said that her uncle and aunt would be delighted to show her off. Another chance! The dressmaker would be called for, the glover would be visited, and dancing shoes would be cut out from brocade. All this finery would be packed up in trunks for Mary, and she would travel with her father to Longleat.

When Mary and her father entered that splendid house, it was already two hundred and fifty years old. In the attic, even the laundry maids' rooms sported rugs, with mirrors over the fireplaces. There was a smoking room and an armory with pikes and blunderbusses and body armor. In the cold dairy an exhausted hound tied to a dogwheel churned their butter.[1] (Longleat House still exists, and you can visit it today. You can pay admission, see the high-ceilinged Great Hall where Mary

danced, descend into the kitchen where the banquets were prepared, then tour the grounds – or just view them on BBC's *Animal Park*. The estate is a safari park now.)

Life for Mary at Longleat was breathless – outdoors in the daytime, riding the horses from the stables, indoors at night where the roasts slopped over the plates, then dancing till exhilarated and exhausted, and rising again the next day. Colonel Bernard Granville was there to watch the precise steps and sometimes the moments of lip-to-lip kissing in his daughter's minuets, her sarabandes, her gigues, seated in his brother's ebony leather-backed chairs. The largess pumped up the Colonel's hope of an increase in his allowance, but his older brother had a different idea. Why should Bernard need his current allowance at all? Shouldn't it, in fact, be reduced? After all, Mary would be living at Longleat, George would be providing for her, and Bernard would have one fewer mouth to feed.

How many times had the younger brother had to humble himself, to ask and be subject to his older sibling's whims? It's not easy to become a man in an atmosphere of lifelong dependency; Colonel Granville did not act like an adult but like a boy in need of understanding when he confessed his desperation to his daughter. Mary had grown into some of her adult wisdom at Buckland, as well as into her adult body. She began to have a command of this new, fresh self that she was developing, partly because of the attention of her father, and the example of his realism, as well as her realistic rejection of Robert Twyford. Her father's sad news that his income would be reduced was a crucial piece of information for her. Hearing his confidential news, Mary took on her father's disappointment, and with it the knowledge that

she was the linchpin in her family's financial life. Colonel Granville left Longleat then, returning to Buckland, leaving his daughter to the violin, the flute, the continuo, the dancing, the platters of game.

Things changed at Longleat after his departure. Strangely, Mary's two aunts, her Aunt Lansdowne and her Aunt Granville (her father's spinster sister Elizabeth, who lived at Longleat), seemed to be conspiring to keep her away from her uncle. During the beginning of her stay, Mary read aloud to her uncle whenever he wanted, and he, the poet and playwright who would one day be the posthumous subject of an essay by Samuel Johnson in *The Lives of the Poets* (Johnson opined that Granville's dramatic poem "The British Enchanters" had "passages which are at least pretty, though they do not rise to any high degree of excellence"),[2] had praised her reading and her voice to these jealous aunts. Now, with the adroitest social moves, they prevented this intellectual intimacy.

Dr. Kate Harris, another lithe, artlessly lovely, makeupless member of that sorority of conservators of corners of the eighteenth century, is curator at Longleat. I found her office up scores of stairs and down multitudes of oak-floored hallways, the kind of oak floors that feel unfinished, unvarnished, because they were scrubbed for centuries with ale. The seventeenth-century library, which is one of the few rooms still existing that Mrs. Delany would instantly have recognized, is off limits to the public, but it contains the silhouette of six children reproduced in this book. Dr. Harris and I sat together on two straight wooden chairs by the shelves where Mary Granville would have gone to fetch books to read to her Uncle George, and we gossiped about the past. I declared

that I hated George Granville, who partied while his younger brother made do, and Dr. Harris told the story of how the Lord conspired with his wife to keep her son, his stepson, ignorant of the fact that the boy would inherit Longleat. The little Viscount thought his house, his lands, his bailiff, and his stables belonged to them. Meanwhile, they spent his money on their high life – and on his older cousin Mary Granville's marriage.

One day at Longleat it rained horribly. Alexander Pendarves had ridden hard from his dank castle with crenellated towers called Roscrow, in Cornwall, nursing an old hurt. It involved his manhood and his family name, which, unless he acted soon, would die with him. Roscrow, whose stone passageways dated back to the fourteenth century, was empty of wife and children. Now, without an inheritor, the widower had dreamed up a plan.

He had a niece who could inherit his estate, and she had recently married. Pendarves's idea was that he, who was sixty years old, would deed his estate to this niece's husband, for them to take possession of and live in immediately, while he would spend his old age elsewhere. All her husband had to do was take his name. It was a fantastic deal the widower thought he offered them, but his niece's young husband refused. His own manhood and family name signified more than money. The nephew-in-law held his ground so firmly that Pendarves had left their home in a rage, slopping his horse through to Longleat to visit his fellow Jacobite Lansdowne.

Sopping wet from having ridden for hours in the rain, the drunken squire of Roscrow appeared at the great doors.

When the servant announced him, the Lord leapt from the table and invited his political ally in to dine. "I expected to have seen somebody with the appearance of a gentleman," Mary wrote decades later to her friend the Duchess, "when the poor, old, dripping almost drowned [Pendarves] was brought into the room, like Hob out of the well, his wig, his coat, his dirty boots, his large unwieldy person, and his crimson countenance."[3]

His behavior fascinated her. It disgusted her. Pendarves, who held political cards that were necessary to complete Lord Lansdowne's hand, was invited to stay awhile. Mary was always at table, observing and recoiling in the intense repulsion that a sixteen-year-old girl might feel at the sight of a slobbering old man. She had developed a friendship with Mr. Villiers, her Aunt Lansdowne's young brother, and together they made fun of the geezer. His wig askew, his blubber hanging over his belt, his face perennially red from drink "were all subjects of great mirth and observation to me," Mary wrote. "I diverted myself at his expense several days, and was well assisted by a young gentleman, brother to Laura; who had wit and malice."[4] (Laura was the name Mary used to disguise her Aunt Lansdowne in her sketch of a memoir.) They were young, they were nasty, and Mary was a little bit afraid. Why was the old guy staying so long?

"His age I have already told you;" Mary wrote, "as to his person he was excessively fat, of a brown complexion, negligent in his dress, and took a vast quantity of snuff, which gave him a dirty look . . . he had an honest countenance, but altogether a person rather disgusting than engaging."[5]

Pendarves's stay lengthened. Day after day he met her at dinner, served at about 3:00 p.m. in those days, and supper, at about 10:00 p.m. The reason why he loitered began to dawn on Mary, and she placed her only stone, a pebble really, in her slingshot of behavior against him. She decided to make herself brusque and ugly. "[I]f he came into the room when I was alone, I instantly left it, and took care to let him see I quitted it because he came there," Mary wrote to the Duchess about Pendarves, slumped in a funk, "much afflicted with gout, and often . . . in a sullen mood."[6]

While Mary dressed her worst, her aunts, of course, did not, especially Lady Lansdowne, the mistress of this stately household. Along with the spinster Aunt Granville, she reinforced Pendarves's desirability. "I was often chid by my two wise aunts," Mary wrote, and "I told them plainly he was odious to me, in hopes they would have had good-nature enough to have prevented what I foresaw; but Laura called me childish, ignorant, and silly, and that if I did not know what was for my own interest, my friends must judge for me."[7]

However ugly she thinks she can make herself, a seventeen-year-old is beautiful, and young Mr. Villiers found her deliciously rude. Across the dinner table he flirted casually. (In retrospect Mrs. D. calls it "undesigning merriment.") Yet Mary, tickled by the young man, became a tickle beneath the old man's skin. "At last a violent fit of jealousy," she wrote, "made him resolve to address himself to [her uncle], and make such proposals as he thought might gain his consent."[8]

By this time Alexander Pendarves had lingered at Longleat for two months.

72

"One night," Mary wrote, "at one of our concerts, all the company (I suppose by agreement) went into the room where the music was performed, which was next to the drawing-room." Everyone was in on the plot. "I got up to follow them, but my uncle called me back," she wrote. Was he nervous, about to sell his niece? He "desired I would bear him company, for he was lame and could not walk into the next room." She became a character to herself when she described this night: "when he bid me shut the door, I turned as pale as death." As if depicting an out-of-body experience, she looked at herself turning into a ghost. "He took me by the hand . . ."[9]

From the music room the chords of the players dimly resounded. Who knows whether she heard them, or only the buzz of foreboding as her uncle informed her that he had found an ideal suitor for her, one who could provide a large house, a castle, in fact. He did not have to remind her that her father, mother, sister, and two brothers depended on him for income. "After a very pathetic speech of his love and care of me," she wrote of her uncle, "and of my father's unhappy circumstances, my own want of fortune, and the little prospect I had of being happy if I disobliged those friends that were desirous of serving me, he told me of [Pendarves's] passion for me, and his offer of settling his whole estate on me."[10] Mary Granville had not once seen the old man entirely sober.

Sixty-three years after she was handed by her uncle to Alexander Pendarves, at Bulstrode Mrs. D. replicated a *Rosa gallica*. She labored over the petals, cutting and pasting to achieve a weird translucency by layering paper over paper, as if the petals were the strata of semi-transparent skin at a young woman's temple. Then she concentrated

on the stems. Twenty-three thorns she cut out from strips of paper.

Since George Granville, Lord Lansdowne, was lame, he was likely to have been sitting down as he delivered the blow. Was Mary permitted to sit or required to stand? Decades later, she leaned over her rose. She made the leaf at the lower right-hand side of the main stem as jagged and prickly as a real rose leaf – for she was determined to replicate what her eye saw, to make it palpable, though it appeared out of nothing but a piece of paper. She poised her scissors or knife. She dove down, as a heron's beak dives through the water for its fish, plunged the point into the leaf, and cut a hole.

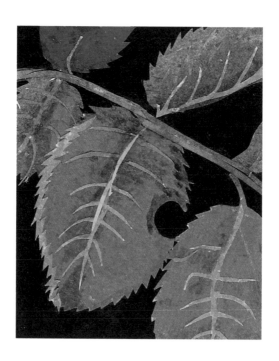

Rosa gallica, detail of leaf

In the context of the finished collage, the hole is less than a hundredth of the parts, and you might not notice it at first. It is as round as a bullet hole. Could she have used a paper punch? No, a magnifying glass reveals that the hole was hand cut. Is it absurd to put the whole turning episode of a woman's life into a single composition she made so many years later? It's no news to anyone that we make art out of the substance of our lives. Still, is the hole that very moment? Better to resort to a simile: the hole is *like* that moment. George Lansdowne bit into his niece's life. When she was eighty, she replicated a hole, a cut circle representing an insect bite. Yet a real insect bite, though round, is also jagged. Mrs. Delany certainly could have cut in a more irregular way. Instead, she made a perfect piercing.

Once you notice the nibble in the leaf, you cannot see the rose in the same way again. It becomes a rose with a story, a bitten bloom. But we all know that a bite, while less than a thousandth of the surface of our body, can be an itchy, overwhelming thing. A person can die from one. But Mary Granville, soon to become Mrs. Pendarves, lived a long life. And a selfish lord, from the vantage point of decades, can be reduced to a bug.

"He then," wrote Mary of her uncle, "with great art and eloquence, told me all [Pendarves's] good qualities and vast merit, and how despicable I should be if I could refuse him because he was not young and handsome; and that if I did refuse him he should conclude my inclinations were engaged to [Robert Twyford], a name I had not heard or thought of for above half a year – a name that had never before given me much disturbance, though now it added to my distress."

The pressure produced in her the confused state of extreme anxiety.

> How can I describe to you, my dear friend [she wrote to the Duchess], the cruel agitation of my mind! Whilst my uncle talked to me, I did not once interrupt him; surprise, tender concern for my father, a consciousness of my own little merit, and the great abhorrence I had to [Pendarves], raised such a confusion of thoughts in my mind, that it deprived me of the power of utterance, and after some moments' silence I burst into tears.

The tears infuriated Lansdowne. "I see, Madam," he said, in a puffed-up manipulator's rage, "you are not to be gained by merit; and if [Twyford] is the obstacle to my friend's happiness, and he ever dares to come to this house, I will have him dragged through the horse-pond."[11] Mary said she trembled after this, for what he said "plainly showed me how resolute and determined he was, and how vain it would be for me to urge any reasons against his resolution."[12]

And so she thanked him. Like one of the vanquished after a battle, she had to submit to him, as Lansdowne himself had had to submit to his jailers in the Tower. "With great difficulty I said I was so sensible of his goodness to me, and of the gratitude I owed him."[13] A year after Mrs. D. made her *Rosa gallica*, on October 19, 1781, across an ocean from Bulstrode, British general Lord Cornwallis was so sick at having to surrender to George Washington at Yorktown that he retreated to his tent. He summoned his Irish underling, General O'Hara, and ordered him to ride out to hand over the British troops.[14] But as a teenage girl, Mary had no

O'Hara to substitute for her, and so she stated to Lansdowne in her own voice "that I would submit to his commands."[15]

Then she asked to be excused. Lansdowne "gave me my liberty, and by a back way I avoided the company and went to my own apartment, locked myself up in my closet, where I wept bitterly for two hours."

Downstairs the party went on.

"Several messengers came to the door to call me, and at last my uncle sent me word he absolutely insisted on my coming to supper."

No, she wasn't getting out of it, though she clung to her sign of rebellion, her tear-swollen face. "Nothing could be at that time more vexatious to me, but I proposed one consolation, which was, that [Pendarves] and the rest of the family should see how unacceptable the proposal that had been made to me that afternoon was."

Mary's parents were called to Longleat, and though the marriage was planned, she seized at a last, feeble teenage strategy. She decided she would turn to someone for help, but "I had nobody to advise with; every one of the family had persuaded themselves that this would be an advantageous match for me – no one considered the sentiments of my heart."

Of course the campaign of asking for help from the very upholders of the system that the whole society depended on completely failed. "To be settled in the world, and ease my friends of an expense and care, they urged that it was my duty to submit, and that I ought to sacrifice everything to that one point."[16]

How does an intelligent, desperate girl keep her mind whole in the face of what she herself describes as a human sacrifice? And what does this have to do with a talent that

lies dormant for decades? "I acted as they wished me to do, and for fear of their reproaches, made myself miserable."[17] To be aware that you are performing for others creates a kind of mask that can also act as a scab behind which you can heal. Mary knew she had to act her part because "if I showed the least reluctance, my father and mother would never consent to the match, and that would inevitably expose them as well as myself," she wrote, to Lansdowne's "resentment."[18]

And retribution.

Maybe the Granvilles' daughter needed to pretend that her parents would have stepped in had she allowed it, to protect herself from an even worse idea, that her parents had willingly let her uncle, well within the norms of their time, sell their daughter to a slobbering rich old man. She told her friend that Lansdowne "represented it" to her parents "in the fairest light," and her parents "wished for nothing more than to see me well married, and hoping I might be so now, came readily to this proposal."

In her commentary in the notes to the volumes of *The Autobiography and Correspondence of Mary Granville, Mrs. Delany,* published in 1861, Lady Llanover, Mrs. D.'s great-great-niece, reinforces how impossible it was to marry for love.

The evidence there is that her father and mother (for whom she ever expresses so much affection) approved of her marrying Mr. Pendarves, and were not at all disturbed by their disparity of years or the complete absence of congeniality in their dispositions, tastes, or habits, not appearing to have even a suspicion that her tears flowed from any other cause than parting from her family, is a very striking illustration of the complete disregard shown in marriage at

that period to everything but the worldly settlement in life. Even Lady Stanley [Mrs. D.'s aunt], though represented as so virtuous and so amiable, evinces in the . . . letter of congratulation to her niece, written to Mrs. Pendarves in 1717, that she considered "riches, honours, and length of years," properly *to represent* "happiness."[19]

For obvious reasons, and very much unlike a fictional heroine, Mary had to say yes to Alexander Pendarves. "I was married with *great pomp*. . . . I lost, not life indeed, but I lost all that makes life desirable – joy and peace of mind."[20]

The Pendarveses stayed at Longleat two months, Mary trying to be civil to Alexander, and Alexander civil to Mary. He "shewed me all the respect and tenderness he was capable of."[21] Tenderness? How did it feel as the pendulous body lowered itself? She doesn't say.

Then they left Longleat, and her sentence, as well as her artistic dormancy, began. "The day was come when I was to leave all I loved and valued, to go to a remote country, with a man I looked upon as my tyrant – my jailor; one that I was determined to obey and oblige, but found it impossible to love."[22] It took them two weeks to go from Longleat (just south of Bath) to Roscrow in Cornwall, since Pendarves stopped the carriage along the way, visiting everyone he knew, to show off his young wife. And in each of these places, the minute she would find herself alone, she would cry.

Finally, they arrived at his castle. Surrounded by high walls, hidden from view – she called the house at Roscrow "Averno," the Roman lake that was thought to be the entrance to Hades. "When the gate of the court was opened and we walked in, the front of the castle terrified

me. It is built of ugly coarse stone, old and mossy, and propt with two great stone buttresses."[23]

She had walked into a Gothic tale.

She had also stepped into the myth of Persephone and Hades – but without a vengeful Demeter mother to seek her out. Not that Mrs. D. herself would have said that, or maybe even thought it. She never utters a word of disrespect to her mother in her letters.

When Mary entered the front hall of the castle, it was so dark that she lurched toward a parlor that did have light, but when she stood in the dilapidated room she realized that the light streamed in from a gaping hole in the roof, and when she stepped farther in, her foot sank into the rotten floorboards. Then she threw herself down on a damp divan and wept. The body of the house was the body of the man.

Another look at the thin neck of the uppermost rosebud in the collage reminds a person how the neck of any rosebud looks as though it will barely support the head of full bloom. That neck recalls Iphigenia, the innocent daughter of the ancient King Agamemnon and Queen Clytemnestra, who was sacrificed so that the gods would release the wind and the Greek warships could sail to Troy. Often when Iphigenia's story is told, she herself has no speaking part. Her father kills her, and then he goes to war. Mrs. D. likens herself to the daughter of the ancient king when she describes the pomp of her wedding ceremony in the dazed, deadpan tone of a disaster survivor responding to an interview question. "Never was woe drest out in gayer colors, and when I was led to the altar, I wished from my soul I had been led, as Iphigenia was, to be sacrificed. I was sacrificed."[24]

But it is palliative to note that the name Iphigenia means "born to strength."

{ FLOWER, AUDIBLE }

Georg Dionysius Ehret was a botanical artist who taught the Duchess of Portland's daughters to paint flowers. He suggested that they dissect them, and likely Mrs. D. dissected them, too. This small fact launched my minor career as an autopsist of dead blooms. With grisly gusto I approached the flowers I grew on my balcony with my kitchen shears, seeking out the ones to deadhead, and yes, deadheading prematurely to get my best specimens. Then I carried them to the kitchen and lay them on my dissection table, the cutting board. It takes a small, sharp paring knife to make the slice that really shows the stamens and pistils, the organs of flowers that make more flowers, and a longer slice down into the ovary at the bottom of the pistil to get to the juicy pre-seeds, what will ultimately dry into a seed-case. Intriguingly, miraculously, steadfastly, the four basic parts appear in every investigation: sepals, petals, stamens, pistils. Even as complex-looking a flower as a muddled rose shares the simple four-part structure.[25] All flowers have both ovaries and semen- (a.k.a. pollen-) forming organs. Pollen is the plant's sperm, so to speak, its fertilizing agent.

"The career of flowers differs from ours only in inaudibleness," Emily Dickinson famously wrote in a letter. "I feel more reverence as I grow for these mute creatures whose suspense or transport may surpass my own."[26] She was a bit of an autopsist, too, taking apart the minutiae of life. Do flowers muffle their sobs as young Mrs. Pendarves did, weeping to herself on every visit to every one of her new

husband's friends and political associates? Everyone I have ever told the story of the selling of the teenage Mary Granville to the drunken Alexander Pendarves has audibly gasped. We all vibrate with a horrified sympathy at the prospect of that girl with the old man. (Except that he was a year younger than I am now.) She was a being who heard a heavy door clang shut on her life. I did not hear such a door clang so distinctly shut in my own, but I continually thought it might.

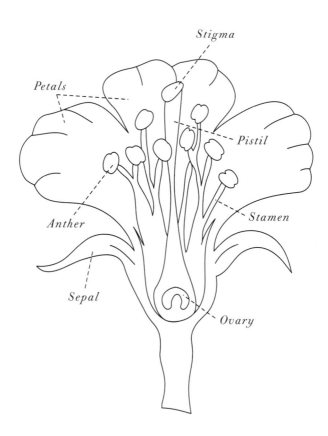

Parts of a Flower

In a house dominated by a violent, alcoholic father, I lived in fear of something happening that would prevent me from getting out of Buffalo, going on to university and my own life. Sometimes I even feared I would die. There is a strange way in which the young Mrs. Pendarves's life lays a ghostly silhouette onto the atmosphere of my own experiences. I was not a sexual victim of my father, though Mary was likely one of Pendarves, despite the fact that there were no children. But as my father stomped through the house in his underpants throwing furniture, he exuded an aura of sexual threat that seemed as much a part of the atmosphere of the house as the alcohol-and-smoke-fumed air. There is a way in which the body of the small suburban house I grew up in was besieged by the body of the man who periodically attempted to destroy most of the objects in it.

One dismal night, in the wake of his having broken the legs off a coffee table when my mother wasn't home, my father insisted that I tell him I loved him. I wasn't rebellious, but at sixteen, I was thorny. I held out, refusing, for . . . could it have been a whole hour? I dug in my heels until his sad, bull-like face hung over me, sobbing. He pinned me to a chair, and I was scared for my life, as, in a different way, Mary Granville Pendarves had been scared for her life, too. Viscerally I recall the moment when I realized that I was too frightened not to say "I love you." To stop his harangue, to remove the crying, vulnerable man whose arms gripped the arms of the chair I had curled up in, I lied. My *yes* kept me safe – by allowing me partly to disappear under a close, matte darkness.

Black pigment is made from charred organic matter – and that includes burnt bones. This chilling fact contributes to the black background of Mrs. Delany's *Rosa gallica,*

Cluster Damask Rose. Not that burnt bones necessarily produced the pigment that Mrs. D. used to create the black backgrounds of her flowers – her pigment could have been made from tar, pitch, lampblack, pine soot, anything charred to get a noir so deep it looks as if it came from the mouth of Hades. But whatever the composition of the dry crystals she ground with a mortar and pestle, then mixed with liquid and adhesive, its source is something burnt. Carbon. Organic. Ashes. Is being burnt a requisite for the making of art? Personally, I don't think it is. But art is poultice for a burn. It is a privilege to have, somewhere within you, a capacity for making something speak from your own seared experience.

Chapter Five.

NODDING THISTLE

The Swedish botanist Carl Linnaeus, also known by the Latin "Carolus" and later as Carl von Linné, was Mrs. Delany's near-contemporary, born seven years after her in 1707 and dying ten years before her in 1778. Before he got the risqué idea of classifying plants according to their sexual organs, various systems for naming had been tried, but none of them was as marvelously effective as concentrating on a flower's reproductive organs rather than its smell, color, blooming time, or petal patterns. Linnaeus shocked plant lovers by revealing the loose, polygamous habits of flowers, then reassured them by reducing multiple flower names to a simple system of two words: the first one for the type of plant, or genus; the second for the specific plant itself, or species. In much the same way that lexicographer Samuel Johnson described words, Linnaeus would write a description of one plant, then keep refining it by comparing it to a similar plant, and another, and another, with each comparison painstakingly subtracting characteristics that were not shared. In this way he would accumulate a general portrait, the genus. *Carduus* (Latin for thistle) is the generic name for the Nodding Thistle

Carduus nutans, Musk or Nodding Thistle, Bulstrode, November 26, 1776

and *nutans* is the species (*nutans* means nodding, also suggesting "to waver or give way").[1]

The Nodding Thistle is not structured like the adorable single-petaled *Omphalodes*. It falls into a group of much more pedestrian flowers: a cousin of the dandelion or the burdock. "No one is so ignorant of plants as not to know the Dandelion," J. L. Comstock, M.D., wrote in the second edition of *The Young Botanist: Being a Treatise on the Science, Prepared for the Use of Persons Just Commencing the Study of Plants,* an edifying textbook published in America forty years after Mrs. Delany flourished her tweezers, scissors, bodkin, and scalpel, zigging and zagging around her *Carduus nutans.* It's a marvel of a handbook for old-style Linnaean classification, and Dr. Comstock treats all his readers like Boy Scouts qualifying for a botany badge.

"*Syngenesia,*" he states with the simple, comforting syntax of a junior high science teacher, "is from the Greek, *syn,* together, and *genesis,* origin, and signifies that the anthers grow together in a single set, or tube."[2] *Polyandria* means many stamens. "*Aequalis,*" the good doctor states, "signifies equal, in reference to the presence of both stamens and pistils in the plants of this order." This means that each floret has both stamens and pistils. (If you have trouble remembering which are the male and which the female reproductive parts of a plant, one mnemonic is to recall that stamen has the word "men" in it.) This group of plants features many small florets that cluster "upon a common receptacle, forming heads," just like dandelions.

The nodding head of *Carduus nutans* is formed by the scaly calyx, which is "armed with prickles" at the base of its cluster of florets.[3] Dr. Comstock gives his description a military air. The idea of being armed suits the defensive

posture of the young Mary Pendarves, and it suits as well the date on which Mrs. Delany cut her portrait of the flower. In the collage of the *Musk or Nodding Thistle* that she created at Bulstrode in November 1776, the spiky purple thistle head bows compliantly above a whirlwind of prickers. Although the head nods in shy assent, its determined spikes poke from turbulently bristling leaves that a wise person would never handle without gloves. Alexander Pendarves, like a burr, always irritated his young wife – she, the thorny object of his love.

A year after her exile to Roscrow, Mary's uncle Lord Lansdowne wrote to commemorate her first anniversary – which his niece spent alone. He and Pendarves, he told her, "are now together" on political business in the House of Lords "to drink your health with an Huzza, and to Roskrow Top-a-Toe."[4] He sent her a number of letters that year, some apologizing for his silence, and each of these guilty communiqués gave off a whiff of rationalization for having horse-traded her to his buddy.

"I soon found there were *degrees of misery*," Mary wrote, because Pendarves fell into fits of jealousy whenever a young man came near her. "I would rather have had a lion walk into the house, than any one whose person could alarm"[5] her husband. The pitch of emotion between the suspicious man and the defensive wife drove them both to weep. Pendarves burst into tears as he warned Mary against his nephew-in-law (the one who had refused to take Pendarves's name in exchange for his estate) while she dissolved into tears in response, declaring, "I am miserable, indeed, if you can be jealous of this ugly man; for what am I for the future to expect?"[6] We'll never know if Pendarves was impotent, but it is certain from Mrs. D.'s reports that he

envied the younger men who crossed his path, men more assured of, to put it botanically, their stamen power. Wherever she turned, she was caught in Pendarves's sulky demands for loyalty. This never let up, and it put her into the low-grade panic of a person who is ever watchful that these imagined rivals might provoke him. Did she desire any of these contenders? Only one, it seems, and on that she did not act. She merely called the man "dangerous" and went on her way.[7] Whatever she was seeking for herself, it was not the diversion of illicit romance.

In the first two years at Roscrow, dressed in the riding habit her uncle sent to her (she was married off with plenty of clothes and pocket money), Mary Pendarves escaped her marriage by horseback, riding on the beach, windblown as those thistle leaves seem to be in her mosaick sixty-eight years later. On the beaches near the castle she searched for shells. If there is any inkling that she turned to making art for solace at this time, it's her shell collecting, but she mentions nothing about the shells except that she looked for them. In her fifties she would design a shell-encrusted grotto at Bulstrode, but at eighteen what she craved was physical escape. "My greatest pleasure was riding."[8] She galloped down the beaches in the sea air, the cantering four-legged beauty between her legs a vigorous inversion of the ineffective beast of a man at home.

Like the nettles in the thistle, the marriage was complicated. Pendarves had taken her off to his dank castle, but he loved her. She would not return the love, and remained an unwilling prisoner. During his frequent attacks of gout, he stayed in, and Mary stayed with him. "I always worked [sewed] and read in his chamber. . . . When he had the gout, he could never bear (even in the midst of winter) the least

fire in his room, and I have read three hours together to him, trembling with cold all the time."⁹ A toughness in her made her behave correctly and even to a degree obligingly toward him as she read to him in his fireless room where no shawl could keep her warm enough. Two years went by in the castle, with Pendarves, under her attentions, remaining sober.

Mary did not seem to have her own closet, or studio, at Roscrow, yet she did sometimes retreat into herself, to look out her window. She sewed, she rode, she looked for shells, she supervised the redecorating of the huge house that had not been lived in for thirty years, and, with increasing reluctance, because of Pendarves's envy, she socialized. She did not get pregnant.

During the third year of her marriage, when she was twenty, Mary's mother, father, and sister came to stay with her while Pendarves's business took him to London – and kept him there. During the year that he was away, he wrote as often as he could. He had "so true an affection" for her that, in retrospect, she saw herself as an ingrate, though she qualified her assessment of her guilt, wondering if that affection "can be strictly called so." She stated that she never showed Pendarves false fondness, "which my honest heart would not let me do," but then admitted, "I must do him the justice to say he was very obliging in his behaviour to me."¹⁰ Mrs. Delany's portrait of the *Nodding Thistle* creates a tall, straight spine, with a masculine upward thrust; but it also swirls around, like skirts whipping. The main character, if that's what we can call the flower, is the obedient, correct, but spiky thistle-head, apparently unwilling, though it seems to be nodding "yes." Her perfect propriety, never wanting to give Pendarves anything

to blame, as well as his attempts to be kind, exacerbated by the acceleration of his alcoholism (and, soon, the deceleration of his finances), proved a constant irritant to both of them: pricked, bit, stung, irritated, rubbed raw.

The year he was gone was a passionate relief. But after the sabbatical, which she spent entertaining her family and neighbors, she followed Pendarves to London. Her husband was thrilled to greet her when she came to "a very unpleasant part of the town (Rose Street, Hog Lane, Soho)."[11] In the house in the downscale neighborhood waited another irritating surprise: Pendarves's ill-humored sister. She would be living with them, despite his promise to Mary that he would not invite her. Her sister-in-law (who had been duped into an ill-fated marriage when she was sixty-one – apparently this late-life marrying ran in the family) spied on her and, according to her great-great-niece Lady Llanover, reported her every move to Pendarves, who was rarely home except when he was sick with gout (though that was sometimes six weeks at a time).

Then he began losing money. "I thought myself at least secure of an easy fortune," Mary mused, but nothing was going to balance the marital scale. Pendarves's "excuse" was "bad tenants and a cheating steward." The more he lost, the more he drank. The more he drank, the later he stayed out. Soon he "never came home sober." He was "frequently . . . led between two servants to bed at six and seven o'clock in the morning."[12] She had become the wife of a drunk.

Mary Pendarves, who had previously loved London life, now begged her husband to return to Roscrow, where at least he had been sober and solvent. He promised her they would leave London, and he broke his promise every month. It was she who left, not for Roscrow but for

Buckland, to be together with her family, where she re-encountered her sister's "lively genius."[13] In her "three months of felicity" there at the end of 1723, she fell into the household routine, and perhaps some handiwork got done. Her life at the dank Roscrow castle made "the dear Farm" look particularly sunny and utterly innocent. In her memoir there is no pricking thought of her father and mother allowing her uncle to sell her into her marriage. Why should there be? This sort of arrangement was not unusual; two decades later, in 1745, William Hogarth (1697–1764) would parody such marriage deals as he finished his series of paintings *Marriage à la Mode*.

Mrs. Delany later knew Hogarth and discussed painting with him; he gave her craft tips, and she admired him. In the first work of the *Marriage à la Mode* series, he paints in dashing detail the figures of an impoverished earl making a contract with a rich alderman to marry off the earl's penniless viscount son to the daughter of the wealthy, untitled merchant. By the second painting the newly married couple have embarked on their separate (though similar) courses: both are hungover, he just home from carousing on the town, she from partying with friends at home. This was the world Hogarth flayed open as he satirized it.

But Mary Granville Pendarves had a more tender, more painfully conscious understanding of the damage that had been done to her. She clung to her belief that her parents were not culpable; her marriage was the doing of her uncle, whom she forgave. In these lyrical three months, she felt "caressed and indulged by the most amiable parents in the world."[14] Then her father fell ill in a "distemper," as her uncle John Stanley described it in a letter. Because of the "violence of the attack,"[15] he stated, at least one of

93

her brothers, and perhaps both (the eldest, Bernard, and the worrisome, younger, scampish Bevil) were summoned so that the family could be together as the Colonel died, forever changing their family constellation. Their reunion "was closed by a most severe affliction," she wrote, "the death of my dear father! That misfortune dispersed us all."[16]

All she says about his death is in that exclamation mark. Mary's father and his sister, her Aunt Stanley, had designed the pattern of her life for her, giving her time to practice all the arts for which she showed so much talent: music, dancing, embroidery, and paper works. Her father had given her a pattern by which to live, and when he'd sent her to his sister, she'd embellished this template, and afterwards, when he'd dispatched her to his brother, and after that, when his brother had traded her to her husband, the pattern had been reinforced – and tattered.

When her father died, her mother and sister moved nearby to Gloucester. Her younger brother Bevil, after trying his hand at theatre, then attempted to make his fortune in Jamaica, where he would die in his thirties.

Her older brother Bernard returned to London with Mary and Pendarves, who blessedly quarreled with his spying sister. Pendarves's sister moved out, a thorn removed. But Mary was "so melancholy on the loss of my father"[17] that Pendarves (who, she says, "really loved me, was much concerned") tried to assuage her by leaving the house in Hog Lane and taking lodgings for them at Windsor, where the court had established itself.

A careful look at the *Nodding Thistle* shows not only prickers on the stems but also terrible points on the leaves, each potentially leaving a little gash in the skin of someone who dares to disturb it. (Nobody ventures out gathering

thistles to make a bouquet, no matter how charming a purple that bit of a nodding flower may be.) *Carduus nutans* is a wildflower, not a typical garden flower, and some regard it as an invasive weed, but Mrs. D. made no such judgment. Just the opposite: she was very interested in native plants. Each specimen that came under her observation was merely itself, something to be examined minutely, engaged with, focused on, and cut out according to a suggestive emotional state.

Thistles adapt to almost any conditions. And, of course, so had she. Carl Linnaeus wondered about how plants adapt, especially in the context of his own psychological life. In 1749, on a research trip after a traumatic year which included the death of his father, the genius botanist

Carduus nutans, detail

journeyed out from his Swedish university town of Uppsala, stopping in Lund, where he had begun his education as a young man. There he went searching for wildflowers and found that even the flora on the town walls had changed. When Linnaeus recorded what was now growing there, he discovered *Carduus nutans,* which he had not seen there before, everywhere.[18] Those adaptable prickers seemed to be a good defense for change – or a way for a person to weather it.

The young wife of an old man was fair game in the eighteenth century, an easy focus for other men who were looking for a dalliance, and the thought of this inflamed Pendarves. One day, after they had settled at Windsor, Mary went out for a walk. In the Great Park at Windsor she met the musical-clockmaker Pinchbeck, whom she knew and admired as a craftsman and who wanted an introduction to a new patron, Lady Walsingham. Mary was delighted to provide it for him, and she met Lady Walsingham for tea. Lady Walsingham suggested that she walk with Mary in a little enclosed park in the cool of the evening, and Mary agreed. But when she went to the park, Lady Walsingham was nowhere to be seen, and a servant locked her in the park with a man she identifies with the pseudonym of "Germanico," who apparently expected to seduce her right then and there. (Lady Llanover identifies him as "M. Fabrici, the Hanoverian Minister.")[19]

Pendarves could see the park from his window (he seems to have had a knack for the perfectly positioned window to watch her every move), and, had he been looking, as Mary feared, he would have seen Germanico "upon his knees, holding my petticoat!"[20] However, since the court of George I was occupying Windsor at this time, Mary told this

Germanico that if he did not go to find treacherous Lady Walsingham, she would run up to the window of Windsor Castle where she knew "the King sat after dinner" and scream the story to the monarch. Germanico had "expected a dove," Mary boasted, "instead of a tiger." Defeated, Germanico called for the gate to be unlocked, the tigress went home, and Pendarves never saw them together.

This wasn't an isolated experience. Her frivolous and manipulative Aunt Lansdowne locked her in a room with the Earl of Clare, a French roué, where, like a real-life but more successful Clarissa, Mary resisted. After a number of hours her aunt and the Earl let her go, but not before he stole her ring, which she had taken off when she washed her hands after supper. She was afraid that this ring would show up and compromise her, but the Earl went to France, and Mary the Tigress triumphed again. Later in her life Mrs. D. would correspond with Samuel Richardson, the author of the epistolary novel *Clarissa*, drawn to the shadow of herself in the underpinnings of Richardson's novel, much as she saw the seed of her situation in Hogarth's satirical paintings.

Imagine a world where someone can lock you in a room and expect you to lift your voluminous skirts for a so-called lover you've never met before, and then to sit down and have supper with the stays of your bodice in place. There was something in Mrs. D. that would not give herself up so easily. She was as prickly with the potential lovers and the risqué aunt as she was with her husband. And as fiercely correct. She lived in an age in which women hid their lights, but to hide a light means you know you have one, and it means you understand that you have to protect it from threat and nurture it for growth.

The legend that the Scots survived barefoot Scandinavian invaders because one of the marauders stepped on a thistle and howled, alerting the Scots to defend themselves, is part of the aura of the thistle. At this point in her life Mary protected herself ferociously.

Even a thistle, even a tigress, needs a friend. Her sister was far away with their mother in Gloucestershire. Her London life was fraught with the social treachery that prevents genuine friendship. Bereft of the mirroring that a friend can provide, she had to turn to her internal life. But her very dreams depict the necessity for friendship. It was rare that she recorded one, but in May of 1724 she described to her sister Anne a dream in which she spent the night confiding in her. "And though my eyes are shut, I see my dearest sister in my dreams. I talked with you all last night and was mortified when the vision fled."[21] Then suddenly she included some surprise information: "The cut paper I will get framed and mended, and send them."[22] This stray reference to cut paper gives a pinprick glimpse into a creative life that still must have been going on beneath the drama of her marriage and the loss of her father.

The capacity for friendship with her sister, and with other, newer friends, such as Charlotte Hyde, the sister of Pendarves's friend Lord Baltimore, also filled Mary's afternoons and evenings with ballast for the terror and disturbance of the middle of each night, for now, night after night, Pendarves returned home inebriated.

Mrs. Delany's dancing thistle with its turned-away head whirls in a wind that has no apparent source. The ghostly fingers of the sharp-edged leaves poke into the blackness with an energized, hallucinatory feel. "I had that day a

kind of foreknowledge of what was to happen."²³ A strange dislocated light, like firelight in a wind, circulates around the toughened leaves of her *Carduus nutans*, the prickers that are at once warding off and feminine, almost dancing. "The night before, shocking dreams, and all the day following a dread on my spirits."

Mary had been married seven years. She had been out that night at the home of her friend Lady Sunderland, but she was so disturbed that she looked at her food on the supper table and could not eat. She sent for a sedan chair. These leather-covered wooden boxes, fitted with oar-like carrying poles, were one-person taxis, small enough to be brought by two men directly into a house, and even up a stairwell. Mary may have stepped into the chair just outside the dining room and wedged her skirts inside it, sitting on the velvet seat. Then she was carried home.

Strangely, Pendarves had arrived just before her. It was not the usual night. Instead of being dragged up the stairs by the servants, insensate, he was speaking his heart. He told her what a good wife she was. He "*wished he might live to reward*" her. She had never heard him compliment her so much. He asked her to ring the bell for a servant to bring paper, so that he might write a new will, or so her descendant Augusta Waddington Hall surmises from what her mother, Georgina Mary Port Waddington, told her, and what her grandmother, Mary Dewes Port, had told her mother. Pendarves's money and estate went to the niece, the wife of the husband he was so jealous of.

But Mary said he could just as well change his will the next morning.

He went to bed a little before midnight, six or seven hours earlier than his habit. He snorted and heaved. "He

slept (as usual) very uneasily, drawing his breath with great difficulty."

But Mary lay wide awake. Finally, about four o'clock in the morning, she closed her eyes and slept till seven. After a mere three hours, in the hypnogogic state that the nodding head of the thistle also suggests, she lifted her hand from her covers and rang the bell. Her servant crept into the room to the window and opened the shutter. Mary pulled the bed curtains aside and softly swung her feet to the floor, not wanting to wake Pendarves. But as the light from the window shone back in through the curtains she saw that the color in his face had changed.

It was the color of iron gall ink, "quite black in the face! At first I thought him in a fit, but immediately it struck me *he was dead!*"

She ran screaming from the room, and the flummoxed servant sent for Mrs. Catherine Dashwood, a neighbor. Then the doctors and the surgeons came running. Then her Aunt Stanley and her Aunt Lansdowne and her friends. The physicians "judged he had been dead about two hours." Offending the aunt who had locked her in the room with the French roué, she fled to her Aunt Stanley and the protection of her Uncle John. She was twenty-three. It was over.

Now she would never have to sleep in the same bed with him again. She would never have to smell the port, the ale, the stout, and never whiff the whiskey breath, never see the slobber, never inhale the reek of piss and fecal residues. She did not have to feel him fumbling up her petticoat or shoving his hand between her legs. She did not have to turn her head as he pinned her down and heaved on top of her. A line had been drawn by his death, as sharp as the line drawn by their marriage. Instead of a

gradual merging of one phase of her life into another, she was startled awake.

{ SHELLS }

When the first-married teenage Mrs. Pendarves walked the beach gathering seashells, she could be at home in herself, looking not up toward the horizon but down into the sand for those inspirations of tight, organized space, shells. She was collecting material specimens, not the vast visions a horizon suggests. Having a collection, taking it out, looking at it, reordering it, and putting it away is creative in itself. It doesn't yield a product, like the results of an art, but it stops time, as making art does.

In gathering shells the young Mrs. Pendarves was preparing for her great work, though she couldn't possibly have known that. She was just watching; shelling trains the eye. However stuck Mary Pendarves was, she could always watch for those mollusks. Robert Phelps, a biographer of Colette, said about watching, "Along with love and work, this is the third great salvation. For whenever someone is seriously watching, a form of lost innocence is restored. It will not last, but during those minutes his self-consciousness is relieved."[24]

Noticing keeps you alive. When we say, "I felt so alive!" doesn't it mean we were observing the ordinary world around us as if it were new? Isn't that what a romance is? But I, around the same age Mary was when she picked up shells on the beach, was killing romance. I stood at the black plastic telephone with its curly wire in my dorm at Harpur College in the spring of 1966 breaking up with Mike Groden. He stood silent at the other end, in the wooden

telephone booth in his all-male dormitory at Dartmouth – though the background noise was full of tenor laughter and the crash of flying beer cans. I had refused to wait for months for a two-day reunion to sustain us. We were over. At nineteen I couldn't manage a commuter relationship between two faraway universities. I wanted a love-fest. At our separate schools, he and I had grown like sunflowers, inches in days in the high heat of the intellectual life that we had been starved for. When we would get together, we'd hardly recognize each other, we had branched upwards so wildly and flowered so madly. In the two days of fumbling transition that was all we had, we'd have to get to know one another all over again.

I stoutly deplored his taste in literature: Eugene O'Neill. Ugh. Why spend time with that epic of drug addiction and alcoholism *Long Day's Journey into Night* – the reverse-role story of the Peacocks pumped up into a Victorian house on stage – when you could read and reread a metaphor in a poem that, like a tightly folded bud, contained all a person would need in life?

I disdained the fact that he was a math major. As the so-called creative one, I never thought of his boyhood organizational capabilities, his endless rearrangement of bottle caps from Vernor's Ginger Ale, Birch Beer, Loganberry, and other local brews of soda pop, his orderly collection of Classic Comics and *MAD* magazines, his collection of 45s, as anything but a waste of creative time. For me, the creative act was the imaginative leap – what Mrs. Delany made when her mind leapt from the geranium to the scarlet paper.

Foolishly, for most of my life I separated looking and organizing from creativity. Poetry, I thought when I was young, sprang solely from the emotions, and emotions

certainly had nothing to do with the orderliness of science. Yet the first thing I did when I was overwhelmed by the vastness of a subject or a feeling was to start observing so that I could describe it to myself. You might not be able to draw a conclusion from what overwhelms you, but if you describe it, you will come to know it. And when you come to know it, you are less afraid of it. And when you are no longer afraid, you have balance. And when you have balance, you have the poise that is control. The systematic noticing of details is at the foundation of science, too. Mrs. Delany did not live in our ultra-specialized world, but she was poised at the beginning of it. She loved differentiating all types of details; in describing as she did, she participated in the birth of taxonomy. The lines between science and art in her day were fluid, but in 1966 they had become as thick as the stays in eighteenth-century ladies' clothes.

Mrs. D. enjoyed taking in vast quantities of particulars. After she collected her shells, she tucked them into special cabinets. She scrutinized them and mentally noted minutiae. Though she hardly could have known it, she was preparing herself for her later work, busy noting the natural world just as carefully as if she'd had to record data for a biology class. Such observing is discipline, practice, a way of being that leads to art. Well, if a person has time.

My mother, after the twenty-year lock-up of her marriage, was running out of time. She might have felt that Mary got off easy when the Squire kicked the bucket in 1726. After all, she might have reasoned, Mary was only twenty-six, whereas she was forty-six. In the finale of her divorce, just after my act of cowardice on the phone with Mike Groden, the soon-to-be ex–Mrs. Peacock had the

Great Throw-Out. She was not in any way a collector. She called both of her daughters and asked them if they wanted anything. Otherwise, it was getting pitched. I shouted at my mother from that same telephone in my college dorm, "I don't care, Polly! Do what you want!" In my fury I called her by her first name.

Then she started her new life. I was resentful and wished she had begun it earlier, but I was happy because she had come into her own energy. She seemed to collect herself, even as she was refusing to collect.

Ten years after the first Throw-Out, when I was twenty-nine years old, just out of graduate school, married and divorced myself, in attendance at a tiny conference held by the funders of the fellowship that had supported me through my degree, I was exhausted by the prospect of fashioning my adult life. In the cushy living room of the mansion commandeered for the purpose of debriefing their newly degreed students, I heard an exasperated voice belting out of me. "I'm sick of being a pioneer!" I declared, but what I meant was that I was sick of the loneliness of having left my working-class family. Not that I loved them in a fairy-tale way – you can't love depression or alcoholism in that way – but my family was a family. Fractured, bleak, and bizarre as it all was, my mother encouraged me to make my own life. She firmly felt it was possible for me, but she didn't know how to show me.

Polly never remarried. Once was absolutely enough. She sold Peacock's Superette. She sold the little suburban house that she and my father had painted pearl white with pink trim. It had glowed in the snow as if it were a shell on a frozen beach. She cared for her sister, who died in

her forties. She cared for her father, then her mother, until each of them died. Every Friday night she drove from her secretarial job at Buffalo General Hospital to the little house-and-general-store that my grandfather had built in the early 1920s near Perry, New York, to take care of them, and then, after they were all gone, to indulge herself in another Great Throw-Out, this time pitching drawerfuls of paper goods: sheet music and dress patterns of the 1930s and '40s as well as all of my grandmother's correspondence. On one of my visits I rescued the diaries.

I think of Anne, Mrs. Delany's sister, saving her letters, and generations saving her embroidery. I saved some of my grandmother's embroidery. To save, one must value. And to throw out, one must value *moving on*. Interestingly, though she threw out a great deal, I don't think my mother did move on. Wholesale throwing out only closes a door against the past, like the door that closed on her life when she married. You have to sort through the details of the past in order to process what happened and then to move. In tossing it all out, I think my mother actually stopped herself from that slow growing, that layering upon layering that is growth in maturity. She had her great triumph of energy when she got rid of so much, including my father, but that force diminished. Eventually, she even sold the little house-and-general-store, by then a dilapidated shell and far from what it had been when my grandparents were alive.

Even as I contemplated moving ahead, I continued searching for role models. The teenage Mrs. Pendarves, now the Widow Pendarves, about to have to move back in with Aunt Stanley, is a role model I would have fled.

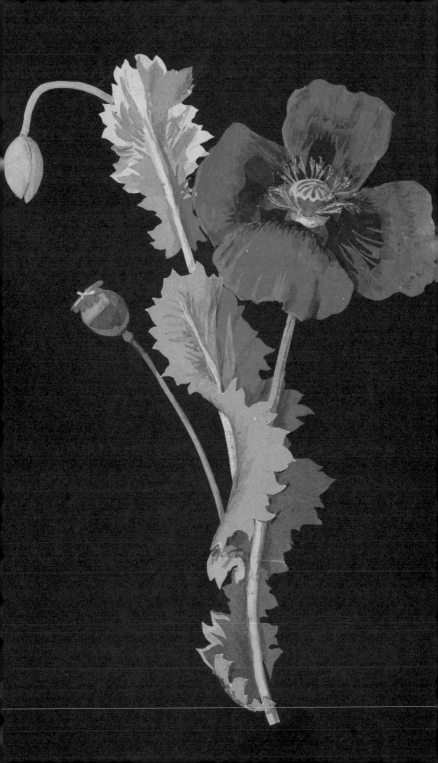

Chapter Six.

OPIUM POPPY

Mrs. Delany's *Opium Poppy* steps from the dark like a hennaed opera diva dressed in a ruby gown, wrapped in the emerald cloak of a leaf. The lower part of the topmost petal, which appears black, is actually composed of purple and violet pieces of paper. The right side of this petal seems to have been cut from dull pink paper dry-brushed over in red. Its crown is bright, orangey red, but detailed in shadowy purple-gray watercolor. The three other petals, in colors from orange to maroon, are likewise pieced. The bloom is as lavishly complex as a mantua, petticoat, and stomacher, the elements of the gowns worn to the courts of George I and II from the 1720s through the 1740s.

When Mrs. Delany pasted the finishing bit of scarlet on her *Papaver Somniferum* at Bulstrode, she dated her portrait October 18, 1776. This was the year that the British colony of Maryland became an American state, drawing up its first constitution. At the time of Alexander Pendarves's death, Maryland's proprietary governor had been the sixth Baron Baltimore, Charles Calvert. He was the brother of Charlotte Hyde, one of Mary Pendarves's friends. Charlotte was the young wife of one of Pendarves's associates, and, like Mary herself, was "of a noble family" but was "of very moderate fortune"[1] – unlike her wealthy brother. Lord Baltimore, with

Papaver somniferum, the Opium Poppy, Bulstrode, October 18, 1776

his haughty brows and slight double chin, was, perversely, the only one of the younger men of whom Pendarves wasn't jealous – though he should have been. The Baron was the man his young wife had called "dangerous."[2]

The *Papaver somniferum* can be dangerous. (*Papaver* is the Latin for poppy and *somniferum* the Latin for "bringing sleep.") The latex-like sap from its unripe seed pods contains isoquinoline alkaloids which produce narcotics. But before the pericarp (the part of a fruit that surrounds the seeds) of a poppy's mature seed capsule is slashed, and before the raw white opium drips and oxidizes black in preparation for its transformation into morphine, codeine, and heroin, it has been surrounded by a deep-lobed temptress of a flower.

After Pendarves died, Mary escaped not to her mother and sister in Gloucester but to her aunt and uncle, where instead of shouting for joy she immediately collapsed and fell ill. The Stanleys took care of her. She needed them not only for emotional succor and nursing but to a degree for financial support, since she had failed to inherit the castle that Pendarves would have bequeathed her if she had insisted that the old coot change his will the night before he died. Settled only with her widow's inheritance of a few hundred pounds a year, Mary couldn't ever be as extravagant as her friends, some of whom had thousands of pounds at their disposal. "As to my fortune," she stoutly claimed, "it was very mediocre, but it was *at my own command.*"[3] When she recovered, she realized that she had joined the freest group of women in Britain: widows with means. (But could she have made that money work for her? Perhaps, according to Dr. Alicia Weisberg-Roberts, another member of the cadre of eighteenth-century women

scholar-detectives. I met the curly-haired curator with the laser-beam eye for detail when she occupied a desk wedged into a row of other desks at the Yale Center for British Art, but she has moved on to a curatorial position at the Walters Art Museum in – where else? – the city named after the family of Lord Baltimore, in the state the dangerous man once more or less owned. She informed me that it was possible that Mary Pendarves was getting financial advice; someone may have been investing her widow's income for her, since she herself could not.[4])

About six months into Mary's widowhood the long-nosed, full-lipped Charles Calvert, then Lord of the Bedchamber to his cousin H.R.H. Frederick, Prince of Wales, rapped at Sir John and Lady Stanley's door. Even though strict Aunt Stanley had given permission for him to call – her niece "consulted" with her "on all occasions"[5] – the old lady was alarmed to see him saunter into her drawing room. He was twenty-five years old and as eligible a suitor as her niece could have imagined – though Aunt Stanley had a different plan in mind. With her pale face above her widow's weeds, Mary must have entered the room like a self-possessed black swan. The potent possibility of her widow's self-determination had begun to infuse all she said and did.

Baltimore may immediately have sensed her gathering strength. It made for a powerful and disturbing visit. She inhaled a few grains of the narcotic that a rich, glamorous, titled man can be and in turn exuded her own allure, the scent of a young woman beginning to own herself – the ultimate tool of seduction. Yet her heat was contradictory; it was fueled by the warmth of attraction but inhibited by the sparks of her new refusal to be tied down. Baltimore

was attracted, yet hesitant. Though independence can be romantically hypnotic, was that what he wanted in a wife? Mary began to fall for him in a complicated, slantwise way. Her "inclination towards him increased," she wrote of her own behavior, at the same time as she "grew more reserved."[6] While Aunt Stanley calculated how to circumvent him and press her case for someone else, the Baron paid his respects, wafting off on a current of charisma.

What does an arty young widow do with her new-found time? Mary woke up, called for her tea, felt the chamber pot cold beneath her derrière, then stood still while her maid put on her day clothes (these were a less-corseted version of the going-out clothes). Then she called for the hairdresser. The hairstyles of the 1720s sharpen the idea of hair*dresser*, because they conjure up a sense of fabric, reminding us that hair, like clothes, wasn't washed very often. The lard-stiffened, sometimes powdered locks took on the texture of a cloth weave. She adhered to the rules of mourning, such as those she wrote to Anne after their father's death and not long before Pendarves died. "Dear Sister, – You should, if you keep strictly to the rules of mourning, wear your shammy gloves two months longer, but in the country if it is more convenient to you, you may wear black silk; you might have worn black earings and necklace these two months."[7]

Happy in her mourning clothes, she saw her friends, she went to concerts, she shopped. By November 8, 1726, eleven months after Pendarves's death, she buoyantly records her afternoon schedule: "at four o'the clock in the afternoon comes my lawyer and my taylor, two necessary animals. Next morning I send for Mrs. Woodfelds to alter my white tabby and my new clothes, and to take my black

velvet to make; then comes Mrs. Boreau to clip my locks, then I dress to visit Lady Carteret, then come home to dinner, then I drink coffee after dinner, then I go to see" other family members, as well as "all the fops and fopperies" in London. ("Tabby" is a kind of fine basketweave cloth, sometimes linen, sometimes silk, used for the white scarves that were tucked into the necklines of the gowns she would have worn. It is not a cat, though she acquired a kitten, too: "white, with a black nose and a black chin.")[8]

Her letters to her sister popped with fresh, brightly expressed opinions. "I was yesterday at the rehearsal of Mr. Handel's new opera called King Richard the First – 'tis delightful," and in the same letter she goes on to tell Anne just what she thinks of marriage: "But to speak seriously, *matrimony is no way in my favour* – far from it."[9] Aunt Stanley entirely disagreed. Mr. Henry Monck, the son of her husband's sister Sarah and part of a branch of the family of the wife of Sir Bevil Granville, was available.[10] If Mary agreed to have him, Uncle John would settle his whole estate on the couple.

Lord Baltimore could easily best the nephew. "A young man in great esteem and fashion at that time," Mary described him, "very handsome, genteel, polite and unaffected. He was born to a very considerable fortune, and was possest of it as soon as he came of age." Neither Henry Monck nor Charles Calvert (Baltimore) was a thinker, much less a reader, as Mary was. She sized up Baltimore as having "the education bestowed on men of his rank, where generally speaking the embellishing the person and polishing the manners is thought more material than cultivating the understanding, and the *pretty* gentleman was preferred to the *fine* gentleman."[11]

On a hot day Baltimore invited her to a party on a barge on the cool Thames, and Mary almost said yes – except that she remembered that she could also say no. In that continuing invention of a life, saying no and turning away from what you may not want, or at least stopping before you act immediately, is a great source of personal wealth. It can position your few hundred pounds a year against someone else's thousands. And so she refused "all his entreaties, at which he left me disappointed and cha-grined."[12] Baltimore was so disgruntled that he gave up the barge party and stalked off to the tennis court, where, in a freak accident, he was hit "between the eyes" with a ball, knocked to the ground (some thought he was dead), and brought, bloody, to his sister Charlotte's house. The next day, weakened from the loss of blood, he begged the enticing, reluctant Mary to go to him.

She did not.

"I could not bring myself to do it," she said, "as he had never *positively* made any declaration that could warrant my granting him such an indulgence." The charmer who depended on his fortune and position and likeability would have to make good on a marriage proposal before she would come to him. Her friend, his sister Charlotte, consid-ered her "inhuman," and she relented by half, agreeing that if he were still as ill the next day, she would go to see him.

But the next day, and the day after that, and after that, Mary herself became "ill and not able to go." She somati-cized her dilemma with insouciant pre-Freudian liberty. What did the owner of the entire future state of Maryland want? Some commitment from her before he himself gave one? (Or so that he didn't *have* to give one?) And she, shying away, unwilling to be teased forward, held him suspect. He

wrote to her. She did not answer. Charlotte continued to press her brother's case with Mary. Was her rejection a cold calculation, as her friend suggested, or was it more like being frozen in the lights of oncoming carriage lamps behind a team of galloping horses?

Baltimore decided to console himself with three months abroad and told Mary that he "had fitted up a little vessel for that purpose; that he had great lowness of spirits, partly occasioned by his late accident at tennis."[13] In the moves of their uneasy dance, he backed away, in a parallel move with her retreat. Then he came forward – unable to resist trying her again. Wouldn't she give him her picture to take with him? A painted miniature that he might hold? "I told him it could not be. . . . *I did not think it right.* . . . he protested solemnly . . . but I absolutely refused him."

"Vexed and disappointed," having made her "a thousand professions of love and esteem," he left. "So we parted," Mary wrote in her lucid, upright, curled hand, "neither of us pleased with each other." She called him "*a flutterer.*" Lord Baltimore, she confessed to her sister, "is really a pretty boy, but I fear he is not so bright *within* as *without,* but traveling will improve his judgment and fancy."[14] Is this noteworthy ability to hold a line against such persuasion part of what would allow her to cut those lines in her collages decades later? Is the coldness her strict adherence to convention? Or did she really think he was a superficial romancer, just the sort of narcissist who would go get himself boinked on the head to elicit attention after she had rejected him? Or had she simply had enough of any thought of another commitment after her harrowing marriage to Pendarves? The power of a no is also the power to create – and be comfortable with – negative space in a life.

Or in a collage. There is negative space in Mrs. Delany's *Papaver*, both in its matte, midnight background and also inside the elongated black triangles between the flower and the leaf and between the leaf and the stem of the seed pod. To assemble bright, organic shapes that create these negative pockets requires an infatuation with sharp lines, a love of clear distinctions. There is nothing blurry or graded about what Mrs. Delany cut in outline. Her over-defined background acts just like a resolute NO.

Mary seemed to be growing as fast as a poppy does. (Seeds flower in two to three months, depending on the climate.) She seemed to leave the injustice of her small widow's inheritance behind her, and even, in the wake of relief's forgetfulness, to have forgiven guilty old Uncle George, Lord Lansdowne, who wrote to her from Paris on January 19, 1725, "I am thankful to my niece Pendarves for the justice she has done me."[15]

Music Lesson:

On a wintry afternoon in late January 1727, Mary nestled her skirts into a chair at her aunt and uncle's table to dine with "the charming Faustina, who is the most agreeable creature in the world . . . and we are to have our senses ravished by her melodious voice."[16] She was enamored of the great Italian sopranos of her day, Faustina Bordoni (1697–1791), known to her dinner partners and her audiences simply as Faustina, and the tempestuous Francesca Cuzzoni (1696–1778), both of whom were lured to London to sing "Mr. Handel's opera" (probably *Admeto*). In moving to the Stanleys' Mary had put herself back into social

circulation and back into proximity with her friend and role model Handel, who was by this time a cultural institution in England. (Alain Kerhervé, a meticulous French scholar, has surveyed Mrs. D.'s letters to find that she mentions twenty-eight of Handel's compositions in sixty-eight of them, beginning with Handel's 1713 *Te Deum* and ending with his *Theodora* in 1750.)[17]

The talented Italian opera divas Handel employed to perform his works and bolster his fame commanded extravagant fees. The long-lived Francesca Cuzzoni at the height of her career pulled down a salary of 1,500 guineas a year. (It's very hard to get an exact equivalency in today's pounds or dollars. A guinea was a gold coin equivalent to a pound sterling or, in negotiating sales, a pound plus a shilling. In sheer comparative earning power this salary represented over two million of today's pounds. But a better way to compare it might be with the way it dwarfed Mary's £300 annual income.)[18] Reverend John Mainwaring, the first biographer of Handel, tells a story about Handel managing the stormy Cuzzoni. When she refused to sing an aria that was not written originally for her, Handel replied (in French), "Oh! Madame, I know well that you are a real she-devil, but I hereby give you notice, me, that I am Beelzebub, the Chief of Devils."[19] According to Mainwaring, Handel then grabbed Cuzzoni by the waist and threatened to throw her out the window. There is something of a she-devil in Mrs. Delany's *Opium Poppy.* The extremely well-behaved Mary Granville Pendarves was a great fan of Cuzzoni's rival, the even longer-lived Faustina. Watching them sing together also meant waiting for a possible outburst of Mediterranean emotion that was not part of Handel's composition.

She heard them just at the moment when she herself was acting like a much more subdued Anglo diva. She was refusing to sing for her supper with her family. Instead of complying with her aunt's plan that she wed a Stanley relative to secure her family's fortunes, she fiercely rejected it, finding him "uncultivated, trifling, without knowledge of the world."[20] "I was struck with astonishment at my aunt's recommending a person to me that I was sure must appear very insignificant to her. . . . I told her sincerely I never could give my consent; that I had no inclination to marry, and less to the person proposed . . ." Unlike Cuzzoni, who capitulated and sang the aria, Mary did not reverse her decision. She risked offending the very people whom she most trusted, even at the cost of a possible family rift. But old Aunt Stanley did not defenestrate her, even figuratively; Mary's objection did not seem to strain her relations with her aunt and uncle. There must have been some tacit acknowledgment that she had paid her dues – even though they would flaunt the names of other suitors periodically, and even though they may have preferred her in a tidy married state rather than stepping out on her own. Mary politely made it clear that no amount of money could be exchanged for her self-possession. She had cut her line.

A year later she pranced off to watch the preparations for another of Handel's concerts on New Year's Eve, 1728. Throughout this period she attended numerous rehearsals of Handel's works, listening to the way her friend and mentor drew his musical lines – the formality of his structures containing their ebullience. On New Year's Day, she delivered this piece of music criticism to her sister: "Yesterday I was at the rehearsal of the new opera composed by Handel [probably *Ricardo Primo*]: I like it

extremely, but the taste of the town is so depraved, that nothing will be approved of but the burlesque. The Beggars' Opera entirely triumphs over the Italian one; I have not seen it yet, but everybody that has seen it, says it is very comical and full of humour; the songs will soon be published, and I will send them to you."[21] It turned out that she loved John Gay's ballad opera, even though it satirized Italian operas (including Handel's) as well as the aristocracy who revered them. After she saw it at Lincoln's Inn Fields, she amplified her opinion in a communiqué to Anne: "I desire you will introduce the Beggar's Opera at Gloucester; you must sing it everywhere *but at church*."[22] She winks her eye at her sister at the thought of the risqué performance in church, delighting in the satirical mode even as it mocked her own interests and her own friend. (Gay spun out his popular creation from an idea Jonathan Swift had sparked in a letter to their mutual friend Alexander Pope.)[23] Mary, full of her opinions, makes her critiques as crisp and fearless as if she were a reviewer delivering to a deadline. To be intimate enough with the composer to attend the rehearsal, to hear the performers as they practiced and revised, allowed her to observe the way a musical composition is brought to peak performance. This exposure to Handel reinforced the high demands of ambitious creation that he had initially inspired in her childhood.

The *Papaver somniferum* leaf is cut from a single green piece of paper. The green is as matte and flat as if it had been painted with gouache, yet there's activity in that leaf: its many points seem to be in sunlit motion. Mrs. D.

ingeniously drew three lines with black ink at parts of the edges of the lower half of the leaf, making it look three-dimensional, raised from the page, as if it were casting shadows. The whole effect is of a kimono-like gown billowed back by a breeze, like the robe of a star soloist falling down from her shoulders. The poppy seems almost to have a voice, full-throated. By the second year after Pendarves died, Mary had come into that voice; she had entered the stage from the darkened wings, as her *Papaver* steps out from its ground.

As Baltimore consoled himself on his winter sea travels, it was rumored that his ship had capsized and that he had drowned. When he returned and appeared at court, Mary was flummoxed at the sight of him – she had thought him dead. To meet him as she might have met a ghost stirred up the contradictory mixture of her previous feelings for him – the ambivalence of being drawn to a nobleman and the simultaneous desire to flee.

Dressing Lesson:
In the wee hours of October 11, 1727, Mary got dressed to attend the processional and dinner for the coronation of George II and Queen Caroline at Westminster Hall. Just before his death in June of that year, George I had signed an act making Handel a naturalized British citizen, and the composer's first commission was to write the anthems for the coronation, including the tour de force *Zadok the Priest*, which has been played at every coronation since. But Mary was not going to hear the anthems in Westminster Abbey; instead she would position herself at Westminster Hall,

where her mind was not so much on hearing as on seeing and being seen.

It would have taken so many hours to put herself together that she might have had to stay up all night to be ready at 4:30 a.m. to leave for the day's festivities. Gussying up meant at least a two-person construction job, by candle-light. Layer after thin layer of clothing was applied to her body, a bit like building up the strata of paper pieces in the center of the *Papaver*. First came her chemise. It was like a fine linen or cotton lawn half-slip. Next came a full slip, its lace-edged drawstring neckline scooped low. (There was no bra. No panties. The idea of structured underwear, protecting the body, would wait a whole century after this, until women abandoned these types of stays.) There would be only the thinnest cloth draping over the breasts. This scant layer didn't protect the skin so much as the clothes from the perspiration of the skin.[24] After all, these gowns weren't going to be thoroughly cleaned. Food stains would be picked off, disastrous wine stains blotted as best the servant could, and grease would be spot-cleaned with fuller's earth, a kind of clay which absorbs oil like talcum.[25]

Now the embroidered ("clocked") silk stockings were rolled and her toes dipped into them. Then she pointed each leg as the stocking was drawn over her feet and up to just below her knee, or just past. The garter of ribbon and lace or silk or velvet (there was a jungle of colors and varieties)[26] was then tied into place by her personal maid.

Next, her stays. Stays were a kind of stiff, three-dimensional form beneath which the body was obscured. They were not like a corset; they did not go around the abdomen and were never laced too tight. Stays were measured precisely to the waist, making it easy to bend.

To create them, a seamstress would stitch whalebone into vertical slots in heavy linen, and sometimes horizontal rows as well. The cloth itself was sometimes stiffened with paste – as Mary's collage flowers would be stiffened decades later – or made rigid with fabric layers. Stays functioned like a bustier, laced at the front or at the back. They lifted up the bosom, still only covered with one layer, and kept a woman's spine upright in a posture that was ready for the minuet at any moment. "Most of the postures of the ballet are predicated on wearing stays," graceful Alicia Weisberg-Roberts told me, adding with a laugh that when she herself tried them on, "they weren't *that* uncomfortable."

Mary Granville Pendarves was not nearly done getting dressed. Now for the pockets in which to keep a few personal items (no evening bag swinging from her hand); they were tied around the stays. Then a hoop, which her maid would tie around her waist. At this time, court gowns had a bell-like look, obscuring the lower body and giving the fabric almost the feel of a lowered curtain-shade. Later on, in the 1740s, the hoops would widen and flatten. All this is a bit like wearing several belly packs. Though at the age of fifty Mrs. Delany wrote that she avoided the extremes of hoops ("I am glad you *detest* the tubs of hoops, – I keep within bounds, endeavouring to avoid all particularities of being *too much in* or out of fashion; youth and liveliness never prompted me to break through that rule . . ."),[27] we can gamble that she wore some sort of hoops for the coronation. She was absolutely tuned in to fashion, she minutely described dresses in all her letters from her twenties to her eighties, and there's no doubt that she would have conformed to the rules for court dress.

Finally, the opium dream of the actual clothes. The petticoat (an underskirt, but one that was meant to be seen) was slipped over the hoops. Penultimately came the donning of her mantua. Katherine Cahill, to whom I am also indebted for my understanding of how these garments were worn, calls a mantua (the name for a gown at this time) "a kimono-like construction,"[28] just as the main leaf of the *Opium Poppy* seems to suggest. The mantua is like an open robe that hangs from the shoulders. It has a back and sleeves, but it doesn't quite reach around the whole body, leaving room to display the petticoat in front. Mary would have stuck her arms behind her to receive the gown, which would have been slipped on as she pulled her arms forward, very much the way the poppy slips on its green leaf.

At last the finishing element, her stomacher, was tied into place by her personal maid. The stomacher was a triangle-shaped, paste-stiffened whalebone shield, covered with the same fabric as the petticoat and mantua, or sometimes contrasting fabric. It was meant to connect the front and the back of the gown, covering the stays. Attached by ribbons and bows to the upper part of the mantua, the triangle of the stomacher would point to her groin, or, as it had been known since the late seventeenth century, her Honour.[29]

By this time Mary's breasts and belly were flattened so that she would have looked like an upside-down flower: her head, neck, and torso the stem; her arms the leaves; and her skirt the flowerhead.

All of this dressing had to have been accomplished before dawn, because at 4:30 in the morning on the day of the coronation, Mary and Mrs. Garland, a friend, were wrapped in their cloaks, so early for the event that the doors of Westminster Hall (where the processional began, and where the newly crowned monarchs would return to dine) were not yet open. They repaired to one of the new variety of gathering places, a coffee house, filled with men (but where women were certainly allowed), that served as people's home bases; some received their mail at the coffee house they frequented.[30] After hanging out for three hours, they decided to try to get to the coronation again, left the coffee house at 7:30 with a grenadier, and plunged through a terrifying crowd that surged like a riptide. In the battering of these human waves Mary's cloak came off behind her, and as she fought for her footing, her arms were bruised. "For some minutes I lost my breath, (and my cloak I doubt for ever)."[31]

At last they were inside Westminster Hall, where George II and his Queen were to eat their coronation meal,[32] and Mary had a ticket to watch them. She and her friend swept their hooped mantuas toward a balcony and a table where they sat down, carefully adjusting their gowns to balance on the chairs. The King was nearly hidden from her view under a canopy, despite the fact that the "room was finely illuminated, and though there was 1800 candles, besides what were on the tables, they were all lighted in less than three minutes by an invention of Mr. Heidegger's, which succeeded to the admiration of all spectators."[33] (James Heidegger was Handel's impresario.)

Mary loved looking at others – and, on this occasion, being looked at herself. "It was not disagreeable to be taken

notice of . . ." Her modesty abandoned, she stepped out into her freedom. All her friends were there and brought her food. "Everybody I knew came under the place where I sate to offer me meat and drink, which was drawn up from below into the galleries by baskets at the end of a long string, which they filled with cold meat and bread, sweetmeats and wine."[34] She, who was filled up by looking and noticing, could look and be looked at the whole long day, finally limping back to her aunt's by 10:00 that night.

What do clothes have to do with late-life paper botanicals? Precision, of course, and an avid interest in detail. A devotion to couture, as any passionate visitor to the displays at museums understands, trains the eye for detail. As Mary matured, her eye was educated on the silkiest spans of textiles. Her gaze developed with a scientific precision and a sensuous apprehension. And she had literary talent for writing her observations. "The beauty of writing," she mused, "consists in telling our sentiments in an easy, natural way."[35] Around this time, from her fireside she wrote, "My clothes were grave, the ground dark grass green, brocaded with a running pattern like lace of white intermixed with festoons of flowers in faint colours. My ribbons were pink and silver, my head well drest, French and a cockard that looked smart, my clothes were a French silk, I happened to meet with a great penny-worth – they cost me seventeen pounds."[36] (A cockard was a feather headdress.) We can loosely calculate what she spent on her outfit in today's currency: just over two thousand pounds, or just over three thousand dollars.[37]

Spending 6 percent of her income on a single outfit – including a feather for her hairdo – indicates how important self-embellishment was to Mary as a young woman.

(In 1776 Mrs. Delany dressed her poppy to the nines.) Young Mary dolled up for socializing, as well as for court levees or assemblies. This meant that she accompanied someone to an assemblage of other aristocrats and waited for King George and Queen Caroline to appear and possibly to speak to her, recognizing her existence. It meant that she stood in their majesties' presence, never turning her back on the King or Queen. It meant that she curtsied and that she spoke prettily. Do not equate this with the superficial. It meant that her whole life depended on how she looked and what she said. Her recognition might lead somewhere, such as to a court appointment, or to Lord Baltimore, who certainly attended court, or it might lead only to compliments. Compliments aren't superficial, either. They are the foundation of recognition of who we are in life.

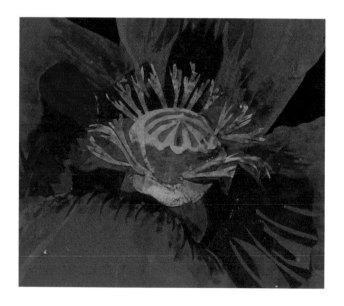

Papaver somniferum, detail

Mary Pendarves had been hidden at Roscrow in Cornwall, but now she was back. When she dressed up for Queen Caroline's birthday on March 4, 1729, she borrowed her friend "Lady Sunderland's jewels, and made a tearing show."[38] There was a huge crowd, and her cousin, Lady Carteret, literally pushed her toward the Queen, who "thanked her for bringing me forward, and she told me she was *obliged to me* for my pretty clothes, and admired my Lady Carteret's extremely; she told the Queen that they were my fancy, and that I drew the pattern. Her Majesty said she had heard that I could draw very well (I can't think who could tell her *such a story*)." Here's a slip of evidence with its self-deprecating parenthetical modesty that she was designing her own clothes and those of friends and family by the time she was in her late twenties.

She spent the almost two decades from 1724 to 1743 going to court, seeing and being seen. Toward the end of these twenty years, she designed her own court dress. Like the poppy, the dress she designed is theatrical – full of stagy couture drama. The petticoat is black – not occasioned by mourning but by choice – and it is embroidered with botanically accurate English garden flowers. One look at even a fragment of this dress (it survives only in fragments) convinces you that couture presages the mosaicks. Those flowers share both the accuracy and the fantasy of her cut-paper works decades later. The black background, suggestive of melancholy, allows her Lily of the Valley, her Harebell, her Geranium, her Rose, and yes, even her embroidered Poppy to step forth. She designed the dress and she orchestrated its embroidery, ordering it professionally sewn.[39] Some amazingly preserved fragments show that the brilliantly-colored blossoms were slightly stuffed

to lift them off the surface of the fabric. Imagine the gown in candlelight, where the black background would recede and the flowers would glow.

A few months before her outburst to Aunt Stanley against matrimony, Mary went with Lady Sunderland "to the Princess Royal's, where there was a vast crowd of people."[40] There she heard a story about rich Lord Thanet, who died leaving his daughter two thousand pounds, as long as she *didn't* marry the man she loved. Just hearing of this will provoked Mary, who wrote Anne, "[W]ho can judge of our happiness but ourselves, and if *one* thousand pound a year and a great deal of love will content me, better than *ten* thousand with indifference. . . . I have no notion of love and a knapsack, but I cannot think riches the only thing that ought to be considered in matrimony."[41]

By 1729 Mary had taken a place of her own, living apart from her aunt and uncle. She managed to make her independence a priority and gracefully extricated herself from their household. She accomplished this by accepting long-distance invitations and spending "the greatest part of the summer and the winter following" out of town. "Towards the next spring I came to town and settled in a house by myself"[42] in Pall Mall. For the first time in her life, she had a room of her own. Immediately she invited her mild-mannered younger sister to stay. On March 13, 1729, she offered Anne "half a maid, half a room, half a bed, and half a French roll for breakfast."[43]

With this invitation, though, came a caveat about the health of their Aunt and Uncle Stanley. "All Sunday," Mary explained about their aunt, "she complained extremely of her head, and was very hot, her spirits very much upon the flutter, and for four-and-twenty hours she neither

slept nor lay in a posture for a minute together. . . . I was very much frightened, and begged her to send for a doctor; but she would not bear the thoughts of it till Sir John came. . . . When he came to town I thought him almost as ill as my aunt."[44] Her ailment (never diagnosed) first flared, then sputtered. After a terrible weekend, she appeared to be all right again. But the sense of her aging, of waning, was powerfully apparent to Mary, who spent a great deal of time with her aunt and uncle, though this did not impede her going to the theatre, to concerts, to visit friends, or to her paying court.

Peppered among the comings and goings in her letters are the names "Guyamore" and the "American Prince," her pseudonyms for Lord Baltimore. She encountered him at court in November 1728, "the only bright thing in the circle,"[45] and again in February 1729. He visited her twice. The following December she met him once more at court, and after he asked about her sister, they talked about the time when he was shipwrecked and people concluded he was dead. He demanded to know if she "*had once thought of him or was sorry* when I heard he was cast away?" She in turn asked him if he thought she was so cold as not to be sorry "for so unfortunate an accident to an acquaintance. '*That common compassion*' (says he in a tiff) would *give me* but *little satisfaction*."[46] It's a zigzag of an exchange as she records it. He leaned toward her and whispered to her, making her pleased – and uncomfortable.

127

All this she confessed to Anne. Anne of the long, straight nose and level gaze, Anne the confessor and sounding board who, her older sister presumed, didn't really have a life, living in the country with Mama. "I expect an answer to every paragraph. I believe this is the fourth letter you

have to answer,"[47] Mary once wrote with the imperiousness of need, mirroring a bit of Baltimore's implacability. She understood the necessity – the value – of expressing distress, both for the one who is sorting out her conscience and for the patient soul who hears it. "It is a mistaken notion that speaking to a friend of the affliction they are under adds to their pain – far from it: 'tis a comfort, for when the mind is possessed of any particular object, it is the greatest satisfaction to talk it over."[48] Mary doesn't stint on saying what it is that Baltimore is causing her: pain.

Yet the Baron's money and position kept exerting their influence, and Mary continued to be drawn to him. She literally drew him, too: his portrait, that is, and sent the sketch, which has not been preserved, to Anne, writing in a juicy letter of March 13, 1729, about both this sketch and one of Henry Hervey, "I am glad my drawing pleases you. I endeavoured to keep up to the originals, but fear I have done them an injury. . . . Regular features may easily be expressed, but there is a certain agreeable air that no limner can hit off, where there is a great deal of variety it will pose the most skillful to describe."[49]

To draw someone is to employ the sense of touch at an intimate distance, moving an extension of one's fingers, the pencil or pen, to touch the face that one observes. "Limning" means drawing in miniature, a word that has been sidelined, as art historian Kim Sloan reminds us, because miniatures are often undervalued.[50] Mary could not resist drawing her American Prince, as she called him with a mix of irony and appreciation.

She understood that she might shipwreck on the shoals of marriage because of her anxiety about financial security, and she needed to figure out how she felt about him.

In the absence of a psychotherapist, one way to accomplish that was to write to her sister. These letters, which always lament Anne's absence, were possibly better therapy than in-person conversation. Letters required Mary to formulate her dilemma, to shape her stories, to do what all personal writers do: become a sympathetic witness to the character of herself as she drew it in words on the page. As a result, she acknowledged the remedy her pain required: an opiate. A few years earlier she was reading the work of French essayist Charles de Saint-Evremond, so taken with what he said about friendship (and for Mary that very much included sisterhood and family) that she described it in detail. "Without the communication of a real friend, sorrow would sink one to the lowest ebb . . . the compassion a friend affords one . . . is like opiate to one in violent racking pain."[51] Friendship doesn't reduce pain, Mary mused, but it can numb it.

In April 1729 Aunt Stanley "continue[d] very weak and low," but on February 7, 1730, even though Mary "grieved at the painful condition she lies in," Aunt Stanley convinced herself that she felt much better, and it was time to take in the opera with her niece.[52] Mary escorted her aunt to the opera, only to find Lord Baltimore sitting in the seat behind them, accusing Mary in the intermission of being the cause of all his erratic behavior. He insisted that she "was to answer for all his flights and extravagance. I told him it was so large a charge, that I should be sorry to have it placed to my account."[53]

Over the weekend Aunt Stanley relapsed.

The following Monday, Baltimore came to see Mary at her own house on Pall Mall. Unlike his initial visit to her, supervised by eagle-eyed Aunt Stanley, now they were

alone. She'd never seen him looking better. He asked if she didn't think that "they were miserable people that were strangers to love" and told her that he dreaded her answer. She said, "I endeavoured to make my life easy by living according to reason."

"My opinion of love," she then quoted herself to Anne, "was that it either made people very miserable or very happy."

"He said it '*made him miserable*.'"

"'That, I suppose, my Lord,'" she went on to say, "'*proceeds from yourself: perhaps you place it on a wrong foundation*.' He looked confounded," and changed the subject. No kiss? No touch? No disordered dress or wrenching away from an embrace? Not in the letters Anne saved, though we don't know what she burned, and not in the letters Lady Llanover edited, though she most certainly did not put in every word or every letter. Not in the surviving letters in public collections, such as the ones you might read at a blond library table surrounded by high school kids doing their homework at the public library in Newport, Wales.

While swimming in the sea of Mary's handwriting, I realized that even though the Newport Library has volumes of her epistles, all attached by library tape into neat leather-bound albums, many of the letters are missing, and the memoir isn't there at all. Yet even among the jostling of high schoolers, the hard chair, the stale air, and the hunger triggered by the smell of a surreptitious cinnamon bun some nearby patron was sneaking, I feel I can trust myself to have woken up for a hint of a sex scene between Mary and Charles. But, no. He "went away immediately after."

Often in her paper mosaicks, just when you think it would be easy for Mrs. Delany to cut more pieces of paper, she simplifies and does less. The bud of the *Papaver somniferum* is a perfect example, made of only two pieces. The stem and main almond shape of the bud are cut from a lime-green paper. She painted a line to give the impression of the parts of the bud as it begins to open. Then she placed a sliver of beige paper on the right side of the bud for sculptural weight and depth. Her eye both simplified and tried to represent the complexity of the bud. There is an aspect of this mosaick that is similar to the drawings Mrs. D. made to serve as patterns for embroidering the flowers on her court dress.[54] Botany, the feel for the flesh of the flower, and aesthetic positioning are so intertwined they are like the double helix of DNA.

This steadiness of observation, the ability to focus – did she cultivate it, or was it simply always there? If the flowers have the feel of a memoir, do they relate to how she remembered things? I decided to test her process of remembering, to check how accurate she was in the recollection of her own experiences. It's possible because we have the letters she wrote at the time of the earlier events in her life as well as the partial memoir she wrote some eleven or so years after. She herself didn't have the letters to refer to – she thought they were destroyed – and she had no way to check herself against what she had said earlier. One can discover the unfolding of Mary's feelings toward Baltimore in the letters she wrote to Anne at the age of twenty-nine, just as the romantic sparring was

131

happening, and also the aborting romance retrospectively in the memoir she began when she was forty.

Her memory has the same unerring ease of exactitude as her hand. Over a decade later she reconstructs her confusion nearly exactly, re-entering it with the emotional flexibility of someone who can dissolve herself again in old feelings. With this access to a central core of experience, she is the living answer to skeptics who buttonhole memoirists and insist they prove how they can repeat whole conversations recollected after many years. The narrative is more settled in her memoir, but it has the same snap as the red poppy making its entrance on the black stage – well, page. The memoir, with its narrative nips and tucks, fits the dress on the diva, detailing it, trueing it, adding color and shadow, but faithfully follows the contour of that core.

> At the opera Baltimore "told me he wondered where I had buried myself" and that since his opportunities were so few he could no longer help declaring that he "*had been in love with me for five years*," during which time I had kept him in such awe that he had not had courage to make a declaration of his love to me. I was in such confusion I knew not what I saw or heard for some time. . . . I softly begged he would not interrupt my attention to the opera. . . . He then asked "if I should be at home the next day?" I said, "I should."
>
> I cannot say I listened much to the music. . . . The next day he came punctually, very much dressed and in good spirits.

They chit-chatted, and finally he got down to it.

At last he said he was determined never to marry, unless he was well assured of the affection of the person he married. My reply was, can you have a stronger proof (if the person is at her own disposal) than her consenting to marry you? He replied that was not sufficient. I said he was *unreasonable*, upon which he started up and said, "I find, madam, this is a point in which we shall never agree." He looked piqued and angry, made a low bow and went away immediately, and left me in such confusion that I could hardly recollect what had past, nor can I to this hour, – but from that time till he was married *we never met*.[55]

It is almost as if they had a scuffle. She's confused, he's confusing. What we'd say now is that he jerked her around. (And that's what Lady Llanover says, more formally, in a footnote to this story in the edited letters.) But Mary sent Baltimore her share of mixed signals as well. He approached and she withdrew and she approached and he withdrew. Each of their unsatisfactory but fiery and enticing encounters had a similar pattern. Lady Llanover felt it came down to money; Mary just didn't have the dowry for the dashing confuser Lord B. But Mary seems never to have sent him a wholeheartedly affirming signal. They sparred. They had an operetta, full of bumps on the head for Lord Baltimore and not one but two physical illnesses for Mary, the second one quite serious.

On the same day of his last angry low bow, she "fell ill of a fever. . . . As it fell on my spirits, I was for some days in a great deal of danger. During my whole confinement he never once enquired after me."[56] Just as she had refused to go to him years before at his sister's house when he'd called for her, he did not return. Instead, he put a coda on

this affair, marrying the very rich Mary Janssen (Janson), and when our Mary saw the couple after nearly a decade had passed, she was still stung. In January 1740 she described meeting "My Lord Baltimore [who] was in light brown and silver, his coat lined *quite throughout* with ermine. His lady looked like a *frightened owl,* her locks strutted out and most furiously greased, or rather gummed and powdered."[57]

Mary's feverish delirium replicated the confusion of Baltimore's baffling overtures and her mixed desires. It also replicated her Aunt Stanley's last illness. Aunt Stanley, her adoptive mother-of-courage, her strict and succoring rescuer, the woman who supported her even as Mary refused to wed the man she wanted her to marry, as a generous mother would exasperatedly but steadfastly love the daughter who went against her advice, also lay ill.

"Before I was well my Aunt . . . died,"[58] while young Mary Pendarves lay in a stupor of illness. Opiated? The older Mary Delany doesn't say. No doubt she was bled. Perhaps more than once, in the belief at the time that bleeding would remove her ills.

The sensuous blood-red poppy also sports a seed pod to the left of the main diva bloom. This pod is the part of the flower that comes into its own after the petals fade and drop to the ground, what exists after the bloom dies. Mrs. Delany cut the seed pod as an abstraction, as close to a Matisse cut-out as she got. She snipped a fascinating straight, absolutely un-organic line right across its main panel, dividing a minty-green top shape from a Prussian-blue bottom and side shape. I know it is a little thing, one sleepy pod among nearly a thousand flowers, so many with seed cases and buds. But here, composed of six

pieces of paper, the top yellow and olive, the bottom the same olive, the midsections mint and blue, is a miniature world, balanced between yellow-based green and blue-based green. It is something to concentrate on when the lavish poppy exhausts your eye. A little pod of life-after-death. Or life-after-marriage, all on your own, knowing you won't have "Lady" in front of your name. An inheritance. Not of money, or of title, but of character, perhaps.

{ BUDDING FORTH, REDUX }

Mike Groden, now a lean man, a marathon runner, sat in the back of my classroom watching the seventh-graders cut and paste in twentieth-century New York City, not nearly as adept with their scissors as those petticoated kids in Mademoiselle Puelle's school in eighteenth-century London. We were savaging magazines with dull, unwieldy, round-tipped scissors, slicing out pictures to paste onto the covers of our *Merchant of Venice* notebooks. He was bald, and his dark chest hair curled up over the T-shirt he was wearing. He had become a literary man, but not a Shakespeare scholar – a modernist. He'd dropped math for James Joyce's *Ulysses* – to me like the paintings of Picasso I was supposed to slog through a gallery to look at and love. He had edited all sixty-three volumes of the facsimile edition of James Joyce's manuscripts. He had written a groundbreaking book on Joyce's writing of *Ulysses*. I never connected my first name with the Molly in *Ulysses*, Molly Bloom, and certainly never made the connection to a deliciously obscure novel by another writer, Katharine Tynan, published eight years before *Ulysses*, called *Molly, My Heart's Delight*. Tynan modeled her Molly's adventures after those of Mary Delany, right

down to her flirtation with Baltimore, and quoted from Mrs. D.'s *Autobiography and Correspondence*. The book then by my bed was the *Collected Stories of Elizabeth Bowen* – reflecting my retrograde taste for miniature, each story small as an egg.

Mike seemed mystified by the clutter of the classroom – the noise, the tables askew, the globs of glue, the hacker-scissors, the construction paper sliding off the surfaces, the kids jostling one another, the lost rulers, the desolation when we ran out of black, their favorite Goth background for their notebooks. From his world of rare book libraries with their paper-scented quiet and pencils-only rules, he exhibited a fastidious curiosity about us, like a clean city boy visiting a farm.

It was the spring of 1986. In a few months I would see my first Delanys.

A year and a half before, two months after my father died, I had published a book of sonnets full of images, some floral, of bodies having sex. They had produced a passing shock in the poetry world. He found me again through a review of that book in *The New York Times* – almost exactly at the same time I heard about him. We were thirty-nine. I happened to sit next to his colleague at a dinner at my alma mater. She was thin, with bobbed hair, and she was sipping consommé. I was tucking into an alp of chocolate. "I think I know someone you might know," she said coyly. The next minute Mike's name hit the air.

"I remember the smell of his mother's laundry deter-gent!" I practically screamed. "I used to dance with my nose pressed into the shoulder of the shirts!"

The thin woman's face folded up and closed. Oh, his girlfriend. This fact deterred me for only a beat. I crammed my address onto the bottom corner of the last page of my

book, tore it out, jammed it into her hand, and said with military firmness, "Give it to him."

"Can't possibly," she said. "I'm on my way to Paris." I followed the bitten nail of her index finger as she pointed toward the restaurant coat check. There, too big to fit in the closet, was an enormous roll-aboard suitcase, obviously bound for a foreign destination. I extorted from her the name of the university where he taught. So, he lived in Canada now. If she wouldn't deign to give him my address, I could find him. But like my mother, the thrower-outer who saved the silhouette, she saved the scrap of paper. An almost empty envelope arrived for him in London, Ontario. Stuck in the corner of it was the ragged triangle with my address.

Before the girlfriend-colleague picked up her suitcase, she told me something else: he had had cancer. Melanoma. In the long dormancy of nineteen years when our relationship was frozen in time, something had bitten away at the seed. Mike wrote to me almost at the time I wrote to him. When we received each other's letters, we devoured them with the complicated hunger of connecting with who we were and not knowing what we really wanted from each other now. We made a date to meet, as carefully circumscribed in time as if it had been set up by a dating service for perfect strangers.

The sun swathed Second Avenue in the East Seventies in its early spring light. He nervously tapped his wrist against the metal outdoor table at a little place called Café Bianco, long gone now. The crisp flag of its green and white striped awning was probably chucked into a Dumpster and sent to a landfill – but then the awning was in full sail. He asked to move farther beneath it, into the shade. My mother's voice from long ago bit its prescient hole in the afternoon. "That

boy had better stay out of the sun." He didn't explain why he wanted to move into the shadows. His health never came up as we listed all our accomplishments to one another, the professor and the poet creating for one another the exterior outlines of our silhouettes in the world. He looked scrawny and raw. I sported a pink blouse that made me look pale as a gerbil, rundown in the way only an overworked, underpaid middle school teacher crawling toward spring vacation can be. He did not tell me about his cancer, and I did not know how to ask him. Instead he said he had become a marathon runner. I took that in, but somehow it didn't dislodge my assumption that he was dying.

We did not say one romantic word to one another about our kisses in the back seat of his Chrysler or our sex in that freezing New Hampshire inn. In an efficient awkwardness we said goodbye.

Was he afraid to tell me? That couple of hours might have been our last exchange. I had to break through that over-defined edge between us, and I did it in the only way I knew how: I wrote a sonnet. Fourteen lines wasn't long enough. A double sonnet, then. It recalled our first lovemaking in that cold hotel. When the poem was published in *The Paris Review*, I sent him a copy.

He was thrilled – but called to tell me the conclusion was wrong.

He was very much alive. He had been diagnosed with

melanoma and had had one recurrence, but he had been cancer-free for two and a half years. Then we began to call each other and remember together. We told each other that our fathers had died. We learned that we had both had early marriages that had begun in the same year and ended in the same year. We learned that each of us was bent on a

gigantic reconstruction job of who we were. We hadn't a clue about ourselves when we were sixteen. Or had we? Here we were on the phone, resuming a conversation we had begun then with the ease of two kids who had shared physical, emotional, sexual, intellectual cores. We tracked our dreams and told them to each other long distance on the telephone. We gradually woke to each other, but it took us six years – we were both in other relationships.

Periodically he called me for advice about his much, much younger girlfriend, of whom I thoroughly disapproved. "Leave her!" I never said as I listened to him analyze this girl who seemed, emotionally, to be just the age I was when I left him in college. And he didn't. He hung on, just as I did through all the storms in my own relationship – replicating my father's rage and my mother's reproaches. In our years of phone calls and lunches when he came to New York, and in his periodic visits to my class, we seemed to be layering tissue papers of our stories, one thin layer on the next, one color on the next, creating through the fractions of filament complete histories for two individual persons.

After our other relationships withered away (in his case) or exploded (in mine), we ratcheted up the phone calls. At last I got on a plane to London, Ontario, just at the time that North American poppies bloom in Canadian gardens. The minute I hurled myself into his surprised arms in the Toronto airport, a new pattern cut in. I certainly didn't know that, within a year of my pressing my nose into the collarbone of Michael Groden at Terminal Two, I would begin a life of negotiating two currencies, two tax systems, two literary worlds, two allegiances to two countries, one that stayed loyal to the very crown that Mrs. Delany had served, and one that had rebelled against that crown.

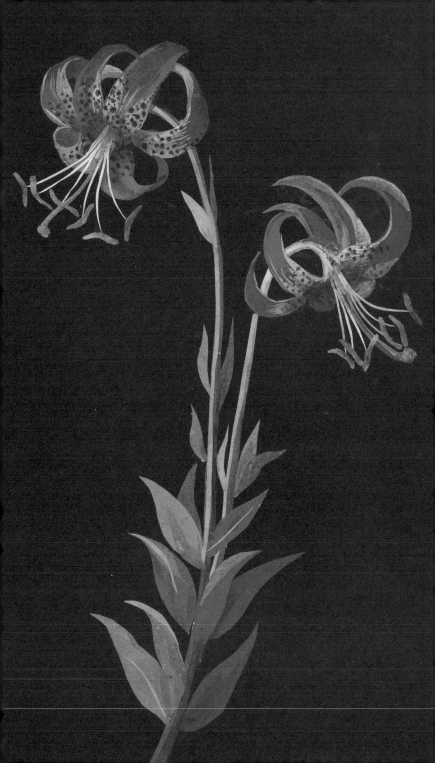

Chapter Seven.

CANADA LILY

When Mrs. D. cut out her *Lilium canadense* (Canada Lily) in the summer of 1779, she positioned twin flowers into her portrait, each sharing nearly the same colors, with only subtle differences in their habits. Their lines swoop and swoon with freckled energy, making a study in positive and negative space. This is one of the collages that she contoured, raising the freckles on the lilies with dots and circles of pasted paper. The left lily contains thirteen of these goosebumps. The Canada Lily can grow to a height of five or six feet, taller than Mary herself (she was probably between five feet and five feet four inches),[1] and she gives the impression of the plant's height in her mosaick by placing the flower heads way at the top of the paper. The plant has the lanky feel of two tall, talky girls.

One Saturday morning toward the end of *l'affaire* Baltimore, Mary settled herself into a wooden pew to hear a rehearsal of church music with Ann Donnellan, her new friend, the daughter of Nehemiah Donnellan, Lord Chief Baron of the Exchequer in Ireland.[2] After the rehearsal, Mary took Ann home and "gave her boiled chick, roast mutton, and apricot tart."[3] Donnellan in turn moved Mary with a story. She described a close friend of her exact age, a girl of "uncommon accomplishments of mind and body."

Lilium canadense, St. James's Place, August 20, 1779, Prov. Mr. Lee

They had grown up together. But Donnellan had lost her companion – twice: first to the breach that marriage brought to women friends, then, tragically, to death from consumption. "She spoke so sensibly and movingly," Mary wrote about Donnellan, "that it touched me . . . I pitied her prodigiously, and it gave a serious turn to our discourse. I could not help indulging her in that way, because I am sure, under the same unhappy circumstances, I should have liked it." In Mary's atmosphere of consolation, and in the aura of Ann Donnellan's parable of deep attachment, their intense relationship began. It strengthened after Ann rushed to Mary's bedside when she lay tossing in a fever just as her Aunt Stanley lay dying.

If the prerequisite to love is understanding – or feeling understood – then it's safe to say that an understanding was forming. The touch of Ann's cool hand to Mary's fevered forehead held a romantic mix of nurture and new intimacy. Rejected by the ambiguous Baltimore, now losing her difficult but loyal Aunt Stanley, Mary was in need of understanding. In an earlier time of ambivalent romantic disappointment, after she'd dismissed Robert Twyford, she had befriended Sally Chapone, whom her father distrusted because he thought the girl too "masculine." One scholar, Lisa Moore, has written eloquently and not without controversy about the atmosphere of gay attachment in Mary Granville Pendarves's life. Did she? Did they? We can't know this any more than we can know if she and possibly impotent Pendarves did it. Given Mary's protean vitality, it makes sense that she was drawn passionately to Ann Donnellan, however we would like to imagine it, but not just for a rebound dalliance. There was something deeper in the reflection she saw in Donnellan's face.

When Mary looked up from the rumpled nightclothes of her illness, she fixed her gaze on an Ann who mirrored her sister Anne, the mainstay of recognition and love. This new Ann was also a like mind and a like spirit. Musically talented, expert at handiwork, lover of her independence, Ann Donnellan had come to rescue, to sing, to sew, to read aloud, to pet the cat, to share a meal, to connect. Mary later nicknamed her "Sylvia" or, more often, "Phil" or "Phill" for Philomela or Phillis. She used affectionate nicknames for many of her friends, partly as a way to disguise them in letters, partly as a custom of her class and time, and partly as a way to outline them against the rest of life. The name Phillis comes from the Greek for foliage, and of course the goddess Phyllis. Philomela means sweet singer, or sweet song. And Donnellan had a lovely voice.

Soon Mary made a proposal to Ann, that they take a house together in Richmond, "the pleasantest village within ten miles of London."[4] They joined their resources and found a spot. She was grateful that Donnellan's "good sense, her peculiar agreeable talent for conversation, our *variety of works* – reading, walking, going on the water, seeing all the fine places in the neighbourhood, gave me a new turn of thinking, shook off the gloom, and restored me to my health."[5]

How unusual was it for two women to set up house-keeping together at this time? Mary certainly could have gone to Gloucester to live with her mother and sister. She was not out of bounds by living on her own, or by living with Donnellan; she was just comfortably within the thick outline of propriety's confines, eased in just at the edge of suitability. Going to Gloucester would have meant leaving masquerades and concerts, and the court – all of the

city's liveliness – as well as leaving someone who deeply understood her. If she had not lived in London's environs, she wouldn't have been able to laze in a boat up the Thames while Donnellan sang, as a gentleman in another boat on the river described it, "the finest water language he ever heard."[6] Nor would she have experienced something so crucial to the development of her late-life art as watching Hogarth paint his portrait of the Wesley family, who included Ann Donnellan in their group, absorbing Hogarth's advice on her own artwork.

> I am grown passionately fond of Hogarth's painting, there is *more sense* in it than any I have seen. . . . Mr. Wesley's family are drawn by him, and Mrs. Donnellan with them. I have had the pleasure of seeing him paint the greatest part of it; he has altered his manner of painting since you saw his pictures; he finishes more a good deal.[7] ["Mrs." is a term of respect; Ann Donnellan never married.]

To watch a multiple-figure portrait being done by a painter she was "passionately fond of" was a striking experience. Hogarth became a role model. "I think he takes a much greater likeness, and that is what I shall value my friend's picture for, more than for the excellence of the painting." It's his accuracy she appreciates, but what made the event even more significant was that "Hogarth has promised to give me some instructions about drawing that will be of great use, – some rules of his own that he says will improve me more in a day than a year's learning in the common way." If only we could know what the rules were. She doesn't say. What would improve a person in a single day more than instruction for a year?

The stems of Mrs. D.'s two lilies start an S-shape as they meet the flower head, but it doesn't continue. Even though we don't have her words about what she learned from Hogarth, we have his from his book *The Analysis of Beauty*, in which he wrote that the "serpentine line," the S-shape, is among "the most expressive figures that can be thought of to signify not only beauty and grace, but the whole *order of form*."[8] Yet, her flower mosaicks seemed to require the opposite of Hogarth's shortcut: a lifetime of trying to get things right.

Part of Mary Pendarves's quest for accuracy was training herself to look intensely, even at her own face in the mirror. "As for my countenance," she confided to her sister, "I cannot say much in its commendation; it is somewhat thinner and paler than usual, and my complexion is altered. . . . thirty years is enough to wear off bloom, and I must submit to be tarnished by time."[9] Soon after Mary saw her dull reflection in that mirror, Ann Donnellan offered to take her to Ireland to soothe the embarrassment after Lord Baltimore's announcement of his engagement. They would visit Donnellan's snooty sister Mrs. Clayton in her grand digs on the south side of St. Stephen's Green in Dublin. Her sister (who had first introduced Mary to Ann) had married Dr. Clayton, the Bishop of Killalla. Thin, pale, altered Mary seized the invitation – but she could not just pick up and go. She needed permission, and she collected her okays first from those quickest to assent: her mother and her uncle John Stanley. Finally she approached her testy brother Bernard, who had for vague reasons, possibly disillusionment after a romance, glumly retreated to the estate he'd bought himself, Calwich Abbey in Staffordshire.[10] (He never married.) Grumpily he gave his assent, and the

women booked passage on the *Pretty Betty*, paying five guineas for the best accommodations, and sailed to Dublin in September 1731. Mary was thirty-one years old.

"As I grow older, though I feel as much warmth as ever, I have not so lively a way of shewing it. I attribute it a great deal to *the fear* I have always had of appearing too gay; a wrong notion I am now convinced, and it hurts the temper," she wrote to her sister. "Our spirits ought to have their full career when our inclinations are innocent, and should not be checked but where they would exceed the bounds of prudence."[11] But how does a person reclaim a full career for her spirits? Had that girl who was going to burn her harpsichord if she couldn't play as well as Handel become so unrecognizable? In the swept-mind sensation that travel gives, the late-summer wind of the Irish Sea blew away disappointment and confusion and the aftermath of death to a clean and genuine relief. By leaving England behind, by being with a new friend and in the embrace of the friend's family, but also simply by being in Ireland, a set of oppressing hierarchies fell away from Mary. If she were in a fairy tale, she would have walked through a mirror. "There is a heartiness among them [the Irish] . . . , and great sociableness. . . . Wherever I go I meet with great civilities."

The minute Mary entered the Clayton mansion, she began recording her visual impressions. It was one way to orient herself, and a way to preserve a travel memory, and simply a result of what travel does: sharpens our capacities to describe things to ourselves, to prepare a running narrative of what we've done and what we'll do next:

> First there is a very good hall well filled with servants, then a room of eighteen foot square, wainscoted with oak, the

panels all carved, and the doors and chimney finished with very fine high carving, the ceiling stucco, the window-curtains and chairs yellow Genoa damask, portraits and landscapes, very well done, round the room, marble tables between the windows, and looking-glasses with gilt frames. The next room is twenty-eight foot long and twenty-two broad, and is as finely adorned as damask, pictures, and busts can make it, besides the floor being entirely covered with the finest Persian carpet that ever was seen. The bedchamber is large and handsome, all furnished with the same damask.[12]

The mansion on the edge of St. Stephen's Green was grand, and it still exists as an Irish government building. It was Mary's home base, and the letters she wrote back to her sister and mother from her damask-bedecked chamber nearly scamper with delight. She gorged on Ireland and the Irish, eating, dancing, picnicking, exploring, talking, snorting the scent of the wildflowers and garden flowers, listening to music, and designing new clothes. She danced at Dublin Castle on the King's birthday in 1731, where she wore "a blue and white satin . . . and a new laced head" while Ann Donnellan sported "her green satin that is embroidered with gold and silver."[13]

She romped till she dropped at all kinds of balls. "I was almost dead yesterday, I never was so much fatigued with dancing in my life," she wrote to her sister on December 4, 1731. "I had Captain Folliat, a man six foot odd inches high, black, awkward, ramping, roaring, &c. I thought he would have shook my arms off, and crushed my toes to atoms." Almost immediately she started to concoct her clothes of Irish poplin. "Mrs. Donellan and I have each of

us made a brown stuff manteau and petticoat, and have worn them twice at the assemblies."[14]

She played quadrille (cards) and made a new Irish friend, Letitia Bushe, a former beauty whose face had been disfigured by smallpox. Letty Bushe's father had recently died, leaving her without much money but with her independence, like Ann Donnellan and Mary. "She paints delightfully," Mary exclaimed to her sister.[15] "She is hard at work for me, she paints both in oil and watercolours. I have enclosed you a little scrap of her drawing, which she scratched out by candlelight in a minute."[16] This letter urged Anne to draw, Mary giving this pedantic older-sister artistic advice: "I hope you draw sometimes. I fancy if you copied some landscapes, and did them in Indian ink, you would like it better than faces. I am sure, with very little application, you would do them very well; but copy only from the best prints." (Long before the ease of digital printing, when Vermeer images can be had as you step up onto a bus or Van Gogh as you drink a cup of coffee, one of the ways people saw images of paintings was through prints of them or, to a lesser degree, through painted copies. Our contemporary disparagement of copying, our training of children not to be copycats, our critiques of poems that merely imitate other poems did not exist in the same way for Mrs. D., nor did the value we place on originality, which took hold only in the late eighteenth and early nineteenth centuries. Someone who was able to copy a painting, imitating a style – and thereby learning that style – did a valuable service in getting the image out into the world.)

The pure physical freedom of Ireland gave Mary a boost of well-being. She got plenty of exercise as she

visited the countryside, and the harder she danced the heartier she ate. The Claytons "keep a very handsome table, six dishes of meat are constantly at dinner and six plates at supper."[17] She describes many meals such as this repast that she ate around 2:00 p.m. as a midday meal at a little house in the countryside: "cold fowl, lamb, pigeon pye, Dutch beef, tongue, cockells, sallad, much variety of liquors, and the finest syllabub that ever was tasted."[18] (Syllabub is a whipped concoction of egg, cream, and liquor, such as brandy or sherry, like a light custard.) Her letters ripened with lists of all she devoured: "all sorts of cold meat neatly cut, and sweetmeats wet and dry, with chocolate, sago, jelly, and salvers of all sorts of wine. While we were eating, fiddles were sent for, (a sudden thought). We began before eleven [p.m.] and held briskly to it till half an hour after two." She stayed up late and got up late. Visiting the Wesley family at Dangan in May 1732, she declared, "We live magnificently, and at the same time without ceremony. . . . Our hours for eating are ten, three, and ten again."[19] She had once before made a retreat to the country (and that was half her life before), when she was fourteen, fleeing London for Buckland. She arrived there in the snow, but in Ireland it always felt like summer, full of idyllic picnics she described to her sister.

[W]e went a-fishing to the most beautiful river that ever was seen, full of islands delightfully wooded. We landed on one of the islands. . . . A cloth was immediately spread on the grass under the shade of the trees. . . . We sat ourselves down . . . our sweet [Ann Donnellan sang]. . . . We staid on the water till eight . . . then went to a cabin . . .[20]

To lie on the grass and listen to song was a fresh experience for Mary – and she was old enough to appreciate it, and to appreciate what she saw as the shabby largess that reflected a reordering of all she'd had to submit to for her first three decades, and all she was freed from just by taking the *Pretty Betty* across the Irish Sea.

> [T]he situation is pretty . . . but the house *is worse* than I have represented. . . . The people of this country don't seem solicitous of having *good dwellings* or more furniture than is absolutely necessary . . . but they make it up in *eating and drinking!* I have not seen less than fourteen dishes of meat for dinner, and seven for supper . . . no people *can be more hospitable or obliging*, and there is not only great abundance but great order and neatness.

Abundance, yet with order, and neatness. This paradox of riches arranged beats at the heart of Mrs. D.'s work – though the Canada Lily is one of her messier efforts. It has all sorts of extra glue marks on it, recalling a comfortable, littered living room.

Back in Dublin, Mary and Ann Donnellan walked St. Stephen's Green, just outside the doorstep of the Clayton household.

> As for Stephen's Green, I think it may be preferred justly to any square in London, and it is a great deal larger than Lincoln's Inn Fields. A handsome broad gravel walk and another of grass, railed in round the square, planted with trees, that in the summer give a very good shade; and every morning Miss Donnellan and I walk there.[21]

St. Stephen's Green, a large, verdant square made all the more green by the fact that it is outlined in a wrought-iron fence, is much the same today as Mrs. Delany described it. Below the gray sky, the vertical black iron posts cut the light just enough so that the leaves gleam, making a person almost feel inside her paper garden.

When Mary went to Killala (where Ann Donnellan's brother-in-law was Bishop), she described a typical day that also replicated the regularity of the hours her father created for her at Buckland: "rise at eight . . . breakfast at ten . . . sit to work . . . dine at three, set to work again between five and six, walk out at eight, and come home time enough to sit down to supper by ten, very pretty chat goes round till eleven, then prayers, and so to bed."[22] The work she is describing is embroidery, crewel, sewing, handiwork. It was in this stable atmosphere, built on a foundation of intimacy, food, and exercise, that she and her Philomela, Ann Donnellan, began a craft project together – a shell grotto. It wasn't a simple endeavor; the shell grotto was highly engineered.

> About half-a-mile from hence there is a very pretty green hill, one side of it covered with nut wood; on the summit of the hill there is a natural grotto, with seats in it that will hold four people. We go every morn[ing] at seven o'clock to that place to adorn it with shells – the Bishop has a large collection of very fine ones; [Ann Donnellan] and I are the engineers, the men fetch and carry for us what we want, and think themselves highly honoured. . . . [F]rom the grotto we have an extensive view of the sea and several islands. . . . [T]his affair yields us great diversion, and I believe will make us very

strong and healthy, if rising early, exercise and mirth have any virtue.[23]

The sheer demands of the project – making an intricate geometrical ceiling and walls of shells, lined up by size, shape, and kind, then set in plaster, then all of it plastered over – required a special discipline, not to mention access to thousands of shells. For an artist it defined well-being: getting up early to be at work, losing oneself in the hugeness and complexity of the planned adventure, losing track of time, and reaching and bending, dragging and placing the shells, making mistakes and rectifying errors – a blissful, repetitive practice. Yet it wasn't only "rising early" and "exercise" that made her "strong and healthy," it was "mirth." They were laughing and teasing, these two engineers of the grotto, enjoying their male escorts as they fetched and carried. This was not art made alone; it was craft in company.

Shell decoration within grottoes was a popular aristocratic fascination, and Mary, with the obsessive nature that would let her later compose 985 paper mosaicks, embraced all aspects of it, the shell collecting and classifying, the creation of the ceiling inside the grotto, and the plastering of the ceiling and walls. Like her flowers, the shells required a knowledge of biology and the absorption with classification and order that would put Mary in the vanguard of botanical classifiers. Like the construction of a court gown, this time-consuming process was accomplished in layers. Part of the glory of Ann and Mary's friendship was being busy together, syncing the rhythms of two minds in the dreamy boredom of these repetitive acts. It was a way of being lost together – lost in time and lost from the demands

of London – as they lined up all the tiny funnel-shaped seashells in one direction, then moved the scallop shapes into another pattern. The grotto was like a secret garden. It was shadowy, moist, and close: sexy. (Their shellwork has been lost, as have many of the fragile, easily damaged shell ceilings and mantels of the eighteenth century.)

Mrs. Delany composed the center of the *Lilium Canadense*, also called a Meadow Lily, with both dull and bright green, but it is the petals that burst with color. The left-hand lily flourishes with peach, salmon, vermilion, pink, ochre yellow, warm red, cool red, coral red, rusty orange, melon orange, burnt orange, and, at the end of the long stamens, purple. She cut the flower heads to give them a sense of both front and back. Like some drawings in anatomy books, she lets you feel that you know how each surface is attached to the next.

The right lily has pink tones that she painted with gray shadows. It is fire red, muted orange-pink, magenta red, light and dark pink, brownish pink, and brown. The petal that comes out of the center at about eight o'clock is composed of six pieces; the petal that comes out at about three o'clock is composed of seven pieces. She built up the surface by pasting red pieces on top of red pieces. The lily petals have a bumpy, labial look to them. And the colors are of excited female sexual organs.

Paul Valéry's Shell Lesson:
What does a coiled shell have to do with a flower? The twentieth-century French poet Paul Valéry, in his essay

"Les Coquillages" ("Shells"), says that "A *crystal,* a *flower* or a *shell* stands out from the usual disorder that characterizes most perceptible things. They are privileged forms that are more intelligible for the eye, even though more mysterious for the mind, than all the others we see indistinctly."[24] It was not only clarity that Mrs. Delany was looking for, as Valéry understood so well about both shell and flower: it was mystery. A shell, like a flower, can be something to meditate on. There is a certain aloneness to a shell. Mary was both coming out of her shell and withdrawing into a shell of her own solitude, away from family and court. Both hiding and surfacing.

One of the things Mary and Ann Donnellan did in Ireland was to visit gardens. It's not that she didn't visit gardens in England; she certainly did, but here the gardens made her lust to have her own – and spend money on it. When she visited Ann's father's gardens at Nenagh in County Tipperary in late October, 1732, she wrote to her sister, "I almost envy him the pleasure his improvements will give him every hour: for next to being with the friend one loves best, I have no notion of a higher happiness, in respect to one's fortune, that that of *planting* and improving a country, I prefer it to *all other expenses.*"[25]

The previous spring, she had directly identified herself with flowers. "This has been a week of great mirth and jollity." Drunk on her senses, bursting with well-being, she had identified with something shyer, "The lily of the valley, which I would rather be than any flower that grows – 'tis retired, lives in shade, wraps up itself in its mantle, and

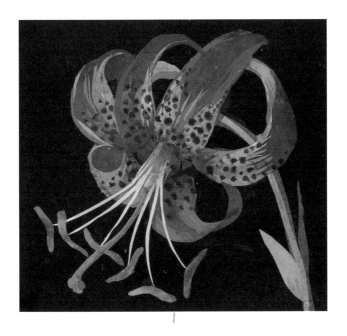

Lilium canadense, detail

gently reclines its head as if ashamed to be looked at, not conscious how much it deserves it. How pretty it is! Who would not be that flower?"[26] Although she now plunged through the countryside laughing and dancing, linking arms with Ann Donnellan, and although as the compleat sensualist she described the details of the world that she imbibed through her senses – especially those things that require at least two senses simultaneously, like eating, or wearing silky clothes, or making music – she also withdrew beneath her mantle. This paradox operates as thoroughly as the two sides of a Lily of the Valley leaf, the open, waxier side and the slightly silver underbelly. The lily was something both to emerge from and hide in.

As Mary Granville Pendarves devoted herself to her own needs, her first reference to the needs of others emerges in her letters. Until this time she rarely looked beyond the confines of her own world, but in the June letter describing the Irish picnic, just at the point of her deepest relaxation into who she was, she did exactly that: "The poverty of the people as I have passed through the country has made *my heart ache*, I never saw greater appearance of *misery*, they live in great extremes, either *profusely* or *wretchedly*."[27] With the loosening of the constraints of constant self-definition, self-restraint, and self-effacement, she became aware of others, and empathy bloomed. Away from the court, away from all that drew her to perform again and again for others, she was able to emerge – and to look out at the greater world around her.

There was a garden more important than the Donnellan garden at Nenagh. It was the lush land that belonged to an open-faced Church of Ireland cleric named Dr. Patrick Delany. He was forty-eight years old. He had never been married. In January 1733, he invited Ann Donnellan and Mary to visit his small estate, called Delville, or Hel-Del-Ville, as it was once dubbed, for it had belonged at first to two men, Dr. Richard Helsham as well as Dr. Delany. They had leased the land jointly, lived there together, and they both had designed its garden.

156 (More than a century later, Mrs. Delany's great-great-niece Lady Llanover commented in one of her juicy footnotes to the letters that "It was laid out in a style then new in Ireland." She quoted Irish country gentleman Cowper Walker as saying that "the obdurate and straight line of the

Dutch was softened into a curve, the terrace melted into a swelling bank, and the walks opened to catch the vicinal country."[28] It's unclear whether Lady Llanover is describing their original garden or the one modified by Mrs. Delany many years later. Possibly when Mary first saw it, Delville had straighter paths and the more tightly turned corners of an earlier garden style.)

By the time that Mary and Ann and Ann's brother Kit arrived, Delville was occupied exclusively by Delany, an immensely sociable bachelor who was about to begin a new phase of his life: he was engaged to marry the wealthy widow Margaret Tennison. However, in that winter he was still entertaining his friends Jonathan Swift and Lord Orrery, and Dr. Helsham, too. To his bright young female guests Mary Pendarves and Ann Donnellan, he added an electric nymphette named Kitty Kelly, knowing that the fifty-something Jonathan Swift would be enamored of her. It turned out that more of the dinner company than Swift would be taken with Kelly. Mary's friend Ann Donnellan would be captivated by her, too.

Patrick Delany knew the value of friendship and expressed it over and over again in all the ways he related to others. He played the linchpin role of host, dropping back to accommodate the ego and fame of Swift. There is an aspect to Delville that is like the shell, a place both to hide and to emerge from. And there is an aspect of Delany's personality that matched Mary's love of that little floral icon the Lily of the Valley. Both Patrick Delany and Mary Pendarves quite independently valued the beauty of reticence, knowing that it can preserve necessary solitude. Compared to Swift, Delany kept his light cloaked.

Compared to Kelly, Mary did likewise. She liked this rector instantly, and wrote later that

> His wit and learning were to me his meanest praise; the excellence of his heart, his humanity, benevolence, charity and generosity, his tenderness, affection, and friendly zeal, gave me a higher opinion of him than of any other man I had ever conversed with, and made me take every opportunity of conversing and corresponding with one from whom I expected so much improvement.[29]

However much she meant that statement (writing by then as a married woman about her husband), at the moment she met him she was diverted by something else: the social drama enfolding before her as Jonathan Swift and Ann Donnellan vied for Kitty Kelly. At first, Mary herself competed for the attention of Swift, contending with the adorable flirt Kitty to get the attention of the venerated satirist. She found Swift "a very *odd companion* (if that expression is not too familiar for so extraordinary a genius); he talks a great deal and does not require many answers."[30] But soon Mary began losing the cranky, difficult, talented old man to the younger woman. "Miss Kelly's beauty and good-humour have gained an entire conquest over him, and I come in only *a little by the by*."

Just as Mary was opposing Kitty for Swift, Ann was challenging Swift – for Kitty. Ann was infatuated by this petite coquette, who also flirted with her. The drama of their triangle began on this January day; but then, as Mary and Ann were swept into a Thursday intellectual group at Delville, a "witty club" hosted by the amiable Patrick, it intensified. Mary confided it all to her sister. She was losing her closest

friend – not to a man's attentions, but to the dazzlement of another woman. Swift's capriciousness she took in stride, but Kitty Kelly "has touched me in a tenderer part, for she has *so entirely* gained Mrs. Donellan, that without joking she has made me uneasy, but what does all this serve to show? why to show me my dear sister's love in all its value, that never has been turned from me by anybody."[31]

Donnellan's fickleness provoked Mary to think uneasily about who she really was. "How uncertain is happyness in this world!" she wrote at the end of that February. "That which we generally look upon as the life of most misery, in the end proves our greatest advantage, it detaches us from the world."[32] The "mirror Ann," whom, by this time, she no longer confused with her sister, presented Mary with problems throughout the years of their relationship. Ann Donnellan was flirtatious and tempestuous, and demanding of Mary's sole attentions. Now she was proving too much for her. Donnellan came with complications of betrayal – and Mary had suffered betrayals of a magnitude that made her shy away, back toward the original, mild Anne, who had never "turned from" her.

Despite Kitty Kelly, Mary didn't give up playing with Swift. She wrote him a number of letters after she returned to England, and these letters are so wholly different from those to her sister that one would barely recognize them as from the same individual. Her tone is arch, brittle, falsely dulcet, a B-movie version of eighteenth-century repartee. These letters open up a camera eye on the social self she constructed – the very opposite of the relaxed inner core she found in Ireland. She banters valiantly but breathlessly – as if she can't quite keep up. These utterances are an elaborately public construction, as layered as

mantua, petticoat, stays, and stomacher; as encrusted as greased and powdered hair.

"Sir," she wrote him from London on May 29, 1733, "You will find to your cost that a woman's pen, when encouraged, is as bad as a woman's tongue; blame yourself, not me."[33] Two months later, as she spent the summer with her sister and mother in Gloucester, she addressed him, "Sir, . . . I am resolved to be even with you for what you say about my writing, and will write henceforward to you as carelessly as I can; and if it is not legible thank yourself."[34] She flirted her quill like a fan. "I protest I am not afraid of you," she continued with lighthearted masochism, "and would appear quite natural to you in hopes of your rewarding my openness and sincerity, by correcting what you disapprove of; and since I have not now an opportunity of receiving your favours of pinching and beating." But since he wasn't about to pinch or beat her from so far away, she demanded instead that he take on the task of "*chiding me* for every word that is *false spelt*, and for my *bad English. . . .*" Slapped though she might be for her spelling and grammar, she became in their brief correspondence his temptress and his witch, and tried to lure him across the sea. "I wish you could make your words good, and that I *was* a *'sorceress:'* I should then set all my charms to work to bring you to England . . ."

It didn't happen. He was more than three decades older than Mary, his health was in ruins, and he stayed home. "Sir," she wrote him from the house she had taken on Little Brook Street in London on September 9, 1734. "I find your correspondence is like the singing of the nightingale – no bird sings so sweetly, but the pleasure is quickly past; a month or two of harmony, and then we lose it till next

spring." She couldn't quite leave the charismatic, cleft-chinned old man alone. Swift knew her family: old Countess Granville, Lord Carteret (and his mother-in-law Lady Worsley), as well as Sir John and Aunt Stanley. He was a member of the literary circles of her uncle Lord Lansdowne. Swift embodied all these connections, and Ireland, too. She insisted on their duet.

Botany Lesson:

John Bartram (1699–1777), the long-lived Quaker botanist, doubled as both America's premier Colonial-era horticulturalist (and friend of Benjamin Franklin) and George III's official "King's Botanist" for North America – for the meager sum of fifty pounds per year, a pittance that Bartram resented.[35] (You can still visit Bartram's Garden, tucked into an industrial area of Philadelphia.) Bartram knew, identified, and collected the tall Canada Lily, which a person can find in marshy areas today – though, like most wildflowers, it is threatened by encroaching civilization. The Canada Lily reproduces by seed, or by offshoots from the corm whose fibrous roots form its anchor in the earth. The designation "*canadense*" doesn't always mean that the specimen grew or was collected in Canada, however; many flowers were identified as "*canadense*" in the eighteenth century, roughly signifying that they grew from what is now Canada south to Maryland or Virginia.

161

Bartram had a like-minded relationship with a horticultural friend in England, a London draper, Peter Collinson (1694–1768), who was one of the premier horticulturists of his day,[36] and with whom Bartram traded specimens. It is

delicious to think of Collinson, a textile merchant dealing in floral patterns, proceeding to cultivate an interest in honest-to-God flowers, then sending and receiving actual floral material. It brings a viewer one step closer to Mrs. D.'s flower mosaicks, she who was obsessed with fabric and floral design, then with gardens, finally in her seventy-ninth year bringing all of her floral focus to bear on a specimen of *Lilium canadense*, the seeds of which Bartram in the new world traded to Collinson between 1738 and 1740 for cultivation in England.[37]

Mrs. Delany, who kept exceptional records, wrote that this specimen came from Mr. Lee. Scottish James Lee (1715–95), a translator of Linnaeus's *Philosophia Botanica*, co-founded the Vineyard nursery in Hammersmith, Middlesex. He specialized in exotic plants from around the world, including North America. (Thomas Jefferson subscribed to the Vineyard catalog.)[38] In a curious way, the Canada Lily is a bridge between the new world and the old. As relations between the crown and the colonies became increasingly strained, bonds strengthened among the plantsmen. If there was something on which both colonists and aristocrats could agree, it was the value of a wildflower.

John Bartram traveled extensively (north to Lake Ontario and south to Florida) in search of new specimens, not outfitted royally with three horses, one for himself, one for his servant, and one to be a packhorse with supplies, as Collinson suggested, but all alone with a single horse and a saddlebag for cramming in what he collected.[39] Sometimes he traveled with his son, sometimes solo, except for the spirit of Collinson, whom he never saw – neither man ever crossed the ocean – but to whom he poured out his floraphiliac thoughts in a decades-long exchange that also

included the sometimes irritable mercantile side of their relationship. Bartram, a Quaker businessman as well as a horticultural genius, was a plain speaker about his expenses, annoying Collinson. Collinson often commissioned Bartram on behalf of others, such as Lord Petre, an avid plant collector. As with all colonists, Bartram needed someone in England to send him goods like glass and nails, which he could not always get in Philadelphia, and Collinson sometimes went to great lengths to obtain them.[40] Through Collinson, who was invited to dinner at Bulstrode in July 1767, Bartram's son William eventually would be commissioned by Mrs. Delany's friend the Duchess Dowager of Portland to draw shells. There are almost as many interconnections in their horticultural circles as freckles on the faces of the Meadow Lilies.

Or on the freckled hands of the round-faced, bright-eyed Patrick Delany, who surfaces in Mary's arch-toned correspondence with Jonathan Swift as a sweet, serious, persistent note, unfettered by the conventions of flirtation. Even as she hankered after the admiration of a genius, she recognized the "more desirable" Patrick Delany.[41] In late winter 1732, she confided to her sister Anne the finale of her envious episode with Kitty Kelly. "I have given up the trial with Kelly, her beauty and assiduity has distanced me, and I will not attempt a second heat." Kelly had become ill. "At present she is disabled . . . confined to her bed with a pleuratic disorder, but the Dean [Swift] attends her bedside." A mere sentence later, she balanced her disappointment with something better. "But Dr. Delany will

make a *more desirable friend*, for he has all the qualities requisite for friendship – zeal, tenderness, and application; I know you would like him," she wrote to her sister, the true Anne whom she felt would never betray her, "because he is worthy."

Kitty Kelly died of this illness the "last week in October, 1733."[42]

Swift returned news of his friend Delany to Mary in his clear, small, neat hand. "Dr. Delany hath long ago given up his house in town," he wrote in January 1736. "His Dublin friends seldom visit him till the swallows come in. He is too far from town for a winter visit, and too near for staying a night in the country manner; neither is his house large enough."[43] The following April she responded with a newsy letter about how she had seen Henry Fielding's play *Pasquin* and judged it not as good as *The Beggar's Opera*, her elegant lily-like loops swooping down to her postscript: "I beg my compliments to all friends that remember me, but particularly to Dr. Delany."[44]

{ ORANGES, A LEAF, & A DREAM }

In a market in Baltimore, Maryland, an elderly man stood in front of me in the cash-out line. We each had a basket of groceries. When it came time for the man to put his onto the conveyor belt, he acted quickly, efficiently, but with a sublimely conscious intent. He arranged his food on the moving belt, the oranges in a Cézanne still life, the cereal box as a Mondrian square against the black rubber, the yogurt containers as round, white, Miró-like punctuation marks on the damp background. In the space of seconds he had made an entrancing composition, a pleasant sense

164

of order to reflect the house of his mind. In a few minutes the items were plopped in bags and he was off. I never saw him again, but because of those oranges on the thick black rubber, I tried to stop myself before I tumbled my groceries, bruising the fruit, denting the cereal box, onto the belt in my usual haphazard externalization of my internal associative jumble.

In a manner of speaking, I had watched a poet of the everyday. One could *be* a poet of the everyday, and not even have to write that poem down, or worry about whether it was good, or try to publish it. I had witnessed a span of seconds of someone else's art of living, in a supermarket in Baltimore where only now does the street name Calvert resonate as Charles Calvert, a.k.a. Lord Baltimore, the fellow who confused and jilted Mary, causing her to take a chance on a trip to Ireland, where she would both lose and discover herself, a shy, leggy lily of the meadow. She tucked away the seeds of her late-life creativity the way John Bartram tucked seeds into compartmented wooden trays to send to his friend Peter Collinson, and which later found their way to the Duchess of Portland's greenhouse, even as the Duchess's cash found its way into the hands of Bartram's son William, who rolled and sent his drawings of shells back to her.

Not long before I first saw the Delanys, after my father died and my sonnets were published, around the time Mike sat watching my seventh-graders make their projects, I took my first and last botanical drawing class. It was a disaster. The instructor at the New York Horticultural Society, whose name I have gratefully forgotten, gave me a dull, half-dead, spear-shaped leaf to draw. Then she asked me to draw it again. And again. I drew the leaf half a dozen

times, and each time it was more frozen: smaller, deader, harder. The sixth time it looked like a rabbit turd.

I left the botanical drawing class with the turd-leaf trophy under my arm and returned home reminded of a facetious definition of the poet: a poet is a failed painter. In disappointment and exhaustion, I fell asleep, but was visited with a poet's compensation: a dream. It was a botanical dream in which I climbed a pyramid of stone steps to view a special flower – not a Canada Lily, but one that bloomed only once every hundred years. As I reached the top, surprising myself because I was not out of breath, I saw a marble pot with a plant inside it on a plinth under a blue sky. The plant that would bear the bloom was, in fact, a strong vine wound round and round into a great mound of green. There, in the foliage, was the bud, pulsating with growth. I stood alone, having arrived on the dot: one hundred years from the last blooming. Before me the unknown flower unfolded as in time-lapse photography, revealing wavy stamens in purplish white: yes, it was the most beautiful flower of the century. Suddenly, other people were climbing up the steps to join me.

The flower I failed to recognize was the *Passiflora laurifolia*. I finally learned its name after I spied it on the wall of the Morgan Library, chosen to be included in the show of Mrs. Delany's flower mosaicks by Ruth Hayden, positioned against its black background as if cut from a dream. And in the gallery, of course, other people began to join me.

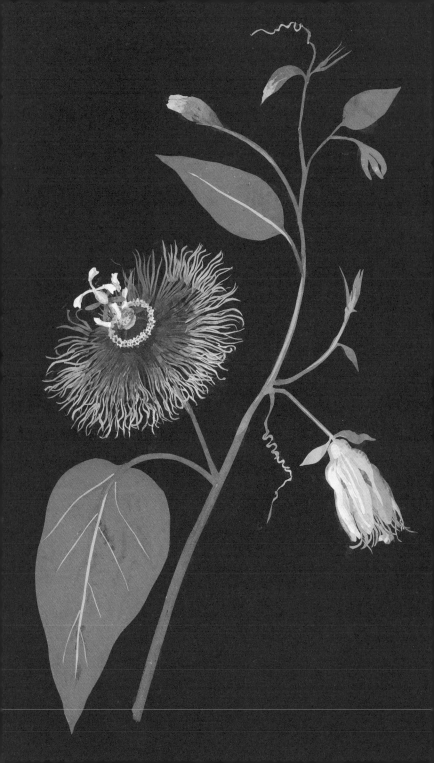

Chapter Eight.

PASSION FLOWER

The main flower head of Mrs. Delany's *Passiflora laurifolia, Bay Leaved* is so intensely pubic that it's as if you've come upon a nude study. She splays out approximately 230 shockingly vulvular purplish pink petals in the bloom,[1] and inside the leaves she places the slenderest of ivory veins, also cut separately from paper, with vine tendrils finer than a girl's hair. It is so fresh that it looks wet and full of desire, yet the *Passiflora* is dry and matte. Laid out diagonally on the page, with its clitoral bump of white and yellow stamens whorled into the central mob of its pistils, it lolls on one side of the stem, balanced by a large bud and two smaller ones with tendrils and leaves. Mrs. Delany often made up her colored papers in advance, washing whole sheets of paper in the endlessly varying green-browns of late summer – olives, lodens, beige-ivories – and this is the palette for the vines and leaves of her Passion Flower.

One day I decided to count all the 230 petals in the main blossom of the *Passiflora* (as totaled by Ruth Hayden), but I kept getting lost. It certainly *feels* as though there are more than two hundred, but the petals are not all separate from each other. They are cut like little grass skirts, where the strands of grass are attached to a belt. The color, which

169

Passiflora laurifolia, Bay Leaved, Luton, August 1777, Prov. Lord Bute

looks purple in any reproduction, is underpinned by the layers of these grass skirts: first rust, then red, then a dark purple, then a deep pink, then a lighter pink, then a lavender. The red, which you scarcely notice without a magnifying glass, is actually the foundation. It goes all the way around the main flower. The white ring shape that defines the flower's center is one whole piece of ivory paper with twenty-something teeny white cut parts. It is watercolored with tiny maroon dots. Under the magnifying lens the petals pulsate with a little bit of the movement of a hula dancer. Even though they are firmly pasted, you can almost see every grass frond waving. Mrs. D. didn't know about hula, but she knew about dancing, she knew about skirts, and she certainly knew about complexity. And passion, too – of many kinds.

Taking in her *Passiflora laurifolia* is half like reading an immensely challenging book, where each sentence shoots you off into a different thought or dilemma or daydream, and half like a sexual experience where the lovers lose track of each other's bodies to such a degree that neither can figure out whose arms and legs belong to whose torso – and neither of them care. Staring at the purplish pinks, one constantly loses one's place.

Mary Pendarves, after her return to England from Ireland in 1732, didn't exactly lose her place, but she had quite a bit of trouble finding one. During the next decade she followed two opposite but intertwining vines of energy. One vine attached her to groups of friends, including Ann Donnellan (who lived peripatetically between England and Ireland, sometimes with Mary, sometimes not), to a closer relationship with her lifelong-bachelor older brother Bernard and summer visits to her mother and sister at the house they

shared in Gloucester. It also attached her to her friend Margaret, who had married the Duke of Portland and moved to Bulstrode. This vine shot off into times for shared handiwork, designing and executing needlework patterns for both herself and others, playing the harpsichord, and living life by touch: the cool sliver of a needle, the wood frame for the stretched linen that would become chair covers or bed curtains, the long, smooth bodkin to pierce holes in the linen, the wool thread, as well as the spinet keys beneath her fingers. Here she would live in circles of people – women, largely – all of whom were occupying their hands usefully or fancifully, with exotic crafts such as the craze for japanning in which black varnish was applied to wooden boxes and frames to imitate lacquerware from Japan.

The woody, stiffer sort of energy creating the other vine that twined through these ten years was social, political, and economic. This was the hunger for a court position that took Mary Pendarves to assemblies again and again, in a round of attempts and disappointments that persisted year after year after year. Her capacity for this social perseverance is astounding. A less diligent, less intrepid social butterfly would have been chloroformed by the hours she spent inquiring, requesting, delicately contriving, and entreating her connections for a court position. If 95 percent of life is simply showing up, then to court she showed up, sometimes twice a day. "Lady Dysart, Miss Dashwood, and I went together. My clothes you know. I was curled, powdered, and decked with silver ribbon, and was told by critics in the art of dress that I was well dressed."[2]

You would think that a grandniece of Countess Granville ("the Dragon," Mary and Ann called her), a cousin of Lord Carteret, a great-granddaughter of Sir Bevil

Granville, and a niece of that rat Lord Lansdowne could obtain an appointment as a companion, say, to a nice little princess. But seeking this aristocratic job was like trying to poke an embroidery bodkin through a heavy leather coat. She could not do it. The surface of the court, with the charged atmosphere between the feuding Prince Frederick and his vindictive father, King George II, repelled any entry. By the late 1730s the prince was effectively banished from the court. "Tis now strongly reported," Mary wrote to Anne, "that there is going to be a reconciliation between the King and the Prince, but the truth of that is doubted."[3] She seems to have been caught in a position of asking for something when the powers that be were far more interested in their own intense familial oppositions than in the needs of some minor Mary in the corner of the court assemblage. Complicating this was her cousin Lord Carteret's entanglement in the feud. (Carteret, one of the few at court who could speak German to the German-speaking George I, was held in suspicion by George II, who quarreled with his father as well as his son.)[4]

But why was she seeking such an appointment in the first place? She didn't quite need the money. Her widow's settlement, if managed conservatively, would allow her to be on her own. Yet she did need the social anchor. As a woman alone, by choice not attached to a man (she continued to turn down suitors, likely even refusing John Wesley, that intense, intelligent founder of Methodism), she was adrift. A court appointment would have meant housing, a clothing allowance, and perhaps meals taken care of. For a person who believed in keeping busy, it certainly would have kept her employed. Without a court appointment, three of her options were to marry, to move

in with relatives, or to retreat from society and live quietly. She crossed off the first two, and her buoyant, culture-seeking nature precluded the third.

Yet court life was the opposite of the rich creative life she led with her family and friends. One's energy was directed purely toward others, not in imaginative ways but in pre-scribed ones. To compare her questing with her sister's country life, she wrote Anne a rhyme, echoing the poetry games they sometimes played in their letters as they sent each other lists of words and created verse from them: "Your country entertainment delights me more in your description, than all that I saw at Court; and I assure you we had no such pretty sport. We had ogling and tweezing, and whispering and *glancing*; no eating or drinking, or laughing and *danc-ing*: there was standing and walking, and *fine ladies airs*, no smart repartee and *not one word of prayers.*"[5] She makes the court sound like an American teen-movie school cafe-teria, full of looking and judging. Without a drop of creative impulse, merely moving back and forth in a side-hooped gown, it seemed that such an assembly would prove a gilded deprivation chamber for a woman who required the daily exercise of her imagination. "After such a day of confusion and fatigue as yesterday, my dearest sister is I am sure too reasonable to expect my head should be composed . . ."[6]

However, it was hard for her to stop positioning her-self, for that would have meant giving up. She had been tantalized by the idea of a court appointment since she was taken by Aunt Stanley to be trained for one as a child. To be promised something since childhood, to try to achieve that promise, and then to be stonewalled is a recipe for bitterness – and desperation. "My Lord Carlisle, his lady, son, and two daughters were all excessively fine.

But I grow sick of the word '*fine*' and all its appurte-
nances, and I am sure you have enough of it."[7]

Sometimes, if one turns away from what one clearly
cannot have, one can grow in another direction. But at that
time Mary Pendarves simply could not see other options.
Her self-pitiless refusal to diminish her efforts is like the
insistence of a vine that climbs up its route even to the
dimmest light source. In another way, she seems more like
the Passion Flower bud in her mosaick, perennially about
to open. The bud is absolutely packed with color beneath
its hanging sepals. It is all formed underneath there and
about to pop, though in the mosaick it's as frozen in
growth as Mary Pendarves was in these ten years.

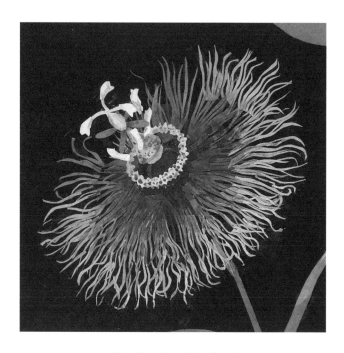

Passiflora laurifolia, detail

Even in this atmosphere of frustration, she remained reluctant to gain security by marrying. After she'd likely refused the upright John Wesley, she fled a future with her wealthy cousin Thomas, Viscount Weymouth, the stepson of her Uncle George, Lord Lansdowne. Thomas was about ten years younger than Mary and the inheritor of Longleat, the stately home that his mother and stepfather had deceived him into thinking belonged to them. In the comfy romance of growing up with an age difference, Thomas was half in love with Mary in a way that she never felt toward him. "I looked upon him as my younger brother. . . . I really had the affection of a sister for him."[8] She didn't take him seriously when he persisted and asked her to marry him, but "He repeated it so often, adding so many fine compliments, that I thought it time to let him see I had no view of engaging him for myself."

Instead of letting the matter drop after she said no, she found a delectable moment of psychological repair. In between rushing to court, socializing with Ann Donnellan, the Duchess of Portland, her brother Bernard, and countless others, in between designing her embroidery, taking her drawing lessons, japanning her frames, and petting her cats (or roaming the streets looking for her lost cat, which was found), she up and decided that she would take charge of Thomas's love life. "I often told him he must let me choose him a wife, which he said I should." Becoming his matchmaker, she disdained her aunt's "indiscretion" and her Uncle George's "indolence" by steering the child of those who had betrayed her toward a deeply satisfactory union – not toward a repeat of her own disastrous coupling. She used the opportunity to make a shining counter-example to what they had done.

The wife she found Thomas was Louisa Carteret, the second daughter of her cousin Lord Carteret, priding herself on matching not only Louisa's small fortune with Weymouth's huge one, but also Louisa's personality with Thomas's. He was "good-natured and affectionate" but "could not bear contradiction," though Louisa, she felt, could deal with him. "Her fortune was small, but she had been bred up in magnificence, and knew how to spend a large one gracefully and manage it prudently." Thomas married Louisa.

And his cousin Mary was left deliciously solo, her beliefs her own. In 1739 she swept herself into a group of nine other women friends to hear the debates in the House of Lords about whether England should go to war with Spain. Instead of being admitted, they were turned back. She spent the rest of the day with them, hammering her fists on the doors for entrance, going without dinner and getting nowhere until one of her friends hatched the idea that they should stop pounding, stay quiet, and trick the ushers into believing they'd given up and gone home. It worked. The doors swung open, and in a *whoosh* of skirts, Mary Pendarves and the other women blew in.

But the full-skirted power of the *Passiflora laurifolia* certainly was not what Mary Pendarves had achieved by April 23, 1743, when, exhausted and gathering herself up for a tenth year of humble pie, she wrote to her sister 176 from her house on Clarges Street in London. "I dined at Carteret House last Thursday; nothing passed concerning *my affairs*."[9] Her cousin was unable or unwilling to return the favor of Mary's brilliant matchmaking, despite the fact that "the Dragon," his formidable mother Dowager Countess Grace Granville, had written to Queen Caroline's

Lady-in-Waiting Mrs. Clayton (a relative of Ann Donnellan's brother-in-law Bishop Clayton) that Mary deserved an act of kindness, if only because she had been "married at seventeen to a drunken monster."[10] But Mary's struggle now was to find an hour to write a letter in a "city, where everybody cuts and carves one's time as they please, without considering the preciousness of the commodity, and that they cannot restore what they rob us of."[11] Her life at this time resembled a kind of permanent waiting room, with all the attendant boredom and anxiety a waiting room breeds.

Yet someone else was growing: her younger sister Anne, now a spinster of thirty-three living with her mother in the country. It was Anne who received an invitation for a position at court! But unlike her older sister, who would have snapped it up, Anne knew she was the wrong fit. She clung to her country life: the brown cows lowing in the fields were more satisfying to view than the silver and cerise bovine herd at court. Intelligent, introverted Anne gloried in her solitude in a letter to her very good friend Miss Kitty Collingwood, later Lady Throckmorton, who was also a friend of the Duchess of Portland. "You are a creature just to my own *goût*," Anne said to Kitty; "you are *lively without romping*, and have the tenderness of sentiment requisite in friendship."[12] But Anne had reservations about the demands the sophisticated Kitty might make on her simple life:

I wish you were near me, but *could you* support this solitary life; which really gives me great pleasure? Can birds and poultry delight you? and a nosegay of wild flowers entertain you for half a day?

Small-town Gloucester chafed at Anne, and she couldn't stand the company of narrow people: "there cannot be *greater unhappiness* to a person of sense, than to be forced to live with those of a *small capacity!*"[13] Anne was curling her quieter passion around an idea. Could she find a life companion, someone smart and sympathetic, someone who would make it possible for her to leave her mother's house but not go too far, and someone who would support the solitude she thrived in? She didn't pursue the answer to this complicated question with her sister, who had written: "Matrimony! I marry! Yes, there's a blessed scene before my eyes of the comforts of that state. – A sick husband, squalling brats, a cross mother-in-law, and a thousand unavoidable impertinences."[14]

Instead, in the frosty February of 1740, blowing her nose from "a very disagreeable succession of colds,"[15] Anne ferreted out some confidential information:

> I have a question to ask you, my dearest Kitty, that requires all your secrecy and prudence, (which I depend upon,) and for your truth I cannot doubt it; therefore without any preamble I desire you will inform me what Sir Robert's [Kitty's husband] *real opinion* is of Mr. Dewes and your's, if you know him.

Anne won't say why she craves the info. She makes up a friend who needs her to perform this recognizance. "There is a person he is recommended to, but she is quite a stranger to him and is my friend, and therefore . . . I must entreat that not a word of it be mentioned to anybody, because the thing is an entire secret." Her friend is an innocent who "has no notion of happiness in a married life,"

and is desperate to know whether Mr. Dewes "has agreeable conversation, generous principles, and is not a lawyer in his manners." Anne desired a real companion, someone capable of "agreeable conversation," a comrade to share the "great pleasure" of her retiring life – and someone generous. If this possible husband was going to hold the purse strings, she didn't want the grip to be too hard. Most endearingly, she didn't want a strict constructionist in matters of behavior – not a "lawyer in his manners."

"I remember Sir Robert told me something about him at the Bath," she wrote to Kitty, "but I have forgot what?" Anne was the kind of person who went to Bath not as a happy spa-seeking socialite but as someone in frail health who required the waters. This cold that she had, or series of colds, lasted throughout the whole month of letters with Kitty.

> *My friend* thinks a *chez nous* with a man of sense and worth is preferable to the unsettled life she now leads, and being continually divided in her heart what friend to remain with; for while she is with one the other wants her, and makes a perpetual uneasiness in her mind."[16]

A single woman at this time became a kind of social floater, the houseguest at the edges of others' lives. At these country distances, married women had to import their friends, requiring them to pack their bags and rumble in coaches over the pitted roads to stay for weeks at a time. Mild, intelligent Anne was in demand as a friend-in-residence, yet she suffered as a perennial houseguest. She wanted to live *chez nous*.

The more she considered this radical move from spinsterhood, the more she absolutely did not want her sister

Mary (or "Pen," as she called her) to know. "Don't mention to Pen when you write."[17] She even gave Kitty exact mailing instructions. "Don't enclose your letter to the Duke, but send it directly to me at Gloucester by way of London." The person who was quietly brokering this marriage deal was probably their older brother Bernard, known to the family as "Bunny." "The parties *are to meet* in about a fortnight to see if they like well enough on each side (for at present they are strangers)," Anne announced between sniffles. "I really have a bad cold." Anne had never before met this John Dewes. When Bernard and Mary attended the glamorous wedding of their cousin Grace Granville, Bernard kept silent about this possibility for Anne.

But someone must have told.

When Mary found out, she composed a formal, chilly acknowledgment. She had not thought of Anne acting alone or even as having such divergent desires. Mary was stiffened by hurt but she breezed on, acknowledging Bunny's collaboration:

> Your letter to my brother has *cheered my spirits* a good deal; I think Mr. Dewes behaves himself like a man of sense, and with a regard for you that must recommend him to the favour of all your friends. My brother and myself will receive him with a great deal of pleasure. . . . As soon as we have met . . . then we may proceed to particulars, buying wedding clothes, and determining where the ceremony is to be.[18]

As a poultice for her injured feelings, Mary took herself to see Holbein's famous portrait of Henry VIII, and then she went out to eat. After mentioning buying the wedding clothes in this letter, her usual chatty, ebullient

voice breaks through with tales of someone's smallpox, of the Holbein, and of that very new concept in 1740, an idea from France: the restaurant. She ate "a very good dinner" at Pontack's in Abchurch Lane – the place Jonathan Swift quipped about ("What wretch would nibble on a hanging shelf, / When at Pontack's he may regale himself?") and Hogarth featured allusively in the third plate of *The Rake's Progress*, when he substituted the restaurateur Pontack's portrait for one of the Roman emperors on the wall.[19]

Anne, like the Passion Flower vine, sought an anchor. She was going to do what her older sister had so assiduously avoided. Mary's friends discussed how uneasy it made her. A guest at Bulstrode, Elizabeth Robinson, later Elizabeth Montagu, founder of the bluestockings and one of the women who had banged on the doors of Parliament, wrote to Ann Donnellan. "Our friend Penny [Mary's nickname] is under great anxiety for the change her sister is going to make. I do not wonder at her fears. I believe both experience and observation have taught her the state she is going into is in general less happy than that she has left."[20]

There was a hiatus in the sisters' letters because of Anne's wedding in late August 1740. The one who resumed the correspondence was the newly married Anne, heartfelt, loving, struck with all the changes that had come to her. She wrote on the lonely morning when Mary left Bradley, her new home – made even lonelier by the absence of her new husband, who was traveling on business. "Melancholy forsaken Bradley," Anne wrote to Mary, who had left without waking her that morning, "Thursday evening, 5 o'clock."

There is a kind of sorrow that enlarges the mind and dissipates all trifling occurrences beyond anything that we call mirth and merriment can do; such is the present sorrow that fills my heart at parting with the best of sisters and most amiable friend. I feel the sharpest pangs for the loss of her company, recollect every tender expression, endearing look and action, that by so many pleasing ways engaged my affection . . . [21]

That ability to understand and to articulate what she was feeling underpins all their correspondence. Anne led by example. Her bright example may even have allowed her arty, stubborn older sister a moment of greater flexibility or balance. Mary had stuck to her guns about refusing distasteful marital unions. But what about the salutary ones? Her little sister, restrained, sickly, had her passions. One of them was for a life she might lead with a companion.

Botanical Politics Lesson:
Mary Delany's flower of passion is so old that it might fall apart in your hands. She made it in 1777, at Luton Hoo, in Bedfordshire, five years after she began her great work at Bulstrode. Luton Hoo was the four thousand–acre home of Scottish John Stuart, Lord Bute (1713–92),[22] King George III's much-disliked former prime minister, who, though personally austere, was horticulturally besotted, even with unprepossessing wildflowers. He provided support to Quaker botanist William Curtis (1746–99) for the illustrations of English plants that became the *Flora Londinensis,*

the first volume of which was published two years before Mrs. Delany dated her far more exotic *Passiflora laurifolia*.[23]

After lean, long-nosed, dark-browed John Stuart married Mary Wortley Montagu (daughter of Alexander Pope's rival, the poet Lady Mary Wortley Montagu), they spent almost the first decade of their life together on the craggy Isle of Bute, about seventy-five miles east of Glasgow, Scotland, where he carried on his study of green existences, botany beneath the gray skies and among the gray stones. Part of his personality preferred nothing to collecting plants, but another part of him, his political ambitions, brought him to London in the 1740s. There his looks and tamped-down, strict demeanor made him a friend of fun-loving, botanically minded Prince Frederick and severe, suspicious, botanically minded Princess Augusta. Frederick named him a Lord of the Bedchamber, and in 1749 Bute advised the Prince on his horticultural enterprise at Kew.

After the Prince died suddenly in 1751, leaving Augusta five months pregnant, along with eight children and her husband's gambling debts, she reduced her number of residences, withdrew from the court, and finagled Bute to be tutor to her sleepy, tall, sandy-haired oldest son, the future King George III. Bute's relationship with the teenage Prince of Wales was intense. At last the boy had found a teacher, a taskmaster, a role model. George resolved to turn his indolence around and get cracking. He strove for Bute, and Bute, in turn, along with his mother, stirred up his love of plants and plant collecting. (Later on, after George III made the mistake of appointing Bute prime minister, they fell out and the King repudiated him.)

Part of Bute's problem was that he was rumored by his enemies to be having an affair with Princess Augusta.

Augusta, wary of courtiers and anti-extravagant, was at home with plants, happy with green life, and she took all her children with her to Kew for the summertime. There she continued her late husband's horticultural project, and Bute assisted her. In 1759 the Royal Botanic Gardens at Kew were born.

Four years later Bute was so out of power that he had to retire to the country. This was when, with his wife's inheritance, he purchased Luton Hoo. There he created botanic gardens, hiring the genius of eighteenth-century pleasure grounds, Lancelot "Capability" Brown, as landscaper. By the time Mrs. Delany came to stay in 1777, George, now King, was embroiled in a North American war, while Bute was busy being a patron of intellectuals and writers like Samuel Johnson and working on his *Botanical Tables Containing the Families of British Plants*, which he wrote to edify ladies about botany[24] and would publish in 1785. Classification, establishing a plant's bloodlines, as both botanists and aristocrats loved to do, literally created a plant's family tree. It nailed things down. All the wobbling uncertainties of life, of being in or out of favor, might be ignored, and perhaps eased, if one could pin things down, just as his guest Mrs. Delany was gluing fragments down on paper.

When Mrs. D. accomplished the miracle of the *Passiflora laurifolia*, she was at the height of her powers. Three months later, in October 1777, she would be cutting out mosaicks at the rate of one per day! If ever there was an occasion for an exclamation mark, it's this. Her median

rate of production for the mosaicks is roughly one every four days over ten years, though the production waxed and waned: more in the summer months, when specimens were available and, of course, daylight lasted longer. All of her years had trained her eyes and muscles – and her inspiration. She also by this time understood how an assemblage of fragments would best emulate a botanical specimen. As a nascent scientist, she worked with deliberation, and as an artist five years into her project, she worked with joy and speed.

Yet in her early forties, after Anne's marriage, Mary pieced her life together with little joy or speed. In April 1743 she dined at Carteret House and learned that there was absolutely no court appointment for her.

But on the very day she suffered through that dinner, someone was traveling toward her from Dunstable, about thirty miles north of London, and doing so with dispatch. Patrick Delany, now a widower, had a mission. He stopped at the house of Sir Clement Cottrell Dormer, Master of Ceremonies to George II, where he was invited to stay, and wrote to Mary Pendarves a simple, direct letter. Little in her past ten years had been either simple or direct. "I have long been persuaded that perfect friendship is nowhere to be found but in marriage. . . . I know that it is late in life to think of engaging anew in that state, in the beginning of my 59th year. I am old, and I appear older than I am; but thank God I am still in health . . ."[25]

A damp, verdant scent comes off the words. Rain-soaked.

"However the vigour of life may be over," Patrick Delany wrote, "and with that the *vigour of vanity*, and the flutter of passion, I find myself not less fitted for all that is solid happiness in the wedded state – the tenderness of

affection, and the faith of friendship." Solid happiness the man was offering her, she who had been so fragmented.

The woman whose "*debt* is *large already*," and who that very year would pay fifty pounds for a hat ("Is that not extravagant?" she asked her country sister),[26] was hearing from the man after whom she inquired in all her letters to Mr. Swift, the kind man, the generous Delany. "I have a good clear income for my life," he wrote, "a good house (as houses go in our part of the world), moderately furnished, a good many books, a pleasant garden (better I believe than when you saw it)."[27] Into the brick and stone and wrought iron, into the gilt and carriage traffic and gossip, into the larded hair, into the tweezing, the teasing, the pleasing of London came the scent of growth, of black soil, damp air, and the burgeoning of a garden outside Dublin. His was not a marriage offer as a financial contract, although Reverend Delany addressed money in the second paragraph, and it was certainly not a marriage offer for a political alliance or a line of inheritance. It was a proposal of friendship. "Would to God," he wrote, "I might have leave to lay them all at your feet."

Then he delivered the sentence she may have read over and over – for this is a letter that she herself, not her sister, must have saved, containing the words of another who recognized who she was and what she had experienced. "As you have seen the vanities of the world to satiety," he quietly wrote, acknowledging her worldly position, "I allowed myself to indulge a hope that a retirement at this time of life, with . . . a man who knows your worth, and honours you as much as he is capable of honouring any thing that is mortal."

She did not respond. Didn't the letter go straight to her solar plexus?

Patrick Delany waited ten days, and on May 3 he tried again, sensing the reason for the stonewall of her reticence: she was a Granville and he was a social zero, the son of a servant to a judge,[28] a mere cleric, and Irish at that.

 "Permit me, madam, to beg to know my fate as far as it depends upon your friends in Gloucester . . ." he wrote in a short note.[29]

She did not answer.

But it was not her mother in Gloucester who was standing in her way.

On May 6, nearly two weeks after he wrote his first letter, Reverend Delany beseeched her, "I can scarcely hold a pen in my hand."[30] Now he was in London. He had come determined to break the logjam that he had guessed was being caused by her older brother Bernard. Lady Llanover, Mrs. Delany's great-great-niece, ventured to say that Bernard was "well known to have been violently opposed to his sister's marrying a man who had no claim of ancestry to bring forward, or anything to offer in excuse for what Mr. Granville doubtless considered unparalleled presumption."[31] Reverend Delany, a bit portly, his face round above his cleric's collar, went straight to Bernard Granville's house to accost him directly. Apparently Bernard slipped out the back door to avoid the confrontation. Patrick found the coward "in the street" and had, as he wildly understates, "a moment's conversation."[32]

What had happened to Mary Pendarves in these two weeks? Clearly she had gone to her family for permission, not only to her mother but to the head of the family, Bernard, and likely to Sir John Stanley. The very fact that she even sought permission, that she didn't reject the offer as she had rejected others entirely on her own, implies

that the letter arrived at a propitious, a rescuing time, and that she wanted their blessing for a leap she was about to make. A leap into the life of a man whose house, whose food, whose laughter and hospitality, and, perhaps most importantly, whose garden she had visited a decade before. In midlife we fall in love with a person's circumstances as much as the person, for even if the lover is entangled in the web of social and political exigencies that created him, that lover has also had choices available to make, and this man had elected to blow his money on a garden and to speak his mind in sermons and to entertain his literary friends and let them shine. He had also selected her. She, in turn, could choose his house, his garden, his tastes, his friends, and the country he lived in, far from feuding kings and princes. At the age of almost forty-three, she could grab his hand and run away. But as she made clear with Robert Twyford long before, she did not want to sacrifice her ties to her family. She was the first to recognize how this constituted her identity. She cared deeply about her position in society, and she did not want to ruin it in seizing this chance for herself. We can only imagine the flurry of communiqués among Bernard, their mother, their sister, and their uncle Sir John Stanley.

But as far as her suitor was concerned, Mary Pendarves was stalling.

The week before her forty-third birthday, he simply and directly put it to her: "I might venture to pronounce that even a parent has no right to control you, at this time of life, and under your circumstances, in opposition to these; and a *brother* has no shadow of right."[33] Wasn't it about time she made her own decisions? Earlier in the letter he paid her a compliment: "God has blessed you

with noble sentiments, a good understanding and a generous heart." Not the gauzy tribute one might get from a lover, but bedrock reassurance from a man intending to be a husband. He trusted that she would listen to him, and he spoke clearly and openly about her brother: "leave me not to [his] caprice . . . let not the decision depend upon the fickle, the uncertain, and the selfish." He enclosed a letter of formal request to her mother. Then he asked to see Mary face to face.

She did not permit him.

Reverend Delany's next letter is dated six days later, "May 12, 6 in the evening." At this point he has insomnia. "They say you sleep better, that is the condition of a heart at ease, – would to God mine were so!" he exclaimed. Her mother had responded to him, owning that her grown daughter should decide for herself. He calls her letter "*not unfriendly*; it *leaves* my happiness where I wish . . . – *at your feet.*"[34]

Mary Granville Pendarves celebrated her forty-third birthday on May 14.

And by the night of this anniversary of her birth, when the sun came into the alignment it held near the day she was born, we can conclude that they had communicated and agreed on a plan to assuage her family. The Reverend had sent a message to "the Dragon," Countess Granville, with a "friend" of the family, and this may have been Lord Carteret, her son, who "undertook it with a zeal."[35] Now they really were acting together, strategizing to preserve all ties, and it must have been the future Mrs. Delany who engineered this, and who may have engineered other negotiations all along. However, it was Reverend Delany who craved her on her birthday evening. "Are you

alone?" he wrote to her in a brief note. "[May I] hope to be happy with you one moment?"

Let's hope she opened the door for him.

Anyone who has ever read a seventeenth-century metaphysical poet knows that the sacred and the sexual are never very far apart. Nor are the botanical and the anatomical: the leaves of the Passion Flower are "petiolate, serrate, and very finely pubescent"; their undersides are hairier than their upper sides. The leaf blades have "extra-floral nectaries."[36] The Passion Flower is the flower of possibilities. To this day it has the Christian overtones assigned it by its first discoverers, Spanish Jesuit priests in South America. The priests viewed the flower as the Passion of Jesus Christ. They played an entrancing numbers game: five petals plus five sepals equals ten disciples (minus Peter and Judas). Three pistils? The three nails of the cross. The purple filament-like petals around the center? It's the crown of thorns. The flower's ovary is the goblet of the Lord.

The flower was viewed as a Christian ceremony, and Patrick Delany, devout cleric and passionate gardener, was proposing a Christian ceremony to Mary Granville Pendarves. She married him on June 9, 1743. In the letters we have, she does not record what she wore, or who was there. It had to have been a small, private ceremony. Then her new husband quietly moved into her house on Clarges Street, just as if she had moved her rump over a little to make room for him on a garden bench. Just like that. Not young, not inexperienced, past the height of her sexuality, she entered into a full-blown engagement with what she thought was her old age, but what turned out to be her middle period.

This second, entirely adult marriage took place in what likely would have been the best month in the garden at

Delville in Ireland, though they did not see it then. In fact, the new Dr. and Mrs. D. did not rush for the boat to Ireland at all. They spent nearly a year in England. There was still the matter of Patrick's social status. Could she manage for him what she hadn't been able to manage for herself: secure him a better appointment in the church? Use the relentless hierarchy of the court and her family to help her new husband and, incidentally but crucially for status-conscious Mary, erase some of the disparity of rank?

A year later, in May 1744, just before her forty-fourth birthday and the month before her first wedding anniversary, her cousin Lord Carteret, in his coat and waistcoat, stockings and buckled shoes, appeared at her door in Clarges Street. She and Patrick were just sitting down to dinner, but Carteret told her to dismiss her servants. When they had scuttled from the parlor, Carteret announced that he had just come from the Duke of Devonshire to offer Delany "the Deanery of Down."[37]

She'd done it. At last Carteret had obtained her a favor.

She'd worked to show the world the merit she found in her husband. Now he would have the title of "Dean" to display this value and lend him power, and a yearly income, too. She could be secure. (Not as secure as she would have liked. Carteret also promised a small bishopric when a position came up, should Delany want to remove himself from Down, and Mary remembered this pledge and attempted to have it fulfilled for years. It was not.)

During their year-long honeymoon in England they spent a good deal of time visiting friends and relatives, venturing to Wellesbourne to introduce Patrick to her sister and brother-in-law, whom she came to like and respect, visiting her mother, who was gracious about her daughter's new

connection, and staying at Bulstrode, embraced by the Duke and Duchess of Portland and their children. Mary was not cut off from society for her decision to marry Patrick. Her sister, the Duchess, her tumultuous friend Donnellan, and much of her intimate female acquaintance understood her position – and remembered how she'd described the anger and horror of her first marriage. Her friends also knew the joy she had experienced when she'd first set foot in Ireland.

But the men in her family would not truly forgive her. Sir John Stanley would die and leave her only a few household objects; Sir Anthony Westcombe, of her mother's family, would ignore her in his will. Her brother Bernard would demand that she woo him with sisterly supplication, which she would do, though it would take years before he would half-forgive her, and even in the illnesses of his old age he refused her at his bedside. Their rapprochement never fully bridged the rift.

At the end of that honeymoon year, in June of 1744, the freshly appointed Dean and his profoundly refreshed wife boarded the ship to Ireland. There, on deck, she was inspired to draw. "I sat on deck the whole day and eat a very good dinner and an egg for my supper, and worked and drew two or three sketches; nothing could be more pleasant."[38] Their windy boat journey recalls that the root of inspiration is breath. When she married Patrick, the newly named Mrs. Delany at last could breathe. She entered into that full knowledge of the self that is possible inside the understanding of another. Then, that night on the rough Irish Sea, the yearling husband, aged sixty-one, and the yearling wife, aged forty-four, in the full intimacy of a mid-life marriage near its first anniversary, got seasick together, puking into buckets in their tiny stateroom.

In marrying another man who was the probable age of the man she had married at seventeen, she was able to ameliorate the trauma of her life. Instead of reading to him with her teeth chattering or being subsumed into his jealousies, she sat on the deck of the boat and drew, leaving everything behind her and touching the world in front of her, as she grasped the graphite in one hand and with the other held the paper down against the salty air currents of the Irish Sea near the summer solstice.

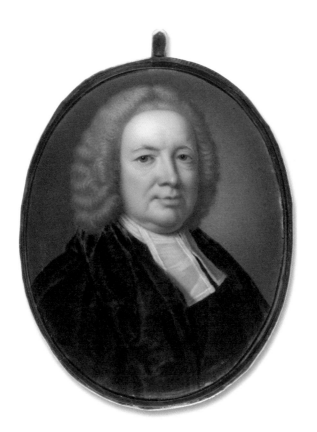

Patrick Delany

One day in February 2003, in the heart of the happiness of mid-life, I found myself waiting for my husband, my derrière parked on a hard bench near the coatroom of the British Museum. By now we had been married for eleven years. He was hunched in a telephone booth yammering away to a colleague, his eyebrows bobbing, his hand waving, his body alive with arrangements and academic gossip. We'd just left St. John's College at Oxford University, where Mike had given a lecture and I had given a poetry reading, ending up in London before we flew back to North America. There was just enough time to peek into the museum's atrium and be enthralled by the winter light. Unusually, that day it had snowed. His phone call seemed to be taking ages. Restless, I looked around and spied the museum shop. Carved into the stone lintel was its name: The Granville Shop. Needless to say, I didn't connect it with Mary Granville Pendarves Delany when I ventured in.

I hovered over the earrings and scarves, the note cards and ties, all things I would have longed to buy years before in New York when I stalked the gift shop of the Morgan Library, though none of it really attracted me now. I wandered through displays, periodically leaning back toward the door to see him still on the phone. I passed the umbrellas, the datebooks. Then the books began. I skipped the books on ancient sculptures, ignored the medieval titles, and somehow persisted to the last table at the end of the shop. There it was! Sixteen years after the show at the Morgan Library, there lay the book that had accompanied it: *Mrs. Delany: Her Life and Her Flowers,*

by Ruth Hayden. This time I could afford it. I snatched it up just as Mike came looking for me.

In the cab he grabbed it out of my hand and turned, as he does, instantly to the fine print on the back of the title page. Since its publication in 1980, he observed, it had never been out of print. But what, he asked, did I buy it for? I had never breathed the name of Delany to him. I hadn't known I needed to.

On the plane home the flowers astonished, amazed, and astounded me again. Seeing them was just like picking up a novel you read long ago, hoping that you'll still be able to relate to it, and finding, now that you're older, that it's even better than when you first read it. I thought of a seventy-two-year-old woman having only the light from a nearby window or, worse, candlelight to work by as she invented a brand new art form. I'd passed over Ruth Hayden's book when I hadn't really needed it. Now it had popped up just when my unconscious required it, except my conscious mind hardly knew why it seemed so necessary. I was always carrying on a sub-rosa search for answers to questions I hadn't even formulated yet. I was fifty-six years old. My father had been dead for nineteen years. My mother had been dead for eleven years. My sister had been dead for seven years. I read the book.

Cramped into my economy-class seat, I found a role model, one born at the start of a century I had previously ignored. ("The eighteenth century!" I remember exclaiming to my sophomore adviser. "Do I have to read *Rasselas*?") But now, from Ruth Hayden's book about a woman whose life spanned the century, I learned that most of Mrs. D.'s collages were in the museum I had just left. Well, I wouldn't have thought of her as "Mrs. D." then.

I'd visit those works on my next trip to London. In the meantime I could read the book and find out some things. And so I did.

As I was reading, I had that familiar but blurry role-model-searching wandering feeling. As I soaked in the *Papaver somniferum* (it was on the cover), a mosaic of images bobbed up and down in my mental stream, carried by a current of years poring through my grandmother's seed catalogs. I was entirely confused looking at the collages. Cut paper? I refused to believe that the poppy wasn't painted. Were the paint-splash-like gestures in the middle actually pieces of paper? I could not process the fact that they were cut with a blade, not outlined with a brush. I leaned closer. Actually, I was encountering the flowers again in just the way Mrs. Delany meant people to meet them: by leaning over them, holding them in their hands, like a book.

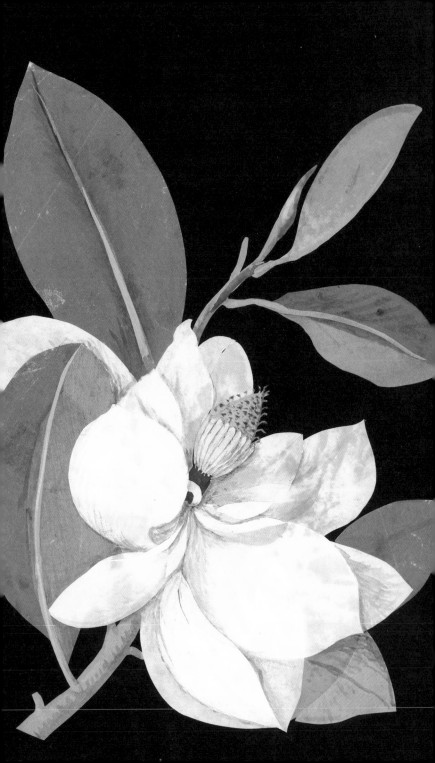

Chapter Nine.

MAGNOLIA

Thin as a billowing white cotton nightgown, Mrs. Delany's *Grand Magnolia* lies back in the balmy darkness of the summer night of its background. Perhaps her most blowsy bloom, plumped with the musk of maturity, it evokes the eighteenth-century gardener's word for a fully opened *Magnolia grandiflora*, "blown." Although it seems that "magnolia" would share a root with "magnificent," in fact the genus name comes from the French botanist Pierre Magnol (1638–1715).[1] Mrs. Delany composed the work with the tissue-like paper she brought with her to Bill Hill, the estate of her friend the Dowager Countess Gower.[2] The realistic effect of rust on the colossal petals gives the mosaick what landscape historian Mark Laird calls its "soapy" imperfection. We can't know the degree of intention that achieves this slightly rain-damaged effect, whether paste leached through the thin paper after she finished the work or whether she took advantage of some discoloration as she was making the collage, but the creamy rustiness conjures up a bosomy sense of maturity. If this magnolia were marriage, it would be *Marriage grandiflora*.

Coincidentally, two magnificent images of magnolias were published in the year the Delanys married, one by

Magnolia grandiflora, the Grand Magnolia, Bill Hill, August 26, 1776

Mark Catesby (1679–1749) and the other by Georg Dionysius Ehret, Linnaeus's illustrator.[3] (Ehret was also the painting teacher of the daughters of the Duchess of Portland.) The images these men created (Catesby's engraved after a drawing by Ehret) display a bit of the lust of eighteenth-century botany grandees who, once they heard about these flowers, were dying to import and grow them. Magnolias heroically survived transplantation, despite the fact that the English climate can't replicate the balmy humidity of the American South.

Mark Catesby had been fascinated by plants since he was a child in Suffolk, East Anglia, playing in the garden created by his uncle Nicholas Jekyll on the grounds of his house, Castle Hedingham. When Catesby's sister married a colonial physician who lived in Williamsburg, Virginia, Catesby escorted her to her new home. While he was there he had a look around – and was astounded by the sumptuous flora.[4] He stayed for five years. With William Byrd II he explored the Virginia tidewater, collecting live specimens, then traveling to Jamaica to do the same. By the time he returned to England in 1719 he had an extensive collection and a deep familiarity with the habitat which he displayed in his lush drawings and watercolors. When British horticulturalists saw the specimens and artwork, Catesby was drawn into the world of botanical expeditions, and in 1722, armed with a twenty-pound-per-annum grant from the Royal Governor of South Carolina, and with other backing, he embarked on a natural history voyage both to the Carolinas and to the Bahamas to draw, study, and collect specimens of flora and fauna, especially birds and snakes.[5]

Thus Catesby began the project of his life, preparing for the etchings of his *Natural History of Carolina, Florida and*

the Bahama Islands, published in its first volume in 1731 using folio-sized color plates, often with animals in the background with plants. The project was financed by a fellow member of the Royal Society, the Quaker Peter Collinson, friend of horticulturist John Bartram, and subscriptions were sold, including one to the Duchess of Portland. The second volume of Catesby's remarkable books of etchings was published in 1743, completing his life's work in the year of Mary and Patrick Delany's nuptials. This volume included his print labeled "The Laurel Tree of Carolina (Magnolia altissima)."[6] In it he positions the bloom on black. Since the Duchess owned these volumes, Mrs. D. almost certainly pored through them; because Catesby's work came into the collection of King George III and Queen Charlotte, there's every chance that Mrs. Delany may have seen his *Magnolia* a number of times.

Georg Ehret's *Magnolia*, also on black, influenced both Catesby and, very likely, Mrs. Delany.[7] Ehret used black on paintings such as his "Echinopsus [*sic*] major" and his "Astrantia and Resida." Since her friend the Duchess owned the "Echinopsus," Mrs. Delany was probably quite familiar with these as well.[8]

Her love affair with flowers on black began long before she ever would have had contact with Ehret's or Catesby's work, back with the black gown embroidered with flowers she designed and wore in 1739. Yet her likely contact with these botanical artists affirmed and strengthened her idea. But the way she fashioned her magnolia flaunted an attitude difference. Catesby's and Ehret's magnolias sit at the tops of their works looking down. Mrs. D's magnolia lolls at the bottom of the page. It almost looks up from the bed linen–like disarray of its petals. The two men style the

magnolia at the top of the missionary position, but hers waits below for a partner to lower onto it.

Her *Magnolia grandiflora* plays with creamy whiteness, but as soon as Mary entered Patrick's house at Delville, she went for red. Seeing Delville again, twelve years after she'd first visited and competed with Kitty Kelly for the affections of both Jonathan Swift and Ann Donnellan, she made her claim in scarlet. Her bedchamber she "hung with crimson damask," and she applied the same to the bed chairs and bed curtains. Then she splashed this rich ruby into the Delville drawing room, "the curtains and chairs crimson mohair."[9] The minute she described their bedroom, she slipped into the pronoun "we" – of being married in the flesh as well as joined in companionship. At the thick, phallic root of the stamen in the very center of her *Magnolia grandiflora* mosaick is a powerful splash of red.

The Delany relatives Lady Llanover and Ruth Hayden both feel that the couple had a sensible marriage, a mid-life union of mutual interest. But there was also a fleshy compact with one another that included perhaps not very sexy but entirely intimate acts, such as upchucking on the Irish Sea. The depth of their familiarity likely included an element of deep touch. Mary lived by her hands. Those hands that the Dean now encouraged to draw and paint were the sensuous extension of their new life and how they apprehended the world. The letters that Lady Llanover collected never give a whiff of their married sexuality. But to me it seems impossible that the woman who ate with the gusto, who wrote with the vigor, who danced with the élan, who walked with the heartiness, who consoled a friend with the vitality, who drew with the energy, who gardened with the spirit, who chattered with the vim that Mary displayed

moment to moment in all her eighty-eight years did not have a little sexy affection in her forties for the man who called her his bliss. She worried over him, she doted on him, and they slept in the same bed.

Though she describes Delville as pleasingly small, the entrance hall she measured was twenty-six feet by twenty-two feet, with twelve-and-a-half-foot ceilings "finished in compartments, with a Doric entablature in stucco round the room."[10] Compared to Longleat or Bulstrode, it wasn't a palace, but the circular road around the house had room "for a coach-and-six [horses] to drive round commodiously." She had a room of her own there, with a view, too. "On the right hand [of a little hall] is a small parlour, where we breakfast and sup, out of it our present bedchamber and a large light closet within it; it is but a small apartment, but very pretty, and lies pleasantly to the gardens."

The Delville grounds, so charming and eccentric, displayed Patrick Delany's attraction to the Picturesque gardens of Alexander Pope. Delany's plantings responded to the natural contours of his land. The grounds sported a bowling green, a high bank, a circular terrace, flower walks, and fruit trees. Delville came with a "kitchen garden" and "two fruit-gardens."[11] The land sloped down to "fields, or rather paddocks, where our deer and our cows are kept. . . . These fields are planted in a *wild way.*" The new mistress of Delville immediately made plans for an orangery and a grotto, and was so captivated that she said she could hardly describe the "several prettinesses": the "little wild walks" and "private seats," including a "*beggar's hut,*" a particular seat in a rock where tame robins came to her husband's hand. The gardens were one of the reasons for the great success of this marriage, the

passionate, lifelong gardener Patrick allowing the imaginative designer Mary to merge with his enthusiasm. Their joy in their gardens reminds us that the root of *enthusiasm* is "*theus*" – the divine.

There is no question that twenty-five years of gardening at Delville led to the flower mosaicks. But the reason to emphasize it is that Mary Delany did not garden alone, but with her husband. It was his first, after all. She exerted her hand and her imagination, but it was a mutual endeavor. They spent many hours together in it, and Patrick Delany taught Mary his trick of feeding robins from his hand. Here was the place where Patrick tamed the wild, a different prospect from preserving the wild, our task today. This was a man so mild, so patient, so willing to quiet himself that birds came to his hand. In contrast to the sharp formality of the training that Mary received as a child, an education that tamed the wild in her, his recognition of the way avian nature can meet human nature when he coaxed a bird to feed from his palm became sharply emboldening – and reassuring. Such a quick, small gesture is like a column. It can support a temple of art, especially one made in grief, when this kind of gesture is absent.

Throughout the decades of her marriage, Mary never stopped reveling in their mini-pleasure-ground at Delville. On the summer solstice of 1750, seven years into their married life, she wrote to her sister, "My garden is at present in the high glow of beauty, my cherries ripening, roses, jessamine, and pinks in full bloom, and the hay partly spread and partly in cocks, complete the rural scene."[12] The couple didn't just walk in the garden or supervise the planting of the garden or cut and arrange the blooms, they ate there, too.

We have discovered a new breakfasting place under the shade of nut-trees, impenetrable to the sun's rays, in the midst of a grove of elms, where we shall breakfast this morning; I have ordered cherries, strawberries, and nose-gays to be laid on our breakfast-table, and have appointed a harper to be here to play to us during our repast, who is to be hid among the trees. Mrs. Hamilton is to breakfast with us, and is to be cunningly led to this place *and surprised.*

It was a complicated pleasure, since gardens require staying home, and the Delanys had to leave at the peak of the summer – when the Dean's commitments as a cleric had to be met – packing a carriage with all their belongings and several of their servants and bumping along the roads between Dublin and Downpatrick (the county town of County Down), unloading, making another house habitable. After reaching these lodgings (over time they used several, including Mount Holly and Mount Panther), they had to go to work, he visiting his congregation and she entertaining them. By early July of that same year she wrote to Anne, "I never enjoyed Delville so much as I have done this year, there having hardly been a day that I could not live in the garden from morning till night. . . . Now I have told you how much enjoyment I have had of Delville, I must tell you we are on the brink of leaving it."[13]

The Dean had promised Mary that they would visit England every third year, and since this journey took place in the summer as well, they were forced to enjoy the garden through a sliphole of time. Three years into her marriage, as they were about to make this first return trip to England, her grounds seemed sweet as music. By now she referred to the Dean by her shorthand, as D.D.:

Our garden is now a wilderness of sweets. The violets, sweet briar, and primroses perfume the air, and the thrushes are full of melody and make our concert complete. . . . Two robins and one chaffinch fed off of D.D.'s hand as we walked together this morning. I have been planting sweets in my "Pearly Bower" – honeysuckles, sweet briar, roses and jessamine to climb up the trees that compose it, and for the carpet, violets, primroses and cowlips.[14]

But just as she immerses herself in this outdoor room complete with a floral carpet, she knows she won't actually "smell their fragrances, nor see their bloom, but I shall see the dear person to whom the bower is dedicated, I hope, and I think I shall not repine at the exchange." She had dedicated this bower to Anne.

The following year, in May 1747, they settled into Delville again.

We had the pleasure of finding house and gardens in perfect beauty; and Mr. Greene has added three beautiful young deer to my stock with a milk white face; my swan is well; Tiger knew me, and I have a very fine thriving colt and calf. . . . I have breakfasted and drank tea in an afternoon in my garden twice; *Pearly Bower* in high beauty, and I have not failed paying my daily homage to it. The robins have *not* yet welcomed us, but one chaffinch has, and hops after us wherever we go.[15]

The garden was catnip to them; it was so irresistible they almost rolled around in it. They loved it; they drank it in. But they stayed only briefly, for they headed up to Downpatrick again. The next year it was the same. She

missed the heart of the summer at Delville because of commitments in Downpatrick and finally returned in August 1748. "My orange-trees come on finely; there is but one that has failed, and four of them bore prodigiously. All my plants and flowers have done very well, that is, all that came up before I went into the country, except the tuberoses, and they promise but indifferently."[16] Buried in her record of the "wilderness of flowers" she found on her return is a seed of her later mosaicks. Here is the way of looking that would portray each flower as an individual, stepping out of its black background, outlined and unique.

> My flower-garden, which is now just under my eye, is a wilderness of flowers, the beds are overpowered with them, and though the enamelled look they have is rich and pretty, I believe it will be advisable to have the different sorts of flowers appear rather more distinct.

"Rather more distinct." When a painter outlines a figure in black, the figure, separated from its environment, becomes more distinct. Her phrase "enamelled look" and the urge to separate the "different sorts of flowers" point to an urge to make the garden appear more like fabric. It is as if her court dress unfolded itself from whatever trunk it was packed in, got up, and wafted across the landscape.

The Delanys' every-third-year trip from Delville to England, then back to Dublin and up north to Downpatrick, continued its triangular course. In June of 1754, seasick yet again, Mary and Patrick returned from another visit to Anne at her house, Wellesbourne, to her friend the Duchess of Portland at Bulstrode, and to myriad friends in London. They arrived after thirteen hours on the ship

from England, which she thought was "a surprisingly quick passage, but a very rough. All on board excessively sick. . . . D.D. pure well, and now my giddy head will allow me to say no more. . . ."[17]

She toured her garden, quickly employed people to take care of it, then packed and hurried again to the north.

> Our gardens are in high order and beauty: I have just agreed with a skilful gardener to take the care of all my fruits and flowers, without having anything to do with any other part of the garden, so I hope Flora and Pomona will both flourish. I have got a cook, housemaid, coachman and postilion to drive with four horses, and we talk of setting out next Tuesday se'night, but I believe our coach will hardly be ready to go so soon, but D.D. is impatient, though in the midst of his haymaking, to be on the spot where he thinks his duty most calls him.[18]

The push-pull tension of establishing a life in a new country and maintaining it there, as well as being drawn to those she loved in the country she'd left, never diminished throughout the years of her marriage. If the garden is the symbol of stability, her carriages are her emblems of perennial motion. They had just as much carriage trouble as anyone now has car trouble: buying new carriages, traveling with them on shipboard (a bit like a car train), breaking down, getting stuck, being endlessly delayed, with all the expense and frustration we experience now with automobiles. Yet inside this life of motion is a core of constancy. The fact that the Dean kept his promise to return her to England gave her life a steadiness. The rooted garden and the uprooting trips combined stability and forward motion,

reinforced her native optimism, and bolstered her conviction that life is made for keeping busy.

Although their own garden was sinuously laid out, at least in Mrs. Delany's drawings of it, it probably retained some shapes of the original garden that the Dean had created with Richard Helsham. Both Mary and Patrick deplored the ridiculous lengths some individuals went to as a result of the dramatic shift in eighteenth-century landscape planning influenced by Lancelot "Capability" Brown. Intimate with their own land, personally involved with all that was grown there, they hated the idea of wrecking landscape for the sake of a trend. When she and the Dean considered redesigning the Delville garden, she mused about the natural contours of the land, and then decided "it would be a pity" to destroy them. "We had thoughts of having a bowling-green before our house in the garden front; but the hill, which descends gradually to the brook, looks so natural and pretty as it is, that it would be a pity to make it level: and so we determine to keep it a lawn, and to have sheep."[19] They scoffed at Lord Chief Justice Singleton, whose estate was halfway between Delville and Downpatrick. Singleton, "like a conceited connoisseur," was "doing *strange things*, building an absurd [outdoor] room, turning fine wild evergreens *out of the garden, cutting down* full grown elms and *planting twigs!* D.D. has no patience with him, and I shall be under some difficulty to-day to know *how* to commend *anything*."[20]

Everything that flowered stimulated Mrs. Delany's ideas, and she turned out to be a garden innovator, too, an early adopter of the ideas of staging we casually use today. She drew one of her designs – a way to display her auriculas – on a January day in 1746 and then sent it to her sister.

"We have a little odd nook of a garden, at the end of which is a very pretty summer-house, and in the corners of it are houses built up for blowing auriculas; it is upon the whole of a triangular form, long and narrow, much like this scratch." She drew a sketch and included this key: "AA, the blow-houses on pillars. B, the summer-house or temple. C, frame for nine-pins."[21]

When you stage a blooming plant, as she did, setting it against a backdrop, the blooming plant is almost like an actor beneath a proscenium arch. It's an easy leap from the plant to the painted image. The play of foreground and background creates a vista both in a garden and in a painting. But in life sometimes the smallest leap needs a hand. As her biggest fan, Patrick Delany's appreciation staged her, just as she staged her auriculas. She became his brilliant focus – and he became her vista, the expansive background that his generosity of spirit provided.

He also had a project in mind. He wanted to add a chapel to Delville, and his talented wife was the perfect person to supply the paintings for the chapel walls. For the most part, these paintings were copies of other works. She tackled a Madonna and Child after Guido Reni, as well as a Transfiguration. With these works she put to use all the information Hogarth had given her, all the lessons she'd had from Goupy, all the times she'd watched over the shoulder of her friend Letitia Bushe, and all she'd taken in from Rupert Barber (a painter the couple patronized by allowing him a little house on their land).

Aside from the paintings in the chapel, she copied portraits by Van Dyck, Lely, and Rubens and made some original portraits of her family, including her parents, aunt, and uncle. Most of this work has been lost, though the

indomitable cataloguer Lady Llanover made a list of it, fifty-nine "Pictures Painted by Mrs. Delany in Oils and Crayons."[22] Her original paintings were made to remember loved ones: *aides-memoire*. She certainly had no idea of creating them for public consumption.

Kim Sloan, Curator of British Drawings and Water-colours Before 1880 at the British Museum, gave me a cup of tea in her office, in a room off a room off a room off a room, deep in the museum's medulla oblongata. We huddled in her book-lined, wainscoted nook and the soft-voiced Sloan, her hair clipped back in a twist, found and served me a slice of ginger cake. In her book, *A Noble Art*, she explains the world of what we would call amateur artists.[23] The paintings and drawings that survive from her marriage would never have catapulted Mrs. Delany into the category of professional artist. There is a charm to the surviving original works, such as the portrait of her goddaughter, Sally Chapone, but also an amateurish, studentish quality. The drawings that survive, especially those in a notebook in the National Gallery of Ireland, have a whimsical assurance and zest. Drawing and painting in the years of her marriage were activities to be taken seriously, but they also fell into a category of personal interest, more than a hobby but less than a calling, something better to be engaged at even than music. "Painting has *fewer objections*, and generally *leads people into much better company*."[24]

Mrs. Delany painted in the course of the obligations of her days, which meant entertaining people, not so much by invitation as by looking up to find them dropping in (she was a cleric's wife, after all, and expected to receive his congregants). She ran a household with servants and conducted a social life with concerts and assemblies, traveling to events

at Dublin Castle; she shopped, she visited, she gave dinners to neighbors and dignitaries. Her friend Ann Donnellan came and stayed for long periods of time, as did her painting-pal Letitia Bushe. As her nieces and nephews grew up, they came and stayed. She became a substitute mother for Patrick Delany's niece. Her goddaughter, Sally Chapone, daughter of her childhood friend, moved in with them.

She painted in the context of planning meals, planning travel, planning her garden, and budgeting for her household bills, not to mention being interrupted by the sheer power of memory, as she was when catapulted back to moments in her life: "I saw in the newspapers that Lord Baltimore was ill: is he dead?" Her memory of Baltimore has the touch of a dried specimen. "*He had some good qualities,*" she mused; then she speculated about his children. "I suppose he suspects they are not his own," she said cattily. Yet in the very next sentence she described her stubborn insistence on getting the Madonna just right for the Dean's chapel. "The Madonna I have painted over twice."[25] Painting and repainting demonstrate a drive to revise, to get things right. "I have been very busy at my picture," she stubbornly insisted in November 1752, nearly two years later, "have painted twice over the upper figures in the Transfiguration."[26] It's not only copies in oils that she labored over for the chapel, but shellwork, too. "I am going on making shell flowers, six of the festoons are finished and fastened on; I have ten more to do, and a wreath to go round the window after the communion table."[27] Heavens, did she have to do *ten*? Unafraid of hard work – in fact, reveling in hard work as the substance of life – she tackled her tasks again and again.

Meanwhile the Dean wrote poetry and sermons and tried to take better care of his parishioners than his predecessors had. His wife, as she had all her adult life, beginning when she was married to Pendarves, continued to do large and small social and financial favors for people. If she loved the craft of an artful clockmaker or a glassmaker or a painter of enamels such as Barber, she tried to get the artist support. Part of this was simply her participation in the system of patronage. She was embedded in it, and she did what was expected of her – but actively, particularly in Ireland, where she felt helpless in the midst of the extreme poverty. Mrs. D. was not Mother Teresa, but she understood very well that the taking up of local social responsibility makes life better for both the giver and the receiver. In November 1745, she wrote about a celebration at Dublin Castle where suddenly people appeared wearing clothing made of Irish fabric, a trend that she herself led, and which gave business to the Irish weavers.

> On the Princess of Wales's birthday there appeared at Court a great number of Irish stuffs. Lady Chesterfield was dressed in one, and I had the *secret satisfaction* of knowing myself to have been the cause, but *dare not say so here*, but I say, "I am glad to find my Lady Chesterfield's example has had so good an influence." The poor weavers are starving, – all trade has met with a great check this year.[28]

Energy begat energy. She walked for miles, sometimes with a "shepherdess's crook," and sketched outdoors.[29] "In our walks this morning we were much amused in finding

a variety of fine caterpillars."[30] She read and was read to copiously. "D.D. reads to me whilst I work cross-stitch . . . and exerts his good-humoured cheerfulness."

"She's lucky she married Pendarves," artist Julie Hedrick told me. Honey-haired Julie is an abstract colorist whose paintings are the twenty-first-century Canadian opposite of Mary Delany's obsession with detail, huge canvases with great swaths of color and light that feel as big as the province of Ontario. At my suggestion, in November 2009 she went off to see the extraordinary display of Mrs. Delany's work at the Yale Center for British Art curated by Mark Laird and Alicia Weisberg-Roberts. I wondered if she would hate it, since it is so unlike her vast, contemporary works. But Julie was enthralled. "If she had first married someone she loved, she would have had children and that would have been the end of her." Yes, I thought, and if she had married John Wesley or her cousin Thomas, that might have been the end of her in another way. Mary herself posed this question to Anne in March 1751:

> Why must women be driven *to the necessity* of marrying? a state that should always be a matter of *choice!* and if a young woman has not fortune sufficient to maintain her in the station she has been bred to, what can she do, but marry? and to avoid living either very obscurely or running into debt, she accepts of a match with no other view than that of interest. Has not *this* made matrimony an irksome prison to many, and prevented its being that happy union of hearts where mutual choice and mutual obligation make it the most perfect state of friendship?[31]

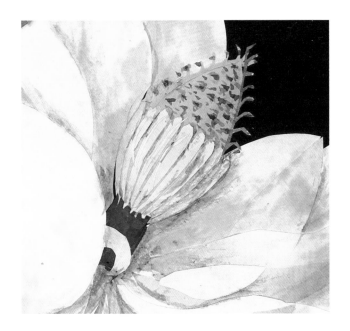

Magnolia grandiflora, detail

By her fifties Mrs. Delany knew the difference between these two kinds of matrimony. Julie Hedrick's speculation feels right from a twenty-first-century point of view. Mrs. Delany's first widowhood allowed her the independence to study as preparation for the artist she became; her second marriage trained her as a painter. The seriousness with which Patrick "hired" Mary for the chapel paintings and the gravity with which she took her job created between them the bond of the patron-enthusiast and the artist. Patrick wrote a postscript to Mary's letter to her sister on March 3, 1753, addressing himself to his sister-in-law.

My dear Sister – The Transfiguration is the sweetest picture I ever saw, and the figures the finest you will ever see till your transfiguration. God in his goodness bless and preserve you and yours!

P.D.

Anne, intent not only on keeping the letters but on annotating them for the future, wrote a note on this letter, which Lady Llanover records: "This is the Dean's writing; he means the picture my sister has just copied, which is from a capital picture of Raphael."[32]

Mary thought of her copies of religious paintings as having a distinct spiritual dimension. The subjects were religious but the process of painting was also devotional. On Ash Wednesday of 1753, she planned to fast, to pray – and *to paint*. However, she was interrupted, ironically, by the secular chat of the Bishop of Killala's wife (Ann Donnellan's sister). She and four other people plonked themselves down at Delville and stayed "till nearly four: I was quite harassed and out of humour."[33]

Painting and drawing were daytime work. Handiwork she undertook at night. "My candlelight work, is finishing a carpet in double-cross-stitch, on very coarse canvass, to go round my bed."[34] During these years she embarked on a frenzy of embroidery. Lady Llanover lists "a number of chairs" including "backs and seats . . . all executed in *worsted* chenille," "other sets of chairs," "bed hangings, and chair and sofa covers."[35] In marriage her embroidery continued, now not so much applied to dressing the body as to dressing up the house.

At about the same time that the Dean was building his chapel – and building his wife an outdoor kitchen, too – and

about the same time that Mrs. Delany began work on her "commission" to copy religious paintings for the chapel, something else began to seep into the atmosphere. The Tennisons, the family of the Dean's first wife, were claiming in court that the inheritance he had received at her death was due to them instead. Some of the very largess that allowed the Dean to contemplate building a chapel and a new kitchen had come from the financial ease he had achieved after inheriting from his first wife's estate. The millstone of the lawsuit would grind against the couple continually for ten long years – as every timber went up in his chapel, as almost every face materialized on her canvases, as almost every auricula blew in their garden, and as almost every fawn was born to their herd of deer (all of whom had pet names after their family and friends). As the chair covers were fitted to their seats, as the words of the Dean's essays were written, as the guests from the Lord Primate to the neighbors were entertained, as Mary's friends the Hamiltons joined Letitia Bushe and Ann Donnellan to read and gossip, as the carriages were packed for the journey from Dublin to Mount Panther, the low noise of the lawsuit droned on like a case of tinnitus. In 1750 Mary described Patrick's situation to her sister: "It is well my good Dean has his garden to relax and relieve his spirits, for now they are much turmoiled with his Tennison lawsuit; it is to come on next term, he prefers his cross bill in a few days."[36]

The Tennison suit hinged on a document that Delany was supposed to have kept track of but which was likely burned. An emissary was sent by the Delanys all the way to Jamaica to obtain evidence in his defense. "Should the man we sent to Jamaica return with any good intelligence from the person he was sent to, which we now hourly

expect, it will make everything easy."[37] Although some documentation was obtained, everything was not made easy, and the allegations went back and forth. Nine months later, prickly Bernard Granville heard about the suit and, always mindful of his family reputation, wrote to ask what was going on. From Mount Panther Mary confided in Anne, "I had a very easy, cheerful letter from my brother, wherein he desires to know *what* the lawsuit is about? I have informed him *as laconically as I possibly could!*"[38]

Though the suit pressured their finances, a stress on their reputation had joined it: allegations that the Dean wasn't spending an appropriate amount of time on his clerical responsibilities and implications that there were irregularities with the tithes brought in under his dean-ship. "He is most *extremely harassed* with his law-suits."[39] But the siege of his reputation got worse as he was accused by the Presbyterians – "those querulous people!" – of other religious irregularities, "a mistake committed on his side of a form at law." A sludge of rumors accreted, and Mrs. Delany herself began to feel responsible. "There is murmuring at his not living more at his deanery, and being absent so long from it when we go to England. This you may believe is vexatious to me, as it is *entirely* on my account he goes." Both public disputes, one civil, one religious, hit Delany where his wife would most suffer – in his reputation.

By 1752 Mrs. Delany methodically counted her bless-ings to bolster her defenses against it all.

I have indeed often thought of late my lot *most singularly happy*, more so than is generally met with in this world of woe: a husband of *infinite merit*, and deservedly most dear

to me; a sister whose delicate and uncommon friendship makes me the envy of all other sisters; a brother of worth and honour, and a friend in the Duchess of Portland not to be equalled, besides so many other friends, that altogether make up the sum of my happiness.[40]

Though the emissary to Jamaica confirmed "what the Dean says about the burnt paper" and found that "the original draft" existed, it turned out that the possessor of the original was dead – and the whereabouts of his papers unknown.[41] Complications proliferated like an infestation of bugs. The case went on; the court recessed. "Yesterday the Tennisons moved for judgement," Mrs. Delany reported in early November 1752. "My Lord Chancellor said, '*Don't be in a hurry; you shall have time enough to make what motion you* please.' I believe the decree will not be given this Term."[42] At the end of the year she added, "As to loss of fortune, I trust we can *very well bear it*, and should they take *all* that came from Mrs. Tennison, we shall *still* have more left."[43] But two years later the Tennisons balked at compromising, and the Delanys had to decamp to England to continue their suit.

Both Anne Dewes and the Duchess urged the Delanys to try to settle. "I have had a most friendly letter from the Duchess of Portland pressing me with great earnestness and delicacy to comply with a compromise, as does my dear sister." But Mrs. Delany and the Dean were adamant. They would not relent in the suit unless his reputation was cleared. "I am sure you would not for any *worldly* consideration have D.D. *submit to anything* that should in the least degree confirm the odium his adversaries would load him with."[44]

It took four more years for the case to be settled, years in which Mrs. Delany suffered from headaches, for which the remedy was being bled (a "cure" that prevented her from joining the Dean in Downpatrick), and a creeping depression. At Christmastime in 1752 she attended rehearsals of Handel's *Messiah* in Dublin, but she was initially reluctant to go, apprehensive of being overwhelmed. "I was a little afraid of it, as I think the music *very affecting*, and I found it so — but am glad I went, as I felt great comfort from it."[45] Handel had gone blind. His loss of sight reminded her of Milton's line "Total eclipse! no sun, no moon!" in Handel's *Samson Oratorio.* "Poor Handel! how feelingly must he recollect the '*total eclipse.*'"[46] By 1753 she despaired of relief "for I feel my spirits harassed, and at times more heavy and gloomy than *ever I knew them.*"[47]

Her painting counterpointed her gloom. In the same letter she says, "I have painted close this week. Our Saviour's figure is quite finished, and the sky about him, and Elias's head." Painting was a poultice, a remedy, a light. Mrs. Delany painted, and repainted. The energy poured into it was her treadmill, her rowing machine, her Prozac.

She submerged the lawsuit into her life. She embarked on vast reading projects: poring through the letters of Madame de Maintenon, in English translation, comparing them to the output of the prolific seventeenth-century correspondent Madame de Sevigné, whose letters she read "in the *French language.*"[48] She finished the third volume of Samuel Richardson's *Sir Charles Grandison*, declaring, "What a soul that Richardson has!"[49] A month later, she remained preoccupied with *Grandison*: "Had a woman written the story, she would have thought the *daughters of as much consequence as the sons,* and when I see Mr. Richardson,

I shall call him to an account for that *faux pas*."[50] She supervised the cooking, served up splendid meals, worried over her neighbors, and learned a "recipe for the headache" from the Duchess, which she passed on to Anne: "eat every morning as soon as you wake a bit of stale bread about the size of a walnut."[51]

The lawsuit ground on, forcing them to cancel visits to England and to make unexpected visits to England as well. In 1754, the Dean had what appears to be a minor stroke. One January night he "complained of a weakness and watering in his left eye. . . . When I met him at breakfast, his left eyelid was much fallen, and his mouth drawn a little awry . . . his voice not quite so clear, which he took notice of it himself; and on looking in the glass saw what indeed had terrified me. . . . He was cupped on Sunday night. . . . It is undoubtedly an attack of the palsy, but everybody assures me it was *as slight* as such an attack can be."[52]

In 1756 both Mary's and Patrick's health was so low that they ventured to take the waters at Bath. She wrote from the spa in chilly November that "the Dean is rather better this evening," but she continued weakly that "I fear I must stay now much longer, as I can only drink the waters very cautiously. . . . I have promised not to write much."[53] Although she eventually felt repaired, the Dean's health would need continual scrutiny and care. By December of that year, back in London, she had little energy left for others. Her depletion led to exasperation with her old friend Ann Donnellan's demands. Donnellan had been involved in family disputes about her own inheritance, fighting with her sister and bringing her troubles to Mary. "When a long train of friendly offices and attention to the *utmost of one's power* has been offered, and the sacrifice not accepted, it is then time

to *grow selfish* and do only what is quite convenient and agreeable to one's self."[54] By 1758 she had sacrificed friendship and her health, and the Dean had almost sacrificed his life for their position in society.

Fearful of the outcome of the lawsuit,[55] the Dean went so far as to buy his wife a house of her own for her security. This moment has the feel of the strange surface of Mrs. D.'s *Magnolia grandiflora*, the paste leached through into the petals, as the lawsuit leached through into everything. The lawsuit and its midnight background. And yet, of course, there is the pink growing tip of the next bud. In Mrs. D.'s mosaicks there is always the next bud.

Finally a settlement was reached. Writing from the house the Dean had bought for her, Mary announced the details:

> We have certainly all the reason in the world to be satisfied with the decree as it now stands, for it seems most equitable, and D.D. is now as if no marriage-settlement had been made; as our opponents could make out *no claim*, (as interested in the deed that was burned).[56]

The Tennisons relinquished a "£4000 mortgage which D.D. has possession of" and split with Delany "half Stephen's Green lease, which is fifty pounds a year," as well as an additional "£1700." The settlement, which favored Delany, "occasioned much talk, as you may believe." What was lost was largely restored – except for the Dean's health, and, to a certain degree, Mary's placidity. "I was not born to be a philosopher," she declared. "Nature has not thrown in enough of indifference in my composition, nor has art attained it; in short, I *like*, and *love*, and *dislike* with *all my might*, and the pain it sometimes costs me is recompensed

by the pleasure."[57] Unabashed as her *Grandiflora*, she exerted her passions. She loved and hated with all her might and found the end of the lawsuit and the labor of having persevered deliciously satisfying.

Mrs. Delany composed her *Magnolia grandiflora* at Bill Hill, the graceful blue-brick early-Georgian house of her friend the Dowager Countess Gower, nee Mary Tufton.[58] (It is still a private residence and now a stud farm.) The magnolia tree had probably cost her friend a small fortune. In her ink-heavy handwriting that – compared to Mrs. D.'s swirly script – was clotted and thick as twigs, the Countess recorded the progress of her exotic, ecstatic magnolia and her battles with her "mule" of a gardener as to what was best for its colossal flowers. In the 1750s, seedlings for the *Magnolia grandiflora* were sold for the steep price of two pounds, two shillings.[59] Compare this to a maple seed, another tree that had to be harvested from North America, nestled into a wooden box, buffeted in that box in a merchant ship across the Atlantic Ocean, and preserved by British nurserymen for sale to botanical collectors like the Countess. That maple seed would have cost a mere shilling, whereas two pounds, two shillings might have been a whole year's salary for a laundry maid. By the end of the century, magnolia trees were selling for a more reasonable fifteen shillings; the Countess likely paid something in between.

Mrs. Delany cut some of the biggest petal pieces of her oeuvre for the *Magnolia grandiflora*. After, or as, she scissored around the luscious thin white petals, she dipped a brush into gray watercolor to paint in shadows and details. When you pore through the collage, you notice the gray – like detecting gray strands in a head of blondish brown

hair. By the early 1760s Mrs. Delany's hair was probably quite gray. Her marriage, now of two decades, had been deeply contented – though half of it had been haunted by the courts.

The Countess, about the same age as Mrs. Delany, considered her magnolia tree a personal associate, the connection between the body of a tree and the human body intimate and material. Not only was her tree human, it was female – mostly. Though she referred to it as "*Mother Magnolia,*" occasionally she called it "he."[60] There's a vigor about this flower with its "lemon and wax" scent that almost makes it both sexes at once.[61] The Countess was truly disappointed that the shiny-leaved beauty with her colossal saucer-like flowers didn't have ears to hear. Three years before the making of the *Magnolia grandiflora* mosaick, she wrote to Mary from Bill Hill that she couldn't "help feeling sorry the magnolia must remain insensible of all the fine things you say of it; 'tis *but a vegetable*, yet one may say of it what one can't say of many things, [that] in its way *'tis all perfection.*"[62] As they watched themselves age, as their skin surprised them with its crepiness – and just think of the floppy body of the eighteenth-century matron sculpted by stays – to be drawn to the image of robustness inserted a perfection into their lives that they would never see in their own physical selves again.

At home in Toronto I pored through Ruth Hayden's book, leaping from the words to the collages, trying to let my own eye be my guide, yet also having to rely on Hayden to verify what I was seeing. It was the collages that drew me.

The gowns and aristocratic goings-on seemed like wallpaper compared to the flowers. The fact that the artist accomplished them in great age intrigued me, but when I realized that she'd had a thriving mid-life marriage, I began responding to her life as well. She had no children. I had no children. She had a deep connection to a second husband. I had such a bond. In her marriage she had begun all sorts of artistic projects that her husband encouraged. In my marriage I had not only continued writing poetry but had started writing prose – a memoir and essays – as well as writing and performing a one-woman show. She had a plethora of arty girlfriends. So do I. When it finally sank in that mourning was the prompt for the great flowers, I felt a hook slip into my own unconscious. Her husband had died. I was afraid mine would.

I had let go of my life alone. I had tumbled down ravines of love and involvement, now so separated from my determined, ambitious, solitary young woman's marching forward that I could never go back to it. Not only was I separated from my youth and the self I recognized, but this separation was vivified daily by the fact that I lived in two countries. Mrs. Delany lived in two countries, exhausting herself traveling back and forth between them and dragging her husband back and forth with her. I knew exactly why she felt she had to do it. Exile, even voluntary, is horrible. At first, the fact that she was born into an entirely different class and in an entirely different century meant little to me. She was an artist. I was an artist, in the sense that a poet is an imaginary painter.

As a poet I was always connecting back through centuries to words. Because poetry exists against time, I can read with indiscriminate gusto poets of all countries and

centuries. Love and death, the great subjects of the lyric poem, manifest in all places and times. Love, James Joyce says in *Ulysses*, is the "word known to all men." And women, I might add. James Joyce, that swaggering modernist, was dragging my husband to Dublin again, and I was going with him to celebrate Bloomsday, June 16 – the day when tourists walk in Leopold Bloom's footsteps.

Why not walk in Mrs. Delany's footsteps, too? Mike and I tromped the southern edge of St. Stephen's Green searching for Bishop Clayton's mansion, where the thirty-year-old widow Mrs. Pendarves stayed on her first visit to Ireland. I was shocked to find it, substantial, with its pillars of stone so anchored that the Irish government felt it still solid enough to govern from. But what shocked me more than finding it was its demonstration of the substantial difference in our wealth. It was the first three-dimensional evidence that she had existed, and the reality of her aristocratic life was so palpable that it stopped me dead in my tracks. How could I have been comparing my life to hers? Mrs. Delany consorted with royalty, with kings and queens, and the mansion she visited was so different from the ephemeral house my grandfather had built all by himself – and quickly, with no foundation, just a dirt crawl space underneath – that to link myself with her felt ludicrous.

Yet the house of my grandfather, who was descended from Northern Irish people like those farmers to whom the Dean of Down and his wife, Mrs. Delany, ministered, charmed the landscape. It was set in an orchard. It was neat and trim as a cottage. Attached to the side of the house and out to the road was a general store and gas station, adorned by gas pumps with round glass heads like the figures of ghosts children are taught to draw at

Hallowe'en. Geraniums at the frosty windowsills bloomed in January. And the view of the rolling landscape of the fruit and wine country west of the Finger Lakes in upstate New York was worthy of the photo shoot that *Gourmet* magazine had featured on the happiness of the upstate weekend. I was shocked when I saw the layout. The photographer must have positioned the camera in places I'd stood to take my own snapshots.

One night in Dublin we met up with Gerry O'Flaherty, a tall, tweed-jacketed Joycean with an encyclopedic knowledge of the city. "Don't take another picture of people!" He held up his hand, stopping me from taking a redundant shot of a group of Joyceans. "Photograph the dishes on this table! It's pictures of people's everyday lives we need!" O'Flaherty remembered the buildings from Joyce's day, which still had stood in his boyhood but which were being destroyed by renewal projects or ravaged by renovation.

"Molly is looking for Delville," my husband told him.

"You missed it," he said with a grim glee. "Torn down." But O'Flaherty urged me to take the city bus out to Glasnevin, the suburb where Delville had been located, anyway.

The spot must have some sort of garden karma: the Dublin Botanic Gardens abut the old Delville grounds. It was an unusually hot, dry day when I wandered out there, walking past Jerusalem artichokes that were taller than I was, trying to get – what? A feel for a marriage, for a companionship that flourished in layers, like the fruit and vegetable mosaicks Mrs. D. also included in the *Flora Delanica*. She concocted collages of a number of edible plants, famously an eggplant that actually demonstrates its name, featuring the white, egg-shaped start of the vegetable before it elongates at one end and becomes bulbous at the

other, and before it darkens into purple. O'Flaherty was right. A dull photograph of Delville in the 1940s exists, as well as Mrs. Delany's sketches of the gardens. Photos of the plasterwork in the ceilings survive. But the lived life of dirty dishes on the table we have to imagine.[63]

Under fabulously different circumstances from a minor aristocrat's second marriage and happiness dipping into her garden at Delville, my own second marriage and happiness dipping into a garden at a little house in London, Ontario, called Villanelle slips and slides as a ghost silhouette. Even as a middle-class woman in the early twenty-first century, I recognized in Mrs. D.'s letters a similar and peculiar mix of push-pull between two countries and job and family obligations. When we lived in London, Ontario, I had a nagging garden (and a reproachful yellow wheelbarrow). The machinations I had to perform to keep a garden going where my husband worked, five hundred miles away from New York City, where I often worked, even included a version of Mrs. D.'s "skilful gardener," my friend's son Bill, as well as Dave's Lawn and Garden Service. The push and pull of house-and-garden guilt involved the same arrivals and departures as the Delanys' over the ten years I felt compelled to maintain a garden, before I gave it up for an eighty-square-foot-balcony green aerie in Toronto. Somehow I had imagined that if my life were retro-ed back into eighteenth-century Ireland, I would rematerialize in a pastoral paradise where time would stretch out in a perennial childhood summer. But Mrs. D.'s life pointed in the same hurried, over-full direction as my own.

In some ways the Delanys had it all too easy with their garden. "Just the kind of gardening I love to do," quipped

my friend Ann McColl Lindsay in the shade of her Victorian house in London, Ontario, beyond which is a fantasy of arched roses in a garden built with back-breaking labor. "Sit in a chair with a martini while you tell the help which plant to move and call that gardening!" In some ways it's more possible to traverse the hundreds of years with botany than to traverse the chasm of class. My friend and I both feel that our families would have been "the help." But we identify with Mrs. D.'s green-obsessed imagination, and Ann Lindsay has anchored herself in a huge, beautiful historic house far from the cramped post-war quarters in Glasgow she came from.

But artifacts let us leap centuries. Artwork to artwork, hand to hand, time falls away in the presence of the marvelous.

Behind LaGrange Garage and General Store, my grandmother Ruth McMann Wright planted a faeryland of perennials after my grandfather, Gilbert, made the plan. To the north side of the store lay an acre that had been an old orchard, and Gillie had cut down many of the old apple trees, leaving the most gnarled and picturesque ones. Then he dug several not particularly shapely rectangular perennial beds, the way they do in upstate New York. But the environment of the orchard made the oblong beds just fine (and easy to mow around). My grandmother planted and supervised this country garden, full of all the standards from crocuses to chrysanthemums. Most summer nights my grandparents, whose lively lifelong marriage was a model to me, toured their acre and a half. In the preadolescent summers when I visited them for extended periods of time, I did the tour, too. My grandmother said the name of each flower and I

repeated it, till I had them all memorized. I spent my time memorizing Bible verses by day (she sent me to Vacation Bible School) and flower names by evening. Now, in a book, I had met another Ruth who was listing the pages of genus and species names of flowers that her ancestor, married to quite a Bible-quoter himself, had written on her works of art.

It was my mother (who wouldn't have darkened the door of a church if you'd paid her) who taught me to grow things. In the style of her father, she dug out a rectangular bed at the back of our suburban house, said it was mine, and handed me several packets of seeds. I was ten when I grew a huge load of *Celosia argentea* (Plumed Cockscomb) and harvested a mess of them, dragging them to school for an art class still-life set-up, shedding leaves and bending flowerheads on the way. In the school cafeteria our teacher taught us to crayon on paper with bright colors, then to cover all the color up with another layer of black crayon. Then we could grip the edge of a pair of blunt-nosed scissors and scrape a drawing through the waxy black to show the color underneath. "You care about things you make, and that makes it easier to care about things that other people make," Louis Menand has written about craft.[64] The caring crosses chasms of adulthood, class, and time.

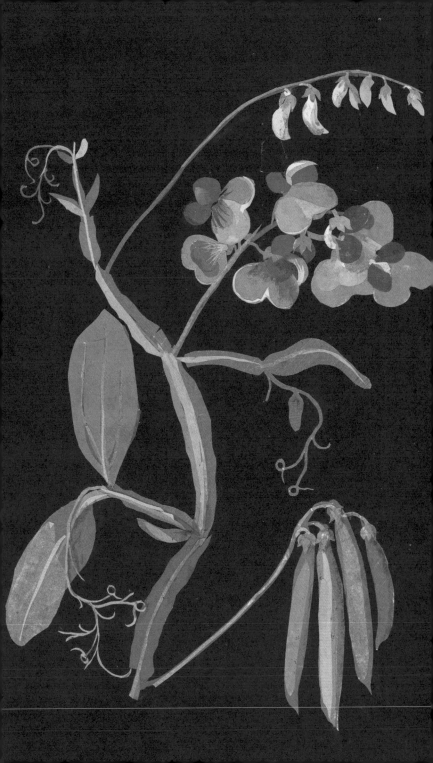

Chapter Ten.

EVERLASTING PEA

Lathyrus latifolius, Broad-leav'd Everlasting Pea, is a collage with a secret. Made at Bulstrode in the last year of Mrs. Delany's great work, it discloses a clue to her process. Almost at the center of the collage she pasted a vine tendril in the exact shape of a pair of scissors, positioned upside down to us, but in the place they might take if they were held in the artist's hand. To the left, above her caption, is a more fragile tendril from what appears to be a dead part of the vine, also in the shape of a pair of scissors. Inside a portrait of a common plant (one that grows wild by the roadside in Canada), Mrs. Delany took the idea of an everlasting thread-like vine, both alive and dead, and made known her method of making her mosaicks.

As Mrs. Delany's eyesight diminished, her work became bolder and closer to that of twentieth-century collage artists such as Henri Matisse. A close-up detail of the pea blossom has a lush abstraction to it, the type of abstraction that, like Matisse's, comes from the experienced hand under constraint. Matisse made his cut-outs in late life, too, in his last four years in fact, sitting in his wheelchair, arthritis having crippled his hands too severely to hold his brushes.[1] As the light was dimming for Mrs. Delany, the blossoms sometimes

Lathyrus latifolius, Broad-leav'd Everlasting Pea, Bulstrode, August 22, 1781

became more profuse. This is one of her most fertile collages, with nine blossoms on the main plant. Combining the pinks with startling abstract red circles of color, she gives an impression of a flower unprepossessing but full of vectors of energy, as the whole twenty-five years of her married life were. Her Great Middle Period, busy with new enterprises like gardening and oil painting as well as the role of wife of a distinguished clergyman, was not everlasting, of course, but it did exist in a kind of heaven for her. "Monday a rage of painting seized me. I took up my pencils and sat down to my picture (at 7 in the morning),"[2] she exclaimed to Anne in April 1760, less than one month before her sixtieth birthday. She thought of herself as old then, though now we know she was just at the end of the second third of her life. There she was, embarked on an adventure of supported creativity she had never anticipated, and much of it was centered around Delville, the house she shared with her husband.

It was a house her sister, her closest confidante and her best friend, never saw.

After their marriages Mary and Anne were separated so completely that, by September 1745, Mary remarked in awe of the chasm that separated them, "Is it not strange, my dear sister, that you and I should dwell in houses that *neither of us have seen* – that I should be *unacquainted* with *your home* and *you with mine?*"[3] As soon as Mary had arrived at Delville the year before, she'd created a guest room for Anne, and she called it the English Room and painted it not crimson, as she had her own room, but olive.[4] The two rooms mirrored the palette of colors Mary would establish for her mosaicks: the calm olives, lodens, blue-greens, browns, and grays of her stems and leaves;

234

and the bright reds, purples, yellows, pinks, and whites of her flowers. The English Room was a kind of room of the mind, standing in preparation for a visitor who was always about to appear. As Mary periodically described it to Anne in her heartfelt invitations over the years, it became like a picture of a room in a contemporary architecture magazine, poufed for a photograph, set, inviting, pre-inhabited. Eventually the chamber, with its Zen-like calm, was used by others, by Letitia Bushe, Ann Donnellan, and Mrs. Hamilton. Her friends slipped in and out, ghostly sister-substitutes, for the better part of two decades.

Part of the reason for Anne's failure to visit was that she and John Dewes had four children in four years: Court (b. 1742), Bernard (called Bunny or Banny, b. 1743), John (b. 1744), and Mary (Mrs. D.'s namesake, b. 1746). From the minute her nephews and niece were born, Anne's childless older sister felt absolutely free to give advice on child-rearing, which (even as an increasingly experienced mother) Anne graciously received. Mary was full of remedies for childhood maladies and opinions on children's education, and what children should be allowed to say and do and wear. Aside from frailer health and greater family commitments, Anne did not muster her energies for the sea-going trip because her intrepid older sister traveled to England every three years. Mary eventually visited Wellesbourne, Anne's house, many times. But no matter how often she invited Anne, her sister never crossed the Irish Sea – even during Patrick Delany's legal and professional crises. By 1752 Mary was begging her.

> Could you not, my most dear sister, come to me conveniently this year? it would lessen my difficulties greatly, but

I know till you have settled your boys you would not care to undertake the journey; and if, as indeed I now hope, we can visit England this year, the next I flatter myself with the charming hope of bringing you, Mr. Dewes, and our dear girl back with me.[5]

In the twenty-five years of her voluntary Irish exile, Mary saw her sister for perhaps eight or nine extended visits, one of which was when their mother died in 1747. For Mary, settled with the Dean and having long before experienced the death of her Aunt Stanley, the period of mourning for Mrs. Granville was less fraught. But Anne lost the person she had modeled her life on. The woman who had loomed over Mary as a shrieking hysteric, whom her father had had to shut up and calm down, was for Anne, the spinner and homebody, the widow who clung to her younger daughter, yet who let her go at the age of thirty-three into a married life. Motherhood was Anne's calling, and if it hadn't been, I wouldn't be telling this story. Anne was the mother of the woman who was the mother of the woman who collected her Great-Aunt Delany's letters and shepherded her flower mosaicks to the British Museum. Not to mention Anne's later direct descendant Ruth Hayden, who wrote the book that hoodwinked me into seizing this potent role model.

One of the strange advantages of Mary's not seeing Anne, yet being so close to her and so confident of being read accurately by her, is that Mary internalized Anne's listening ear. Her letters grew to be part diary (and part blog). But Anne took advantage of her distance as well. It allowed her the time to process all that Mary told her, and it gave her time to compose her own wise personality.

Mary was looking for a friend and a sister's good sense, but what she got, because of the physical absence, was an eighteenth-century version of a twentieth-century psychoanalytic experience. What benefited Mary Delany, artist, was a physical embodiment – in iron gall ink on paper – of episodes of her life. In a way, Mary's letters to Anne are a paper mosaick of days and weeks, hundreds into the thousands of sentences cut in organic shapes to form the art of living.

An actual specimen of a *Lathyrus latifolius* flower is shaped a bit like a paper airplane. It has aeronautical names for its different petals: under the standard petal (the one shaped like a headdress) sits the "keel" petal, and to the sides of the keel petal are two "wing" petals. John Keats (1795–1821), born fourteen years after Mrs. D. cut out her *Everlasting Pea*, wrote about the quality in a sweet pea that seems to be standing "on tip-toe for a flight," like a letter about to be posted, in "I Stood Tip-Toe upon a Little Hill":

> Here are sweet peas, on tip-toe for a flight:
> With wings of gentle flush o'er delicate white,
> And taper fingers catching at all things,
> To bind them all about with tiny rings.[6]

For Keats, the vines were "taper fingers"; Mrs. Delany slipped her own fingers into the "tiny rings" of the vines and designed them as scissors. Even though the flowers and buds are more abstracted in her collage, Mrs. Delany probably dissected the plant to get her sense of how the flowering vine was put together. If you dissect the pea blossom, it looks like this:[7]

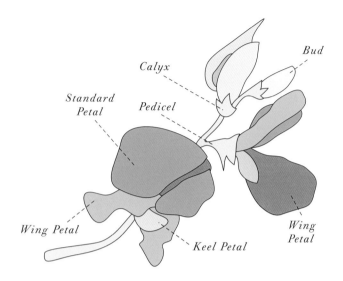

Cross-section of a Pea Blossom

But Mrs. D.'s *Everlasting Pea* also focuses on the pea vine itself. There is a hinged quality to it; the vine comes in long, almost rectangular links (there are five in the main stem of the plant in the collage), and these links have joints like little elbows or wrists. A sturdy, multiple-hinged plant, it's willing to scramble anywhere – up a hillside, down a ditch, over a lattice, around a pole. The *Everlasting Pea* bears four pea pods, just as there were four siblings in Mary's family and four children born to Anne. "What a pleasure it is to see the growing friendship of your children!" Mary wrote from Mount Panther in the summer of 1752. Yet, as she thought of her niece and nephews playing together, she was struck with a bitter wistfulness. "And yet, my dear sister, it is laying in a store of woe; for if they partake of each other's joys they must also feel each other's

sorrows, and the lot of sorrow in this world is generally a larger check than that of joy." A streak of sadness seized her. "And yet for all my experience, which is now of a very long standing, I cannot relinquish the least part of your love, nor you of mine; – it is *wove* with our *thread of life*, and it must last as long."[8] That scrambling vine, with its determined tendrils, does not relinquish its intertwining.

Both of the sisters hung on to one another. In fact they found their adult leave-takings so painful that they chose never to say an actual goodbye. Each one left the other early in the morning, before breakfast, as Mary did when she snuck away from her first visit to the newlywed Anne, who woke in shock to find her gone.

> You was so cruel, my dear Penny, as not to let me hear one of your dear steps this morning, for which I listened most attentively, but since you denied me that pleasing pain I composed my spirits, went to sleep and took a nap, rose with heavy steps, and came to the deserted parlour and solitary breakfast, which I swallowed like a pill, as fast as I could, then took up a Guardian, then the Bible, then rummaged upstairs, opened and shut your drawers a hundred times, because they *had been yours*.[9]

Fifteen years later Anne snuck quietly away from Mary's house in London in the early morning to go home. That day Mary wrote, "I knew you meant to *steal kindly away. . . .* I arose at half an hour after seven and prepared my colours [pigment for painting] – they all looked dull. It was well my business was only to dead colour; it suited my somber thoughts." But when she received a note from Anne later that day, she was full of

energy to paint. "I ran up to my picture at ten, D.D. followed me and read a manuscript."[10]

The sisters shared every aspect of their everyday lives, from cooking to servants to home medicine. They suffered each other's reversals of fortunes, too. When Mary and Patrick went to England during their legal crisis, Anne and John Dewes came to London and stayed three months. When John Dewes lost a great deal of money, the Delanys did what they could to help. By the time the sisters reached their fifties, it is hard to say who was the lattice and who the vine. By March 1756, Mary's niece Mary Dewes, age nine, was old enough to come for an extended stay with the Delanys in London. Mrs. D. easily took on this child, knowing also that she was taking on an expense for her sister when the Dewes household was in financial straits, and knowing something else, too: Anne's health had begun to fail. "The girl is neither trouble nor confinement to me, but a great delight to D.D. and me."[11]

That month, while her daughter was attending what her Aunt Delany called her "*school in Spring Gardens,*"[12] Anne quietly wrote a will. Until the Married Women's Property Acts of 1870 and 1882, the only way a woman could keep her fortune was to be widowed (or, if single, as Ann Donnellan was, to have a dowry assigned to her by her father).[13] Anne's will involved only personal objects of property.

Welsbourn, 23rd March, 1756.

I desire my daughter, Mary Dewes, may have all that is in this drawer, and in the middle part of the escrutoire that is over it, and the little cabinet that is there, and all that is in it; and besides, my watch, chain, and seals that Mr. Dewes gave me, and all my rings, earrings, necklaces, boxes, little pictures

Anne Granville Dewes

that are in my Japan cabinet, and shells that are there, and all my clothes, linen, and work, &c. that are not otherwise disposed of; only if she should have another picture or more of her Aunt Delany *besides* that of mine enamelled by Zincke and that in water-colours, she will give them her brothers – first Court, then Bunny and Jackey, that they may each of them have a picture of their dear and good Aunt Delany.

The ruby ring she must have, as mentioned in a paper by itself. What of my French books she chooses, and my English books with "*Anne Granville's*" name in them divided between her and her brothers as they shall agree, and I hope they will never disagree about things of more consequence.

The old china cup with the gilt cover and saucer, that has a setting in gold belonging to it, Mary must have, and give it to *her daughter* if she has one, if not to one of her

brother's *daughters*, as it has gone from *daughter* to *daughter* these *three hundred years.*[14]

As she composed this moving document, her sister was writing to supply information about that very daughter who was to inherit the old china cup. "Mary is now practicing the clavichord, which I have got in the dining-room that I may hear her practise at my leisure moments. She reads an hour every evening to the Dean, and then they play two games at cribbage."[15] As an aunt and uncle, Mary and Patrick were warm and generous, but Aunt Delany had a bit of Aunt Stanley in her when it came to compliments. "The Duchess of Portland has just drank tea with Mary and me," she told her sister; "the girl looked in *great beauty,* and the Duchess thinks her *very pretty,* but this you may be sure she did not say before her face."

When Anne felt better, she put away her will. She read her books, kept the china cup on its shelf, and proceeded to eat four more years of meals with her husband, daughter, and sons at Wellesbourne – and to write four more years of letters to her best friend and big sister, who dispensed advice about her niece, right down to her cough remedy. "Does Mary cough in the night? two or three snails boiled in her barley-water, or tea-water, or whatever she drinks, might be of great service to her; taken in time they have done *wonderful cures.*"[16] As soon as Mary Dewes was old enough, she, too, started corresponding with her Aunt Delany – who corrected her niece's handwriting and tried to improve her study skills. "I think your last [letter] was tolerably written considering you have not practiced much without lines; your f's do *not stick out their elbows quite so much,* and in time will have a *free and easy air!* . . . I wish you

good success with *your spinning*; you have undertaken a large work. I shall be very glad to receive any of your French performances; and if you write or translate but six lines every day it will improve you very much."[17] Handwriting represented a person; it was tantamount to clothing. One sharpened one's quills, dipped them in iron gall ink, and set forth as if stepping out of the house onto the street, or even only into the garden, where in the summer of 1760 Mary saw two albino robins and told her sister a prophetic story.

"I must tell you of an extraordinary curiosity at Delville; two young robins *as white as snow* were taken in the garden." The Delanys, or members of their household, captured and caged the white birds and must have hung the cage outdoors in proximity to the mother robin, "a common robin red-breast, [who] fed them in the cage

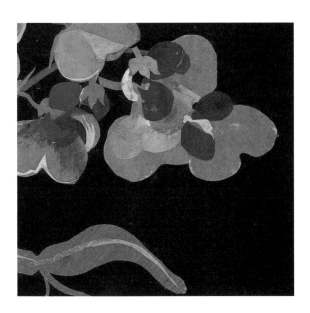

243

Lathyrus latifolius, detail

every day!" Of the two robin siblings, one became weak and began to fail. The other one thrived. "One is dead, the other alive and well . . ."[18]

By October of 1760, the Delanys, with goddaughter Sally Chapone and their servant Smith, had arrived at Bath for the healing waters. The Dean, by now about seventy-five years old and palsied, might have been picked up by a sedan chair from their lodgings and carried by two men to the baths, which were (and are) located adjacent to the Abbey Church. The waters were taken from pumps in buildings erected over the ruins of Roman baths that had been constructed directly over the healing hot springs.

On the Sunday morning after King George II died, at whose coronation years ago Mrs. D. had had her cape torn off in the crush, she woke in her bed at Bath "with the news of the King's death!" That day they "attempted the pump room – *so crowded no admittance*."[19] Had she and presumably the Dean been admitted, they would have stood by an urn, filled their cups with water from the springs, and imbibed. They might have had a meal there. With her husband's health, the old King's death, and a new King's reign on her mind, a few days later she knelt in a pew at the Abbey Church near the baths, where she found herself praying "most fervently for the recovery of my dearest sister's health."[20] By now she was compelled to transfer some of her trust to her niece, because it was Mary Dewes who wrote to her about her mother's condition and to whom Mrs. D. confessed her anxiety over Anne's "*several* attacks of . . . giddiness."[21]

Leaving her husband to continue "his course of drinking the waters" under the watchful Smith, Mrs. Delany took Sally and left Bath to visit her cousin Thomas at

Longleat, where a famous landscaper had tackled the grounds, now "*all modernized* by the ingenious and much sought after *Mr. Brown* [Lancelot "Capability" Brown]."[22] It may have been during this time that Mrs. Delany, full of energy herself, cut the silhouettes of her cousin's children. Yet in days she was back at Bath, writing an anxious letter. She had consulted Mr. Henshaw, an expert, about Anne's condition. He was "*convinced your giddiness was a bilious disorder; that he was confirmed in that opinion by the bark and the valerian not agreeing with you.*"[23] Bark tea and valerian must have made Anne vomit. Not only was she throwing up these strong, assaultive homemade potions, but the doctor was holding a scalpel, much like the scalpel Mrs. Delany might have used for her collage of the *Everlasting Pea*, to the inside of Anne's pale, fifty-three-year-old arm. She was bled but "had a giddy fit or two after it."[24]

Mrs. Delany and the Dean meanwhile traveled from Bath to Bulstrode, still accompanied by Sally Chapone and Smith. They must have visited Wellesbourne on the way, because Mary reported that D.D. was "better than he was" there,[25] though now he had contracted a cold and a sore throat. In counterpoint to her husband's illness and Anne's wretched state, Bulstrode spun with scientific and artistic activity. At this time Mary and her friend the Duchess embarked on a design for a shell grotto there. "The great cave is begun, and will be, I hope, when finished, very handsome. . . . I am making some shell-work . . . visiting the cave every day."[26] As they sorted shells for their grand design, Mrs. D. learned that Ann Donnellan was ill as well, and she was full of practical advice for her sister, recommending Henshaw, and Dr. Oliver, a famous physician at Bath. She volunteered to meet her sister at Bristol should

she be sent there for the waters, "provided D.D. is well enough for me to leave him!"[27] The more intense her concern for her sister became, the more energy she poured into her shells, and the Duchess began to substitute for Anne's listening ear. "Our works go on here very well; I am glad to be so much employed, as it *hides a little what my heart is so full of;* . . . [the Duchess] indulges me every day by talking of you . . . but what you suffer at present, that *dwells on my mind.*"[28] After Mary, with a helpless fervor, wished Anne a happy new year on January 2, 1761, the letters broke off.

Anne Dewes lived for another six months at Bristol (about a dozen miles from Bath), with her sister and the Dean in attendance. Yet, although Mrs. D. must have spent much time with Anne in these six months, she was not present when Anne died, shortly after one o'clock in the early morning of July 6, 1761, not quite fifty-five years old, almost an exact year after she received the letter with the story of the white robins. Just after midnight, Anne drank a cup of pennyroyal tea (an emetic), and then her speech began to falter. Anne did not call out for her sister, keeping their pattern of parting, leaving silently before the other could notice, avoiding the scene of saying goodbye.

As many of Mrs. Delany's letters survive from after the death of Anne Dewes as from during her lifetime, but none of them match the joie de vivre of the letters to her sister. A bleakness set in after Anne's death, mitigated by the fact that her daughter Mary wrote lively letters, following her father's advice to "endeavour to follow [your mother's] bright example."[29] In turn, she received from her aunt advisory "sermons," as she called them. But the full-pillowed intimacy of what had been four decades of

letters was never the same. Neverlasting Pea. There are many nevers in a long life, but Anne's death pierced her surviving sister, who did not have a chance to mourn purely, since as soon as Anne died, the health of the Dean demanded her attention.

Mary Delany entered into seven years of caring for her husband as he slipped away, then rallied, slipped, then rallied. By 1765 the Dean had "such frequent returns of his disorder that he can hardly bear going out at all." She fretted about his "*constant pain*," which, "though slight, is *very dispiriting*."[30] He gave up going to Downpatrick, and Mary gave up a trip to England to visit her family and friends. He is "unable to bear so long a journey without great inconvenience. The same painful reason puts a stop to an English journey this year." Mrs. Delany did what any well spouse of a sick husband does regarding time and plans. "I *dare look no farther!*"[31] The daring not to look, in her case, though, is literal. She developed eye trouble and could not take respite in painting as she had when her sister was ill. "I am *afraid* to begin with painting; there is a time for all things, and when the sight grows dim I think it is a warning to leave off *without* losing the small credit I may have gained!"

She turned to the natural world. "I have lived much in my garden."

The following year she wrote to her callous brother. "The Dean continues pretty well; soon fatigued with any exercise."[32] Still, twenty-two years after their breach at her marriage, she was apologetic to Bunny. Even ten years after Mary and the Dean were married, Bunny ceremoniously invited the Duke and Duchess of Portland and their sons as well as his sister to his estate at Calwich for dinner, but he disinvited the Dean on the flimsiest of insulting pretexts:

"my brother made an excuse to D.D. for not asking him, as his table would hold but six."[33] He, the collector of Handel manuscripts and the new neighbor of the daring philosopher Jean-Jacques Rousseau (who introduced our modern concept of childhood and a whole new style of education for children, whose romantic ideas would galvanize the French Revolution and the next century), had room for the famous and the titled but not for a low-born brother-in-law who made it possible for his sister to thrive. Mrs. Delany in turn held her brother's new neighbor Rousseau entirely suspect. She considered him "*dangerous* . . . to young and unstable minds."[34] She was firmly a Lockean product of the early eighteenth century who believed in knowledge determined by experience and the perception of the senses. One look at the *Everlasting Pea* shows that.

But the discipline of art gave way to a fretwork of anxiety. "I have been sadly anxious for some time past for my dear D.D., he has been very ill, and reduced very low, which, to a man of his years, must give cruel apprehensions," she stated flatly and openly, without disguise, to her friend the pixie-faced Lady Andover, a superb needlewoman and sympathetic listener. Then she broke down. "My nerves have been more shocked than I thought them capable of, for though my heart *has felt extreme sorrow*, I cannot say my nerves were ever so much affected before. Why should I tell you this? It was unawares. And yet, why should I not? a sigh relieves an oppressed mind . . ."[35]

It was not only the Dean's health that oppressed her, it was money. The legal bills had come in, and they were enormous. Radically, Mrs. Delany decided to sell the Spring Garden house that the Dean had given her in London, the house that was supposed to secure her for the

rest of her life. Behind her back the concerned Duchess wrote to her brother, enclosing a letter she had received from Mary. The Duchess thought that selling the house was a terrible idea, and she was apprehensive that if Mary did sell it, "the money [should] be *secured to her*."[36] In the real estate deal and in the payment of legal fees, Mary could easily have been left out of the equation. But she was determined to sell, and the Dean was determined simply to hang on. That March of 1767 he turned eighty-three. Debt dogged them. As to the Tennisons, those "pecuniary adversaries have pursued us ever since the [legal] decree." What this required the Delanys to do, before they could "lay hold of what *they* [the Tennisons] *are to pay us*," was to pay them three thousand pounds with interest *and* an additional two thousand pounds.[37] If the Delanys could have gotten their part of the settlement, they could have paid this money, but since they could not, they came up with a drastic solution. They would close Delville and remove themselves to visit their friends in England for the summer, and then stay at Bath for the winter so that the Dean might drink the healing waters.

But where would the Dean, on his last legs, stay, now that Anne had died? In a startling reversal, her brother Bernard extended his hospitality, and Mrs. D. wrote Lady Andover from Calwich in June that "the Dean is *so greatly overcome* with his fatigue that it is impossible for him to think of moving yet."[38] What would the voyage across the Irish Sea have meant for a man too fatigued to move? And then to end up in the house of the man who had hated him for twenty-four years?

By now, seven years after her sister's death, all Mrs. Delany could do was practice a discipline of thankfulness.

"Am I not in England, are not my dear friends better to me a thousand degrees than I deserve, and is not the Dean miraculously well *considering what he has undergone?*"[39] By November they had moved into their winter quarters at Bath, bringing Mary Dewes with them to help with the Dean so that Mrs. D. could march off to London to sell her house. It was such a huge job it left her head spinning. "I am so hurried with business that my head turns round, for on examining the house in Spring Gardens I found so much to do."[40] This is the last letter we have from Mrs. Delany for many months. What happened to her and the Dean we learn from the correspondence of Mary Dewes and her brother John. Apparently she even felt the need to sell their coach, which they had brought with them on the boat. "The coach has been made but six years, and by Wright," Mary Dewes wrote; "it cost a hundred and thirty pounds."[41] Once all their cash was assembled and all their debts paid, she could look for more permanent rooms in Bath. By the time she returned from the empty house at Spring Gardens, she was exhausted and soon entered the state of vigil for the Dean's last days.

In the final week of the Dean's life, he could not sleep, and he quoted to Mary Dewes the lines that begin, "Sleep, thou Sabbath of the mind / And greatest friend of human kind, . . . / Thy brother Death thy place supplies, / And kindly seals the wretch's eyes." (The last two lines are from Mary Barber's 1734 poem "An Hymn to Sleep.")[42] At 6:00 p.m. on the Thursday night before he died, according to Mary Dewes, he spoke to their amanuensis Mrs. Smith and said, "I thought it would have been over long before this time."[43] The Dean died on Friday, May 6, 1768, at 9:00 in the morning at the age of eighty-four, eight

days before Mary's sixty-eighth birthday and near their twenty-fifth anniversary. He was lowered into his coffin in Bath, the coffin was loaded into a coach, the coach drove to the Irish Sea, sailors took the coffin aboard a ship, and the ship sailed the choppy waters almost twenty-four years after he and Mary first were seasick together.

Before they had left Ireland, the Dean had chosen the spot in the churchyard next to Delville where he wished to be buried. According to Lady Llanover, it was once part of the Delville gardens that he and Mary had created together.[44]

Here lyeth the body of an orthodox Xtian believer, an early and earnest defender of Revelation to the utmost of the abilities wherewith it pleased God to endow him, a constant and zealous preacher of the Divine laws, and an humble *un*meriting penitent. Patrick Delany, D.D., formerly Senior Fellow of Trinity College, Dublin, late Dean of Down, hoping for mercy in Christ Jesus, he died the 6th day of May 1768, in the 84th year of his age.

This is the epitaph he probably dictated to his wife, for it was written in her hand on the scrap of paper preserved by Mary Dewes. It was the epitaph inscribed on his tombstone, except that, so wisely, a decision was undertaken by someone to exclude the word "unmeriting."[45]

Merit: value, worth, importance, significance. Merit: deserve.

Everlasting peace, both the Dean and his weary wife believed in it with their whole hearts.

She never saw the tombstone. She never returned to Ireland. She may not have accompanied the casket to the sea for its travel home, or even seen the Everlasting Peas

that often grow at seaside, straggling amidst the detritus on the beach.

{ COTYLEDON }

By the time he reached fifty-six, my husband had grown into his looks. A muscular assurance had supplanted the scrawny nervousness of his youth. His forehead, cheeks, and chin had filled out around his prominent nose, his features now proportional and open. Occasionally across this capable yet vulnerable face would flash the quick expression of a child, the boy he was, alight in the man. The boy would make a joke or run to his computer to get an idea down. The man who had lived with his cancer for twenty-three years accommodated appointments with myriad specialists within his professional comings and goings. The checkups came and went, occasionally with something scary needing to be investigated, often not.

But sometimes, sitting in a hospital gown on an examination table in Princess Margaret Hospital in Toronto, the man seemed to shrink to half his size, and someone else seized and froze his face, not the fleet boy but a static, narrow half-being, afraid and deathly still. It was as if he were diminished into a sculpture, all of the gestural energy that makes a person large sized down into gray stone. It was as if the blue snowlight from that freezing hotel room in New Hampshire had funneled its cold energy into him but stunned him, as if he had become an illustration from a fairy tale. He was gone, lost to me, in a netherworld of ice that also was his youth, my youth, our first sex together now frozen and – dead. Suddenly he would mobilize on the gurney and lift an arm for the doctor, and become flesh again.

By the time he was dressed and ready to repair to a coffee shop, his easy mature self would have fully reappeared. The frozen youth had pierced a needle into my heart, though. I'd spend most of such a day worrying it out. By the time we'd been married eleven years, the pattern was horrible but familiar.

"I think I'm going to write something about Mrs. Delany," I said to him one day after one of those checkups, "but I don't know what."

What remained unspoken went like this: *It's just us two in the world! If you go, I'll be alone in the boat.*

"Hey," my husband said a couple of weeks later, "there's an edition of Lady Llanover's edited letters of Mrs. Delany for sale. Should I bid on it?" Wasn't he supposed to be grading his graduate student essays? "And I found them online, too. I got you a PDF of them." All six volumes? Nearly four thousand pages? I prefer my literature in poem pages. About fourteen to twenty lines is just fine.

"And here's this article on Mrs. Delany from *The New York Times* in 1986." It was the long-ago review I had read, which had gotten me to the Morgan Library.

"So, should I bid?" The boy who had collected the golden Buffalo pop-bottle caps and Classic Comics had a gleam in his scholar's eye. But the thought of Mrs. Delany defeated me. Role models. Love. Death. Give me sunlight and Philip Larkin, not nine hundred and eighty-five flower mosaicks and chalky curatorial gloves. I didn't have the personality of a scholar. I'd never read all that.

253

"Nah," I said. "Too expensive."

Another fall was approaching with its equinoctial light – time to go to England again. I'd teach a workshop in London and a book of my poems was coming out. We

had rented a short-term apartment and I had absolutely insisted that it be located in proximity to the British Museum. Not that I was serious about Mrs. Delany. It was just idle curiosity, a break from memorizing lines for a theater piece I had written which I would perform back in North America. But I made arrangements with the Prints and Drawings Study Room. I had my appointment to see the mosaicks. It was crazy cold that November of 2003. I hurried along Red Lion Square and scooted to the museum, burst in the front door, and walked all the way to the back, turning left in the last gallery, past cases of Buddhas toward a little Alice-in-Wonderland wooden door, which I opened, and lifted the receiver of an old telephone, which rang in the Study Room, then under renovation. "Coming right down!" a voice said. I didn't realize that yet another Alice threshold was right across from me. It was a wooden elevator door, and a brisk attendant ushered me up, ordered me to divest myself of purse, passport, coat, leaving me in my street clothes with a tiny blank notebook and a pencil.

Then I was led into the main room and ushered to a seat at one of the long tables. Above, an even, gray, just-about-winter light leaked through the glass ceiling. Which Delany did I want? They gave me a copy of Ruth Hayden's book and I located the first dated mosaick, the *Scarlet Geranium*, and filled out a white scrap of paper. Off someone went to get it, only to return with the information that I couldn't have it. A botanist was already looking at it, checking facts against Mrs. Delany's vision of that specimen, plainly reliable after two hundred and thirty years.

The curator lent me a pair of white, powdery gloves, descended an encased short flight of stairs, and heaved up

a box stacked with matted mosaicks. I leapt up, leaned over, and started turning them inside the box instead of mounting them one by one on the wooden stand in front of my chair. Three curators dove like raptors and swarmed me. I should hold them like this, with one gloved hand on either side, and prop them on the stand like this, and arrange myself in front of them like so.

Mortified, I repositioned myself. All the other people at all the other tables, the ones staring at me, drifted back to their prints and drawings, taking notes. How dry the mosaicks were, how fragile. I was used to the glossy photos in books, the online versions on a brilliant computer screen. The real ones are matte, soft, old. It was a miracle that the museum was allowing me to get within inches of them without a plate of glass in between. It seemed they could fall apart just from the intensity of a gaze. The botanical material, the leaves and other plant parts she pasted on with the papers, had all stayed in place for a couple of centuries – hundreds of times the ordinary life of a plant. And several times the life of a human.

"I'm not serious," I said to Mike that evening. "Just curious." The next day I ordered up a volume which the curator placed on a foam-rubber support with a whole new protocol. Now I wasn't to wear gloves. With the volumes, where the mosaicks are loosely interleaved between pieces of paper, gloves are thought to be such a hindrance they could actually cause damage. Not knowing what else to do, I began drawing them. How free my hand was, just following her lines!

"Are you writing a book?" Angela Roche asked me. Roche, dark-haired, gray-eyed, and as gravel-voiced as Lauren Bacall, is a mythical figure in the Prints and

Drawings Study Room. She sits at a high desk, something like a witness booth in a courtroom, and surveys the area. Among her many responsibilities is the handing out of magnifying glasses – not that it had yet occurred to me to ask her for one. "No, I'm a poet," I said. "I just have a poet's attachment to them." It's always a disaster to introduce yourself as a poet. Now of course she thought I was crazy. Especially when I returned for a third day, determined to look at every single one. Of course I wouldn't get through all of them this time. This time?

Back in North America, in the midst of a rehearsal schedule for that theater piece, with no time to spare but to eat, sleep, exercise, and pay a bill or two, I sat down and started an essay on Mrs. Delany, whose flowering at the age of seventy-two I contrasted with my mother's death at almost the exact same age. Anything to complicate life. Anything to make sure I wasn't alone in the boat.

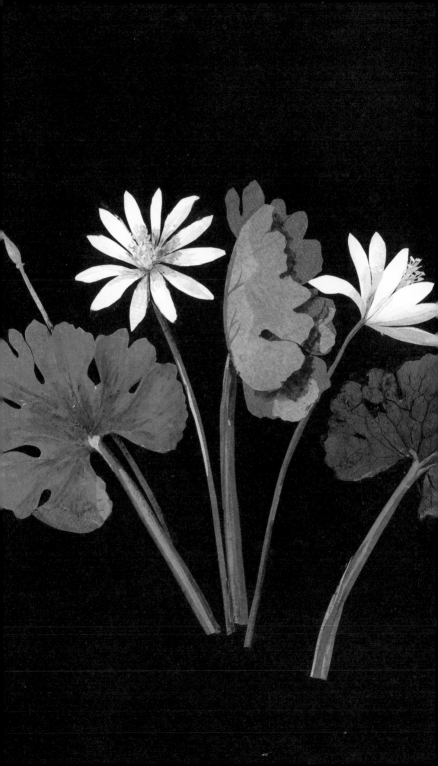

Chapter Eleven.

BLOODROOT

{ INTERLUDE }

Mrs. Delany was alone in her exhaustion in Bath. Sally Chapone (now Sandford) packed her godmother's possessions and sent them from Ireland. Never again Delville. Never Mount Panther, Mount Holly, Downpatrick. Never Barber painting his enamels at the foot of her garden. Never an itinerant harper to play his strings for breakfast. Never the Pearly Bower or the robins that came to Patrick Delany's hand. They all fluttered behind her. Her Irish life was behind her, caught in an updraft like a kite's tail.

Now let Mrs. Delany be blooded.

Let her eyesight fade.

Let her stop painting.

Let her sit in a stupor.

Let food be tasteless in her mouth.

Let Mrs. Delany's friend's son Harry Hamilton be sent with General Wolfe to conquer Quebec. Let the French General Montcalm surrender.[1]

Let George Washington don his French and Indian War uniform and stride into the Continental Congress.

Sanguinaria canadensis, St. James's Place, April 25, 1777, Prov. Kew
[also known as Bloodroot]

Let George III take his former tutor Lord Bute as his adviser and then discredit him.

Let the George in his blue wool on the western side of the Atlantic dedicate himself to the same enthusiasm as the George in his ermine on the eastern side of the Atlantic: horticulture, green plants, trees, shrubs, flowers, agriculture, the land.

Let Martha Washington bear four children before she marries George, and let one of them survive, while Queen Charlotte bears fifteen children and thirteen of them survive.

Let George Washington give the order to scourge the Iroquois nations from their settlements, and let Joseph Brant lead his people across the Niagara River and pass north of Peacock's Point.

Let blood be shed.

Let the British take Fort Washington, on the current West 184th Street in Manhattan, 147 blocks from the Morgan Library.

Let Martha Washington insist that the Revolutionary troops be inoculated against smallpox. Let an army be frostbitten but not pocked and dead.

Let boils erupt on Benjamin Franklin's body when he crosses the Atlantic with his grandsons and lands at the French court.

Let Louis XVI finance the American Revolution.

Let the Loyalists stream from New York up the Hudson and cross the Adirondack foothills to the St. Lawrence River, and let them row into Canada and freeze and die and freeze and live.

Let the Canada Lily reseed the scorched fields as

Damask Roses are cut from the gardens at Kew and placed in silver vases on Queen Charlotte's breakfast table.

Let Captain Cook set off on his voyage with Joseph Banks and Daniel Solander.

Let John Bartram get sick with fear that the Colonial Army will overrun his garden in Philadelphia, but let the British soldiers bivouac there and save it.

Let blood be bled from every sick man and sick woman in England, let cups of blood, pints of blood, gallons and galleons of blood be tapped from the veins, just as the Ontario Loyalists would learn to tap maples for their syrup. Let some of the sick survive.

Let bloodlines be formed.

Let the generations fly.

Sanguinaria canadensis, or bloodroot, an early springtime flower in North America, is easy to miss, since each bloom lasts for only a day – or less, sometimes a few hours. Each ice white blossom grows sheathed in a leaf that unfurls as the flower matures. In 1777, her fabulously productive year as well as a year of revolution in North America, Mrs. Delany positioned the leaf sheath at the center of her collage. The stem of each leaf and her two snowy daisywheel flowers are pinkish red, and each stem is cut off, separated from the plant, as they were cut in the wild, for when the stems are broken, bright, beet-like juice spills out. It was perfect for warpaint, for embellishing tomahawks, but also perfect for dyeing decorative deerhide with which to make dresses. The Algonquin name for the plant is *puccoon.* It was a medicinal plant, from the poppy family, and used as an emetic, a cathartic, and as a sedative with

multiple common names: Indian Paint, Snakebite, and Sweet Slumber.[2]

John Bartram had a special interest in medicinal plants, and in 1751 in Philadelphia he wrote a "Description of a Number of Plants peculiar to America, their Uses, Virtues, etc." Here he lists "*Sanguinaria canadensis,* bloodroot" and describes its curative properties:

> Chelidonium, or Sanguinaria, called by the Country People, Red Root, or Turmerick.
>
> The Root dried and powdered is commended by Dr. Colden, as a Cure for the Jaundice, the Powder being given to the Weight of a Drachm in Small Beer; and by others, for the Bite of a Rattle-Snake.[3]

Let citizens be snake-bitten.

Let them vomit.

Let their bowels be stopped.

Let a deerhide dress need decoration.

Let a bloodroot be the answer.

Let Sarah Chauncey Woolsey become a nurse in the American Civil War. Let her call herself Susan Coolidge and write a book for children called *What Katy Did.* Let her get sick of writing the Katy books and edit an abridged version of Lady Llanover's edition of *The Autobiography and Correspondence of Mrs. Delany* (1879) and also *The Diary and Letters of Frances Burney* (1880) for North American audiences.

Let begats beget.

Let Mary Dewes beget Anne, who was called Georgina.

Let Georgina beget Augusta.

Let the winds disperse the Nodding Thistle seeds.

Let Augusta beget two more generations, and let them beget a boy, and call him Robert Whytehead.

Let Margaret Barbour draw Forget-me-nots in her scrapbook.

Let Ruth Hayden be born to the Reverend Robert Whytehead and Margaret Barbour in 1922.

{ RUTH }

In 1930, in a leaky Tudor rectory in the Norfolk town of Diss, Canon R. L. Whytehead, an Anglican clergyman, later Honorary Chaplain to the King, and the great-great-great-great-great-nephew of Mrs. Delany, took the hand of his youngest daughter, Ruth. He explained to her that they would be traveling by train to London because he wanted to show her something.

"It was just my father and me," Ruth said to me about this excursion to the museum. "I was immensely impressed by the enormous stairs leading up to the Print Study Room."[4] In 1930, as it does still, the museum allowed children into the august room with its tiers of sliding drawers. Her father sat her down at one of the thick wooden tables, the same tables used today, and requested a volume of Mrs. Delany's flower mosaicks.

Canon Whytehead let Ruth turn the pages. She must have had to stand or kneel on the chair to obtain the height she would have needed to lean over the massive volume – each of the ten volumes into which Mrs. Delany collected the mosaicks is around two feet tall, a foot-and-half wide, and three inches thick.

She slightly disturbed the edge of a mounting.

"Careful, careful!" she remembers her father saying.

Ruth was more taken by the fact that she had been chosen by her father out of all his four daughters to go on this adventure than by the artworks themselves. Still, she knew she was the relation of someone who had done an important something.

"Did you take art lessons?" I naively asked her.

"Well, I might have done," Ruth said, "if it hadn't been for the war."

Of course, bombs trump art lessons. I was embarrassed, as I often am, by my ignorance of the hardships of my mother's generation.

As I was talking to her, Ruth was eighty-six. We sat surrounded by her books and cookies and teacups and a cabinet full of eighteenth-century inherited china, all in the sitting room of the small, airy, light-filled two-story house, just outside of the city of Bath, where she has retired. She invited me to meet her there after I had pressed Angela Roche, the supervising godmother of the Prints and Drawings Study Room, to forward the essay I had written about Mrs. Delany and my mother to her. It's not the magnificent, leaky house she grew up in, or the rambling, romantic house where she raised her two children, but it is adorned with carefully selected objects from those times. A huge piece of framed flower-embroidered black silk from one of Mrs. D.'s fabulous dresses dominates its entranceway. "As children," she wrote in her book *Mrs. Delany: Her Life and Her Flowers*, "my sisters and I were instructed by our father . . . that if the house should catch fire there were two items which should be rescued first, his sermons and the Delany."[5] (By "the Delany" he meant this panel of the dress.)

"I've left the door open for you!" she called in her strong, clear voice from her kitchen the first time I visited, just after the solstice in June 2008. So my first impression of her (I'd just gotten out of a cab and was stepping up toward that open front door) was actually hearing out loud the very voice I had been hearing internally while reading her book and her letter inviting me for mid-morning tea. Ruth came bustling down the hall, handsome and ebullient. I had had a fantasy of someone very frail – hah! Before me stood a tall woman with thick white hair, Spode-china-blue eyes, and a devilish smile: a sexier, twinklier version of John Opie's portrait of Mrs. Delany.

"Didn't you feel, meeting her," ventured Mark Laird after I told him I had had tea with Ruth, "that you might have been…" He hesitated. Both a distinguished garden historian and a garden restorer, and, incidentally, my neighbor, he generously introduced me to many of the scholars who are creating what he drolly calls "Delanymania."

"Might have been what?"

"Well," he said a bit sheepishly, "meeting Mrs. Delany herself?"[6]

Oh, yes.

That day Ruth wore a navy blue linen mid-calf A-line skirt, navy blue pumps, and a floral denim jacket. She moved efficiently as she guided me to my place at the tea table. We gabbed so long that she invited me to stay for lunch. She led me through the comfy living room toward a table set with two placemats in her dining room as she defrosted some homemade watercress soup. But before she served me sandwiches, she asked me to step outside to look at her garden, a small green glade rising up a slope to a vine-covered wall.

As she drew the curtain aside and opened the sliding glass doors, she took a handful of dried currants from a bowl. "Now I'll let you know how old I really am," she said. "Only a very, very old woman such as I am has time for this."

The garden had few flowers, mostly varieties of green, with shaped ornamental shrubs.

"Quick!" she whispered, commanding me. "Go back inside and hide behind the curtain!"

She has the kind of ringing but encouraging voice one instantly obeys, though after I was tucked behind the curtain, peering out, I wondered why I was following orders. Why hadn't I asked why I was to hide? Was I simply in the thrall of a batty old lady? Just because she had the same first name as my embroidering grandmother? Just because her ancestor shared a first name with – well, at this point I should probably confess it – me? Although I've always been called Molly, Mary is in fact the name on my birth certificate. Now Ruth stood in the sunshine, looking toward the vine-covered wall. It was a bit like a wall to nowhere, or a wall to Somewhere Else in a fairy story.

"Here, Blackbird!" she was calling. "Here, Blackbird!"

A diminutive crow-like bird popped up on the wall. He cocked his head toward Ruth. He owned the wall, the way the robin in *The Secret Garden* owns the wall of the garden to which the sallow, lank-haired heroine Mary Lennox hopes to gain entry. That robin drops the key to the garden at Mary Lennox's feet.

"Here, Blackie!" Ruth's voice was bell-like, high. She held out her palmful of currant nuggets.

The blackbird flew straight toward her, hovered in the air like a tiny midnight blue helicopter, landed on her hand, plucked a currant, and flew back up to the wall.

Then he did it again.

"Now stay behind the curtain!" she whispered. (I had been edging out.) "Here comes Mrs. Blackbird."

The missus, much shyer, was a brown female who hopped at Ruth's feet, waiting for her mate to knock currants to the grass so that she could pluck them out of the clover and eat them.

"I must get the rest of our lunch now, my dear. You take some currants and see what you can do." Me? I was never going to get a bird to eat from my hand. There she was, like Ben Weatherstaff, the crabby old gardener who takes a shine to Mary Lennox and lets her keep the key to the secret garden, handing me the rest of the currants as I stepped out into the sunlight. The door banged. Now Ruth was watching from her kitchen window.

"Here, Blackbird!" I called with my American accent, my *a* flattening.

He hung in the air, inches from my palm. Then, with his feet, he almost but not quite landed, purposely knocking the currants from my hand toward his nervous wife.

Pretty good, I congratulated myself. *A wild blackbird almost ate from your hand.*

Then, as if sent by Dr. Delany, a small, puffy robin redbreast landed on the back of a wrought-iron chair. When he suddenly flew to my hand and began to eat, the light pinch of his claws and the whirl of his flight feathers startled me. I barely kept myself from leaping back and frightening him away. To have an animal eat from your hand (well, to have anyone, or anything, even a pet cat, take food from your fingers) feels like a visitation from a minor god. A message from the natural world we have abandoned but which generated us. The past, to me, feels like

267

this neglected natural world. I felt that light claw of something living through hundreds of years.

Ruth was full of enthusiasm from the kitchen window. "Oh, did you get the robin to come to you? Good for you!"

I was in a magic place, though it was quite real. It had a street address. It had a phone number. It had an old navy blue car in the driveway, the color of the skirt on the woman who was moving back and forth in the kitchen preparing lunch. She was quite real. Just as real as the robin from which I'd felt a scratch of the past. Not just memory or metaphor but a scratch – the way a fact can scratch, palpable, undeniable, inflexibly pertinent.

The rush of waters from the past seemed to swell up and flood the garden, and Ruth seemed to be swept from the kitchen, and I seemed to dive into a current of years moving to us and through us. You can't step twice into the same river, Heraclitus reminds us, but there is that moment when, jumping into the rapids of time, two people surface together – or more than two: all the generations of Granvilles and Deweses and Delanys, and my own generations, all the Wrights and McManns, all the Peacocks tossed up out of the river of connections.

After they left the British Museum, Canon Whytehead helped his eight-year-old daughter to negotiate the steep steel steps of the return train to Diss. At home Ruth shed her tight-necked city dress for her country clothes and dashed off with her sisters into the ten acres of garden and three ponds and a wood that belonged to the rectory. She was on a mission to discover flowers and nests, as her mother had done as a girl. Her mother, Margaret Barbour, no relation to Mrs. Delany at all, had painted a watercolor book of her own

childhood observations of nests and flowers, an enchanting piece of natural history that Ruth Hayden still owns, and a felicitous thread of connection to the excitement of the world of Mrs. Delany's specimens.

This household, with its maids and maids' rooms and its governess for the four sisters, is a picture postcard from the Edwardian past, the way my mother's girlhood (she rode a blind pony from her grandmother's farm to a one-room schoolhouse for her elementary education) is a romantic American postcard. But in 1937, Canon Whytehead sat his then fifteen-year-old daughter Ruth down and explained to her that she, like her sisters, was going to have to earn her living. The family fortune was not going to keep Ruth in the style to which she was accustomed, even if that style was a leaky Tudor roof and chilblains from the lack of central heating. Now, in order for Ruth to secure her adulthood, she was going to have to pass her exams. To ensure this, she was sent to live with friends of the family to be tutored along with the family's daughter by a young governess who barely had command of the exam requirements. Every day they made feeble attempts to cover the material.

When the morning for Ruth's examination came, she put on her wool skirt, her fresh blouse, her jumper, and proceeded to fail the test. "I was a dummy!" she exclaimed to me, still blistered by the disaster. Her parents gave her another try. She studied, sort of. It wasn't at all clear what exactly she was supposed to do. The young governess was as clueless as ever. The next round of exams came, and Ruth failed again. "Twice!" she chortled in her rich, reedy voice. "I had failed both times!" We were back in her dining room now, eating sandwiches.

By the following year it wouldn't matter to the world whether a teenage descendant of the Granvilles had flunked an exam or two, even though it took a permanent bite out of her self-esteem. Disconsolate, she lay in her bed and listened to the rats rolling apples overhead in the attic, until she could stand it no longer. She got up and traded the wool skirt for the uniform of the Women's Royal Naval Service. She donned the blouse, knotted the tie, put on the double-breasted jacket with its nipped-in waist, buttoned the black buttons.

When she was twenty-one, the WRNS transferred Third Officer Ruth Whytehead to Dunoon, Scotland, home to an anti-submarine naval training base. Her job was to look after the cipher books; she was to hand them personally to the straight-postured, clean-shaven naval officer who stopped by to pick them up. The officer was Royal Navy lieutenant Freddy Hayden. "I was attracted to him," Ruth said to me one Sunday on the telephone, when I was in Toronto and she in Bath. "I knew he was attracted to me because he didn't send someone to pick up those books; he came himself." She bought a bicycle and rode it through the Scottish hills, passing fields of that national flower *Cirsium vulgare,* the Scottish thistle, a cousin of *Carduus nutans,* the Musk or Nodding Thistle.

Freddy Hayden, formerly an ordinary sailor "from the lower deck," as Ruth described him, was one of the few working-class sailors to be commissioned as an officer before the war. Aboard the destroyer *La Flore* (*The Flower!*) he listened to hours of pinging noises, auditory clues for depth charges. But he still went to retrieve those cipher books. Soon the narrow-waisted Ruth Whytehead abandoned her bicycle to sit in a car next to him. "He invited

me on board *La Flore*, and that was quite entertaining," she said with practiced understatement.

"Then he came to see my family. Poor man, he was terribly cold, he told me. We put him in a room upstairs – no central heating. He took a rug up off the floor and put it on his bed to keep warm." A chilly reception. Freddy "had a very good brain and was such a very good leader of men," Ruth mused. Freddy of the very good brain had decided to marry the girl who had twice failed. "My parents liked him in many ways," Ruth said stoutly. Her father promised to marry them.

Silks and satins, the fabrics Mrs. Delany would have chosen for a wedding dress, were impossible to obtain under clothes rationing. But netting was not rationed at all. Ruth went down the aisle wearing a wedding dress sewn from white net household curtains, "with a wreath of artificial flowers around the bosom and another wreath around the hem." They were married by her father on August 10, 1944, less than a year after they had first laid eyes on one another, at St. Margaret's Church, Lowestoft, in Suffolk, the same church where, in a Delany-esque coincidence, Edward Smith, the founder of the Linnean Society of London, is buried, as I learned from botanist John Edmondson.[7]

Ruth carried a posy of sweet peas.

After the war Freddy stayed in the navy and Ruth became an unlikely navy wife. A terrible sailor, just like her ancestor, she got seasick almost the minute she set foot on any vessel. However, she stayed safely stowed on land, for on August 29, 1946, in extreme heat in the Lowestoft hospital, Ruth gave birth to their first child, Katherine, or Katy. Less than two years later, she gave birth to their son, Mark.

Now she and Freddy had their family, and their separate journeys on land and water. "There were no naval quarters for wives whose husbands were at sea. We hadn't got a home; we were living all over the place – in digs, rooms in people's houses. Landladies!" she exclaimed in her high, clear soprano, then lowered her voice. "Awful places." A far cry from Longleat or Bulstrode. "Our standards were so low in those days, we didn't expect much."

By 1955 the Haydens were living in Portsmouth, nowhere near family or friends. "We were not at all well off. One hadn't the money for anything like a hotel room. Even taking trains was prohibitive." At the age of thirty-three, she was all alone with her children, now aged nine and seven, one a year older and one a year younger than she was when her father took her to see her first Delany collage. Freddy was in command of the destroyer HMS *Cockade* in the Far East. "I didn't see him for eighteen months." Between food shopping, cooking, cleaning, walking her children to school, there lay a space of inactivity, something like the negative space that defines the relationship between flowers in so many of her great-great-great-great-great-great-Aunt Delany's collages. Ruth had nothing to seize on. No energy to seize, anyway. Silence in the house. Children at school. Wheeze of the hinge on the mail slot. Stuck between the boredom of child chores and the anomie of house chores.

"You see, Molly," Ruth said levelly, "I was severely depressed."

One day, as she was feeding her children alphabet soup for lunch, she eyed the train schedule: Portsmouth to London. London. She had to do something. Suddenly she up and dressed Mark and Katy in their city clothes, got on her matching jacket and skirt, tied a silk print scarf around

Ruth Hayden, artist unknown, ca. 1954

her head, and ran for the train, the children's legs pumping. They were going to London, to the British Museum. She would show them the Delanys, as her father had shown her. From Waterloo Station she ushered her girl and boy down the steps into the Underground and from there to Russell Square. They hurried down Great Russell Street and careered across the front courtyard and up the steps through the portico of the museum. She pushed the children directly toward the back and the great staircase, which all three of them navigated. It was 4:01 p.m. The Prints and Drawings Study Room, then and now, closes at exactly 4:00 p.m. She stood there, flushed with disappointment. "Having come all this way!" Her herded children stared up at her.

To the side of the door is little electric buzzer.

She buzzed.

Slowly the inner door from the Study Room to the small entry foyer opened, and a kindly gentleman in a dark tie crept to the door. He opened it a crack. "Please, may we see the albums of Delany flowers?" Ruth asked, holding the hands of the two children, bringing them slightly forward.

"Madam, the Study Room is now closed."

She looked down pathetically at the tops of her children's heads. "But I've brought my son and daughter all this way!"

She could see him softening.

"To see the Delanys. We've come all the way from Portsmouth, and Mrs. Delany is my great-great-great-great-great-great-aunt." She smiled with the full Ruth Hayden smile, expectant, subtly flirtatious, and with an accompanying slight jut of her chin – an in-the-bone connection to her distant, distant aunt. "I was hoping to give my children their first glimpse of the flowers."

The curator caved in to her request, of course. He did not give them white gloves to turn the pages of the thick volume he brought. Ruth and Katy were already wearing their white travel gloves, and Mark was too busy being distracted by the switches on the table lamps. The curator brought only the first volume of one hundred flower mosaicks. Slowly Ruth turned the pages for her children. They saw the four Alliums, the two Aloes, the two Alstroemerias, the three Alyssums, the twelve different Amaryllises, the seven different Anemones, and the first two of the Asters. Somehow, with the hour, with the children wriggling in the same chairs in which she had squirmed as a child, with the curator's hawk eyes watching, hearing the ghost of her father saying, "Careful, careful!" and telling her children the story of their ancestor, whom Ruth knew only as a grand lady in a great

ballgown who curtsied for three Georges and who cut out such evanescent flowers, she thought that the first volume of mosaicks was all there was. The nine others unknown to her dozed in a cupboard.

But what awoke in Ruth was a power of amazement, a thread to her original awe as a child. As she viewed the flowers for the first time in twenty-five years, a forgotten feeling of wonder surfaced again in her, an emotion she saw in the eyes of her children as they settled down and gazed at the tiny handwritten labels and the tinier dots, squiggles, and loops of color. "Amazement of this kind is rarely felt twice," French philosopher Gaston Bachelard said of the experience of the naive observer.[8] But, sitting between her two children, she realized she *had* felt it twice, once at the age of eight, and now. And that was that, for fifteen years.

Ruth went back to housework. Her children grew up. Freddy retired from the Royal Navy and got a job as a management consultant. Just before her fortieth birthday, in 1962, the family moved to a rambling house in Bath. She joined the Heather Society and started a garden. She took in foreign students for extra income. Freddy's company kept a flat in London where he could stay on business and where sometimes Ruth would stay. In the early 1970s, she braved her luggage room to find a suitcase for Freddy, stumbling over the Sainsbury's box where she had dumped the six volumes of Mrs. Delany's letters in Lady Llanover's edition that her sister June had asked her to store after their father died. Now her children were both at university. "I was never a great reader," she told me, but she stood there, starting to read about the Granvilles, the Jacobites, and Aunt Stanley. The choirboys at All Saints

Weston church needed new cassocks, however, and Freddy needed to pack, and both her grown kids would be coming home on university break. She grabbed the suitcase and Volume 1, then turned to the next matter at hand: a fundraiser for the cassocks. She was stumped.

She felt stumped a great deal. She was no longer depressed the way she had been when she'd sat in Portsmouth all alone with two kids and Freddy at sea, but still, nothing seized her. She finished cooking for the evening meal in the tamped-down haze she seemed to operate in, efficient but clouded. At last she sat down. She turned back to Volume 1 and read the terrible story of Pendarves and the castle.

The next day she tied her scarf beneath her chin, cinched the belt on her raincoat, and walked more briskly than usual to catch a train to London. The lure of that flat sparked her imagination. She could stay in the city. She could visit the British Museum, inspect the Delanys. This time when she rang the bell at the Prints and Drawings Study Room she was alone and nearly fifty years old, and when she requested the flowers again, this time several volumes of the mosaicks came up. Oh, so there were lots of these flowers. At first they were crisp and individual. Then, after two volumes, they began to blur.

On her way to get a cup of tea, she passed the gift shop, where she discovered that the museum had printed postcards of a Mrs. Delany rose and a Mrs. Delany lily. On impulse she bought all they had. She'd give a talk about her ancestor in aid of the choirboys and sell the postcards with a twenty-pence-each markup for the fundraiser. "Everyone loves a flower," she thought. She hurried home, sold all the postcards, and, with the other churchwomen's

contributions, the choirboys got the cassocks. The lecture she gave "went down very well indeed. It was after that lecture that I was asked to speak at the Bath Festival of Music and Art." Then, for the first time, she really looked at her framed portion of her Aunt Delany's gown, and at each of the exquisitely embroidered Lilies of the Valley and Roses and many other species. Suddenly she became more interested in needlework.

Throughout the 1970s, in her fifties, Ruth made repeated return trips to the Study Room. First she looked for the heathers, just to satisfy her membership in the Heather Society. Then it became a routine, almost like going to church. There is a bit of a church-like silence in the Prints and Drawings Study Room. And a bit of the smell of wood polished over and over and the seats of wooden chairs shined by the wool derrières of hundreds of skirts and hundreds of trousers. Over time she viewed all 985 mosaicks. Probably no one had viewed every single one of them since Lady Llanover donated them. But Ruth was just looking. She had nothing particular in mind. Yet an impulse *had* seized her. Despite herself, the dummy she was, the non-reader, the woman who divided her irises, the soup-maker, she went back to the Prints and Drawings Study Room. Nothing special in mind. Just looking. But she had never looked in quite this way. Despite herself, she was developing a gaze. The gazing was allowing her to become an expert. One of the antidotes to depression is actually doing something, provided you can manage the energy to put one foot in front of the other. And expertise is an antidote to a poor self-image. In 1975 she came across the *Antique Dealer and Collector's Guide* and read an article by Mary Gostelow called "A Talented Lady

of the Eighteenth Century," all about Aunt Delany's paintings, shellwork, collages, and embroidery.

"You know, Freddy," Ruth said to him after supper, her voice infused with a confidence that surprised her, "I could have written that article."

"Yes, darling," she remembers he said, "I think you could have done."

By now they were familiar with Ruth in the Study Room. She signed in routinely and everyone said hello. She met Dudley Snelgrove, a retired curator who was a great admirer of Mrs. Delany's collages and who also happened to be philanthropist Paul Mellon's agent in England. She chatted with other curators, she slung her tray on the metal shelf when she had lunch in the cafeteria, and, having given those successful lectures, she had ideas. "There was something in my mind: talks. Talks for the Women's Institute. I was just thrilled that the Women's Institute might listen to me." She did give the talks, but she wasn't paid; she loved giving them, but somehow she had to make her expenses for doing it.

Unexpectedly, one day Freddy turned to her and said, "What would you say if I retired completely?"

"He must have known," she mused; he must have felt his energy depleting. His jaw had squared, his profile thickened. When he retired, his finances were further stretched, and the Haydens would have to continue taking in student boarders. Daily Ruth strode to the shops, bought her groceries, and returned to cook for Freddy and the students. She worked in her garden. She called her children. She volunteered at church. Six weeks after Freddy retired, she got an idea of how to meet her expenses for the talks: Delany postcards. She could sell them after

the talks. But when she called the museum to order some, she learned they were going to be discontinued. "Oh dear, I wanted lots of them!" They said they would scour their cupboards for as many as they could find. Could she pick them up the next time she came in from Bath? She could run to London easily now that her children were grown.

When she was next at the Study Room, the telephone rang. Shockingly, it was for her. The voice on the other end of the line was Celia Clear, the editor at the British Museum Press, wanting to know more about the paper flowers. "We must have a good number of Mrs. Delany's works, twenty or thirty of them?" the editor guessed. "Heavens, there are nearly a thousand!" Ruth exclaimed. Ruth knew the holdings better than the professionals now.

"She's asked . . ." Ruth said at home, slowly walking toward the fireplace and the slumpy chair Freddy always sat in to do the *Times* crossword puzzle. She could hear that old word "Dunce!" echo in an extra track in her head. "They've asked me to write a book about Mrs. Delany!"

"Who has?"

"The British Museum Press, darling," Ruth said with slow amazement and delight. "The editor, Celia Clear."

Freddy looked up from the sports pages and directly into the eyes of his wife who had no formal education whatsoever.

"Did you say yes?" she remembers him asking her.

"Yes," she said slowly, and then the bright hysteria charged up. "But all I've ever written is a shopping list!"

Freddy went immediately to business. "Now, what's your deadline?" He put the paper down and rose out of the chair.

"I have two years." Ruth spoke it like a death sentence. Then they both went upstairs to bed.

"How do you propose to do it?" Freddy's voice, with a slight note of his old naval officer's command tone, emanated from the next pillow.

"I shall . . ." Ruth stopped. Through their bedroom window the few lights of the village blinked through the heavy embrasure of the tree branches. "I shall go right through her life," Ruth remembered she whispered.

"That's right. Reread all the six volumes."

"And I shall go to Wales, too, and read her original letters there."

"We've got to map it out," he said sleepily.

And so they did. Fifteen months on research, Freddy ordered. The captain was back. The next eight months writing, six days a week. Four days' holiday at the end of each chapter. All letters fine-tooth-combed for six categories: shellwork, needlework, silhouettes, flowers, gardens, social history. Notes taken in columns.

I was writing notes furiously in Ruth's living room, looking at a photo of Freddy in his Royal Navy uniform as Ruth remembered what he said and mimicked his voice. Good ideas, I thought: organized, businesslike. Capable. Breaking it all down. *Just what I need to do*, I thought, though I was entirely incapable of it. I had to contend with the leaps of the poet's mind.

"But Molly, you see, I had never had any serious tutoring or formal education past the age of twelve!"

By the end of the first week, Freddy found her at the kitchen table in tears. Where else would a woman research a book about her great-great-great-great-great-great-aunt except at her own kitchen table? Each day she did a portion of the housework, ran to the market, whipped up lunch for Freddy and the students, squeezed in the note-taking, and

cooked the evening meal for herself and Freddy as well. "I can't do it!" she sobbed. "I'll never get it done!" Freddy put his hand gently on her shoulder. She felt the firm comfort of it. Suddenly he insisted on doing the shopping. And after that he whipped up some of the lunches, too.

"You cannot have too many *innocent* amusements," Ruth reminds me that Mrs. Delany wrote to her niece, "provided you do *not neglect* what is essential to learn."[9] She was learning the essentials. She had begun her life's work. "This gripped me intellectually and emotionally."

It also helps when the person who loves you is the former captain of six ships, footloose, retired, and ready to sink his teeth into something. Through the next two years they kept to their schedule. At lunch they would sit down and discuss what Ruth had written. Michael Hoare, the director of the British Museum Press, was gathering the budget for the book. Periodically both Ruth and Freddy went to London to pore through the collages, to take notes, and to confer with Celia Clear. What a shame that so many of the flowers were going to have to be reproduced in black and white. But Dudley Snelgrove, Mrs. Delany's advocate, told collector Paul Mellon about the project, and Mellon offered to up the budget for the expensive color plates.

After the fifteen months of research came the eight months of writing. The new schedule was to write for four weeks straight, then to break for four days. They kept to the plan: seven chapters on her life, one on the collages. All the while the foreign students went to and fro, talking of, well, probably Mrs. Delany. Freddy tackled the indexing.

Neither of them had academic training. Neither of them had written a book. But Ruth had developed an eye.

Freddy had a passion for detail and structure. The book was the project of a marriage, of the kitchen and the talking. Of the talking on the train and the talking in the Study Room. Of the looking and examining and collecting and exclaiming. Of the conclusions. Of the voice of Mrs. Delany in her letters. The voice of Anne. Of the Duchess of Portland. Even of Queen Charlotte. They ventured everywhere an artifact of Mrs. Delany's surfaced. It was absolutely a family affair.

"I didn't realize he was so ill," Ruth said to me, though she was looking toward the picture window in her living room. "He'd be dead in two years from when we started."

They did not know that the storm of activity they whirled in was also the culminating project of their lives together. Freddy Hayden, born on March 31, 1916, died of lung cancer on June 9, 1980. He was sixty-four. Ruth was fifty-eight. Two months after his death, in August 1980, *Mrs. Delany: Her Life and Her Flowers* was published.

Mrs. Delany's portrait of the Bloodroot plant projects the feel of something useful. It's not a dramatic flower, just an elusive and effective one. In her world of illness and death, where a walnut-sized bit of bread first thing in the morning was a headache fix, the fact that a plant could cure something as dramatic as a snakebite or something as ordinary but nagging as constipation was a wonder – and it reminds us that that our twenty-first-century pharmacopoeia derives from plants. It also reminds us of the extreme importance of the Chelsea Physic Garden, originally called the Apothecaries' Garden, begun before Mrs. Delany was born, in 1673 – more than a hundred years before she cut out the *Sanguinaria canadensis*. Medicine was a major

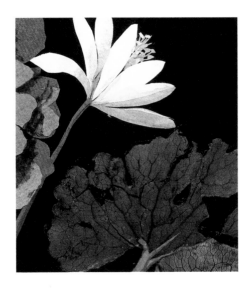

Sanguinaria canadensis, detail

prompt for the study of plants. When Mrs. D. pasted a specimen of a Bloodroot's lobed leaf prominently in her composition, it was as a full partner of the other leaves and flowers – not a hidden mystery or a witty fillip, but a piece of the plant immediately noticeable to the eye. This portrait does not say beauty; it says medicine. The Chelsea Physic Garden functioned as the preeminent medical research garden for physicians and apothecaries. Dr. Hans Sloane, that phenomenon of a museum founder and physician who happened to have been born in County Down, Ireland, bought the Manor of Chelsea, which included the Physic Garden, then leased it to the Society of Apothecaries in perpetuity.

283

By Mrs. Delany's time the Garden was conducting seed exchanges around the known world – and it still does.

The Garden still exists, and you can go down Royal Hospital Road in London to the banks of the Thames (which provides a salutary environment to plants in winter) and visit, and even see the rock garden established by Sir Joseph Banks.[10]

Ruth and Freddy Hayden felt the great practicality of what they were writing: a Bloodroot, a way to rescue from obscurity not only the miraculous flower mosaicks but also the six volumes of letters, and the amazing enterprise of the busy and long life of Mary Granville Pendarves Delany. Ruth wrote a book that engages with art history, fashion history, political history, and letters, as thorough and comprehensive a look at her ancestor as there was after Lady Llanover's amazing, if eccentric, piece of editing of the letters in the nineteenth century. Ruth's book has prompted the research of textile historians, garden historians, botanists, paper detectives, experts in court life, and feminists. The core of her research, although it has been revised, reviewed, and amended by scholars, has inspired them, perhaps because she's a marvelous storyteller and also because Ruth was a very savvy selector of quotes and images. Oh yes, there's a third reason. Ruth had a cause, a mission, a root: she had made her ancestor her life's work.

"Living with negative things is not much fun, is it?" she said to me twenty-eight years after Freddy died. It was a chilly November 28, 2008, and I had brought her a White Hellebore, a plant that had thrilled Mrs. Delany's friend the Duchess and which Mrs. D. had portrayed (the British Museum put it on a Christmas card). "Thankfulness and forgiveness," Ruth said as we mused about all that had passed in the past three decades, "that's where religion

comes in. That's what Christianity is for." Soon it would be the sixteenth anniversary of my mother's death. Ruth was preparing a guest sermon on flowers to be delivered at All Saints Church. The compassionate Rose, she said, "gives off the scent of empathy." Love-in-a-Mist suggests that God's response is in a mist, as St. Paul says in Romans 8:38 and 39. Heartsease? "Let the ease of Christ rule in your hearts," she planned to say. Forget-me-not? "Well," Ruth chuckled, "we all like to be remembered."

I was busy checking facts with her and she was busy making lunch. In our meetings we always seemed to chat much longer than we'd planned. "The old blackbird," she said, "I think he's died." She brightened. "But I have two robins, and one day I stood with one in each hand!"

{ POLLY }

At the age of sixteen my mother, then Polly Wright, graduated early from high school, cut off her hair, got a factory job, and bought a car, a Model A. It was 1935. With her first paycheck she made a down payment on new furniture for her parents and bought clothes in a store, vowing never to wear another homemade garment. My grandmother Ruth had sewed all of Polly's clothes to that point. (Watching her sew as a child, I knew firsthand the creative power of a pair of scissors.)

By the time my mother was twenty-two, with six years of semi-independent living under her slender belt (she still lived with her parents), she packed her car to head for a new life in California. I think of Polly's California as the equivalent of Mrs. D.'s Ireland. It was Sunday night, December 7, 1941. She planned to set out with her two

best girlfriends from the factory the next morning. But by breakfast on the eighth the news that Pearl Harbor had been bombed reached their hamlet in upstate New York. My grandmother pleaded with my mother not to go to California – where she would surely die when the Japanese invaded. But Polly and her friends had the car packed! Their compromise was to drive one and a half hours to Buffalo instead and get assembly line jobs at Bell Aircraft. My mother's boss was Mary Peacock, my father's aunt. Soon Polly Wright would become Polly Peacock, and a door would shut. California didn't really become her Ireland. Polly never got there.

A creeping depression overtook her after she stopped working at her aircraft job to care for her two young daughters at home, and her former exhilaration dissolved into hours of fantasy reading. My mother was never without a book, usually a romance novel or a western. She read while she cooked; she read in the bathroom, of course; she read in bed eating chocolate-covered cherries; she read behind the cash register of Peacock's Superette, always with a cigarette ash growing to a curved, stem-like shape before it dropped to the page, sometimes burning a little spark-hole in the paper before it went out. She read behind the closed, locked door of her own life. It was the mid-twentieth century, and one would have thought she could have gotten out of the marriage to a degenerating alcoholic, but locked doors can be psychological as well as sociological, and it took her twenty years to extricate herself.

How is it that Mary Delany, two hundred years before my mother, seems to have led a life of greater liberty? Personality and heredity aside, of course there was the

little matter of class. My immediate branch of the family –
farmers and small business people on my mother's side,
truck drivers and factory workers on my father's – had
little wealth, and little wealth of memory. I know much
more about Mary Delany than my own ancestors at this
point, but not for long. Mrs. D. and my husband have
turned me from a searcher into a researcher, even though
a metaphor can feel truer to me than a fact.

My mother thought about things she might do and things
she might have done, but she never did them. She never
seemed to decide anything. Drifting from stage to stage in
her life, she had ill-formulated goals and never seemed to go
after things in a straightforward way. She settled for less in
every situation except friendship, whether it was the choice
on a menu or the choice of a divorce lawyer. Was this the
limitation of class or the limitation of the post–World War II
return to a traditional society? Or was it due to the very

Pauline Wright Peacock, 1940

close mental quarters that were the result of her depressive personality? Or to the fact that she did no art or craft?

Craft is engaging. It results in a product. The mind works in a state of meditation in craft, almost the way we half-meditate in heavy physical exercise. There is a marvelously obsessive nature to craft that allows a person to dive down through the ocean of everyday life to a seafloor of meditative making. It is an antidote to what ails you. At about the age of thirty-six, my mother executed six paint-by-number paintings, three winter landscapes and three exotic jungle-scapes prominently featuring peacocks. She spread the work out on the kitchen table and, over several happy years, went at it. One can lose oneself, even in paint-by-numbers, and the loss of the self within safe confines nurtures the imagination. To ornament one's existence, even with six paint-by-numbers paintings, is a key to understanding one's personal wealth – and acknowledging that wealth in others, too.

But she stopped. For the next thirty-seven years she did no making.

In my life I never received a full-length letter from my mother. She did not write anything the length of a page, let alone a book, although she read thousands of paperbacks and library books and kept them in chronological order so that she would know when enough time had lapsed for her to begin a cherished rereading. Her mother, Ruth, the embroiderer, was an impressive epistolarian who probably wrote the equivalent of Mrs. Delany's six volumes of letters, to friends and cousins from Florida to Alberta. But my mother even refused to write to her mother. I have a few scraps of notes in Polly's hand. A postscript on a Christmas card was the most you'd get. She

generally refused to make social phone calls, though she would answer the phone. You had to come to her. The fury this ignited in me was lifelong. Yet I called. I wrote. Refusing to make, she made me into a maker – into a writer, in fact. Polly inched her way forward in life, making me seize every opportunity. I had to leap, I had to bound. She did nothing fanciful, and nothing ornamental, except putting her makeup on. She was an attractive woman who drew a line of red lipstick with assurance. She drove a car exceptionally well, and even knew how to fix one.

She did have one important link with Mary Delany: they both had lifelong friends. The two women who started out driving in that car to California and ended up in the aircraft factory with my mother were all devoted until the day she died. I grew up watching their friendships flourishing, foundering, being patched up, and barreling on toward eternity. It took me until I graduated from college to realize that many people feel that husbands are for life and friends are temporary, instead of the other way around. These women's husbands and lovers came and went, but the three of them were wedded fast, for better or worse, in sickness and in health. "Be careful about reading the nineteenth century back into the eighteenth century," Alicia Weisberg-Roberts warned me in a telephone conversation. "In the eighteenth century, marriage wasn't personal. It was contractual. It was external. A woman would never feel personally responsible for a failed marriage. The idea that you could entrap yourself because of your own poor choice didn't exist." It was only in the nineteenth century, when women began marrying for love, that your personal responsibility came into play, and guilt. My mother, who felt she made a terrible choice

of husband and had to rectify it, would have loved that a woman of Mrs. Delany's day could have been guilt-free.

Why go on comparing my mother to Ruth Hayden and to Mary Delany, essentially non-comparable women? Have I secretly never outgrown the fantasy everyone has that they have been swapped at birth? That really I'm the daughter of a childless 247-year-old mother? That I could throw away my mother's motto and adopt Ruth Hayden's? I don't know if Ruth has a motto, but if she does, it might be: *You never know what will happen!* My mother's motto was: *People never change.* But they do. They grow. And they grow old. And despite her motto, my mother changed. It was not in the way Ruth Hayden did, discovering her life's work aided by a trusty partner, or like Mrs. D., uncovering her life's work first through the support of a beloved husband, and then through the enthusiasm of a gutsy friend. But in view of the medicinal aura of the Bloodroot, the healthy changes in my mother's life were the kind you hope your role model will make just so you, too, can tackle orders as tall.

She gave up marriage.

And she gave up smoking.

I know it sounds bizarre to equate the two, occurring almost two decades apart, but they were both things she felt were destroying her, and after a painfully long engagement with each, she did something about them. In a way, my mother entered something like Mrs. D.'s first widowhood after she divorced my father: released into a buoyant freedom. Equating her husband with the toxicity of 300,000 cigarettes, she backed out of that suburban house with a single piece of furniture for her new apartment – a lawn chair – then she slid into a restaurant booth to share a meal

with her friends, who convinced her to break the lease and move in with them. And she did, for seventeen years.

An intense two-pack-a-day lifelong smoker, Polly up and quit cold turkey at the age of sixty-five, eliminating a defeating habit. I had done this some years before, but it had taken me eleven tries, and finally I stopped through a Cancer Society group that held my hand through every stage. My mother walked away from smoking like a gunslinger from a shootout, turning on her heel and striding out of town. Well. There's hope.

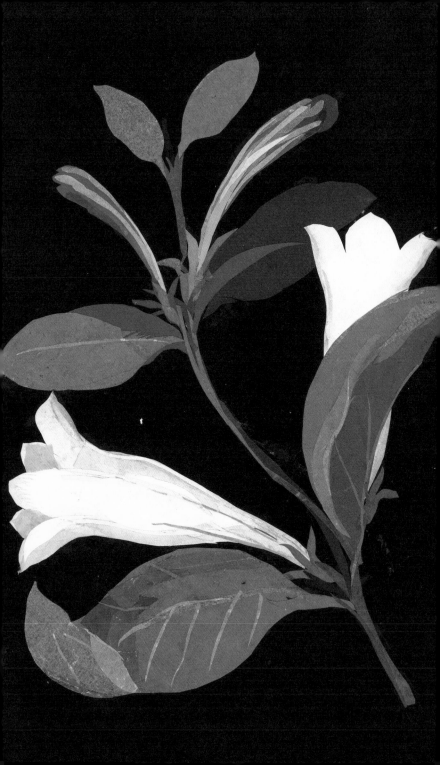

Chapter Twelve.

PORTLANDIA

Portlandia grandiflora, like the woman it is named after, comes alive at night when its huge flowers, sometimes five inches in length, give off an earthy, chocolatey fragrance. Linnaeus, in the second volume of his *Systema Naturae* (1758), named the *Portlandia* after Margaret Cavendish Bentinck, the Duchess of Portland,[1] and his tribute embraced two of her most prominent qualities – her largess and her insomnia. *Portlandia* is a generous, night-blooming plant that will flower almost continually inside if you keep it both in filtered light and somewhat humid and warm, reminding it of its tropical Caribbean home. It is a member of the family Rubiaceae, a large group of plants (which includes coffee and quinine) that grow their leaves opposite from each other, as Mrs. Delany's mosaick portrait of her flower-friend demonstrates.[2] It is cold-sensitive – and so was Margaret, the Duchess, who ran to get quilts to tuck herself and her friend Mary into their chairs so that they could continue their non-stop conversation and their non-stop work. Calling the Duchess Margaret is an anomaly; no one in her lifetime would have done it. But a first name wraps this celebrity up in a blanket of human gestures, the ordinary virtues she displayed day after day to another woman she called her friend. In

Portlandia grandiflora, Bulstrode, August 9, 1782, Prov. Kew

Mary's fragment of an autobiography she called herself "Aspasia," but she gave Margaret an Italianate version of her own name, "Maria," identifying with her friend and circumventing the formalities of class and address.

Mrs. Delany's mosaick reminds us that sepals are the source of flowerings. The bud grows inside them, then the sepals peel away. During the first four years of Mary's mourning, Margaret became a sepal-like protector. A seeing, noticing, looking-out-for pal. In asking Mary to come to visit for an extended stay of six months every year, Margaret was inviting her to the specially sealed mini-universe she had created at Bulstrode, a protecting environment.

And Mary Delany really needed it.

It's shocking to view the letters she wrote after the death of the Dean. Her hand is shakier, her writing more rushed and haphazard. Her blots and mistakes alarmed her. Rereading a letter she had written to her niece the night before by candlelight embarrassed her. "Saturday morning, eight o'clock.: Now that I see my letter by daylight I am ashamed to send such a blot; but if friends will not excuse infirmities and mistakes there can be no scribbling with ease."[3] She couldn't grip the quill in quite her usual way. The hand-eye coordination that had been so reliably superb had broken down.

As I sat in the Beinecke Library at Yale University poring over her letters to Lady Andover, they revealed to me the physical fact of her mourning, the tactile evidence of degeneration of nerves, coordination, poise, perspective, life-force. Most of us notice that our handwriting deteriorates with age. But Mrs. Delany! Her handwriting, *c'est elle*.

Margaret had palpable, personal evidence of the weird fragmentation of mourning, the sense that the world goes

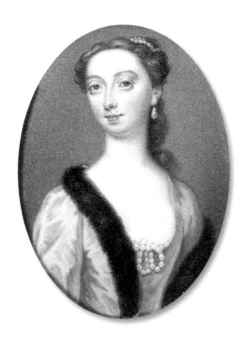

Margaret Cavendish Bentinck, Duchess of Portland, in gold box,
by Christian Friedrich Zincke, ca. 1740

its way on the other side of a piece of glass. She knew what her friend was undergoing, largely alone. Mary had nieces and nephews, but Margaret had had her children to rally around her, and the stability of her house and her lands. She knew that Mary had none of this. When Margaret's husband died in 1762, she was able to retain Bulstrode and its magnificent park as her home. She was able to live there as if she were queen of a minor country within England – let's call it Portlandia.

Her courtiers were not politicos or major aristocrats. They were men, not usually of rank, who had astonishing intellectual interests and artistic accomplishments, and they

were women of rank who participated in the interests of science and art and ideas. She surrounded herself with botanists, ornithologists, conchologists, and entomologists. Eight miles down the road from her tiny country lived the King and Queen of England, George III and Charlotte, and their myriad children, thirteen little princes and princesses. They, too, shared many of the interests of the Portlandians.

Portlandia was also a state of mind – the state of mind of a woman so ambitious she had decided to try to collect all the previously unknown animals, minerals, and vegetable life in the world. For this woman, creative life was not a question of having a room of her own, but a cosmos of her own. Her energy buzzed into the wee hours. She had to exhaust herself before she fell asleep. (That is what her bevy of attendant readers was for; she was often read to well into the night, and she kept actor's hours, rarely rising before noon.) A hungry intellectual and a voracious collector, everything interested her: fine art, minerals, shells, fish, wildlife, plants, ceramics – and people, too. Her cosmos, over which she was intellectual, financial, emotional queen, spun on her wealth, her vigor, and an energy born of a curiosity about the world that bordered on the fabulous, since her collecting had begun in childhood and continued with a child's grandiosity.

Margaret, the only surviving child of Edward Harley, second Earl of Oxford, and Henrietta Holles (daughter of the Duke of Newcastle-upon-Tyne), had been around eight years old when she'd encountered Mary Delany, then the twenty-two-year-old Mary Pendarves. They'd met through Margaret's mother, the prim Henrietta, to whom Mary was closer in age. (Lady Harley was just six years older than

she.) In the summer of 1722, when Mary was living in Rose Street with Alexander Pendarves, she described being "all night upon the water with Lady Harriot Harley. We went into the barge at five in the afternoon, and . . . rowed up the river as far as Richmond, and were entertained all the time with very good musick in another barge. The concert was composed of three hautboys, two bassoons, flute . . ."[4] In other circumstances, Mary might not even have met Margaret, but as an extremely precocious only child, Margaret had been brought up among her parents' friends. When she was only five the poet Matthew Prior dedicated a poem to her, "A Letter to Lady Margaret Cavendish Holles-Harley, when a Child." (The poem told her to please her parents, Edward, a collector of fine arts, and Henrietta, so strait-laced that Mrs. D., many years later, felt she wrecked all the fun at Bulstrode.)[5] The child and the young woman bonded with a big sister–kid sister jocularity. What perhaps also knit them together was their shared interest in plants and animals, as well as Margaret's collector's instincts, already formed at an early age and encouraged by her father. A sheer sense of play pervaded all they did together, a buoyant creativity that sparked between them as they connected and reconnected with one another over time, through Margaret's marriage to her "Sweet William," which joined her considerable fortune with that of William Bentinck (1709–62), the Duke of Portland, through the bearing of her six children, through Mary's marriage to the Dean.[6]

The two became the kind of friends who made each other laugh, who nudged each other when they shared a private opinion, and who grew up to read each other's thoughts, such as their disbelief in the hopeless lie told by

Lord G. (a.k.a. Bunny, Mrs. D.'s brother Bernard, Lord Granville) one night at Bulstrode:

> We were talking the other night after supper of "*Will-in-the-wisp*," one person in the company said he "had seen one once;" some said they had never seen one, but wished to do it, and others that they were not sure that they had ever seen any such thing. "Oh!" says Lord G., "I have had twenty of them round my chaise at a time, nay, 30 or 40." A profound silence ensued, and the wicked Duchess trod on my foot, so that with the utmost difficulty I kept my countenance.[7]

Together the two friends noticed everything around them. They loved to walk, look, catalog, and describe. Because Mary was a consummate noticer and noter, perhaps the way she rendered into words what she saw satisfied some of the younger Margaret's extreme need to grasp the world before her. The gap in their ages gave the older Mary a way to balance herself against the younger woman's much greater wealth and glittering rank. Mrs. D. had a calm sense of her own worth that allowed her to appreciate how riches, eccentricities, and avid interests shaped Margaret's lust to accumulate all there was to know about animals, minerals, and plants, and the specimens and artifacts to support that knowledge, too.

By the time Margaret invited her friend to live at Bulstrode, just after the Dean's death, the two had achieved an intriguing balance of age and experience with title and wealth. The widow and the mother of six children stepped into her friend's grief, directing her, insisting that she listen, and reinforcing her views, in candid correspondence with her friend's niece Mary Dewes:

I think it very proper Mrs. Delany should have a house of her own, but beg she will not determine immediately, nor can I see any reason for her settling at Bath. Why not have a house in London? that would certainly be the most advisable; she would then be *amongst* her friends and relations, and she could spend every summer with her friends, who would be *so happy* to have her company.

Mary's earlier decision annoyed Margaret. "I hope she remembers how much I was against the selling her house in Spring Gardens. How vexatious that it is gone! . . . I beg she will not take a sudden resolution, at least by no means *to buy* a house at Bath."[8] By the time Margaret had persuaded Mary to rent another house in London and then to spend six months a year with her at Bulstrode, to recover from years of worry as well as to relax into the guilty relief that anyone who has attended an ill person, however beloved, feels upon that person's death, the two women had been friends for more than forty-five years.

At first she treated Mary as a convalescent. She assigned her a suite of ground-floor rooms at Bulstrode so that her friend could avoid stairs, and made the great house into a bit of a rest home for her. In the fall of 1768 Mary breakfasted with "the little Jonquil parrot . . . the prettiest good-humoured little creature."[9] Then the Duchess strolled her through the Bulstrode grounds toward a pond where Mary witnessed "gold and silver fish . . . in shoals, thousands I am sure, all swimming up in a body to the Duchess, who fed them with bread." They walked the acres of the estate together, making "frequent stops . . . to examine plants and funguses."[10] This was all part of an attempt to distract Mrs. D. from her grief, because she had simply fallen apart.

In mourning, she walked alone through the Bulstrode grounds trying to "[banish] sad thoughts" by feeding the wild hares and pheasants the Duchess had tamed:

> I took a basket of food for the creatures, fed them, and walked an hour and three quarters, so much amused with the variety I met with and the delightfulness of the place, that it for some time banished sad thoughts, and I was not sensible I had walked rather too much till I came home and sat down. I was chid by my kind friend, who says she will not trust me again alone.[11]

Like her fictional heroine Marianna, the main character of the novella she'd written ten years before in 1759 but never published, Mrs. Delany lost track of time and where she was. Marianna, all alone, got lost on a long walk and was kidnapped by gypsies, but at Bulstrode Mary had Margaret, her worrying guardian.[12] Again and again Mrs. Delany was consoled by the safe view from her ground-floor windows. "A pretty and uncommon scene is now before me on the lawn: a flock of sheep, shepherd and dog at a little distance, and in the foreground (to talk like a painter) fifteen or sixteen hares *feeding with peacocks and guinea-fowl.*" Bulstrode felt like a painting come alive.

Streams of visitors passed through daily. One day, when the Duchess's son Lord Edward was ill, Lady Wallingford, Mrs. Pitt, Prince and Princess Czartoriski, a collector named Mr. Archard, and Dr. Tuxton – who bled the ill Lord Edward of "fifty ounces of blood" – all rode carriages up the long drive through Bulstrode Park and entered talking. The chatter, the servants scurrying, the caged birds squawking, wearied the bereaved Mrs. Delany, who cared little for

"what's doing in the Grand Monde. The Duchess and I were comfortably at home the whole day."[13] Yet when she returned to her apartment she was excruciatingly alone. "How solitary my dressing room . . ."[14] Delville was auctioned off. Never once in the known letters from this time does she mention the Dean's name, though she alludes to Ireland.

"Company . . . rather fatigues than entertains me."[15] But the constant company was part of the whole ambience of Portlandia. Mrs. D. was going to have to find a way to balance stimulation and fatigue, because she had accepted an invitation to enter what became affectionately known as the Hive. Besides being a social hub, Bulstrode buzzed with the activity of a nascent research institute. It was more than a grand house; it had become a prototype for a museum.

A serious botanist, Margaret possessed one of the most extensive natural history collections in England. She had began amassing shells as a child, and after her marriage collected butterflies, insects, fungi, and coral. She had purchased shelves upon shelves of antiquities, as well as paintings and ceramics and other fine art. She had designed the gardens of Bulstrode, and she had ordered its greenhouses built. She had collected countless plant specimens for those gardens and glasshouses. She built a zoo. She encouraged the local wildlife to roam her lawns, and at sunset a host of hares would nibble at the tender grass shoots below the long windows of her fortress.[16]

The life work of Margaret's widowhood was her startlingly ambitious project "to have had *every unknown* species described and published to the World," as her personal chaplain, the Reverend John Lightfoot (1735–88) wrote.[17] Lightfoot doubled as her personal botanist and conchologist, consulting as she drew and catalogued her specimens.

(He himself was the author of *Flora Scotica* and the winningly titled *An Account of Some Minute British Shells, Either not Duly Observed, or Totally Unnoticed by Authors.*)[18] Our sense of specialization today can barely accommodate a person who both took holy orders and was a substantial scientist – and was employed by one woman for his expertise in religion and in God's creations, not to mention gracing her dinner table.

As well as Lightfoot, Georg Dionysius Ehret was part of the Hive. Ehret was the stellar botanical draftsman who illustrated for Linnaeus and was also the drawing and painting teacher of the Duchess's daughter Elizabeth. As one of Ehret's patrons, the Duchess owned hundreds of his energetic, pulsing botanical works on vellum.[19] Lightfoot was giving sermons and collecting specimens; Ehret was identifying specimens, dissecting them, and then drawing and painting them. The elderly Philip Miller, who brought the Chelsea Physic Garden into prominence and who traded specimens with John Bartram, also contributed specimens and information to the Bulstrode Hive. (Miller, a conservative who favored pre-Linnaean classification, wrote *The Gardeners and Florists Dictionary: or a Complete System of Horticulture* in 1724 and *The Gardener's Dictionary: Containing the Methods of Cultivating and Improving the Kitchen, Fruit and Flower Garden* in 1735.)

Slowly Mary began to incorporate Margaret's lightness of feeling into her numbness. "It is pleasant to see how [the Duchess] *enjoys* all her own possessions."[20] Picking up on others' energy, she began to find an energy within herself again. "Mr. Ehret is here, and [the Duchess] is very busy in adding to her English herbal; she has been transported at the discovery of a *new* wild plant, a Helleboria."[21]

When it was time to leave Bulstrode, Mrs. D. was able to lift herself up, bump along in a carriage to London, and settle in at her rental, Thatched Court House. She gathered more energy in the city, and by the time she returned to Bulstrode in the fall of 1769 she found it irresistible not to have her own project. She took up multiple quills (the flight feathers of geese were common),[22] to prepare to copy out in her own hand 474 pages of Hudson's *Flora Anglica*, which had been published in London in 1762. She added notes, "among them one on '*The Fir-coned Hydnum*' – 'this was found at Bulstrode on fir-cones, in November 1769.'"[23] By the end of this effort, her copperplate hand had returned to its elegance. Lady Llanover marveled at her handwriting: "Mrs. Delany was then in her 70th year! but there are no blunders of the pen!"

Simply by copying the many pages of the *Flora Anglica*, Mrs. Delany was retraining herself, re-forming her hand, reconnecting nerves and tissue, focusing herself on composition and line. As she re-educated her fingers, she revised her vision. Her copying project was like a self-constructed program of physical therapy.

Still, nothing tasted good to her, and she had bad dreams, as she wrote her niece from Thatched Court House in London. "I eat half a roasted onion for my supper, and I dreamt of hobgoblins! . . . Sunday morning tasted my *new* tea, and was almost poisoned with it; made my complaint immediately, and hope for redress."[24] She carried her doldrums to Bulstrode, writing to her friend Lady Andover in June 1770 about "the stupidity of my spirits . . . how low an ebb must they be . . . In such a state I ought to wrap myself up in my own web, and not carry my infection abroad. All this is a gloomy indulgence of broken spirits, and I will

shake it off."[25] She marshaled herself for the massive social-
izing that life at Bulstrode required. She and Margaret
dined with the talkative, theatrical Garricks, and she under-
took to do battle again with her brother.

Bunny was attempting to thwart yet another marriage,
this time the union of Mary Dewes to John Port; they
were guests at Bulstrode. The warrior-friend Margaret
put the kibosh on Bernard's interference by refusing to
let the couple leave her house unmarried. With the silver
overlay of faeryland that Portlandia seemed to retain, the
couple were transformed, married and safe from Bernard,
the wicked warlock of Calwich, ever ready to do mischief.
The wedding of the young couple coincided with more
work on the Cave – a grotto Mrs. Delany had been work-
ing on at Bulstrode since the 1750s. Now she was lining it
with more shells.[26] She got a chenille-work project under-
way, a set of chair covers embroidered with splashy
images of birds.[27]

"And now for a little of Self & Co.!" she was able to joke,
back in London. "I am an old, a very old puss in a corner."[28]
Metaphor crept back into her expressions as she compared
the newly married Mary Port to jewelry: "I shall want my
brilliant Mary to be the *locket to the bracelet.*"[29] By the
summer of 1771 Mary Port had become pregnant and her
old puss of an aunt bought a house for herself on St.
James's Place in London, hiring workmen and moving fur-
niture and securing recipes for pap, or pablum, to feed
Mary Port's newborn.[30] By now Mrs. D. had had three years
of gradual rousing from the somnolence of mourning.

By December of 1771, the "old puss" ventured with the
Duchess to Joseph Banks's house.

We were yesterday together at Mr. Banks's to see some of the fruits of his travels, and were delighted with paintings of the Otaheitie plants, quite different from anything the Duchess *ever* saw, so they must be very new to me! They have brought the seeds of some of them which they think will do here.[31]

Sir Joseph Banks (1743–1820) and his friend the Swedish naturalist Daniel Solander (1733–82) were perhaps the most glamorous contributors to the Duchess's Hive. When the energetic Banks inherited his family estate, he pursued his interests in botany, meeting Solander at the Chelsea Physic Garden. Solander was a student of Linnaeus who came to England, charmed the aristocracy, and was elected to the Royal Society (the equivalent of an Academy of Science). Through Solander, Banks corresponded with Linnaeus.[32] Banks, too, was elected to the Royal Society, and it was there, after he made a name voyaging to Newfoundland and Labrador, that he wangled a chance to board Captain James Cook's ship, the *Endeavour*. Banks and Solander accompanied Cook as ship's botanists and zoologists on his famous voyage to the Pacific Ocean, where they collected specimens in Brazil, Tahiti, Australia, and New Zealand. By the time Banks returned to England in 1771, loaded with botanical exotica, he was famous.

While Solander was busy making the first description of the kangaroo, Banks was cataloguing hundreds of plants, from eucalyptus to mimosa.[33] King George III and Queen Charlotte immediately championed Banks, who became adviser to the Royal Botanic Gardens at Kew. "They are preparing an account of their voyage," wrote Mrs. Delany to her niece Mary, "but the Natural History will be a work by itself, entirely at the expense of Mr.

Banks, for which he has laid by ten thousand pound. He has already the drawings of everything (birds, beasts, plants, and views) that were remarkable."[34]

Banks and Solander showed the visiting women not only seeds and paintings but petite parrots, too. "The branches are frequently full of a little blue parrot, not bigger than a bullfinch, and they snap off the flowers so fast that the ground is quite strewed with them." Banks and Solander confessed to Mrs. Delany about their plant-nabbing in South America, perhaps not meaning for the old puss to note their haul for the permanent record. "At Rio del Janeiro, . . . they landed by stealth, and in two hours time got near forty plants."

By February 1772, Mrs. Delany, "who looks well, fresh, *en bon point*," according to a friend of her niece, was so completely settled into her new house that the friend described it as "cleverly-arranged."[35] Even Mrs. D.'s impossible brother didn't faze her. Harnessing his sadistic impulses, he contrived to make Anne's third son, the Reverend John Dewes, his heir instead of the person who had all along expected to inherit, Anne's first-born son, also named Bernard. "Alas, poor Bernard!" Mrs. Delany's friend Countess Cowper exclaimed about the expected inheritor. "Some people contrive to make their family unhappy, even after they are dead!"[36] In her cozy place Mrs. D. happily received gifts of food from her friends: "Venison from Mr. Montagu; pork and turkey from Mr. Dewes; fowls and hares from Sandford; a perigot pie from Duchess of Portland on the road, and potted rabbits, all within one week!!"[37] Sanguine about her family, safe in her house, four years after the death of the Dean, whom she still hadn't mentioned by name, she came to the simple

statement of her turning point: "An ingenious mind is never too old to learn."

Her insistence on keeping busy resurfaced. She was calm, engaged, located, and alive. Refreshed, her appetites had returned. And though she was not painting, and perhaps never would again, she wrote, copied, sewed, and soaked in information from all around her. She had been so parched in the years after Anne's death and so depleted in the years taking care of the Dean that only gradually was she able to begin to take in the brilliant facts of the world one ignores when training attention on illness and death. Starting with the delight of a "jonquil parrot" or a "yellow carnation," it took four years – the equivalent time of a university education – for her to reclaim and wake, though not to forget.

By her fourth summer at Bulstrode, Mrs. D. was completely a part of the household and the routine – and venturing about in the Duchess's carriage. In August 1772, the two drove to Wroxton Abbey to see the Gothic Picturesque gardens planned by Sanderson Miller.[38] "An open country is but a canvass on which a landscape might be designed," Horace Walpole famously said,[39] but Wroxton proved a canvas that Mrs. Delany made little progress into, because something stopped her forward motion.

The thing that many of us dread – not being able to get around, being dependent, our range of mobility narrowing – had happened. The cause was just a little accident of nature. Mrs. Delany was stopped literally in her tracks because she was stung on the foot by an insect. Her foot swelled to such a degree that it was impossible for her to put on a shoe. (I do not mean a leather twenty-first-century shoe, one made for the right foot, one made for the left. I mean an eighteenth-century woman's

shoe, often made of fabric and sewn to order, but without a concept of left and right – both shoes cut out the same.)

The bite gave her a fever.

The fever kept her further immobilized.

> The bite of the gnat (I rather think it must have been something more venomous), was a very troublesome affair, and came at an unlucky time, for I was not able to walk at Wroxton, and in so much pain (which made me very feverish), that I could not enjoy the place.[40]

Mrs. D. went back to Bulstrode but was hardly able to ride very long in a chaise and couldn't wear a shoe for some time. "It is now pretty well again, though not yet able to wear my shoe, but a large slipper." It seemed that just as soon as she had gotten mobilized from mourning, just as her life-saving busy habits had been able to return, as all her friend's ministrations had paid off, as she'd thwarted her brother, as she took up her embroidery needle, as she walked, and walked, and walked, she was stopped. By a fever and a "gnat."

Now she was mandated to be off her feet. Just as she had revved up into her former self, she was obligated to take a pose of meditation, to sit still, obliged to keep her swollen foot raised and in its slipper.

It was at this moment, retrained in her calligraphy, awakened to the world but required to be motionless, that she noticed something. Immobilized at a table in her apartment at Bulstrode, she inspected the air as a scarlet petal from a geranium (*Lobelia cardinalis*) dropped to a dark surface below. Assembled around her were the tools of her entertainment while she was off her feet: wallpaper, paints, inks,

thread, scissors. At that moment, the lifelong habit of simile dropped into place just as that petal descended. Nearby lay a piece of paper nearly the identical color.

As Ehret drew and painted, as Lightfoot classified, as the Duchess received yet another shipment of porcelain or bugs or roots or shells, Mary, alone at her table, took up her scissors, having been told like a child that she must sit still. When the Duchess came in to check on her friend, shocked that she had taken apart her new scarlet geranium, then delighted that what Mary had composed were the petals in paper replication, the first of the great work had begun.

"I have invented a new way of imitating flowers."[41]

Right then Mary Delany's friend of more than forty years supplied exactly what was necessary: applause.

309

Portlandia grandiflora, detail

A magnification of the sepals at the base of the pink buds of the *Portlandia grandiflora* shows the abstraction beneath its realism. With a palette of eight types of green, two ochres, and a yellow, Mrs. Delany demonstrates theoretically how a flower grows. Out of the pointed chaos of the confusion of green vectors comes a fireworks of pink and lighter pink, directed upward as bloom. What's fun about this detail is that you can actually see the jagged edges of the cut marks. Although scholars have speculated about the many types of implements that Mrs. D. would have relied on, and though we have the embroidery tool kit that Queen Charlotte gave her, the one item that Lady Llanover emphasizes in her descriptions of Mrs. Delany's technique (and Lady Llanover probably based her descriptions on her mother Georgina Port's direct observations), is a pair of scissors.[42] Magnification of the *Portlandia*, finished when Mrs. Delany's eyesight was at an ebb, reveals the rough edges of paper cut by scissors, not sliced by scalpel.

Portlandia grandiflora is one of the very last flowers that Mrs. Delany's fading eyesight allowed her to complete. It was good to save it for among the last, since the type of eyesight she still had left enabled her to see both the huge, pink-tinged white flowers, gardenia-like but also a bit like Moonflowers, and the large, shiny, stiffish leaves, and to cut them out in large swaths. It is one of her simpler mosaicks, *Portlandia* being a flower designed for simplicity. But she did not forget to cut out the sepals, to feature them almost as bows at the necks of the big blooms. When she fashioned the collage, she commented on it in writing, copying its description from Browne's *History of Jamaica* and noting that "This plant is called by the name of '*Portlandia*,' after the present Duchess of

Portland, who is a great lover of botany, and well acquainted with the English plants."[43]

Below her description, Mrs. Delany wrote a poem, not directly to her friend but to the flower that emblemized her.

Fair flower! that bears the honoured name
Of HER whose fair and spotless fame
 Thy purity displays.
Emblem of Friendship's sacred tie,
Thy form is graced with dignity
 Superior to all praise.

At the time of her most intense mourning, more than a decade earlier, Mary had turned to another friend, Lady Andover, to describe Margaret, not with the formality of her poem but with the force of her daily expression. "She ever forgets her own sufferings when a friend wants her to sooth her grief, or support her under any tryal. . . . *She* is wise without insolence, and entertaining without a grain of conceit! I could say a thousand things more, but to crown all, and what I feel with the most affectionate gratitude, she is the best and steadiest of friends."[44]

Margaret began applauding Mary in 1772 and continued non-stop for ten years. Her delight, her approbation, her support, her enthusiasm, and the weight of her opinion because of her enormous wealth carried the word of her friend's innovations throughout the botanical, artistic, and aristocratic worlds. Horace Walpole, Sir Joshua Reynolds, Hannah More, and Sir Joseph Banks talked about Mrs. Delany, evaluating what she did, because her friend the powerful Duchess brought her work to their attention. The provenance of this mosaick is Kew. The flowering plant

was sent to Bulstrode from Kew Gardens at the request of the King and Queen just so Mrs. Delany could see the specimen and make her botanical art from it. The fantasy kingdom of Portlandia allowed a real King to notice the flowering of one of his oldest subjects.

{ S E P A L S }

The exterior of Bulstrode today bears little resemblance to the stately, Dutch-gabled Bentinck house. For one thing, it received a Victorian facelift in the nineteenth century; for another, it was, like Evelyn Waugh's Brideshead, commandeered by the army during World War II, in this case the British Women's Auxiliary Air Force. Its great rooms became huge institutional kitchens and mess halls. After the war it fell into disuse and is now used by an evangelical Christian organization as its headquarters and to bivouac missionaries between assignments.[45] A long private drive winds up a hill toward it, surrounded by acres and acres of rolling lawns and woods and grazing horses. The private drive does not replicate the direction that the Duchess's carriage would have taken Mrs. Delany, that stout Anglican. Mrs. D. took her Christianity straight up: she certainly felt she would meet the Dean in Heaven; nowhere does she fear that they might roast in Hell.

In an atmosphere creepy with the cordiality of evangelism, I crossed Bulstrode's great hall, the walls swaddled with coats of institutional beige, the floor swathed in ancient, trod-on brown carpeting exuding a perfume of mold and institutional food. Up the grand staircase the rooms were broken up into warrens of apartments by makeshift fake-wood walls. No Polish princes, no jonquil

parrots, no letters anyone could write about "an imperial ambassador" dressed in "blue velvet, the buttons and *buttonholes* set with diamonds."[46]

An angle of an approximate view from the direction of Mrs. Delany's windows still exists, down toward the allée of lime trees the Duchess planted, a vague trace of some garden beds, and the water where Bulstrode goldfish must have swum. I was invited to look out of those windows with a similar view, and I did. It was hard to get a Margaret-and-Mary feel, though. Because the missionaries were anxious for me to surrender my coat (I was doing anything to avoid being sat down and given a sermon), I excused myself to walk through that allée, to see and touch some of the lime trees, not to be confused with lime fruit trees, that Mrs. Delany must have seen. Outdoors in frigid, damp late-November 2008, even a poet's imagination had a hard time conjuring the glorious summers of the mid-1770s. No hares nibbled on the lawn. Eventually I fled to the warm taxi I had paid to wait in rescue.

I wished I had a friend waiting for me. I was traveling and researching all alone; Mike was back in Canada teaching. In the taxi, as I totaled up the reasons why a woman could start a great work of art in her seventies, all the way from the training she'd received at the age of six to the retraining of her hand in copying at seventy, and from the intense observing and envisioning she'd done her whole life to the mood of reflection and remembering she had entered just because a bug took her off her feet, I wished I had a friend to tell. Approbation. The recognition and praise of the Duchess for Mrs. Delany's imaginative act triggered more acts.

How many times in the back seat of a taxi had I jabbered on about my poems to my friend the poet Phillis Levin, and she to me? We have each seen every single poem that the other one has written for almost thirty-five years. If I total the dinners, lunches, breakfasts, and teas minimally at every other month, it's well over two hundred meals lazily, dreamily, talkily, intensely shared over poetry. I really mean sharing, since we order a little banquet and divide each dish, passing copies of our poems back and forth over our lamb shanks, basil eggplant, and sole almandine, and over endive, frisée, potato pancakes, sesame noodles, espresso, jasmine tea, sake, Burgundy, Soave, biscotti, fortune cookies, crème brûlée, and all the other dishes we have eaten together from 1976 to the present.

We have never critiqued one another. That's not our point. What we do is read and spin off from lines as we think out loud, in a whirl, an atmosphere of mutual adventure, although we are quite different from one another aesthetically. Because the point is exploration, we've never made any attempt to change each other. Our poems stimulate our talk, whether the talk is of technique (we could easily do a complete appetizer course on the uses of the semicolon) or attitude (the loneliness of an acorn) or idea (how does a gap resound?). Phillis is more of an intellectual than I am, more of a brown-eyed beauty with her Pre-Raphaelite dark hair; I'm the fair-haired one who cradles the idea. In terms of our poems, I'm the sensualist; she can live on air. Somehow, probably because I am seven years older and started my literary life earlier, we've never really competed, though we're both ambitious and both, miraculously, have had our share of success.

Where would the ten volumes of poetry we've written between us be without our mutual excitement, exploration, and talk? From the moment we met in a graduate poetry workshop on a humid September afternoon in the echoing basement of Gilman Hall at The Johns Hopkins University, we instantly liked – and now that I look back, I would say we loved – each other's metaphors, stanzas, lines, vocabulary, punctuation, each sourced in a separate wellspring of creativity. We don't feel we have to adore everything the other does; I write about some things I know Phillis won't connect to (plants, for one thing), and she writes about some things that dumbfound me (Zeno's paradox, for instance).

We are part of the same literary family. You don't get to choose the members of your biological family, but you do get to pick your literary sister. Your chosen literary family can extend over thousands of years and beyond the borders of empires, poet connecting to poet, sharing the mitochondria of imagination. Neither Phillis nor I can conceive of how a person can process the material of a life, and by that I mean love and death and every insect bite in between, without practicing an art. The creativity of everyday existence, the balance and poise of being able to ride it all out, the flash of connection, the image that reveals and tells all, sways back and forth between us like an aerialist's swing that we catch and fly from. Though Mary Delany sat in her solid body, anchored by its swollen foot, her imaginative leap was light and aerial, and her friend Margaret caught her in midair.

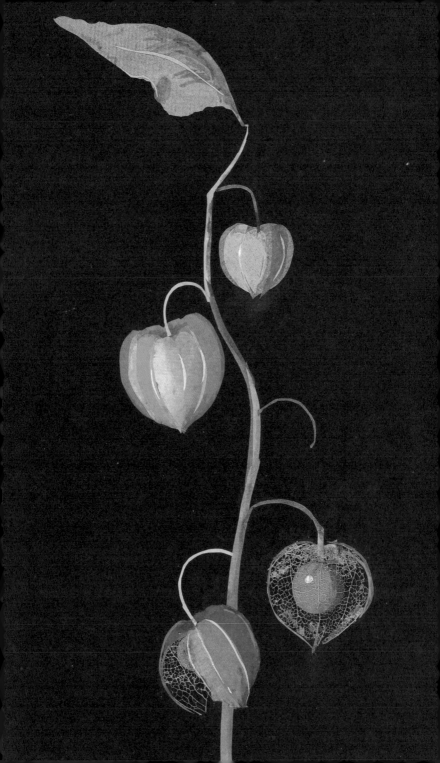

Chapter Thirteen.

WINTER CHERRY

The *Physalis alkekengi* is among the paperiest of plants. The lanterns, which are the seedcases, start drying so early on the stem that all you have to do is harvest the stalks and lay them on their sides for a few days, and you have one of the most brilliant dried autumn bouquets a person could want – except for the fact that the orange lanterns are attached to the main stalk by stems so brittle that half the damn things break off. Mrs. Delany was all too aware of this when she left one of the little prongs without its lantern. A ghost of one hangs there in the middle of the mosaick of the plant she called *Winter Cherry* but which many of us know as Chinese Lantern or Bladder Cherry.

Encased in each lantern is a tiny red fruit which is supposed to be edible – I've never tried one. As the fruit matures, the lantern around it becomes like vermilion wrapping paper, but then that wastes away to a net-like skeleton, leaving the cherry at the center visible. Mrs. Delany pasted the desiccated netting of the real plant into two of the *Winter Cherry* lanterns. The astounding fact that this most fragile, web-like material has stayed put for these last – well, we don't quite know how many years, since this particular collage isn't dated – gives the mosaick a feel of a

Physalis, Winter Cherry (Berry), Bulstrode, November [year not specified]

page of an artfully arranged floral scrapbook. The use of the dry material is so sensational that anyone with experience of this plant can't believe it has held up, and anyone without experience can't assimilate how Mrs. D. managed to glue something so brittle and make it stay. *Winter Cherry* is an analogous name for Mrs. D.'s whole enterprise. It was the winter of her life when she began them, and any woman by that time of her existence probably feels very dry indeed.

It's a reminder that the Latin *hortus siccus* – used since the 1530s, according to Mark Laird, to denote "albums of dried and labeled specimens"[1] – means "dry garden." All Mrs. Delany meant to be doing at first was to concoct something like a book of pressed flowers. She had crossed her plain of mourning, and a scrapbook suited her launch into remembering. "The paper Mosaic work was begun in the 74th year of my age (which I at first only meant as an imitation of an hortus siccus)."[2] But over ten years her idea would become an analog to experience, a memoir in paper flowers, an autobiography in botany.

On the stalk she placed four lanterns in four stages of life, letting the mosaick work as a portrait of the whole enterprise of 985 flowers. (And let's not quibble over whether she was seventy-two, the date of her first mention of the mosaicks, or seventy-three, as she suggests by "in the 74th year of my age" when she started them.) The *Winter Cherry* is also an emblem of the woman who executed them, a self-portrait of the artist as a single stalk of a plant, showing her at four of life's stages: the green lantern of childhood; the fully dressed, bright orange one with slight hip hoops – young womanhood; the lower lantern with part of the dress removed to show the interior of the plant – increasing maturity; and the last lantern, the heart of the

aged woman. The fine ribs of the plant material make the skeleton of the former lantern into something like a rib cage, with the cherry beating inside.

In some ways the *Physalis* answers the question of why it took her so long to make the leap from limner (as she would have known herself) to artist (as we know her). The Winter Cherry is a biennial. Though there are some common biennials (parsley and Sweet William, for instance), they're not that big a plant group. Biennials take two years to complete their cycle, usually growing only leaves in the first year, then in the second year bolting up to produce flowers (little white ones in the Winter Cherry's case) and fruit. *Physalis alkekengi* is a plant of withheld growth. The biennial is an obvious analogy to Mrs. D.'s life: her two marriages, two widowhoods, and artistic dormancy. Some of us flash into floral peak like prom queens, but others of us have to dry like the Winter Cherry in order to unfold into productivity.

With her foot in a slipper, with her friend in her Hive, with a lifetime of craft skills and seven decades of sheer noticing, Mrs. D. at last had become a virtuoso. Her earlier drawings, for instance, were charming – charm is entrancing, but it is not requisite for art. Mere self-expression is not art. Nor is excellent technique on its own. But the art that Mrs. Delany's life bolted up into, as the biennial bolts, came with all the mesmerizing boldness of confident expression molded by technique. Both passion and virtuosity are required for this leap, and at last she had attained equal levels of them. The combination brought the flower mosaicks out of the category of curiosity and into one of enduring vision.

After that insect bite tossed Mrs. Delany to the breast of memory and then to the breast of inspiration, she

proceeded to experience the best decade of her artistic life. The letters of the next ten years display the amount of activity this woman engaged in, and it is staggering. The letters are not a journal of how she made her *hortus siccus*. To find out about her materials, her order of making, her enterprise requires digging through mounds of socializing, philosophizing, servant worries, opinions on education, remedies, maladies, and royals. Here and there in the leafy glade of her letters a ripe berry of information gleams. These letters are not boring. They're never quite as intimate as the letters to her sister Anne, but they zip. They career. They carom. And they yield a handful of modest clues.

Because she was making the mosaicks at Bulstrode, and because of the sheer foot traffic through the place, not to mention the horticultural and botanical talent, a wide number of people began to know – and discuss the fact – that Mrs. Delany had embarked on this enterprise, even though she had a slow start, only a smattering in the first couple of years. Yet on July 11, 1774, Samuel Johnson stopped to visit her niece and nephew-in-law, John and Mary Port, at their house at Ilam, in Derbyshire, about 170 miles from London. Someone, probably Mary Port, wrote in a notebook, "*Dr. Johnson at Ilam.*" Dr. Johnson quoted Edmund Burke's breathtakingly hyperbolic statement about their aunt which was already circulating: "She was a *truly great* woman of fashion, that she was not only the woman of fashion of the *present age*, but she was the *highest bred woman in the world*, and the woman of fashion of all ages; that she *was* high bred, great in every instance, and *would continue* fashionable in *all ages*."[3]

This statement may not have been made exactly about what she was fashioning on paper, but it was made in a kind

of awareness of her age and venerability. An old lady was intact, with her brains, with her sense, with her imagination. She was beginning to be abrupt with people in order to do her work, asking their forgiveness for "my being in haste to finish a flower for my hortus siccus."[4] This abruptness – not demonstrated before as she gracefully, if sometimes resentfully, accommodated the hundreds of visitors in her life – shows the incivility of the artist at work (what others call selfishness). She was compelled – especially since she worked from live specimens, and living plants change every day, some of them minute to minute.

As she inspected her specimens – plants in bloom first from the Duchess's greenhouses and gardens but soon from a variety of sources, from nurseries to neighbors – she was struck again with a spiritual connection between the artist as creator and the Creator of nature:

> I hope it is not only the beauty and variety [of the natural world] that delights me; as it is impossible to consider their wonderfull construction of form and colour, from the largest to the most minute, without admiration and adoration of the great Author of nature.[5]

In the previous years, she looked to nature for distraction, but now the natural world talked back. "We are now consoling ourselves, with books, work, butterflies, fungus's, and lichens: they entertain us and tell us pretty moral tales."[6] The mosaicks were telling their tales, too, like diary entries. In 1775 she amped up the number, completing, according to scholar Lisa Ford, around fifty-five.[7] In June of that year, a young Chinese man traveling in England was introduced at Bulstrode. "Last Friday we had an extraordinary visitor

here; Mr. *Whang at Tong*; thus he writes his name: – You know the Chinese write perpendicularly."[8] Mrs. D. promptly learned from him to write Chinese characters, then cut a mosaick of a plant called Old Tyger's Ear, labeling it in ideograms. Emily Dickinson's musing about the "career of flowers" that "differs from ours only in inaudibleness" vivifies – and reverses – as Mrs. D. makes each flower talk. "I feel more reverence as I grow for these mute creatures whose suspense or transport may surpass my own," Dickinson wrote to her Norcross cousins almost a hundred years later,[9] and the whole idea of the "language of flowers," corny in hands other than Dickinson's – and Mrs. Delany's – begins to form syllables of meaning in blossom after bloom, of hortomorphized memory combined with the sheer joy of observing the world as it is.

By the spring of 1776, when a revolution was about to take place on the other side of the world, Mrs. Delany was at the inner circle of Bulstrode's court, snug as a Winter Cherry in its orange jacket. Not oblivious to the American problem but without interest in politics, she warmly reflected: "Happiness may seemingly retire sometimes under the disguise of losses, trials, or worldly disappointments, which in the train of life may happen, and indeed in some degree must, but you are *sure* of *finding her* again with *added luster*."[10] It was the *hortus siccus* that was adding luster. "The *spring flowers* now *supply me with work*, for I have already done since the beginning of March *twenty plants*," she wrote at the end of April.[11] Among them was the *Hound's Tongue*, with its blue flowers that were both cleaving and leaving. By the end of 1776 she had added 135 pages,[12] including the billowing white nightgown of the *Magnolia grandiflora,* which she cut out in August at

322

Bill Hill, the *Opium Poppy* in its green cape and red gown, fashioned in October back at Bulstrode, and the *Nodding Thistle* with its prickly bow of the head in November, snipped out at Bulstrode, too.

Though Mrs. D. was so observant of all the details of life, right down to ladies' teasing their hair so high that they couldn't fit into their carriages – "I hear of nothing but balls and high heads – *so enormous* that nobody can sit upright in their coaches"[13] – her letters are dry of her trials and errors, except for one succulent reference to technique from June 1776: "I have been busy at my usual presumption of copying beautifull nature; I have bungled out a horse chesnut blossom that wou'd make a fine figure in a lady's cap, or as a sign!"[14] "Bungled," easy to read as ordinary false modesty, also implies mistakes, and that Horse Chestnut mosaick is so complicated and so big that it must have invited plenty of errors. This little nugget of explanation also shows that she intended her collages to be portraiture. It's an easy leap from a woman's hat to a figure itself. In another letter from the same day she speaks of her flowers as ladies, and explains the reason that she is writing on this day rather than the day after. "I began my letter to-day, as I have made an appointment for to-morrow with a very fair lady called 'Lychnidea.' If I neglect her, she will shut herself up, and I shall see her no more."[15] Her assignation was with a variety of Phlox in perfect bloom, ready for her portrait to be taken. Later in the same letter, Mrs. Delany debriefed: "Monday. The fair lady was true to her appointment, and we parted friends." There it is, three lines out of more than a hundred thousand lines that she wrote: a flower is a lady, a lady in a portrait, just like the religious portraits she had copied, or those Sir Joshua Reynolds was painting of young ladies of

marriageable age. Through the portraits, Mrs. D. regained her flexibility – and her hope. The rigidity we fear in age relaxed into balance. "I never quit *resting on hope*, which often opens a pleasant view. *Rigid* Wisdom says, 'Don't hope, and then you will not be disappointed;' but your philosophers are *rare talkers*, and *sad comforters*," she wrote in this June of 1776 as some Loyalists in North America were selling off houses and packing carriages to drive to Canada or sail to the Caribbean.

On a Monday night in late August 1776, between six and seven o'clock, Mrs. Delany was hiding out at Bulstrode in "the dressing room belonging to the blue damask apartment," having begged the Duchess to let her go to London for the day.[16] Margaret had refused: "she was inexorable."[17] Instead, the Duchess ordered her servants to see that "the drawing-room [was] divested of every comfortable circumstance." At exactly the time Mrs. D. had secreted herself away came "a chaise with a pair of horses and grooms attending," and in the carriage were "their Serene Majesties" King George III and Queen Charlotte, attended by the Duchess's daughter. They were coming on this long summer night for respite from their political troubles, to visit the animals and plants and vases and shells at Bulstrode as well as the two ladies, hardly concerned with political matters, who puttered around the estate. The Duchess went out to greet them on the steps, but Mary Delany, who hadn't consorted with royalty for decades, hoped to "be overlooked," or at least to see "their royalties thro' the window, or thro' the keyhole!" She was old, she was out of practice, she was, she joked, fit only to be shelved among the antiques.

But the Duchess's daughter, Lady Weymouth, knew where to hunt for her mother's friend. (Lady Weymouth

had married the son of Mrs. Delany's cousin Thomas, whose marriage to Lord Carteret's daughter Mrs. D. had helped to engineer years earlier. Now she was mistress of Longleat, the house where Mary had been given up in marriage to Alexander Pendarves, and also where she hollow-cut the silhouettes of the Weymouth children.) Lady Weymouth peered into the blue damask room. There she saw a gray-haired antique in a black dress, not one embroidered with bright flowers like the one she had once ordered made, but an old woman's somber gown. She told that old woman that she "was sent by the Queen to desire" that Mrs. D. "would bring the *hortus-siccus*." And she obeyed. This was the first time that the horticulture-loving King and Queen had seen the mosaicks, and they marveled at them just as we do. "I was charm'd and I was pleased," Mrs. Delany wrote, "and I even wish'd they had staid half an hour longer." Four years earlier, when the Duchess showed such instant appreciation of her work, she had leapt to do more. Now, when the Queen and King so deeply approved, she leapt again. After this evening, she doubled production of the mosaicks.

Approval played a major role in the production of her art. The idea of the solitary artist is undercut at every turn by Mrs. D. The lonely artist who struggles on unappreciated is opposite to what she did and felt and how her class, sex, and era conceived of makers and limners. Her increased pace of work demonstrates the role that approval plays in productivity.

In 1776 William Gilpin visited Bulstrode to see the antiquities and discovered instead Mrs. Delany, "who enjoys her faculties in such vigour," and the *hortus siccus*. "The work of hers, which I allude to, is an herbal, in which

she has executed a great number of plants. . . . And what is the most extraordinary, her only materials are bits of paper of different colours. . . . [T]he work, I have no doubt, into whatever hands it may hereafter fall, will long be considered as a great curiosity," he wrote in his *Observations Relative Chiefly to Picturesque Beauty, Made in the Year 1776, on Several Parts of Great Britain.*[18]

As news got around about her paper flowers, Mrs. Delany continued to travel to create them. She climbed into carriages with her tools and accoutrements and bounced her eighth-decade kidneys and bladder along toward the houses of her friends. She traveled to Luton Hoo to Lord and Lady Bute, she traveled to visit her nieces and nephews, and later on she visited her friend the Countess at Bill Hill. At each place she selected plants in bloom, set up, and began to cut, carve, scissor, and position, reposition, think again, pose, re-pose her assemblage of botanical portraits. Did she take all her papers with her? Probably not all. Were there wallpapers and resources at each of the houses she visited? Highly likely. Pigment, kept dry, is eminently packable. And she must have packed her scissors, scalpel, bodkin, and tweezers – one would want to have one's own tools. These must have been tucked in along with her clothes and, in a separate case, the few belongings of her personal maid. But it was at Bulstrode, the Hive, where she was able to go into *hortus siccus* overdrive. Bulstrode, that destination where all visited.

By five years into the process, she had a pattern for accomplishing the mosaicks. She was very likely doing them in stages, coloring paper, stockpiling her resources (she had a distinct color palette for her multitudes of greens, and those colors don't change a great deal across

the many collages), and completing them in stages so that her one-a-day month very likely had been prepared for in advance. Part of her thrust forward was driven by the arrival of the plants that the Queen was sending under the auspices of Sir Joseph Banks at Kew. And the blooming plants were dispatched to wherever Mrs. Delany was. In the spring of 1777, the Bloodroot arrived in London at the house she had bought in St. James's Place. By the following summer Lord and Lady Bute had opened Luton Hoo's horticultural riches to her. "I am now very busy with my hortus siccus, to which I added, at Luton, twelve rare plants."[19] By July of 1777 she was cutting the hundreds of hula skirts that made the fabulous purple *Passiflora* at Luton.

"This morning I finished my 400th plant!" she crowed in September 1777.[20] Almost half the opus was completed. Exotic plants from around the globe arrived in profusion back at Bulstrode. "I am so *plentifully* supplied with the hothouse here, and from the Queen's garden at Kew, that natural plants have been a good deal laid aside this year, for foreigners, but not less in favour. O! how I long to *show* you the progress I have made!"[21] She was approaching her big month, October 1777, when she would finish *one a day*. Because there's every reason to believe that she had assembled a number of collages but not finished them, completing one a day is both spectacular and possible.

The botanical world had turned its attention to her and she was absorbing its information. "Dr. Solander, &c. came as expected, and I am now going to get a botanical lecture and to copy a beautifull flower called *the Stuartia*."[22] Because the work was intimately tied to the plant explorers, botanists, and nurserymen, and to aristocrats and royalty, too, in a way Mrs. Delany was holding court: the court of the

art of her flowers. The King and the Queen were coming to her – well, at least to breakfast at Bulstrode on August 12, 1778, on the Prince Regent's birthday.[23] Breakfast was served at mid-morning, and the Duchess, who was throwing this little birthday party for the Prince, had been scurrying around Bulstrode in preparation for days. All the collections were stocked back in their grand cabinets, chairs were put away, plants returned to the greenhouses.

Mrs. Delany, who did not seem to feel her age when it came to climbing into a carriage to go to Luton Hoo or Bill Hill on the hunt for a plant, very much felt her age at the coming spectacle of this breakfast. She took to her previously unsuccessful tactic and retreated to her ground-floor apartments. There she peered out of her windows and down the long approaching road from Windsor at the entourage of gold-dipped equipages. Two princes on horseback with their riding master, two footmen, two grooms, the King and Queen in a phaeton, two more servants, a post-chaise with four horses and another prince and a princess and the Duchess's daughter Lady Weymouth jostling inside, then two more servants on horseback, then a coach with six horses ferrying more princes and princesses and governesses, more footmen, more servants, more attendants, two more coaches with six horses with more princes and their preceptors and more servants and footmen and more dignitaries, as well as a phaeton with the Duke of Montague and other aristocrats – even Mrs. Delany didn't record all the ranks, totaling "33 servants, and 56 personages" for a total of 89 guests at breakfast.

Mrs. Delany still crept behind the curtains of her long windows. She wasn't dressed for company, but Queen Charlotte sent Lady Weymouth to find her, and, the fact that

she wasn't in a party dress notwithstanding, Mrs. D. was escorted to the Queen and the princesses. The King meanwhile was inspecting the Duchess's china collection with his two eldest sons; then everyone except Mrs. D. joined them. She was catching her breath sitting quietly in the drawing room, but when they returned, the Queen sat down with her again, and they talked – what? Court gossip? The fractious American colonies? No, they talked craft, "*the chenille work*."[24]

Then the birthday fare entered on platters and salvers, in tureens, bowls, and cups: tea and hot chocolate, "bread-and-butter, roles, cakes, and – on another table all sorts of fruit and ice." The King drank chocolate, the princes and princesses ate everything. The Duchess brought the Queen her tea but she insisted on carrying back her cup herself. Then His Majesty, who had retreated for relief from his public life into his family and his childhood hobby of tracking his chlorophylled subjects to the exclusion of his human ones, called for the great floral scrapbook.

"The King asked me if I had added to my book of flowers, and desired he might see it. It was placed on a table before the Queen, who was attended by the Princess Royal and the rest of the ladies, the King standing and looking over them." Like any artist who has to stand by while people peruse the work, Mrs. Delany said, "I kept my distance, till the Queen called to me to answer some question about a flower." As she came toward the table, seventy-eight years old and perhaps unsteady on her pins, George III did something endearing and unusual. He brought Mrs. Delany a chair. Then he "set it at the table, opposite to the Queen, and graciously took me by the hand and seated me in it." Mrs. D. was totally flustered. Not the thing that royalty was expected to do. But Queen

Charlotte said, "Sit down, sit down . . . it is not every body has a chair brought them by a King."

And so she sat. It seems a little bit as though the party were for her.

By this time she was amassing all types of papers to color. Watercolors were handmade in Mrs. Delany's day, not commercially available until the very late eighteenth century, after her collages were complete.[25] Either she made her own paints or commissioned them. Pigments were ground by hand with a muller (a flat-bottomed pestle) and a stone or a heavy slab of glass. Whether she ground her own or ordered it ground – and since it was hard to grind, it makes sense that someone else applied the muscle power – she probably experimented with her formula for watercolors, figuring out the best proportion of gum arabic to water to pigment to honey to ox gall. Gum arabic binds the color to the paper, but it also helps disperse the pigment into a colloid, suspending the particles of color in the water. Honey acts a smoother. Ox gall alters the surface of both the paper and the paint, so the watercolor doesn't soak into the paper immediately. She also used gouache or body color, a watercolor to which white is added for greater opacity. She was washing colors for translucency in some instances and deepening colors for the opposite effect as well. Intuition was at work in the combinations, and inspiration. She was varying her papers, too. Most of the papers were white, but in some of the mosaicks she worked with "a green paper with mica flakes."[26]

When she made her black backgrounds, she probably wet the papers to stretch them, using a rag or wide brush to wash water onto the surface of the paper to "relax" it, preparing it to accept the most quantity of paint. Kohleen

Reeder, a book and paper conservator to whom I am indebted for this reconstruction of Mrs. Delany's process, speculates that she sometimes also took a brush and painted over the flowers after they were assembled.

In the next three years, from 1778 to 1781, she did between eighty and one hundred per year – about one every fourth day.[27] Her juggernaut went on, even when she received such disturbing news from her niece Mary Port in 1778 that she became ill with a fever. Mary Port's husband, John, had suffered extreme financial difficulties, and Mrs. D., in between making a collage every four days, decided to do something about it. "I thank God I am much better," she wrote to her nephew John Dewes's wife, "tho' sensible of being weaker than before my illness, which indeed, I believe, was much owing to my great agitation of mind on your dear sister-in-law Port's account, who bears her *great reverse* of fortune with uncommon fortitude; but I hope they will sett their affairs in such a train as may enable them to enjoy what is left. It is truly an heart-breaking sight to see her suffer so much anxiety."[28] At seventy-eight, she under-took an act of motherhood.

There may be those of us who have decided that the reason Mrs. Delany could accomplish such a great deal at an advanced age is that she had nothing else on her mind except her mosaicks. Let us disabuse ourselves of this. Mrs. D. up and decided, without missing a beat, to take on the care and education of her great-niece Georgina Mary Port. Her niece Mary journeyed to London to deliver her little daughter, and Mrs. Delany swooped up seven-year-old Georgina into her household, taking the opportunity to re-enact her own education at the hands of Aunt Stanley, softening it, rectifying it, restoring it

through her ensuing seven decades of experience. And a little girl bloomed.

"Mrs. Delany's affections seemed to revive and to be concentrated upon this child," the astute Lady Llanover, Georgina's daughter, wrote. Her mother "was then about the age that her grandmother Anne Granville was when she and her sister Mary Granville (afterwards Mrs. Delany) were carried off by their aunt, Lady Stanley, at the period when Lord Lansdowne and his brother, Colonel Granville, were arrested and sent to the Tower."[29]

With her great-niece in tow, in the midst of her massive memorial project of the mosaicks, Mrs. D. entered into a mind-boggling level of activity. Here's the agenda on two typical days with Georgina at home with her industrious great-aunt at St. James's Place:

After they gulp their breakfast, aunt and child look over a drawer of shells; aunt puts a shell to the child's ear, who hears the *whoosh* inside and says "it always puts her in mind of dear mama."[30] At noon the daily guests start arriving, "Mr. Cole with his friend Mr. Symonds, and afterwards Mr. Martheille, Lady Andover, and Miss F., and Lady Stamford, who came from Whitehall to *spirit me up* to accept of Lord Exeter's ticket for his concert, which I unwillingly assented to." Then her nephew Court arrives with a companion. At last it's time for mid-afternoon dinner. That evening, "Lady Bute, Mrs. Vesey and Miss Gregory, Lady Beaulieu, Lord Dartmouth, Lady Stamford, Duchess of Portland till eleven," while Georgina, "'*the sweet bird*' perch'd at my elbow till her usual hour of retirement, and *not unnoticed*!" Somehow in there a mosaick is getting looked at, thought about, or executed. Meals have been planned, visits to the privy made, and all details of life,

from scratchy stays to farts and burps and a child's spills and exclamations seen, heard, smelled, dealt with.

In the same letter she describes another morning, when she had only four visitors, doesn't record what happened in the afternoon – a collage, perhaps? – and in the evening goes to that concert she was reluctant to take the ticket for, conveyed in the Duchess's coach with their friend Lady Stamford. When she got home, she reflected, "On the whole I was well, and entertained, slept better than for many nights before."

In two days she entertained twenty different individuals, supervised a child (who was not sent to her nursery but was kept by her aunt's elbow), got gussied up and attended an evening concert, no doubt worked on a mosaick or maybe more, and climbed into bed peacefully exhausted. She barely had time to write to her niece Mary about her daughter's progress in the spring of 1779, "so busy now with *rare* specimens from all my botanical friends, and idle visiters and my little charge must have a share of my time (tho' not near so much as I wou'd most willingly bestow on her) that it generally drives my writing to candlelight, which does not suit my age-worn eyes."[31] Age-worn eyes. A signal. Well, she ignored that for the present. She swooped up the seven-year-old and took her to the nurseries to track down plants. "I took *my little bird* and Mrs. Pott to Upton in Essex, 10 mile off, to Dr. Fothergill's Garden, crammed my tin box with exoticks, overpowered with such variety I knew not what to chuse! G. M. A. [that is, Georgina] delighted, fluttering about like a newborn butterfly, first trying her wings, and then examining and enjoying all the flowers." That August, home at St. James's Place, she rendered the freckles on the

Lilium canadense from a specimen provided by nursery-man Mr. Lee.

She was also busy obtaining paper. The papers Mrs. Delany worked with were imported from Holland or made in small local English mills.[32] Linen rags, dumped in a vat with water, were washed and beaten to disintegration, mixed with hemp from old sailcloth or rope, packed down to a pulpy mass, and diluted again. Then a wire mold was dipped into the thinned linen-hemp slop and fished up. As the pulp dried on the mold, a single piece of paper was made. The variations in the sheets, plus the variations in the different mills (right down to how clean the vats were, the quality of the local water, and the fineness of the rags), made the differences in texture and thickness Mrs. Delany played on continually in the mosaicks. The papers were usually white, though they could be brown, blue, buff, gray, or olive. She seems to have employed anything at her disposal, from the laid paper she used for writing letters to the fine imported sheets of Dutch makers such as the Van Gerrevinck family at Phoenix Mill, Alkmaar, North Holland. (Earlier, she used papers made by James Whatman the Elder at Turkey Mill, Boxle, near Maidstone, Kent.)[33] Forensic paper specialist Peter Bower has tracked down the water-marks and the various families, Dutch and British, who made the sheets Mrs. Delany used. The varieties are cornucopic. She used both Dutch and English papers for the backings, and she largely worked on the "felt side" of the paper.

There are two sides to a handmade paper, the "wire side," which bears the markings of the wire mesh of the mold (including the watermark) which was dipped into the linen pulp, and the "felt side," or the smooth side of the paper, the top of the pulp in the wire mold. Mrs. Delany

used the smooth sides, not allowing the markings to inter-
fere with her surfaces. Yet she also used laid writing paper,
which we still use today for stationery, and she let those
lines become part of the texture of the collages.[34]

She used papers imported from China, too, and possibly
from India. Bower has detected brush marks on some of
the papers, typical of Chinese papermaking. A friend of
Mrs. Delany's, Mrs. Boscawen, offered her paper from
India, but we don't know whether the paper was used.[35]
Mrs. D. approached the papers as she had long before ap-
proached the satins, silks, and linens for her clothing. She
got them from abroad, she got them locally, she lusted after
the exotic, yet she grabbed what was at hand when she
needed it. Luscious, varied, and detailed as the patterns on
cloth, she transformed the papers made from fragments
of cloth into the textures of flowers that were very much
like clothes. Bower, a lean, elfin man with the gusto of a
detective, revealed in a lecture at the Yale Center for British
Art on September 23, 2009, the underlying fact of Mrs.
Delany's papers, an emblem for her life: they were strong.
Because they were handmade of strong fibers they were
"infinitely better suited to such cutwork than the much
weaker modern papers."[36] We cannot read the flimsiness of
the papers we touch every day back into her collages, just
as we cannot read our insubstantial, silky microfibers back
into the elegant strength of the textiles of the eighteenth
century. The fibers had a strength we do not usually imag-
ine. And, of course, so did the woman who used them.

Mrs. Delany took Georgina everywhere, including to
Bulstrode and to court. After the encounters with King
George and Queen Charlotte, Mrs. D. had been invited to
visit them at Windsor. She described in fabulous detail the

colors of the Queen's private rooms, "all furnished with beautiful Indian paper,"[37] as well as the gentle, informal, and warm conversation she had with the royal couple and the genuine enjoyment she took in meeting the whole passel of princes and princesses. The corm of a friendship had begun to increase between the elderly woman and the beleaguered royal couple. She was perfecting her role as a sympathetic aunt, energetic but wise, modest but witty, so utterly experienced in the world that one could relax with her, a mother figure aslant – not really a mother with a matriarchal judgment and claim, but an auntie with her own life who could also turn toward the couple with her whole attention and without a political interest, let alone an argued political bias. Combined with the devotion to botany all three shared, a thin but tensile tendril of attraction attached. By the time the King's birthday came around in May 1780, Mrs. D. was outfitting Georgina in pink lutestring (glossy silk) and supervising the shaving of her hairline to get the effect of a high forehead. Mrs. D. asked Georgina's mother's permission to supply the child with a posture device that would keep her shoulders back, as suggested by the coat-maker.

And all of this is in a letter describing her redecorating! "After this week I shall be monstrous busy, as I am under a necessity of whitewashing, new papering, and painting my drawing room; and I have delay'd in hopes of a more convenient time, but can do it no longer; and removing pictures, books, and China, &c., &c., will find me a good deal of busyness."[38] That was just after her own birthday: eighty years old. By July she was back at Bulstrode, aiming her scalpel for the insect bite in the leaf of her *Rosa gallica, Damask Rose.*

There was nothing to do but take on an assistant, an apprentice, back in London the following November. "Miss Jennings, who I believe I have mentioned to you as a sensible, agreeable, and ingenious woman, a pupil of mine in the paper mosaic work (and the *only one* I have *hopes* of), came here last Thursday."³⁹ She barreled through the winter, Georgina returning to her mother and father, and by August 1781 was back at Bulstrode, cleverly, wittily, self-reflexively cutting the tendrils of the *Everlasting Pea* into scissor shapes. This was the year she dropped using the terms "herbal" and "*hortus siccus*" and began calling her work the *Flora Delanica.*⁴⁰ She had her oeuvre, and she knew it. Her reputation had flowered. Hannah More, the bluestocking and friend, wrote about her in a poem called "Sensibility," grouping her with luminaries like Sir Joshua Reynolds, David Garrick, Jonathan Swift, and Dr. Johnson, as well as women we hear less about, like the writer Hester Chapone (wife of the son of Sally Chapone, Mrs. D.'s godchild):

> Delany shines, in worth serenely bright,
> Wisdom's strong ray, and virtue's milder light;
> And she who bless'd the friend, and grac'd the page
> Of Swift, *still lends her lustre to our age:*
> Long, long protract thy light, O star benign!
> Whose *setting* beams with *added brightness shine!*⁴¹

George Keate published a relentlessly metered nine-page poem called "A Petition from Mrs. Delany's Citron-Tree, To Her Grace The Duchess Dowager of Portland" in 1781, in which the citron (probably Mrs. D.'s portrait of the *Citrus medica*) becomes audible, speaking out about the good fortune that befell it when Mrs. Delany portrayed it.

O could my Sister Plants, and Flow'rs,
That spring beneath your beauteous Bow'rs,
Before the Good DELANY stand,
And share the Magic of her Hand![42]

However it might not quite appeal today, published praise is published praise – and in couplets, too.

An apprentice, laurels, royals – and dimming eyesight. What impaired her vision? It's very hard to know; it may have been as simple as cataracts. It will take a medical historian with a detective's bent to find out. The next year she was able to cut out fewer than thirty mosaicks. That was the number she had done in her single most productive month, five years before, at seventy-seven. Yet she contrived to scissor out the big flowers of the *Portlandia grandiflora* that August at Bulstrode. By September 1782, she confessed to Mary Port, "My eyes are much in the same state as they have been for some months past."[43] She hadn't managed stairs well for quite some time – the King made special arrangements to see her on the ground floor at Windsor.[44] Whatever it was, it would "serve me with some difficulty to attempt a flower *now and then*."

It was a doctor, the Greek Dioscorides (40–90 C.E), who described the Bladder Cherry growing in Rome.[45] (*Physalis* means bladder.)[46] Crowning her four-stages-of-life (plus one ghost) *Winter Cherry* is a dry leaf, not a real one but a cut leaf, sailing off like a cap waving farewell, or the recent Queen Mum giving one of her famous waves, as Ruth Hayden remembers.

Do you have advice for living in one's eighties? I asked Ruth once. "Not to look back too much," she said resolutely. "Not to let life make you bitter." Not to be a decrepit,

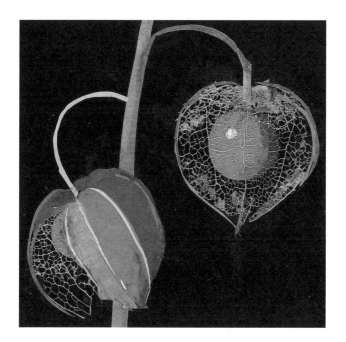

Physalis, detail

bitter old thing but to dry beautifully, like the Winter Cherry. Better to write a poem, or tell a story. "Shall I tell you about the Queen Mum?" Ruth asked. Of course.

"Well, Father preached at Sandringham, and the Queen Mother used to drop in. Once the Queen Mother called and gave half-an-hour notice for lunch. Once she came with Princess Margaret. She was fascinating. Very tiny. But the third time she came with five minutes' notice! I was visiting, I was about thirty years old, and I was in bed with a temperature of 102. The rectory was a big Regency house, and my mother came running upstairs, and she opened the door to my room, looked around, then she tore downstairs looking for my father. The Queen Mother

would be there in four minutes! Now, the bedrooms opened onto a gallery. And I could watch from the gallery, feverish as I was. I leapt out of bed and seized a very ancient eiderdown and wrapped it around myself, with my hair looking ghastly. There was a huge Edwardian mirror downstairs going all the way up to the ceiling. When the Queen Mother came and disappeared into the dining room, I practiced curtsying in front of it. I looked like the Caterpillar in the Tenniel drawing. After half an hour (it was a quick lunch), the Queen Mother came back out, looked up, and caught sight of me.

"I curtsied like a caterpillar and the Queen Mother said, 'You ought to be in bed! I do hope you'll get better soon.' She gave me a wave. Then she turned from the garden step and gave me a second wave."[47] There's just a shadow of a waving hand in the topmost leaf of the *Winter Cherry*, where you can see the lines from the laid paper, the simple stationery paper that Mrs. Delany used to paint and cut out her leaf.

Leaving.

By 1783 Mrs. Delany had stopped the entire enterprise of the *Flora Delanica*. She simply couldn't see well enough to complete her goal of one thousand.

The set goal is almost never the body's goal. As ceremonially as she had laid each of the 985 mosaicks, alphabetically, in one of the ten leather volumes and made a Table of Contents for each one, she put her *Flora Delanica* to rest, surrendering the spectacular level of energy she had sustained for a decade. She was eighty-two. Typically, she did not describe the letdown. By the time she'd reached the *Portlandia*, she'd known that she was near the end. But she also knew what she had accomplished, and in the front

of the first volume she wrote a short poem to commemo-
rate what amounted to her miracle. Then she entered a
dedication, writing down why she'd done it, and for whom.

PLANTS

Copied after Nature in Paper Mosaick, begun in the year
1774.

Hail to the happy hour! when fancy led
My pensive mind this flow'ry path to tread;
And gave me emulation to presume
With timid art to trace fair Nature's bloom:
To view with awe the great Creative power
That shines confess'd in the minutest flower;
With wonder to pursue the glorious line,
And gratefully adore the Hand Divine!

The paper Mosaic work was begun in the 74th year of
my age (which I at first only meant as an imitation of an
hortus siccus) and as an *employment* and *amusement*, to
supply the loss of *those* that had formerly been delightful
to me; but had lost their power of pleasing; being depriv'd
of that friend, whose partial approbation was my pride,
and had stampt a value on them.

Tho' the effect of this work was more than I expected,
I thought that a *whim* of my own fancy might fondly beguile
my judgment to think better of it than it deserved; and I
shou'd have dropp'd the attempt as vain, had not the
Duchess Dowager of Portland look'd on it with favourable
eyes. Her approbation was such a sanction to my undertak-
ing, as made it appear of consequence and gave me cour-
age to go on with confidence[.] To *her* I owe the spirit of

pursuing it with diligence and pleasure. To *her* I owe more than I dare express, but my heart will ever feel with the utmost gratitude, and tenderest affection, the honour and delight I have enjoy'd in her most generous, steady, and delicate friendship, for above forty years.

<div align="right">

MARY DELANY.[48]

</div>

Her poem is a realist's manifesto, the stated desire to recreate the overwhelming awe that nature can produce. Her dedication and her reasons for making her singular art – and it is singular, since few other people have followed it – are the guiding principles of the artist as memorialist, the gift spurred on by praise.

{ TO MAKE THE CHERRY RED }

Somewhere in the world around me, which included the life of a woman who woke to the smell of woodsmoke, who opened her door to a whiff of horse manure, and whose tea never came from a little bag you dipped into water boiled in a kettle with an electric cord, I had misplaced my fear. Where did it go, the underleaf of panic that my husband would die and that his death would eject me into a grief-chasm? It hadn't vanished in an obvious epiphany. It seemed a gradual thing, like one of Mrs. Delany's colors merging into the next. No, it is one paper pieced next to another; if you really look, there is a line. There must have been a line, because the absence of panic has a distinct quality to it, like the bits that look seamlessly painted in the mosaicks. It feels like air. Something neutral and necessary and so ordinary you almost can't think about it, except abstractly. A line was slipped past rather than

boldly crossed, but I felt the difference the way a room feels different after the cat has slipped out. There must have been a moment when the animal left, but I never knew it till she was gone.

The absence itself became a presence when I had dinner with an old friend who loves bullying ideas to their bottom-line conclusions. What, he growled, is the *real* reason that she was able to make those flowers? *Some things take living long enough to do*, I said. I was speaking from across the line, across the cut. It just took time, I went on to tell him, and it wasn't purposive. It evolved, first from silhouettes, and then from handiwork and collecting shells and designing shell grottoes, and then designing her dresses, and then from drawing and painting and gardening, and from being supported in her enthusiasms by her sister and her husband, and lastly from not being able to paint, from a feeling of the world dimming, and from the energy of the natural world and the way she was supported by her friend.

The whole combination of things amounted to how Charles Bukowski defined age. Of all the sloppy, unbound-aried, drunken poets I never thought I'd have a good word to say about, he nailed it. On the radio one day I heard him wisecrack, "Age is the sum of all we do." That's a bit of what happens to a plant, too. It keeps adding up until it blooms, but even after blooming, after mid-life, so to speak, it keeps going, because it has to start withering. Only in drying does the real fertility begin, the seedcase forming, and only then are the seeds available to be blown apart and travel and settle. The fierce winter of dormancy is part of it all – the biennial approach to life.

Some things take living long enough to do, I thought as I punched the boxing guards with our trainer. I never

343

considered that my husband, the jock and serious athlete, and I, the bathrobe diva, would share a trainer at a private gym. But through taking agility training when I was doing some acting, and from dragging my husband with me to the training because I needed a partner, and from the trainer and my husband hitting it off as fellow athletes, and from giving up our car, which freed the cash to pay for it, I've ended up being a sparring partner with both of them. Now I pass them the basketballs if they're shooting baskets and I do all the weight and balance training my husband does. I'd gamble that Mrs. Delany would have had a trainer if she had lived in the twenty-first century. She was a walker; she loved the brace of air. She walked all the way from Delville (in the suburb of Glasnevin) to the center of Dublin, at the Dean's suggestion, just for the exercise. Side by side, punching away at our trainer Jasen, right foot forward, left foot forward, left jab, right hook, it dawned on me that I was flying. A heavy hyper-vigilance was absent. It has been close to three decades since Mike's first diagnosis. He has lived with his melanoma, as it turns out some individuals do, as if it were a chronic condition, like diabetes. Here we are, *slam!* having accumulated, *bam!* all the strands of whatever it is that will take shape in our lives. Somewhere in the depths of her paper garden, almost in the experience of lost time and lost care that working in a real garden produces, the panic had evaporated.

344

"Have you started to hate her yet?" lithe Jasen asked. "I hear all biographers come to hate their subjects." No. I feel an abiding affection for Mrs. Delany, even more so now that she's stopped her great work, just fifteen mosaicks short of her goal. Human after all.

Some things take living long enough to do. Deep into my investigations of how Mrs. D. managed to make the mosaicks, I discovered I really did want to own the six original Lady Llanover–edited volumes of her correspondence, and Mike found them for me – in an antiquarian bookstore in Dublin. Receiving the package from Dublin in Toronto, I winced at my earlier refusal (now I'd paid twice as much), and at another mistake I'd made when we were last in Ireland. I had decided that it was time to visit Down Cathedral, where Patrick Delany was Dean, and I wheedled Mike into venturing north with me. We arrived in Downpatrick and drove immediately up to the cathedral, on a gorgeous day in July that summoned up Mrs. Delany's pure delight in her walks around Mount Panther and Mount Holly and the surroundings. I raced into the cathedral and up to the pulpit. "Here's where he preached!" I shrieked to my husband, who was not behind me. He had stopped in the cathedral gift shop to buy a history of the church.

No guidebooks between me and an experience. I never rent headphones in museums, I buy guidebooks only after the fact so I can recall things, I can't bear sticking a camera between me and an object, a person, a scene. Freshness of encounter – I insist! I walked back down the nave and found him at the little shop. "Hey, come on! You've got to see where Delany preached." I tugged at his jacket as he was paying for his book.

"He didn't." I looked back at him. I had surged ahead again.

"Didn't what?"

"Preach – here, I mean. The cathedral was in disrepair then, it was a ruin. He couldn't have said a word in that pulpit. It didn't exist in his time." He opened the book to

the page that made this fact explicitly vivid – the cathedral was in ruins from the late sixteenth century on and was reopened only in 1818.[49] I had dragged us both up there to inspect a place of worship that one check of one reference would have told me not to go near. Well. You have to laugh.

Which he did all the way to the car, parked outside the Down County Museum.

"Want to go in?" he asked. "Consolation prize?" In the very entrance to the museum we found a copy of a drawing by Mrs. Delany.

You have to love a happy coincidence.

Mike gabbed with the guard, who summoned a curator who told me things I already knew, but it's reassuring when an authority figure confirms the facts, and this curator pointed to where the original of the drawing was. Back in Dublin, in the National Gallery of Ireland, I viewed Mrs. D.'s Irish pencil drawings, the limnings that probably wouldn't be remembered except that they were done by the woman who had made the mosaicks. She tried to get at the landscape lightly, quickly, modestly.

The natural world is at the cherry heart of Mrs. Delany's mosaick explosion, and though her cutting style is quick and light, it is not modest. Her collages display the matter-of-fact boldness of the relaxed eye and hand. Obviously there wasn't the same concept of abstraction in Mrs. Delany's sphere as there is in ours, but the words of a twentieth-century realist painter explain something of the intensity of her dazzlement with nature. Avigdor Arikha was an Israeli artist and Holocaust survivor who lived in Paris with his wife, the poet Anne Atik. A friend – and illustrator – of Samuel Beckett, he abandoned abstraction for a love affair with the forms of the world right before him. "When I was

an abstract painter I thought I was the well . . . and I thought the well was bottomless. But of course it was all wrong. After seven years I hit rock. I felt that all the forms I was expressing were the same form, *my* form. . . . I soon realised that there is only one thing that is not reachable, never knowable, truly infinite, and that is the world around us."[50] When you are young, you often cannot find yourself in the infinite. Where is your own form among the endless varieties of life on earth? Worse, how can you be a mere speck in the universe? And if you are a speck, which speck are you? But when you are old, the infinite is your home. It is comfortable to be a speck among specks.

"What is there / like fortitude!" Marianne Moore exclaimed in her poem "Nevertheless." "What sap / went through that little thread / to make the cherry red!" Moore's first name, just a vowel different from the heroine of Mrs. Delany's novella *Marianna*, reminds me that Mrs. D. also managed to copy out that work again by hand in 1780, as she was churning out the mosaicks and delivering Georgina back to her parents, who had returned to relative solvency.[51] Before she asks about fortitude, Moore says, "The weak overcomes its / menace, the strong over- / comes itself."[52] Mrs. Delany, who had long overcome her menaces, had somehow cut through herself to the world before her, 985 times. Her fortitude has the botanical feel of Moore's exclamation: it was like the sap osmosing through that little thread connecting the lantern of the *Winter Cherry* to the stem.

347

Observation of one thing leads to unobserved revelation of another. That's how I don't know exactly when I crossed the line to lose my fear. I was walking along in life like the amateur conchologists I have watched for years on

the beaches of Sanibel Island, Florida. They never see the sunsets. They are always looking down to grab their finds, their shells. While I was examining the mosaicks, looking down at my finds, above me another part of my life was standing, unknown to me, looking at what I'm not sure, perhaps a metaphorical sunset. This other part was transforming even as I looked as hard and as closely as I could at papery things all tiny and nearly incomprehensible. Direct examination leads to indirect epiphany. You can overcome yourself. Examine this world, Arikha and Moore say to us in their more elegant ways, as does Mrs. D. in hers: even if that is only the gristle in the drain trap of a sink, or the pearly glue at the tip of a pistil.

Chapter 14.

LEAVES

Mrs. Delany wouldn't have dreamed of publicly showing or selling her artwork. Aside from the mosaicks that she gave to Queen Charlotte, Horace Walpole, Lord Bute, and a few others, her *Flora Delanica* was handed down similarly to her letters, first to her nephew Court Dewes, who made them available by appointment, and then down through his sister Mary Dewes Port's daughter Georgina Mary Ann Port Waddington, and then to Georgina's daughter Augusta Waddington Hall (Lady Llanover). I have no idea if Mrs. D. thought that the fame, however minor, of the *Flora Delanica* would live for centuries. She had no fortune or title, nor did she think of a public as we do. It's a safe bet that she would have imagined that the Duchess's legacy would live on. Could she have known that Margaret was manically spending so much on her collecting that she could have bankrupted her children, who had no interest in minerals, plants, and antiquities, and that this was their reason for a fabulous thirty-day auction after she died, dispersing all she had collected to the ends of England and beyond?

For the strange thing happened. The younger Margaret, Duchess of Portland, did die, suddenly. In July 1785, she rushed into Mrs. D.'s apartments at Bulstrode and asked her to look at all the red spots on her arms – just like

Painting of Mrs. Delany by John Opie, 1782

those on the butler, who had already died. The physician was summoned, she took to her bed, and like that she was gone, dismantled collections in her wake. She left mementos to her older friend but not money, and Mrs. D. never expected money. This is something Lady Llanover can get fairly exercised about, since Fanny Burney, whom Mrs. Delany helped to get a position as dresser to Queen Charlotte, and about whom Queen Charlotte bitterly complained since Burney had no gentleness of hand and always caught the Queen's hair in her clothing, declared that the Duchess had been a patron of Mrs. D., supporting her. Not so. That relationship was friendship, not patronage. Mary Delany insisted upon it. How else could she have maintained her balance on the seesaw of friendship with a woman of such high rank and fabulous wealth – well, a woman who spent fabulously.

When, after Margaret's death, Mrs. Delany was helped up into the carriage with all her belongings and the *Flora Delanica* and her personal maid to jounce down the dirt road to London and St. James's Place – never to see Bulstrode again, even through her dimming eyesight – the Duke of Portland, the Duchess's son, sent immediately after her with a question: besides the mementos she had in the carriage with her, wasn't there something else from the estate's vast collections that he could send her before the auctioneer's gavel came down? Shells? China?

352 The sight-impaired old artist asked for one thing, nothing hard and made and material, but alive: a little bird that had sung in a cage at Bulstrode, like the bird she'd listened to seventeen summers before, when she had entered that house in the bleakest distress of her life.

And so the creature was sent, while Mary Delany, at the age of eighty-five, took to her bed in grief and exhaustion again. Queen Charlotte knew that she had asked for the bird and also knew that, unbeknownst to Mrs. D., the animal had died in the journey to her. The Queen ordered a search for another bird to replace the one that had perished without Mrs. Delany's knowledge, and the duplicate, in whose feathers whatever slight discrepancy the previously fully sighted Mrs. D. would have detected in an instant, arrived, whole and alive, and was added to Mrs. Delany's household.

One of the people who was shocked to learn that the Duchess hadn't provided for Mrs. Delany was King George III himself. He queried her directly, and she stoutly responded that she had never asked the Duchess for more than "mementos of herself" which would "testify her regard."[1] Several were paintings that she had once seen clearly – but now, given her sight, more precious were things to touch, including what the Duchess had described as her "fine enamelled snuff-box, the small blew and black enamelled snuff-box."

The King paid more attention to her situation than his grandfather might have, had she been able to obtain that court appointment she had angled for in her thirties and early forties. George III presented her with a cottage at Windsor Castle, the summer home of the court, and, knowing that she could never afford to keep up her house in London as well, with a three-hundred-pound annual stipend. He and Queen Charlotte ordered Mrs. Delany's new house cleaned to within an inch of its life for her – right down to the soap to wash the wainscoting. A raft of

353

supplies was ordered and a phalanx of workers readied the place, using up "12 lb of Sope – a Piece of flannel, & Linnen Cloth – a long Scrubbing brush – a hand do. – a Mop – 2 hair brushes – fullers Earth – Sand – Emory Paper – Sweet Oil, & Candles, &c. – for Scowering Wainscot, & Cleaning all ye Apartments, in Mrs. Delanys House St. Albans Street."[2] Fanny Burney, during her days as a less than suitable dresser to the Queen, before she wrote her novel *Evelina* and became Madame D'Arblay, wrote in her diary that Mrs. Delany's house was supplied with "plate, china, glass, and linen" as well as "wines, sweetmeats, pickles, etc., etc."[3]

When yet another carriage with Mrs. Delany, her clothes, her *Flora Delanica*, plus, this time, her waiting woman Mrs. Astley, arrived on September 20, 1785, the King stood there expecting her. The following day Queen Charlotte personally delivered the first quarter of the stipend for expenses. The princesses knocked on her door and played there. Mrs. D.'s great-niece Georgina Port came to accompany her, to write letters for her, and to help Mrs. Astley. A souped-up special sedan chair arrived for her – another gift from the King – so that she could ride to morning prayers with the royal family. George and Charlotte adopted her not only into the court but into their own circle. She went to concerts and to royal feasts, where the King helped her from room to room, saying, "Come along, Mrs. Delany,"[4] and placing her by Queen Charlotte's side because, by the age of eighty-seven, she was getting deaf. "My powers are not always equal to my will," she said, "though, upon the whole, I find myself tolerably well; my days are unequal,

and I am subject to a langour at times that makes me unable to dictate." By the second summer at Windsor, Georgina was taking her dictation, and her correspondence sailed on under the new hand she instructed. The pair were content to visit the royal apartments in the Queen's Lodge or to welcome the King, Queen, and princesses as they popped in on them. Portrayed by Thomas Lawrence and John Opie, Mary Granville Pendarves Delany became a serene presence. The court she had longed for half her life before had enveloped her.

One night the Queen slipped into Mrs. D.'s house unexpectedly for dinner, surprising her and Georgina at their "veal cutlets and an orange-pudding," which Georgina served to Charlotte.[5] In the homey way of returning to your mother's for a meal, the exact taste of which you never in your life can replicate, the Queen attempted to have the royal cooks imitate the pudding, but it never worked. At last it was "sent up for the Queen's dinner by Mrs. Delany from her own house ready made," becoming known as "Queen Charlotte's orange-pudding." In the mid-nineteenth century, Lady Llanover still had this recipe. Oh, to taste it. Or to taste one of the great dinners cooked under Mrs. Delany's auspices in her kitchen at Delville years and years before, when the Dean was alive and Mrs. D. joked that she had become fat as "*a porpuss grown.*"[6]

On a fragment of a letter from those Delville days, her sister Anne saved one of Mrs. D.'s menus, an elaborate meal served to the Lord Primate, his sisters, and the Bishop of Derry. She wrote the name of each dish in the place she intended to set it at the table.

FIRST COURSE.

Fish.

Beef-steaks. *Soup.* *Rabbits and Onions.*

Fillet Veal.

SECOND COURSE.

Turkey Pout.

Salmon Grild. *Pick. Sal. and Quaills.*

Cream.

Little Terrene Peas. *Mushrooms. Terrene.*

Apple Pye.
Crab. Leveret. Cheesecakes.

DESSERT.

Blamange. *Raspberries and Cream.* *Almond Cream.*

Cherries. *Sweetmeats and Jelly.* *Currant and Gooseberries.*

Dutch Cheese. *Strawberries and Cream.* *Orange Butter.*

I have scratched it out very awkwardly, and hope the servants will place my dinner and dessert better on the table than I have on paper. I give as *little hot meat* as possible, but I think there could not be less, considering the grandees that are to be here: the invitation was "*to beef stakes*," which we are famous for.[7]

To think of all the dishes in each course being brought at once, piled on the table and served about room temperature, since keeping things hot between the kitchen and the dining room was a losing battle. To think how, at half her age, the ebullient engine of her digestion worked at maximum performance. She would just have taken complete ownership of her role as queen of the deanery at the time

she served this meal. To think of the Dean alive, writing a portrait of her, an essay for a journal, *The Humanist*, which she was too modest to let him publish. "She was bashful to an extreme," he wrote indignantly, "and if I may use the expression even blameably so."[8] Even in her fifties she was his ruby-lipped beauty, his indelible first impression of her at thirty-one overlaid on this portrait of his flower for the essay: "Her stature was in a middle proportion . . . fitted alike for activity and strength. Her walk was graceful, beyond anything that ever I saw in woman; . . . she is almost the only woman I ever saw whose lips were scarlet, and her bloom beyond expression."

He could never figure out what color her eyes really were. "Her eyes were bright – indeed I never could tell what colour they were of, but to the best of my judgment they were what Solomon called '*dove's eyes.*'"

Now Mrs. D.'s visual and auditory senses had dimmed, but taste and touch and – if craft can be said to be a sixth sense for her – craft persisted. She had enough sight to design furniture cushion covers for the Queen, in "leaves in various shades of brown, cut out in satin, and shaded with embroidery on a dark-blue ground."[9] Although Georgina lived with her and wrote her letters, and although her personal amanuensis Mrs. Astley guided her from room to room, she propelled herself through days of continued encomiums for the mosaicks. The artwork was brought out for scores of visitors, both at St. James's Place and at Windsor. Sir Joseph Banks attested to their botanical veracity (though botanists today find mistakes here and there). Fanny Burney catalogued her comings and goings. Horace Walpole marked her forever among English women artists when he wrote in his *Anecdotes of Painters* that she "was a

lady of excellent sense and taste, who painted in oil, and who at the age of 74 *invented* the art of paper mosaic, with which material (coloured) she executed, in eight years, within 20 of 1000 various flowers and flowering shrubs with a *precision and truth unparalleled.*"[10]

But on Sunday, April 6, 1788, after Mrs. Delany had gone on an excursion with the royal family to Kew to see what she could, but more to touch and smell the plants in the greenhouses, she caught an upper respiratory infection. A doctor was summoned and she was bled. Two days later, she was blistered. Then bark was administered, the abominable mixture that had been spooned into her sister Anne's dry throat before she died. "I have always had a presentiment that if bark were given, it would be my death," Mrs. D. whispered to Mrs. Astley, who wrote the description of her final days.[11] Astley offered to hide the mixture and pretend that she had taken it. "Oh, no!" Mrs. D. said. "*I never was reckoned obstinate and I will not die so.*" She took the bark, the vile chemical cocktail, and rallied for another three days.

On Tuesday, April 15, at 11:00 p.m., she died.

The flow that is our lives until the very last minute then became a form. The sudden appearance of a life's shape at the moment of its end always provokes our shock, even if the death was expected. Yet, old as she was, few around her anticipated it. They thought she would recover. "Oh, madam, she is no more!" So seventeen-year-old Georgina, cast into a chasm of bereavement for the woman who had taken on her motherhood at the age of seventy-eight, wrote to Mrs. Frances Hamilton after leaving her Aunt Delany's bedside, her aunt's eyes closed, her nightcap settled on the head that, without the life force it had moments before, looked so much smaller.[12] The line had been crossed. Cut.

Mrs. Delany had written a will, of course, in which she insisted, somewhat as she had insisted that the Dean not publish his romantic portrait, on being buried "*no matter where*" and at as little expense as could be said to be proper.[13] But she was buried in a vault at St. James's Church, where her epitaph, written by the Bishop of Worcester, appears on a wall:

> She was a lady of singular ingenuity and politeness, and of unaffected piety. These qualities endeared her through life to many noble and excellent persons, and made the close of it illustrious by procuring for her many signal marks of grace and favour from their Majesties.

This generic epitaph does not mention the flowers, but at least it leads with her "singular ingenuity." The Bishop didn't have the words of Dean Delany to rely on. His dove-eyed love had forbidden it, but Anne, ever that saver of all, had rescued those words, which the Dean had enclosed to her in a Christmas message. The pages lay at John and Mary Port's house in Ilam.

John Opie's portrait of Mrs. Delany in old age and the enamel portrait done by Christian Friedrich Zincke when she was about forty (in the first chapter of this book) invite a person to trace the lines of the wise, old face against the fullness of the middle-aged one, a bit like mirroring the cut petals of one of the flower mosaicks back to its bloom. You see the face in its prime in the aged person, and, more fascinatingly, you see the older woman in the full flush of the younger woman. Each draws up the same life force in both sets of those eyes that exhibited, as far as her husband could discern, an almost unnamable variety of hues. There

in the eyes of those portraits is her pluck, young and old. There is her fast commitment to the diamonds caught in the glazed nettings of life that appeared before her, in the profile of a silhouette, in the shine of floss over sewn into roses – or in the lucky glimpse of a petal of a geranium the same shade as a piece of paper below it. Not just lucky. Her whole life flowed to the place where she plucked that moment.

{ THRESHOLD }

Living a full life requires invention, but that needs a previous pattern, if only to react against or, happily, to refigure in the making of something new. A multitude of vectors brings us to the moment where we are, and where we love, or cough, or say the wrong thing, or fail, or feel our fate in what we fear, or to a moment where clarity descends, and we understand the world simply from having observed it. Uncontrollable events hurtle toward us until the very moment of our deaths, yet in each instance figuring out how to go on, even on to the next world, repeats the confusion of youth. Of course we need our role models long past adolescence.

To search a drawer or a pocketbook or a botanical bibliography, even to search a littered table or beneath the leaf of a geranium, means feeling for one's conscience and one's heart, looking for something that will complete – with a key, a tissue, a truth, a love, a victory, a seed – an instant of one's being, or perhaps one's whole life. In a sliver of knowledge, time is obliterated and reinstated. A single instance, the fall of a petal, or the swirl of the paper that imitates and becomes it, flourishes an answering likeness.

I am now and then haunted by some semi-mystic very profound life of a woman, which shall be all told on one occasion; and time shall be utterly obliterated; future shall somehow blossom out of the past. One incident – say the fall of a flower – might contain it.

Virginia Woolf, in her diary,
Tuesday, November 23, 1926[14]

NOTES

Note on the Endnotes:

AC = *The Autobiography and Correspondence of Mary Granville, Mrs. Delany: With Interesting Reminiscences of King George the Third and Queen Charlotte*, ed. Lady Llanover, 6 vols. (London: Richard Bentley, 1861 [first series], 1862 [second series]). Each series contains 3 volumes, numbered from 1 to 3, but I have followed Lady Llanover's practice in her index to the series in numbering them as a continuous series from 1 to 6.

The letters in these volumes are identified by writer, recipient, and date. I have referred to Mrs. Delany throughout these notes as MD. Mary Granville became Mary Pendarves after her first marriage, in 1717, and Mary Delany after her second marriage, in 1743. Her sister Anne Granville became Anne Dewes after her marriage in 1740; I have referred to her throughout these notes as AD. Anne's daughter (Mary's niece), Mary Dewes, became Mary Port after her marriage in 1770; I have referred to her throughout these notes as MP. The dates have been standardized to the Gregorian calendar, with the new year beginning on January 1, although Mrs. Delany used both the Julian calendar, with the new year beginning on March 25, and the Gregorian.

The autobiography of her early life that Mrs. Delany, the widow Mary Pendarves at the time, wrote in letters to the Duchess of Portland in 1740 is identified as "Autobiography," and the remarks that Lady Llanover included in passages between the letters and in footnotes is identified as "Lady Llanover's commentary."

I have retained Mrs. Delany's spelling, grammar, punctuation, and italics in the quotations, including all her variations. All italics in the quotations are in the originals, and all ellipses in them are mine.

CHAPTER ONE: SEEDCASE

[1] *AC* 4:469; MD to MP, October 4, 1772. biography
[2] Kohleen Reeder, "The 'Paper Mosaick' Practice of Mrs. Delany

and her Circle," in Mark Laird and Alicia Weisberg-Roberts, eds., *Mrs. Delany and Her Circle* (New Haven and London: Yale Center for British Art/Sir John Soane's Museum/Yale University Press, 2009), pp. 224-35.

3 The British Museum Web site is: http://www.britishmuseum.org.

4 Interview with Alicia Weisberg-Roberts, April 12, 2010.

5 Inscribed on the first page of the first volume of her *Flora Delanica*, and quoted in *AC* 5:443; Lady Llanover's commentary.

6 Robert Hogan and Donald C. Mell, eds., *The Poems of Patrick Delany* (Newark: University of Delaware Press, 2006), p. 23. The next quotation in this paragraph is also on this page.

7 Lisa L. Moore, "Queer Gardens: Mary Delany's Flowers and Friendships," *Eighteenth-Century Studies* 39, no. 1 (Fall 2005), pp. 49-70.

8 Jonathan Swift, "An Epistle upon an Epistle from a Certain Doctor to a Certain Great Lord: Being a Christmas-Box For D. D———Y," in Hogan and Mell, *Poems of Patrick Delany*, p. 130, ll. 61-63.

9 *AC* 2:432; MD to AD, March 29, 1746.

10 "Thou Modest Rose, of Blushing Bloom," in Hogan and Mell, *Poems of Patrick Delany*, p. 185.

11 *AC* 2:291; MD to AD, April 3, 1744.

12 *AC* 1:156; MD to AD, January 19, 1728.

13 "Orlando: British Writing in the British Isles from the Beginnings to the Present – George Paston: More Biography and History": http://orlando.cambridge.org/public/svPeople?person_id=pastge.

14 The original letters have been dispersed, and some of them have been lost. The biggest cache of them is located at the public library in Newport, Wales, where the letters still in Augusta Hall, Lady Llanover's possession were donated.

15 Interview with Alicia Weisberg-Roberts, April 12, 2010.

16 Ruth Hayden, *Mrs. Delany: Her Life and Her Flowers* (1980; 2nd ed., 1992; rpt. London: British Museum Press, 2000), p. 130.

17 For a review of this show, see Vivien Raynor, "Art: Flower Collages from the 18th Century," *New York Times* (September 5, 1986): http://www.nytimes.com/1986/09/05/arts/art-flower-col-lages-from-the-18th-century.html.

CHAPTER TWO: SEEDLING

1 *AC* 1:1; Autobiography. The other quotation in this paragraph is on page 1:2.

2 *AC* 1:2, 1:3; Autobiography.

[3] *AC* 1:3; Autobiography.

[4] *AC* 1:3; Autobiography.

[5] "Classic Encyclopedia – Based on the 11th Edition of the Encyclopaedia Britannica (pub. 1911)": http://www.1911encyclopedia. org/Etienne_De_Silhouette.

[6] *AC* 1:230; MD to AD, December 20, 1729. The next quotation is also on this page.

[7] Interview with Helen Sharp, British Museum, June 23, 2008.

CHAPTER THREE: HOUND'S TONGUE

[1] Nicholas Culpeper, *Culpeper's Complete Herbal, and English Physician* (1652): "Hounds Tongue": http://www.naturalhealthcrafters. com/culpepper/houndstongue.html.

[2] Hayden, *Mrs. Delany: Her Life and Her Flowers*, p. 21.

[3] Clarissa Campbell Orr, "Mrs. Delany and the Court," in Laird and Weisberg-Roberts, *Mrs. Delany and Her Circle*, p. 46.

[4] Hayden, *Mrs. Delany: Her Life and Her Flowers*, p. 15.

[5] *AC* 1:8; Autobiography.

[6] *AC* 1:8; Autobiography.

[7] *AC* 1:6; Autobiography.

[8] *AC* 1:8; Autobiography.

[9] *AC* 1:10; Autobiography.

[10] *AC* 1:9; Autobiography.

[11] *AC* 1:10; Autobiography. The next four quotations are also on this page.

[12] Bruce Chadwick, *The General and Mrs. Washington: The Untold Story of a Marriage and a Revolution* (Napier, IL: Sourcebooks, 2007), pp. 199-200.

[13] John Butt, ed., *The Poems of Alexander Pope* (New Haven: Yale University Press, 1963), p. 243, ll.1-4, 7-10. The poem's title here is "Epistle to Miss Blount, on her leaving the Town, after the Coronation."

[14] *AC* 1:17-18; Autobiography.

[15] *AC* 1:14; Autobiography.

[16] *AC* 1:15; Autobiography.

[17] *AC* 1:13; Autobiography.

[18] *AC* 1:15-16; Autobiography. The other quotations in this paragraph are also on these pages.

[19] *AC* 1:18; Autobiography.

[20] *AC* 1:30-31; Autobiography.

[21] *AC* 6:17; MD to MP, May 3, 1781; also Mark Laird, "Mrs. Delany's

Circles of Cutting and Embroidering in Home and Garden," and Lisa Ford, "A Progress in Plants: Mrs. Delany's Botanical Sources," both in Laird and Weisberg-Roberts, *Mrs. Delany and Her Circle*, pp. 25, 212.

CHAPTER FOUR: DAMASK ROSE

[1] David Burnett, *Longleat: The Story of an English Country House* (1978; rev. Stanbridge, Dorset: Dovecote Press, 1988), p. 97.

[2] Samuel Johnson, *Lives of the Poets* (1779-81; Garden City, NY: Dolphin/Doubleday, n.d. [ca. 1960]), p. 62.

[3] *AC* 1:22-23; Autobiography.

[4] *AC* 1:23; Autobiography.

[5] *AC* 1:34; Autobiography.

[6] *AC* 1:24; Autobiography.

[7] *AC* 1:24; Autobiography.

[8] *AC* 1:26; Autobiography.

[9] *AC* 1:26-27; Autobiography.

[10] *AC* 1:27; Autobiography. The next two quotations are also on this page.

[11] *AC* 1:27-28; Autobiography.

[12] *AC* 1:28; Autobiography.

[13] *AC* 1:28; Autobiography.

[14] Frank E. Grizzard, Jr., *George Washington: A Biographical Companion* (Santa Barbara, CA: ABC-CLIO, 2002), p. 59.

[15] *AC* 1:28; Autobiography. The next four quotations are also on this page.

[16] *AC* 1:28-29; Autobiography.

[17] *AC* 1:29; Autobiography.

[18] *AC* 1:29; Autobiography.

[19] *AC* 1:32; Autobiography.

[20] *AC* 1:29-30; Autobiography.

[21] *AC* 1:30; Autobiography.

[22] *AC* 1:31; Autobiography.

[23] *AC* 1:36; Autobiography.

[24] *AC* 1:29; Autobiography.

[25] "Journey North: A Global Study of Wildlife Migration and Seasonal Change": www.learner.org/jnorth/images/graphics/t/flower_parts.gif.

[26] Emily Dickinson, *The Letters of Emily Dickinson*, ed. Thomas H. Johnson (Cambridge: Belknap Press of Harvard University Press, 1958), p. 505; Emily Dickinson to Louise and Frances Norcross, ca. April 1873.

[1] François Gros d'Aillon, "Flora, etc.: *Carduus nutans* Linnaeus": http://ariel.minilab.bdeb.qc.ca/~fg/MyFlora/Asteraceae/Carduus/ Nutans/nutans.e.shtml.

[2] J. L. Comstock, *The Young Botanist: Being a Treatise on the Science, Prepared for the Use of Persons Just Commencing the Study of Plants* (2nd ed., New York: Robinson, Pratt, and Co., 1836), p. 162. The other two quotations in this paragraph are from pp. 165 and 162 of this book.

[3] Comstock, *Young Botanist*, p. 163.

[4] *AC* 1:49; Autobiography.

[5] *AC* 1:50-51; Autobiography.

[6] *AC* 1:39; Autobiography.

[7] *AC* 1:106; Autobiography.

[8] *AC* 1:55; Autobiography.

[9] *AC* 1:55, 1:63; Autobiography.

[10] *AC* 1:55; Autobiography.

[11] *AC* 1:61; Autobiography.

[12] *AC* 1:63, 1:62, 1:63; Autobiography.

[13] *AC* 1:85; Autobiography. The two other quotations in this paragraph are also on this page.

[14] *AC* 1:85; Autobiography.

[15] *AC* 1:87; Sir John Stanley to MD, December 10, 1723.

[16] *AC* 1:85; Autobiography.

[17] *AC* 1:89; Autobiography. The following quotation is also on this page.

[18] Wilfrid Blunt, *Linnaeus: The Compleat Naturalist* (1971; rpt. Princeton, New Jersey, and Oxford: Princeton University Press, 2001), pp. 198-203.

[19] *AC* 1:83; Lady Llanover's commentary.

[20] *AC* 1:91; Autobiography. The other quotations in this paragraph are also on this page.

[21] *AC* 1:98; MD to AD, May 30, 1724.

[22] *AC* 1:99; MD to AD, May 30, 1724.

[23] *AC* 1:107; Autobiography. The next four quotations are also from this page.

[24] Robert Phelps, Editor's Foreword to Colette, *Earthly Paradise: An Autobiography*, ed. Phelps (New York: Farrar, Straus, and Giroux, 1966), p. ix.

[1] *AC* 1:105; Autobiography.

[2] *AC* 1:106; Autobiography.

[3] *AC* 1:109; Autobiography.

[4] Interview with Alicia Weisberg-Roberts, April 12, 2010.

[5] *AC* 1:110; Autobiography.

[6] *AC* 1:130; Autobiography.

[7] *AC* 1:96; MD to AD, March 28, 1724.

[8] *AC* 1:123-24; MD to AD, November 8, 1726.

[9] *AC* 1:144-45; MD to AD, November 11, 1727.

[10] *AC* 1:111; Autobiography.

[11] *AC* 1:105-6; Autobiography.

[12] *AC* 1:131; Autobiography. The next four quotations are also on this page.

[13] *AC* 1:133; Autobiography. The next five quotations are also on this page.

[14] *AC* 1:148; MD to AD, November 11, 1727.

[15] *AC* 1:113; Lord Lansdowne to MD, January 19, 1725.

[16] *AC* 1:129; MD to AD, January 26, 1727. The next quotation is also on this page.

[17] Alain Kerhervé, *Mary Delany (1700-1788): Une épistolière anglaise du XVIIIe siècle* (Paris: L'Harmattan, 2004), p. 294.

[18] "The Marteau Early-18th-Century Currency Converter": http://www.pierre-marteau.com, and "Measuring Worth" Web site: http://www.measuringworth.com.

[19] John Mainwaring, *Memoirs of the Life of the Late George Frederic Handel* (London: R. and J. Dodsley, 1760), p. 110. Mainwaring quotes Handel as saying, "Oh! Madam, je sais bien que Vous êtes une véritable Diablesse: mais je Vous ferai savoir, moi, que je suis Beelzebub le *Chéf* des Diables."

[20] *AC* 1:111; Autobiography. The next quotation is also on this page.

[21] *AC* 1:158; MD to AD, January 19, 1728.

[22] *AC* 1:163; MD to AD, March 14, 1728.

[23] "What think you of a Newgate pastoral, among the whores and thieves there?": Jonathan Swift to Alexander Pope, August 30, 1716, cited in Richard Traubner, *Operetta: A Theatrical History* (2nd ed, London: Routledge, 2003), p. 11, and in Calhoun Winton, "*The Beggar's Opera*: A Case Study," in *The Cambridge History of British Theatre, Vol. 2: 1660 to 1895,* ed. Joseph Donohue (Cambridge: Cambridge University Press, 2004), p. 128.

[24] Katherine Cahill, *Mrs. Delany's Menus, Medicines and Manners* (Dublin: New Island, 2005), pp. 262-66; also Madeleine Ginsburg, "Women's Dress Before1900," in Natalie Rothstein, ed., *Four Hundred Years of Fashion: Victoria and Albert Museum* (London: V&A Publications, 1984), esp. pp. 13-31, and Norah Waugh, *Corsets and Crinolines* (1954; rpt. New York: Routledge/Theatre Arts Books, 2004), esp. chapter 2.

[25] Interview with Alicia Weisberg-Roberts, April 12, 2010.

[26] Interview with Alicia Weisberg-Roberts, April 12, 2010.

[27] *AC* 2:580; MD to AD, undated (probably August 1750).

[28] Cahill, *Mrs. Delany's Menus, Medicines and Manners*, p. 265.

[29] In the seventeenth century a whalebone busk was "thrust down the middle of the stomacher to keep it streight and in compass, that the Breast nor Belly shall not swell too much out. These Busks are usually made in length according to the necessity of the Persons wearing it: if to keep in the fullness of the Breasts, then it extends to the Navel; if to keep the Belly down, then it reacheth to the Honour." Randle Holme, *The Academy of Armory* (1688), cited in Cahill, *Mrs. Delany's Menus, Medicines and Manners*, p. 264.

[30] Stephen Miller, *Conversation: A History of a Declining Art* (New Haven: Yale University Press, 2006) pp. 88-102.

[31] *AC* 1:139; MD to AD, day after coronation of George II (that is, October 12, 1727).

[32] Hayden, *Mrs. Delany: Her Life and Her Flowers*, p. 40.

[33] *AC* 1:138; MD to AD, day after coronation of George II (that is, October 12, 1727).

[34] *AC* 1:139; MD to AD, day after coronation of George II (that is, October 12, 1727).

[35] *AC* 1:196; MD to AD, March 14, 1729.

[36] *AC* 1:198; MD to AD, March 14, 1729.

[37] "The Marteau Early-18th-Century Currency Converter" and "Measuring Worth" Web site.

[38] *AC* 1:191; MD to AD, March 4, 1729. The next quotation is also on this page.

[39] Clare Browne, "Mary Delany's Embroidered Court Dress," in Laird and Weisberg-Roberts, *Mrs. Delany and Her Circle*, pp. 66-79.

[40] *AC* 1:154; MD to AD, January 19, 1728.

[41] *AC* 1:155; MD to AD, January 19, 1728.

[42] *AC* 1:239; Autobiography.

[43] *AC* 1:202; MD to AD, March 13, 1729.

[44] *AC* 1:201; MD to AD, March 13, 1729.

[45] *AC* 1:179, 1:190; MD to AD, November 19, 1728.

[46] *AC* 1:230; MD to AD, December 20, 1729.

[47] *AC* 1:149; MD to AD, November 25, 1727.

[48] *AC* 1:236; MD to AD, February 7, 1730.

[49] *AC* 1:202; MD to AD, March 13, 1729.

[50] Kim Sloan, *"A Noble Art": Amateur Artists and Drawing Masters c. 1600–1800* (London: British Museum Press, 2000), p. 40.

[51] *AC* 1:222; MD to AD, November 8, 1726.

[52] *AC* 1:208; MD to AD, April 19, 1729; and 1:236, MD to AD, February 7, 1730.

[53] *AC* 1:233; MD to AD, December 25, 1729. The quotations in the next six paragraphs are also on this page.

[54] Reproductions of drawings for the court dress and details from the court dress are in Hayden, *Mrs. Delany: Her Life and Her Flowers*, pp. 93, 98.

[55] *AC* 1:240-41; Autobiography.

[56] *AC* 1:241; Autobiography.

[57] *AC* 2:72; MD to AD, January 22, 1740.

[58] *AC* 1:241; Autobiography.

CHAPTER SEVEN: CANADA LILY

[1] Interview with Alicia Weisberg-Roberts, April 16, 2010. Mrs. Delany's height has been extrapolated from the surviving skirt of her court dress.

[2] Ellen T. Harris, "Three Ladies of Handel's Will," *Newsletter of the American Handel Society* 15:2 (April/August 2000), pp. 1, 4-6, esp. p. 4: http://americanhandelsociety.org/newsletter/newsletter.htm.

[3] *AC* 1:223; MD to AD, November 21, 1729. The quotations in the next paragraph are also on this page. Lisa L. Moore discusses Mary Delany's female friendships in "Queer Gardens: Mary Delany's Flowers and Friendships."

[4] *AC* 1:241; Autobiography.

[5] *AC* 1:241-42; Autobiography.

[6] *AC* 1:276; MD to AD, June 8, 1731.

[7] *AC* 1:283; MD to AD, July 13, 1731. The quotations in the next paragraph are also on this page.

[8] William Hogarth, *The Analysis of Beauty: Written With a View of Fixing the Fluctuating Ideas of Taste* (1753; new ed., London: Printed by W. Strahan for Mrs. Hogarth, 1772), p. xvii.

[9] *AC* 1:252; MD to AD, April 4, 1730.

[10] *AC* 1:222; Lady Llanover's commentary.

[11] *AC* 1:292; MD to AD, September 26, 1731. The other quotation in this paragraph is also from this letter and is on pages 1:291-92. Angélique Day has edited a one-volume collection of Mrs. Delany's letters from Ireland (based on *AC*): *Letters from Georgian Ireland: The Correspondence of Mary Delany 1731–68* (Belfast: Friar's Bush Press, 1991).

[12] *AC* 1:305; MD to AD, October 21, 1731.

[13] *AC* 1:326; MD to AD, December 4, 1731. The next two quotations are also from this letter and are on pages 1:325 and 1:324.

[14] *AC* 1:334; MD to AD, January 17, 1732.

[15] *AC* 1:316; MD to AD, November 25, 1731.

[16] *AC* 1:336; MD to AD, February 3, 1732. The next quotation is also on this page.

[17] *AC* 1:289; MD to AD, September 22, 1731.

[18] *AC* 1:345; MD to AD, March 30, 1732. The next quotation is also from this letter and is on page 1:346.

[19] *AC* 1:348-49; MD to AD, May 17, 1732.

[20] *AC* 1:351; MD to AD, June 12, 1732. The next quotation is also on this page.

[21] *AC* 1:300; MD to AD, October 9, 1731.

[22] *AC* 1:356; MD to AD, June 21, 1732.

[23] *AC* 1:361; MD to AD, June 28, 1732.

[24] Paul Valéry, *Les merveilles de la mer: Les coquillages* (Paris: Plon, 1936), p. 5, quoted in Gaston Bachelard, *The Poetics of Space*, trans. Maria Jolas (New York: Orion Press, 1964), pp. 105-6.

[25] *AC* 1:388-89; MD to AD, October 30, 1762.

[26] *AC* 1:345, 1:344; MD to AD, March 30, 1732.

[27] *AC* 1:353; MD to AD, June 12, 1732.

[28] *AC* 1:398; Lady Llanover's commentary.

[29] *AC* 1:296-97; Autobiography.

[30] *AC* 1:396; MD to AD, January 24, 1733. The next two quotations are also on this page.

[31] *AC* 1:403; MD to AD, ca. February 1733.

[32] *AC* 1:400; MD to AD, February 20, 1733.

[33] *AC* 1:414; MD to Dean Jonathan Swift, May 29, 1733.

[34] *AC* 1:415; MD to Dean Jonathan Swift, July 21, 1733. The next three quotations are also from this letter and are on pages 1:415-16, 1:416, and 1:417.

[35] Edmund Berkeley and Dorothy Smith Berkeley, *The Life and*

Travels of John Bartram: From Lake Ontario to the River St. John (Tallahassee: Florida State University/University Presses of Florida, 1982), p. 227.

[36] John Edmondson, "John Bartram's Legacy in Eighteenth-Century Art," in Nancy E. Hoffmann and John C. Van Horne, eds., *America's Curious Botanist: A Tercentennial Reappraisal of John Bartram 1699–1777* (Philadelphia: American Philosophical Society in Cooperation with the Library Company of Philadelphia and John Bartram Association, 2004), p. 143, also Berkeley and Berkeley, *Life and Travels of John Bartram*, pp. 22-24, 32-33.

[37] Joel T. Fry, "John Bartram and His Garden: Would John Bartram Recognize His Garden Today?" in Hoffmann and Van Horne, *America's Curious Botanist*, p. 173.

[38] B. D. Jackson, rev. Anne Pimlott Baker, "Lee, James (1715-1795)," *Oxford Dictionary of National Biography* (2004): http://www.oxforddnb.com/view/article/16291.

[39] Berkeley and Berkeley, *Life and Travels of John Bartram*, p. 45.

[40] Berkeley and Berkeley, *Life and Travels of John Bartram*, p. 48.

[41] *AC* 1:402; MD to AD, ca. February 1733. The other quotations in this paragraph are also on this page.

[42] *AC* 1:404-5; Lady Llanover's commentary.

[43] *AC* 1:552; Dean Jonathan Swift to MD, January 29, 1736.

[44] *AC* 1:555; MD to Dean Jonathan Swift, April 22, 1736.

CHAPTER EIGHT: PASSION FLOWER

[1] Hayden, *Mrs. Delany: Her Life and Her Flowers*, p. 134.

[2] *AC* 2:70-71; MD to AD, January 22, 1740.

[3] *AC* 2:29; MD to AD, January 23, 1739.

[4] "Classic Encyclopedia – Based on the 11th Edition of the Encyclopaedia Britannica (pub. 1911)": http://www.1911encyclopedia.org/John_Carteret,_Earl_Granville.

[5] *AC* 1:175; MD to AD, June 18, 1728.

[6] *AC* 2:70; MD to AD, January 22, 1740.

[7] *AC* 2:72-73; MD to AD, January 22, 1740.

[8] *AC* 1:297; Autobiography. The quotations in this and the next two paragraphs are all on pages 1:297-99.

[9] *AC* 2:207; MD to AD, April 23, 1743.

[10] Countess Granville to Charlotte Clayton (nee Donnellan), quoted in Orr, "Mrs. Delany and the Court," p. 51.

[11] *AC* 2:206; MD to AD, April 23, 1743.

[12] *AC* 1:561; AD to Kitty Collingwood, Lady Throckmorton, July 8, 1736. The next quotation is also from this letter and is on page 1:562.

[13] *AC* 1:443; AD to MD, March 20, 1734.

[14] *AC* 1:164-65; MD to AD, March 19, 1728.

[15] *AC* 2:74; AD to Kitty Collingwood, Lady Throckmorton, February 7, 1740. The inset quotation and the quotations in the subsequent two paragraphs are all from this letter and are on page 2:75.

[16] *AC* 2:77; AD to Kitty Collingwood, Lady Throckmorton, February 20, 1740.

[17] *AC* 2:75 and 2:77-78; AD to Kitty Collingwood, Lady Throckmorton, February 7, 1740, and February 20, 1740.

[18] *AC* 2:81; MD to AD, April 22, 1740. The next quotation is also from this letter and is on page 2:82.

[19] Henry C. Shelley, *Inns and Old Taverns of London* (1909; rpt. Whitefish, MT: Kessinger Publishing, 2004), p. 32.

[20] *AC* 2:93; Miss Robinson to Ann Donnellan, August 21, 1740.

[21] *AC* 2:116; AD to MD, undated (probably late October–early November 1740).

[22] "Kew, History and Heritage: John Stuart, 3rd Earl of Bute (1713–1792)": http://www.kew.org/heritage/people/bute.html.

[23] E. Charles Nelson, "Some Publication Dates for Parts of William Curtis' *Flora Londinensis,*" *Taxon* 29:5/6 (November 1980), pp. 635-39.

[24] See Maureen H. Lazarus and Heather S. Pardoe, "Bute's Botanical Tables: Dictated by Nature," *Archives of Natural History* 36 (2009): 277-98.

[25] *AC* 2:210-11; Patrick Delany to MD, April 23, 1743. The next quotation is also from this letter and is on page 2:211.

[26] *AC* 2:225, 2:227; MD to AD, November 18, 1743.

[27] *AC* 2:211; Patrick Delany to MD, April 23, 1743. The next quotation is also on this page.

[28] Hogan and Mell, *Poems of Patrick Delany,* p. 23.

[29] *AC* 2:212; Patrick Delany to MD, May 3, 1743.

[30] *AC* 2:213; Patrick Delany to MD, May 6, 1743.

[31] *AC* 2:213; Lady Llanover's commentary.

[32] *AC* 2:213; Patrick Delany to MD, May 6, 1743.

[33] *AC* 2:213; Patrick Delany to MD, May 6, 1743. The other two quotations in this paragraph are also on this page.

[34] *AC* 2:214-15; Patrick Delany to MD, May 12, 1743.

[35] *AC* 2:216; Patrick Delany to MD, May 14, 1743.

[36] "The Saw Palmetto Harvesting Company: Passion Flower/ Passiflora": http://www.passionflower.org/herbal_monograph.html.

[37] *AC* 2:301; MD to AD, May 8, 1744.
[38] *AC* 2:306; MD to AD, June 28, 1744.

CHAPTER NINE: MAGNOLIA

[1] John Fisher, *The Origins of Garden Plants* (1982; rev. London: Constable, 1989), pp. 109-10.
[2] Mark Laird, *The Flowering of the Landscape Garden: English Pleasure Grounds 1720–1800* (Philadelphia: University of Pennsylvania Press, 1999), p. 76.
[3] "Victoria and Albert Museum Botanical Illustration: A Study Room Resource – Georg Dionysius Ehret: 'Blue Bay, Magnolia grandiflora, 1743": http://www.vam.ac.uk/images/image/40730-popup.html.
[4] Amy R. W. Meyers and Margaret Beck Pritchard, "Introduction: Toward an Understanding of Catesby," in Meyers and Pritchard, eds., *Empire's Nature: Mark Catesby's New World Vision* (Chapel Hill: University of North Carolina Press, 1998) pp. 2-3.
[5] Meyers and Pritchard, "Introduction," pp. 9-10.
[6] Mark Catesby, *The Natural History of Carolina, Florida and the Bahama Islands* (London: Mark Catesby, 1754), Vol. 2, Plate 61.
[7] Laird, "Mrs. Delany's Circles of Cutting and Embroidering in Home and Garden," p. 159.
[8] Laird, "Mrs. Delany's Circles," p. 160.
[9] *AC* 2:308-9; MD to AD, July 12, 1744.
[10] *AC* 2:309; MD to AD, July 12, 1744. The other quotations in this paragraph are also from this letter and are on pages 2:309 and 2:309-10.
[11] *AC* 2:316; MD to AD, July 19, 1744. The other quotations in this paragraph are also from this letter and are on pages 2:315 and 2:316.
[12] *AC* 2:558; MD to AD, June 22, 1750. The next quotation is also on this page.
[13] *AC* 2:570; MD to AD, July 15, 1750.
[14] *AC* 2:432; MD to AD, March 29, 1746.
[15] *AC* 2:460; MD to AD, May 26, 1747.
[16] *AC* 2:499-500; MD to AD, August 20, 1748. The next two quotations are also from this letter and are on page 2:500.
[17] *AC* 3:277; MD to AD, June 15, 1754.
[18] *AC* 3:279; MD to AD, June 22, 1754.
[19] *AC* 2:417; MD to AD, January 25, 1746.
[20] *AC* 2:557; MD to AD, June 17, 1750.
[21] *AC* 2:416-17; MD to AD, January 25, 1746.

[22] *AC* 6:499-501; Lady Llanover's commentary.

[23] Sloan, *"A Noble Art,"* p. 40.

[24] *AC* 3:207; MD to AD, February 17, 1753.

[25] *AC* 3:5; MD to AD, January 12, 1751.

[26] *AC* 3:175; MD to AD, November 25, 1752.

[27] *AC* 3:5; MD to AD, January 12, 1751.

[28] *AC* 2:400; MD to AD, November 23, 1745.

[29] *AC* 2:363; MD to AD, June 21, 1745.

[30] *AC* 2:458; MD to AD, May 19, 1747. The next quotation is also from this letter and is on page 3:457.

[31] *AC* 3:25; MD to AD, March 16, 1751.

[32] *AC* 3:211; MD to AD, March 3, 1753.

[33] *AC* 3:212; MD to AD, March 8, 1753.

[34] *AC* 3:176; MD to AD, November 25, 1752.

[35] *AC* 6:502-3; Lady Llanover's commentary.

[36] *AC* 2:603; MD to AD, October 13, 1750.

[37] *AC* 3:75; MD to AD, January 9, 1752.

[38] *AC* 3:163-64; MD to AD, October 14, 1752.

[39] *AC* 3:71; MD to AD, January 3, 1752. The other quotations in this paragraph are also on this page.

[40] *AC* 3:70; MD to AD, January 3, 1752.

[41] *AC* 3:106; MD to AD, March 27, 1752 for both quotations.

[42] *AC* 3:172; MD to AD, November 9, 1752.

[43] *AC* 3:189; MD to AD, December 30, 1752.

[44] *AC* 3:207-8; MD to AD, February 24, 1753.

[45] *AC* 3:184; MD to AD, December 15, 1752.

[46] *AC* 3:177; MD to AD, November 25, 1752.

[47] *AC* 3:202; MD to AD, February 3, 1753.

[48] *AC* 3:54; MD to AD, November 7, 1751, and Lady Llanover's commentary on this page; *AC* 3:213; MD to AD, March 17, 1753.

[49] *AC* 3:244; MD to AD, November 28, 1753.

[50] *AC* 3:257; MD to AD, December 21, 1753. The other quotations in this paragraph are also from this letter and are on page 3:259.

[51] *AC* 3:259; MD to AD, December 21, 1753.

[52] *AC* 3:266-67; MD to AD, January 29, 1754.

[53] *AC* 3:446-47; MD to AD, November 4, 1756.

[54] *AC* 3:456; MD to AD, December 21, 1756.

[55] *AC* 3:346; Lady Llanover's commentary.

[56] *AC* 3:491-92; MD to AD, March 9, 1758. The other quotations in this paragraph are also from this letter and are on page 3:492.

[57] *AC* 3:294; MD to AD, October 30, 1754.

[58] Orr, "Mrs. Delany and the Court," p. 43; "David Nash Ford's Royal Berkshire History: Bill Hill, St. Nicholas Hurst, Berkshire": http://www.berkshirehistory.com/castles/bill_hill.html.

[59] Laird, *Flowering of the Landscape Garden,* pp. 154, 156.

[60] *AC* 5:230; Dowager-Countess Gower to MD, June 30, 1776.

[61] Laird, *Flowering of the Landscape Garden,* p. 347.

[62] *AC* 4:548; Dowager-Countess Gower to MD, September 27, 1773.

[63] The photograph of Delville is in Day, *Letters from Georgian Ireland,* p. 169. Some of Mrs. Delany's sketches are in Laird and Weisberg-Roberts, *Mrs. Delany and Her Circle,* pp. 8, 127, 139, and 151. The plasterwork photos are in C. P. Curran, *Dublin Decorative Plasterwork of the Seventeenth and Eighteenth Centuries* (London: Tiranti, 1967).

[64] Louis Menand, "Show or Tell: Should Creative Writing Be Taught?" *New Yorker* (June 8-15, 2009), p. 112.

CHAPTER TEN: EVERLASTING PEA

[1] "Matisse Lithographs after Cut-outs": http://www.henrimatisseprints.com/view_article.php?article_id=135&sort_by=.

[2] *AC* 3:590; MD to AD, April 24, 1760.

[3] *AC* 2:386; MD to AD, September 7, 1745.

[4] *AC* 2:330; MD to AD, September 23, 1744.

[5] *AC* 3:78; MD to AD, January 11, 1752.

[6] John Keats, *Selected Poems and Letters,* Riverside Edition, ed. Douglas Bush (Boston: Houghton Mifflin, 1959), p. 21, ll. 57-60.

[7] "The National Sweet Pea Society" Web site: http://www.sweetpeas.org.uk/Graphics/whatisasweetpea.

[8] *AC* 3:136; MD to AD, July 10, 1752.

[9] *AC* 2:116; AD to MD, ca. late October–early November 1740.

[10] *AC* 3:347; MD to AD, May 15, 1755.

[11] *AC* 3:413; MD to AD, March 16, 1756.

[12] *AC* 3:412; MD to AD, March 8, 1756.

[13] "Channel 4 Time Traveller's Guide to Victorian Britain: Married Women's Property Act, 9 August 1870": http://www.channel4.com/history/microsites/H/history/guide19/timeline56.html; also Mary Lyndon Shanley, *Feminism, Marriage, and the Law in Victorian England* (Princeton: Princeton University Press, 1989), pp. 103-4.

[14] *AC* 3:633-34; quoted in Lady Llanover's commentary.

[15] *AC* 3:414-15; MD to AD, March 27, 1756. The next quotation is also from this letter and is on page 3:417.

[16] *AC* 3:477; MD to AD, January 21, 1758.

[17] *AC* 3:600; MD to MP, September 1, 1760.

[18] *AC* 3:598; MD to AD, July 12, 1760.

[19] *AC* 3:606; MD to AD, October 28, 1760.

[20] *AC* 3:607; MD to AD, November 2, 1760.

[21] *AC* 3:609; MD to MP, November 3, 1760.

[22] *AC* 3:611; MD to AD, November 8, 1760.

[23] *AC* 3:613; MD to AD, November 13, 1760.

[24] *AC* 3:617; MD to AD, December 19, 1760.

[25] *AC* 3:623; MD to AD, December 28, 1760.

[26] *AC* 3:621; MD to AD, December 19, 1760.

[27] *AC* 3:617; MD to AD, December 13, 1760.

[28] *AC* 3:624; MD to AD, December 28, 1760.

[29] *AC* 3:631; John Dewes to MP, July 8, 1761.

[30] *AC* 4:46; MD to Lady Andover, April 27, 1765.

[31] *AC* 4:48; MD to Lady Andover, June 8, 1765. The next two quotations are also from this letter and are on page 4:50.

[32] *AC* 4:64; MD to Bernard Granville, July 3, 1766.

[33] *AC* 3:249; MD to AD, December 3, 1753.

[34] *AC* 4:76; MD to Lady Andover, September 4, 1766.

[35] *AC* 4:88; MD to Lady Andover, November 8, 1766.

[36] *AC* 4:90; Duchess of Portland to Bernard Granville, December 26, 1766.

[37] *AC* 4:108; MD to Lady Andover, May 16, 1767.

[38] *AC* 4:112; MD to Lady Andover, June 16, 1767.

[39] *AC* 4:119; MD to Lady Andover, July 20, 1767.

[40] *AC* 4:127; MD to MP, December 10, 1767.

[41] *AC* 3:600; MP to Rev. John Dewes, April 27, 1768.

[42] Mary Barber, "A Hymn to Sleep, Written When the Author was Sick," *Poems on Several Occasions* (London: C. Rivington, 1734), in *Women Writers Online.* Women Writers Project, Brown University: http://textbase.wwp.brown.edu/cgi-bin/newphilo/getobject.pl?c.185:3:31.wwo.

[43] *AC* 4:143-44; cited in Lady Llanover's commentary.

[44] *AC* 4:142-43; Lady Llanover's commentary.

[45] *AC* 4:143; Lady Llanover's commentary.

CHAPTER ELEVEN: Bloodroot

[1] *AC* 3:570-71; MD to AD, October 13, 1759.

[2] "In the Garden of Paghat the Ratgirl – Sanguinaria Canadensis: The Flower that Bleeds." http://www.paghat.com/bloodroot.html.

[3] Quoted in Fry, "John Bartram and His Garden," p. 178.

[4] Conversation with Ruth Hayden, June 20, 2008. The other conversations quoted in this chapter occurred at Ruth Hayden's house in Bath on this date, as well as on June 22 and November 28, 2008, February 21, 2010, and in scattered telephone conversations between 2008 and 2010.

[5] Hayden, *Mrs. Delany: Her Life and Her Flowers*, p. 7.

[6] Conversation with Mark Laird, Toronto, July 9, 2008.

[7] E-mail correspondence with John Edmondson, April 21, 2010.

[8] Bachelard, *Poetics of Space*, p. 107.

[9] *AC* 4:18; MD to MP, ca. summer 1763.

[10] "Chelsea Physic Garden": http://www.chelseaphysicgarden.co.uk/garden/index.html.

CHAPTER TWELVE: PORTLANDIA

[1] John Edmondson, "Novelty in Nomenclature: The Botanical Horizons of Mary Delany," in Laird and Weisberg-Roberts, *Mrs. Delany and Her Circle*, p. 193.

[2] "Gardino Nursery Corp.: Rare and Unusual Plants" Web site. http://www.rareflora.com/portlandiagran.htm; "Classic Encyclopedia – Based on the 11th Edition of the Encyclopaedia Britannica (pub. 1911): Rubiaceae": http://www.1911encyclopedia.org/Rubiaceae.

[3] *AC* 4:157; MD to MP, September 2, 1768.

[4] *AC* 1:70; MD to AD, July 14, 1722.

[5] *AC* 2:230; MD to AD, November 30, 1743.

[6] University of Nottingham Manuscripts and Special Collections, "Biography of Margaret Cavendish-Bentinck, Duchess of Portland (1715–1785)": http://www.nottingham.ac.uk/manuscriptsandspecialcollections/collectionsindepth/family/portland/biographies/biographyofmargaretcavendish-bentinck,duchessofportland%281715-1785%29.aspx.

[7] *AC* 3:317; MD to AD, January 1, 1755. Lady Llanover identifies Lord G. as Lord Granville on p. 3:237.

[8] *AC* 4:146; Duchess of Portland to MP, May 1768.

[9] *AC* 4:161; MD to MP, September 6, 1768. The next quotation is also from this letter and is on page 4:162.

[10] *AC* 4:170; MD to MP, October 4, 1768.

[11] *AC* 4:170-71; MD to MP, October 4, 1768. The next quotation is also from this letter and is on 4:172.

[12] *Marianna* is transcribed by Alicia Weisberg-Roberts in Laird and Weisberg-Roberts, *Mrs. Delany and Her Circle*, pp. 250-61.

[13] *AC* 4:200; MD to Lady Andover, January 19, 1769.

[14] *AC* 4:214; MD to MP, June 7, 1769.

[15] *AC* 4:149-53; MD to MP, August 25, 1768; *AC* 4:167; MD to MP, September 21, 1768.

[16] "The Duchess of Curiosities: Exhibition at the Harley Gallery," "Nottinghamshire Tourism" Web site: http://www.visitnottingham. com/exec/102918/9068/.

[17] Quoted in Jane Wildgoose, Preface to *Promiscuous Assemblage, Friendship, and the Order of Things: An Installation by Jane Wildgoose in Celebration of the Friendship Between Mrs. Mary Delany and the Duchess Dowager of Portland* (New Haven: Yale Center for British Art, 2009), p. ix.

[18] Jean K. Bowden, "Lightfoot, John (1735–1788)," *Oxford Dictionary of National Biography* (2004): http://www.oxforddnb.com/view/ article/16649; Royal Society, Table of Contents, *Philosophical Transactions*, January 1, 1786: http://rstl.royalsocietypublishing.org/ content/76.toc.

[19] *AC* 3:255; Lady Llanover's commentary.

[20] *AC* 4:162-63; MD to MP, September 6, 1768. The next quotation is also from this letter and is on 4:163.

[21] *AC* 4:163; MD to MP, September 6, 1768.

[22] Deb Williams, "The Writing [Implement] of Jane Austen – The Quill Pen": http://www.jasa.net.au/quillpen.htm.

[23] *AC* 4:243; described and quoted in Lady Llanover's commentary. The next quotation is also from Lady Llanover's commentary, on the same page.

[24] *AC* 4:255; MD to MP, January 15, 1770.

[25] *AC* 4:272; MD to Lady Andover, June 24, 1770.

[26] *AC* 4:285; MD to MP, 1770 (probably mid-July).

[27] *AC* 4:290; MD to MP, July 22, 1770, and Lady Llanover's commentary.

[28] *AC* 4:318, 319; MD to Lady Andover, December 27, 1770.

[29] *AC* 4:324; MD to MP, January 18, 1771.

[30] *AC* 4:341; MD to Lady Andover, June 3, 1771; 4:353; MD to Lady Andover, June 28, 1771; 4:357; MD to MP, September 5, 1771.

[31] *AC* 4:384, MD to Bernard Granville, December 17, 1771. The next two quotations are also from this letter and are on pages 4:384 and 4:384-85.

[32] John Gascoigne, "Banks, Sir Joseph (1743–1820)," *Oxford Dictionary of National Biography* (2004): http://www.oxforddnb.com/view/article/1300.

[33] John Robson, *The Captain Cook Encyclopaedia* (London: Chatham, 2004), p. 38.

[34] *AC* 4:372; MD to MP, November 19, 1771.

[35] *AC* 4:416; John Fitzwilliam to MP, February 13, 1772.

[36] *AC* 4:389; Countess Cowper to MP, December 22, 1771.

[37] *AC* 4:407; MD to MP, January 27, 1772. The next quotation is also from this letter and is on page 4:406.

[38] *AC* 4:447; MD to Lady Andover, August 16, 1772.

[39] Horace Walpole, *Essay on Modern Gardening* (1780; rpt. BiblioBazaar, 2008), p. 87.

[40] *AC* 4:454; MD to Rev. John Dewes, September 5, 1772. The next quotation is also on this page.

[41] *AC* 4:469; MD to MP, October 4, 1772. Lady Llanover describes the Duchess of Portland's first reaction in her commentary on page 5:215.

[42] Lady Llanover discusses Mrs. Delany's technique, including her scissors, in her commentary on *AC* pages 5:215 and 6:95-98.

[43] *AC* 6:95; quoted in Lady Llanover's commentary. The poem that follows is also quoted in Lady Llanover's commentary on the same page.

[44] *AC* 4:418; MD to Lady Andover, November 20, 1772.

[45] "Bulstrode – WEC Headquarters," "WEC International – UK" Web site: http://www.wec-int.org.uk/cms/content/view/175/402/.

[46] *AC* 4:201; MD to Lady Andover, January 19, 1769.

CHAPTER THIRTEEN: WINTER CHERRY

[1] Mark Laird, "Introduction (2): Mrs. Delany and Compassing the Circle: The Essays Introduced," in Laird and Weisberg-Roberts, *Mrs. Delany and Her Circle*, p. 34.

[2] *AC* 5:443; quoted in Lady Llanover's commentary.

[3] *AC* 5:12; quoted in Lady Llanover's commentary.

[4] *AC* 5:48; MD to MP, October 28, 1774.

[5] *AC* 5:40; MD to Bernard Granville, October 10, 1774.

[6] *AC* 5:54; MD to Lady Andover, November 3, 1774.

[7] Ford, "A Progress in Plants: Mrs. Delany's Botanical Sources," in Laird and Weisberg-Roberts, *Mrs. Delany and Her Circle*, p. 212.

[8] *AC* 5:134; MD to MP, June 11, 1775.

[9] Emily Dickinson, *Letters of Emily Dickinson*, p. 505; Emily Dickinson to Louise and Frances Norcross, ca. April 1873.

[10] *AC* 5:210; MD to MP, April 27, 1776.

[11] *AC* 5:214; MD to MP, April 29, 1776.

[12] Ford, "A Progress in Plants," p. 212.

[13] *AC* 5:189; MD to MP, December 21, 1775.

[14] *AC* 5:224; MD to Lady Andover, June 9, 1776.

[15] *AC* 5:223; MD to MP, June 9, 1776. The following quotation is also from this letter and is on the same page.

[16] *AC* 5:249; MD to MP, August 5, 1776

[17] *AC* 5:251; MD to Lady Andover, August 12, 1776. The other quotations in this and the next paragraph are also from this letter and are on pages 5:250-51.

[18] Quoted in Alicia Weisberg-Roberts, "Introduction (1): Mrs. Delany from Source to Subject," in Laird and Weisberg-Roberts, *Mrs. Delany and Her Circle*, p. 10.

[19] *AC* 5:318; MD to MP, August 31, 1777.

[20] *AC* 5:320; MD to MP, September 19, 1777.

[21] *AC* 5:326; MD to MP, October 20, 1777.

[22] *AC* 5:366; MD to MP, July 27, 1778.

[23] *AC* 5:370; MD to MP, undated (August 12 or 13, 1778). The details that follow in this paragraph and the next are also from this letter and are on pp. 5:370-71.

[24] *AC* 5:372; MD to MP, undated (August 12 or 13, 1778). The quotations in the next three paragraphs are also from this letter and are on pages 5:372 and 5:373.

[25] Reeder, "The 'Paper Mosaick' Practice of Mrs. Delany and Her Circle," p. 231. The facts on watercolors in this paragraph are from Reeder's essay.

[26] Reeder, "The 'Paper Mosaick' Practice," p. 230.

[27] Ford, "A Progress in Plants," p. 212.

[28] *AC* 5:404; MD to Mrs. John Dewes, January 22, 1778.

[29] *AC* 5:406; Lady Llanover's commentary.

[30] *AC* 5:407; MD to MP, February 27, 1779. The other quotations in this paragraph are also from this letter and are on pages 5:407-8.

[31] *AC* 5:421; MD to MP, April 17, 1779. The next quotation is also from this letter and is on page 5:422.

[32] The information in this paragraph is from Peter Bower, "An Intimate and Intricate Mosaic: Mary Delany and Her Use of Paper," in Laird and Weisberg-Roberts, *Mrs. Delany and Her Circle*, p. 237.

[33] Bower, "An Intimate and Intricate Mosaic," p. 238.

[34] Bower, "An Intimate and Intricate Mosaic," pp. 239-40.

[35] Bower, "An Intimate and Intricate Mosaic," p. 242.

[36] Bower, "An Intimate and Intricate Mosaic," p. 243.

[37] *AC* 5:379; MD to MP, August 21, 1778.

[38] *AC* 5:527; MD to MP, May 24, 1780.

[39] *AC* 5:571-72; MD to MP, November 3, 1780.

[40] Ford, "A Progress in Plants," p. 212, citing *AC* 6:17; MD to MP, May 3, 1781.

[41] *AC* 5:361; quoted in Lady Llanover's commentary.

[42] George Keate, *Poetical Works of George Keate, Esq.* (1781), quoted in Weisberg-Roberts, "Introduction (1): Mrs. Delany from Source to Subject," p. 11.

[43] *AC* 6:114; MD to MP, September 29, 1782. The quotation at the end of this paragraph is also from this letter and is on the same page.

[44] *AC* 5:377; MD to MP, August 21, 1778.

[45] David Stuart and James Sutherland, *Plants From the Past* (New York: Viking, 1987), p. 214.

[46] Alice M. Coats, *Flowers and Their Histories* (London: Adam and Charles Black, 1956, 1968), pp. 205-6.

[47] Conversation with Ruth Hayden, Bath, November 28, 2008.

[48] *AC* 5:443-44; quoted in Lady Llanover's commentary.

[49] J. Frederick Rankin, *Down Cathedral: The Church of Saint Patrick of Down* (Belfast: Ulster Historical Foundation in association with the Board of Down Cathedral, 1997), Chapters 8 and 9, esp. pp. 91 and 119.

[50] Avigdor Arikha, quoted in Stephen Coppel, "The Prints," in Duncan Thomson and Coppel, *Avigdor Arikha: From Life: Drawings and Prints 1965–2005* (London: British Museum Press, 2006), p. 23.

[51] Alicia Weisberg-Roberts, introduction to her transcription of *Marianna* in Laird and Weisberg-Roberts, *Mrs. Delany and Her Circle*, p. 250.

[52] Marianne Moore, *The Poems of Marianne Moore*, ed. Grace Schulman (New York: Viking, 2003), p. 254.

CHAPTER FOURTEEN: LEAVES

[1] *AC* 6:272; quoted in Lady Llanover's commentary. The Duchess's words later in this paragraph are also from Lady Llanover's commentary, on the same page.

[2] Quoted in Olwen Hedley, "Mrs. Delany's Windsor Home," *Berkshire Archæological Journal* 59 (1961), p. 51 n. 3.

[3] Quoted in Hedley, "Mrs. Delany's Windsor Home," p. 51.

[4] *AC* 6:451; MD to Mrs. Frances Hamilton, August 11-13, 1787. The next quotation is also from this letter and is on page 6:450. The first collection of Mrs. Delany's letters, published more than forty years before Lady Llanover's six volumes, was the short one-volume *Letters from Mrs. Delany (Widow of Doctor Patrick Delany,) to Mrs. Frances Hamilton, From the Year 1779, to the Year 1788* (London: Longman, Hurst, Rees, Orme and Brown, 1820). The two quotations are on pages 93 and 90 of this book.

[5] *AC* 6:472; Lady Llanover's commentary. The following quotations in this paragraph are from Lady Llanover's commentary on the same page.

[6] *AC* 2:504; MD to the Duchess of Portland, February 14, 1749.

[7] *AC* 2:468; MD to AD, June 20, 1747.

[8] *AC* 3:388; Dean Patrick Delany to AD, December 25, 1755. The next two quotations are also from Dean Delany's description in this letter and are on pages 3:388 and 3:389. The full description is on pages 3:387-93.

[9] *AC* 6:341; Lady Llanover's commentary.

[10] *AC* 6:417; quoted in Lady Llanover's commentary.

[11] *AC* 6:480; quoted in Lady Llanover's commentary. The other quotations in this paragraph are from Lady Llanover's commentary on the same page.

[12] *AC* 6:480; quoted in Lady Llanover's commentary.

[13] *AC* 6:481; quoted in Lady Llanover's commentary. The epitaph is also quoted in Lady Llanover's commentary, on the same page.

[14] Virginia Woolf, *A Writer's Diary: Being Extracts From the Diary of Virginia Woolf,* ed. Leonard Woolf (London: Hogarth Press, 1953), p. 102.

FLOWERS AND FACES
A List

opp. p. 1: Portrait of Mary Granville Pendarves (later Delany) in gold box, by Christian Friedrich Zincke, ca. 1740. © The Stuart Collection / Courtesy of the National Portrait Gallery, London

p. 17: *Scarlet Geranium and Lobelia cardinalis*, Bulstrode, 1773; Collage of colored papers, with body color and watercolor; 11-1/4 x 7-1/4 in. (28.7 x 18.3 cm); British Museum, Department of Prints and Drawings (1897,0505.529*) [Vol. 6, p. 29]; Inscribed on label with Latin name; verso inscribed with place and date of composition, "first essay" and "[5 - erased]"

p. 22: A silhouette cut by Mrs. Delany in the late 1760s at Longleat, thought to be the children of the third Viscount Weymouth and his wife Elizabeth, daughter of the Duchess of Portland (Margaret Cavendish Bentinck). Courtesy of Longleat Historic Collections

p. 27: Silhouette of children, detail

p. 36: *Cynoglossum omphalodes, Hound's Tongue* [now known as Omphalodes verna], Pentandria monogynia; St. James's Place, April 1, 1776; collage of colored papers, with body color and watercolor and a leaf sample; 8-3/4 x 7-3/8 in. (22.3 x 18.7 cm); British Museum, Department of Prints and Drawings (1897,0505.260) [Vol. 3, p. 59]; Inscribed on label with Latin and common name; verso inscribed with Linnaean classification, place and date of composition: "1[st?] april 1776"

p. 43: *Cynoglossum omphalades*, detail of plant matter (bottom leaf) and painted leaf (top)

p. 64: *Rosa gallica, Cluster Damask Rose*, Bulstrode, July 1780; collage

of colored papers, with body color and watercolor; 13-1/4 x 8-7/8 in. (33.5 x 22.6 cm); British Museum, Department of Prints and Drawings (1897,0505.739) [Vol. 8, p. 38]; Signed with monogram, and inscribed on label with Latin and common names; verso inscribed with place and date of composition: "July 1780"

p. 66: *Rosa gallica*, detail

p. 74: *Rosa gallica*, detail of leaf

p. 82: Parts of a Flower

p. 86: *Carduus nutans, Musk or Nodding Thistle*, Syngenesia polyandria aequalis, Bulstrode, November 26, 1776; collage of colored papers, with body color and watercolor; 12-1/2 x 9-1/8 in. (31.8 x 23.1 cm); British Museum, Department of Prints and Drawings (1897,0505.161) [Vol. 2, p. 60]; Signed with monogram in collage and inscribed on label with Latin and common name; verso inscribed with Linnaean classification, place and date of composition: "26 Novr 1776"

p. 95: *Carduus nutans*, detail

p. 106: *Papaver somniferum, the Opium Poppy*, Polyandria monogynia, Bulstrode, October 18, 1776; collage of colored papers, with body color and watercolor; 13-1/2 x 9 in. (34.3 x 23.0 cm); British Museum, Department of Prints and Drawings (1897,0505.648) [Vol. 7, p. 48]; Signed with monogram in collage and inscribed on label with Latin and common name; verso inscribed with Linnaean classification, place and date of composition: "18 Octr 1776"

p. 124: *Papaver somniferum*, detail

p. 140: *Lilium canadense*, St. James's Place, August 20, 1779, Prov.: Mr. Lee; collage of colored papers, with body color and watercolor; 13-5/8 x 9 in. (34.5 x 23.0 cm); British Museum, Department of Prints and Drawings (1897,0505.514) [Vol. 6, p. 14]; Signed with monogram in collage and inscribed on label with Latin name; verso inscribed with place and date of composition: "20 Augt 1779" and with donor of plant to Mrs. Delany: James Lee

p. 155: *Lilium canadense*, detail

p. 168: *Passiflora laurifolia, Bay Leaved,* Gynandria pentandria, Luton, August 1777, Prov.: Lord Bute; collage of colored papers, with body color and watercolor; 13-7/8 x 9-1/2 in. (35.2 x 24.2 cm); British Museum, Department of Prints and Drawings (1897,0505.654) [Vol. 7, p. 54]; Signed with monogram in collage and inscribed on label with Latin and common name; verso inscribed with Linnaean classification, place and date of composition: "Augt 1777" and donor of plant to Mrs. Delany: Lord Bute

p. 174: *Passiflora laurifolia,* detail

p. 193: Patrick Delany, attributed to Rupert Barber, ca. 1740. Courtesy of the National Gallery of Ireland. Photo © National Gallery of Ireland

p. 198: *Magnolia grandiflora, the Grand Magnolia,* Polyandria polygynia, Bill Hill, August 26, 1776; collage of colored papers, with body color and watercolor; 13-1/4 x 9-1/4 in. (33.8 x 23.4 cm); British Museum, Department of Prints and Drawings (1897,0505.557) [Vol. 6, p. 57]; Signed with monogram in collage and inscribed on label with Latin name; verso inscribed with Linnaean classification and place and date of composition: "[27 - crossed through] 26 Augt 1776"

p. 215: *Magnolia grandiflora,* detail

p. 232: *Lathyrus latifolius, Broad-leav'd Everlasting Pea,* Bulstrode, August 22, 1781; collage of colored papers, with body color and watercolor; 13-1/8 x 9-1/2 in. (33.3 x 24.0 cm); British Museum, Department of Prints and Drawings (1897,0505.501) [Vol. 6, p. 1]; Signed with monogram in collage and inscribed on label with Latin and common names; verso inscribed with place and date of composition: "22 Augt 1781"

p. 238: Cross-section of a Pea Blossom

p. 241: Anne Granville Dewes, frontispiece to *Autobiography and Correspondence of Mary Granville, Mrs. Delany,* ed. Lady Llanover, volume 3

p. 243: *Lathyrus latifolius,* detail

p. 258: *Sanguinaria canadensis*, Polyandria monogynia, St. James's Place, April 25, 1777, Prov.: Kew; collage of colored papers, with body color and watercolor and with a leaf sample; 9 x 8-1/8 in. (23.0 x 20.7 cm); British Museum, Department of Prints and Drawings (1897,0505.766) [Vol. 8, p. 65]; Signed with monogram in collage and inscribed on label with Latin name; verso inscribed with Linnaean classification, place and date of composition: "25 april 1777" and source of plant: Kew

p. 273: Ruth Hayden, artist unknown, ca. 1954

p. 283: *Sanguinaria canadensis*, detail

p. 287: Pauline Wright Peacock, 1940

p. 292: *Portlandia grandiflora*, Bulstrode, August 9, 1782, Prov.: Kew; collage of colored papers, with body color and watercolor; 13-5/8 x 9-3/4 in. (34.5 x 24.6 cm); British Museum, Department of Prints and Drawings (1897,0505.692) [Vol. 7, p. 91]; Signed with monogram in collage and inscribed on label with Latin name; verso inscribed with place and date of composition: "9 augt 1782" and with source of plant: Kew

p. 295: Margaret Cavendish Bentinck, Duchess of Portland, in gold box, by Christian Friedrich Zincke, ca. 1740. © The Stuart Collection / Courtesy of the National Portrait Gallery, London

p. 309: *Portlandia grandiflora*, detail

p. 316: *Physalis, Winter Cherry (Berry)*, Bulstrode, November [year not specified]; collage of colored papers, with body color and watercolor, and with plant fibre samples; 11-1/2 x 7 in. (29.2 x 17.9 cm); British Museum, Department of Prints and Drawings (1897,0505.672) [Vol. 7, p. 71a]; Signed with monogram in collage and inscribed on label with Latin and common name; verso inscribed with place of composition

p. 339: *Physalis*, detail

p. 350: Painting of Mrs. Delany by John Opie, 1782. © National Portrait Gallery, London

PEOPLE, PLACES, PLANTS,
AND PRACTICES:
An Index

Notes on the Index:
Mary Granville Pendarves Delany is abbreviated as MD.
Italicized page numbers refer to illustrations.

394

Acknowledgments

I was welcomed into the world of eighteenth-century scholarship and generously educated by many. First among them is Alicia Weisberg-Roberts, Assistant Curator of Eighteenth- and Nineteenth-Century Art at the Walters Art Museum, who patiently and wittily contextualized Mrs. Delany's life for me on many different occasions. Mark Laird, Senior Lecturer in the Department of Landscape Architecture at the Harvard Graduate School of Design, bolstered my initial enthusiasm and introduced me to many in his circle who would inform my ideas about Mrs. Delany. John Edmondson, Editorial Secretary of the Linnaean Society of London, gave me the education in botany that *The Paper Garden* required, correcting all my misconceptions with his good humor, generosity, and élan.

Kim Sloan, Assistant Keeper of British Drawings and Watercolors Before 1880, and Francis Finlay, Curator of the Enlightenment Gallery, at the British Museum, graciously welcomed me and instigated my thinking about amateur artists. My gratitude extends to many at the British Museum, especially Helen Sharp, Senior Conservator, Western Art on Paper, for her thorough explanations of conservation dilemmas, and the staff of the Prints and Drawings Study Room, particularly Angela Roche, Supervisor of the Study Room, for her ebullience (and magnifying glass), as well as Marta Cacho Casal and Alison Wright, who located and heaved up the albums of collages on multitudes of occasions. All of the women at the British Museum spiced my work with a detective's sense of fun, as did the perceptive Kate Harris, Curator, Longleat Historic Collections, UK, and the intrepid Marie Long, Curator-Librarian at the LuEsther T. Mertz Library, New York Botanical Gardens. Needless to say, with this sort of collaboration, any mistakes in this book are solely mine.

I also wish to thank for his generosity Ken Soener, Director of the Watson Library at the Metropolitan Museum of Art, and, for their vision in mounting the 2009–10 "Mrs. Delany and Her Circle"

exhibition, Amy Meyers, Director of the Yale Center for British Art, and Tim Knox, Director of Sir John Soane's Museum.

The Paper Garden began as an essay, "Passion Flowers in Winter," published in *PoemMemoirStory* no. 6 (2006), for which I thank editor Linda Frost. I am grateful as well to the late David Foster Wallace, who chose the work for *Best American Essays 2007*, and to the leadership of Robert Atwan, Series Editor for *The Best American Essays*. Without the foresight and gift of Shelby White, Trustee of the Leon Levy Foundation, I would not have been privileged to be one of the first-year Fellows at the CUNY Graduate Center Leon Levy Center for Biography. It was a life-changing experience, especially aided by the guidance and support of Nancy Milford, Founding Director Emerita, and Faculty Director David Nasaw.

To my agent, Kathleen Anderson of Anderson Literary Management, and to Ellen Seligman, Vice-President and Senior Editor at McClelland and Stewart, Canada, both long supporters of my work, I have the pleasure of layering the thank-you for this book onto the thank-you for others, blessing my career. To Scott Richardson, the stellar designer for the book, and to Erin Kern, sweet-spirited facilitator, a garden full of thanks. And to Susan Renouf, the editor at McClelland and Stewart for *The Paper Garden*, whose visual imagination and editorial gusto let it grow into what it has become, I am grateful nine hundred and eighty-five times.

Margaret Maloney and George Gibson at Bloomsbury USA trusted in the electricity of Mrs. D., and Henry Rosenbloom at Scribe Books believed that craft is life. They have given this book world wings.

Two artists, Canadian painter Julie Hedrick and American collage artist Caroline Golden, ventured to the Yale Center for British Art to see the "Mrs. Delany and Her Circle" show and to report back with their impressions. Friends Ann McColl Lindsay, Dale Mathews, and Barbara Feldon read drafts at crucial moments, and Joan Stein commented when the work was at a precipice. I thank them all for the bounty of their candor.

I am more grateful to Ruth Hayden than I can express here. She has been my teacher and my prompter, with the help of her good-natured son-in-law, Roger Verrier-Jones. My last thanks of course go to my husband, Michael Groden, note-checker, joke-maker, scholar-model, and runner. Some projects burgeon as if planted under a new spring moon, and our *Paper Garden* was one of them.

397

Molly Peacock is the award-winning author of six volumes of poetry, including *The Second Blush*. Her poems have appeared in the *New Yorker*, the *Paris Review*, and the *Times Literary Supplement*. Among her other works are *How to Read a Poem … and Start a Poetry Circle* and a memoir, *Paradise, Piece by Piece*. Peacock is a member of the Spalding University brief residency MFA graduate faculty, and is currently the general series editor of *The Best Canadian Poetry in English*. A transplanted New Yorker, she lives in Toronto.